FASHION DESIGN
ON COMPUTERS

M. KATHLEEN COLUSSY

Prentice
Hall

Library of Congress Cataloging-in-Publication Data

Colussy, M. Kathleen.
 Fashion design on computers / M. Kathleen Colussy.
 p. cm.
 Includes index.
 ISBN 0-13-083838-1
 1. Costume design—Computer-aided design. 2. Clothing trade—Data processing. 3.
Fashion merchandising—Data processing. I. Title.

TT518 .C73 2000
746.9′2′0285—dc21

 00-033651

Publisher: Dave Garza
Director of Production and Manufacturing: Bruce Johnson
Acquisitions Editor: Neil Marquardt
Marketing Manager: Ryan DeGrote
Editorial Assistant: Susan Kegler
Managing Editor: Mary Carnis
Manufacturing Manager: Ed O'Dougherty
Production Liaison: Denise Brown
Production Editor: Carol Eckhart
Interior Design and Composition: York Production Services
Art Director: Marianne Frasco
Cover Design Coordinator: Miguel Ortiz
Cover Design: Liz Nemeth
Cover Art: Marina/sis/images.com
Printering and Binding: Banta Harrisonburg
Cover Printer: Banta Harrisonburg

Prentice-Hall International (UK) Limited, *London*
Prentice-Hall of Australia Pty. Limited, *Sydney*
Prentice-Hall Canada Inc., *Toronto*
Prentice-Hall Hispanoamericana, S.A., *Mexico*
Prentice-Hall of India Private Limited, *New Delhi*
Prentice-Hall of Japan, Inc., *Tokyo*
Prentice-Hall Singapore Pte. Ltd.
Editora Prentice-Hall do Brasil, Ltda., *Rio de Janeiro*

10 9 8 7 6 5 4 3 2 1
ISBN: 0-13-083838-1

Dedication

To the two men in my life who have always loved and believed in me.

First to Jesus-thank you for your foresight in sending me on sabbatical to Italy

and encouraging me to go for a destiny instead of settling for a career,

and to Peter-who always knew when to make me coffee, give me hugs,

and most of all for always having listening ear and heart!

CONTENTS

Focus: Commercial and Industrial-Based Systems, Software and Jargon

Focus: Commercial and Industrial-Based Systems, Software, Desktop, and Tool Commonalities

Focus: Commercial and Industrial Vector- and Raster-Based
Software Distinctions and Universal File Management Operations

Focus: Commercial/Industrial/Vector-Based Drawing Tools
and Techniques, Including Managing Text

SECTION TWO Skill Level: Intermediate 133

Focus: Commercial/Industrial/Vector- and Raster-Based
Drawing Tools and Editing Techniques

Focus: The Principles and Secrets of Fashion Design and
Fashion Marketing to Design a Successful Line

Focus: The Business Side of Fashion (Sourcing and Researching Data via the Internet as Well as Using Other Traditional Resources)

Focus: The Principles and Secrets of Working with Color and Design

SECTION THREE Skill Level: Advanced 285

Focus: The Principles of Surface Design-Prints for Fabric or Flats on Vector- and Raster-Based Software

CHAPTER 11 Advanced Fashion Design Rendering Fabrics, Flats, and Prints 287

PREFACE

Remember when your parents displayed your elaborate "refrigerator art"? You know, the landscape pictures, the funny faces, and even the desktop doodles? In fact, I bet you can recall those oh-so-intricate patterns that bordered your notebooks and classroom notes. Some of us never moved beyond our basic artwork, but some very creative individuals found that their talents reached far beyond the basic sketches. These innovators fostered their interests to learn about design, colors, textures, shapes, and symmetry with the hope of using their creative talents in a professional artistic arena. Some entered the art world, surrounded by watercolors, oils, pastels, and canvas. Some found creativity buoyed by the excitement of the advertising field, and some found their focus as designers.

Designers have endless opportunities to expand their creative nature. Many have found success in the fields of industrial design, furniture design, interior design, and even special effects or set design. Some designers, recognizing the basic need for clothing for people of all ages, have found their niche in the textile and garment industry.

No matter what road the designer travels, the foundation and elements of color and design are similar, but what makes each unique is the specific skills and training they pursue. As designers develops their skills, they quickly learn to be competitive in their field. They must trade in their paintbrushes and sketching tables for a computer screen and a mouse pad.

With many years of experience both in the industry and the classroom, I know the overwhelming fear that grips you as you look for textbooks and manuals to help you make that transition. I also know that there are far too many books that will tell you what the industry wants you to learn, but few show you how.

Fashion Design on Computers is a firsthand look at today's designers and the demands they face in the global marketplace to produce products that will sell at profitable levels. More importantly, this book is a series of practical skill development using the computer as a design tool, written in a style that is easy to follow. The text, supported by a good sense of humor, is quite frankly, "down to earth," so everyone can understand the process.

Specifically, *Fashion Design on Computers* is geared toward the textile and garment designer. There is a particular emphasis on two types of fashion designers:

- Current fashion-design students, the designers of tomorrow. These individuals are filled with enthusiasm, ideas, and zeal, but generally have limited computer skills and limited or no practical business experience.
- Designers with experience who are working in the fashion industry, who have limited or no computer savvy or perhaps are very hesitant or resistant to designing with computers.

Both the novice and the seasoned designer will find this book helpful. In this workbook I will show you, through explanation and examples, the key elements of design using the computer. Then, I will provide hands-on exercises for you to complete.

The computer, which I call the "brain center," will be your tool to process your talents and accomplish the highest degree of professional work regardless of the hardware or software you are using. The exercises will be easy to follow and will help you develop more complex and detailed designs, with a great deal of self-confidence.

It is critical that you keep in mind that it doesn't matter which computer software program or version you are currently using. You will be discovering and learning the basic concepts of designing for fashion on computers. You are not going to learn specific software, you are going to master the concepts" then you are going to apply those concepts to any software.

It won't matter if you have industry-driven software while you are working in this book or if you are using commercially produced software programs; our exercises and projects have been developed for you to create and master using most industry-driven hardware and its companion software, as well as if you are using any commercial off-the-shelf software that can be used on virtually any personal computer.

I feel this is a win–win situation, especially if you have an opportunity to move into an exciting job, but find that the computer hardware and software may be different from what you have used in school or at your current job.

I realize that there are many systems are in workplaces today, and I wanted to give you the opportunity to learn how to design no matter what your tools.

So, with that worry out of the way, let's talk about some other fears that may be on your mind. One of the best facets of this book is that it will deal with many of the realities facing today's designer, including the biggest—coping with change. Many designers suffer with a natural resistance—frustration and fear—to using computers because they are a new tool.

The fact is that today many terms are tossed about on this subject from "shifting paradigms" or "models" (translation: the ability and willingness to embrace change).

Any way you say it, the fact remains: switching from manual designing to computer-aided designing (CAD) is a change in direction and a change in thinking. If you feel that fear or frustration because of all the changes, it's OK; it's only natural. Relax, you are not alone. It doesn't matter if you are new on the job and overwhelmed with responsibility or an old pro feeling the pressures of "teaching an old dog new tricks."

I have taken all of that into consideration when designing the exercises. The goal of this book is to keep the frustration and fear down, and the success and confidence high.

Every artist and designer starts with a vision of their final project—the goal they want to reach. I am no different. The goals for this book are to teach the basic concepts of CAD and then to allow you apply them. What this means is that I will be teaching you how to be the one driving the computer.

Although this might seem like a strange analogy, throughout this workbook I will often compare the development of your computer skills to the progress you made while learning to drive a car. I've asked you if you can remember your refrigerator art, well, can you also remember the first time you backed the car out of the driveway? Or what about the very first time you ever tried to parallel park—ugh! I know that some of those first attempts were rocky, and this transition, designing on the computer, may produce the same anxiety. Relax. The exercises will show you how to avoid "speed traps" and "potholes." Soon you'll be speeding along the computer highway as effortlessly as you did the interstate.

This book is about helping you "drive the computer" successfully into the new millennium!

Section 1 focuses on the foundational skills necessary for designing on the computer, discovering and using the universal drawing tools and menus shared by almost any vector- or raster-based software.

Section 2 is geared to the intermediate skill level of fashion design on computers, including applying the principles of design, fashion marketing, and color to create and render fashion on computers. Also included is a special section on sourcing, connectivity, and the Internet.

Section 3 focuses on the advanced techniques used by fashion designers on computer to design, render, and simulate prints and fabrics. In addition, there is a section for creating your own digital swatch book.

Section 3 is also a valuable resource for marketing and promoting fashion, including personal advanced promotional tools for the fashion designer.

From here it is important that we share with you what is *not* included in this book:

- Pattern making
- Grading
- Marker making
- Garment construction
- Actual production of garments
- Manual illustration
- Cost sheets and spec sheets

These highly technical topics won't be covered because a brief overview could not do them justice. Actually, each of these topics deserves to be a separate book unto itself.

The one thing we can say—using this book is like any journey, it is done one step at a time. To some of you it may feel like you are driving in heavy fog or blinding snow. Everything in you wants to panic, but if you just pay attention as far as your headlights will light up the road, pace yourself, and stay alert, you will get to where you want to go. In the grand scheme of things, so what if it takes you a little bit longer than the next car?

Just concentrate on developing your CAD skills. Those with flexibility, creativity, persistence, and "the" skills will be rewarded with the best job opportunities. So be prepared to know the industry and your competition. Designers who choose to master these computer skills will make a place for themselves in the world of fashion.

I hope for those of you still in school that you'll consider this workbook a part of your daily work tools long after you graduate. To those of you already in the field (maybe even struggling to learn how to adapt from the manual skills of design to computer design), I hope you will consider this book a valuable resource as you enter the "on ramp" of the computer highway.

Remember you are the designers who are kicking off the 21st century. And while you're learning some new technical skills, I hope you'll dig out an old piece of "refrigerator art" and tape it up as a reminder why you chose this exciting creative field in the first place! Now let's get started!

M. Kathleen Colussy

A special thanks to manuscript reviewers: Professor Ann Kellogg, The Illinois Institute of Art; Karen Guerra, San Jacinto College South; Doris M. Davis, Los Angeles Valley College; Kathy Callahan, Central Missouri State University; Lark Caldwell, Texas Christian University; Carolyn Blount, Shoreline Community College; Sue Sharp, University of Southern Mississippi.

P.S. Don't forget to utilize the special area designated for you, entitled: Student Notes. On each page there is ample room for you to jot down any new notes, ideas, renderings or doodles as they pertain to topic or exercise . . . *so enjoy!*

ACKNOWLEDGMENTS

Nobody does anything of any value alone in this world and this project was no different. There are many people that must be acknowledged.

First and foremost to Peter Friedrich—you helped bring Zippy to life! You are amazing!

And to Robert Layton Massengill and the AIFL Fashion Department for 16 years of being my other family. . .I love and appreciate you.

To the folks at Prentice Hall, Elizabeth Sugg for taking the chance sight unseen. To the others who have helped "birth the baby"—Denise Brown, Mary Carnis, Debbie Yarnell, and the Marketing Department and Delia Uherec, Carol Eckhart and the team of York Graphic Services, and especially Debbie Stone. To my editor, Neil Marquardt, for sharing the enthusiasm!

Finally to the members of the fashion industry and others who have graciously given time, talent, products and support: Thank you!

Adobe Inc. (Kevin Connor and J. Fowler)

AOL

Bill Glazer and Associates, specifically Wendy Carbona

Corbi's Stock Images

Corel Corp.

Diane Blazy

Doug Hicks

Gerber Technology, specifically Del Rose (You're in the will.) and Hugo Marellto

Helena Hart and Meredith Rossi of StyleClick (formerly ModaCad)

Jane Vigna, Debbie Rose-Meyers, Clara Stewart, and Alejandro Delgado for their computer savvy and support!

John Linsk

Kara Delgado

Karen Kane (P.S. I wear an 8—just kidding!)

Kris Boatright (Gee, thanks for sending me to Denver. Look what you started!)

Lorna Hernandez

Marcia Wratcher and Michael Maki of EMC (can we think outcome objectives?)

Margarita Kiang, Gudrun Ossurar, Katalina Quiroga, Yannique Richards, and all of my students who have been my inspiration and joy!

Mary Sherman of Ned Graphics, Inc.

MetaCreations (T. Bridwell)

Micrografx, especially Ryan Packor

Monarch, Inc., especially Steven Greenberg, Bruce Pernick, David Matsil, and Jessica DiPalma

Pamela Dennis (A woman whose Yes means Yes! Can we all be like you when we grow up?)

Reviewers: To all the faculty reviewers across the country, thank you. "Wounds from a friend are better than kisses from an enemy!"

Robin Lenart (to dreaming, submission, and to a cow shouting from the roof top. Now it's on to the camels!)

Quark Inc. (Nellie Evans)

Software Excellence by Design (Grab-it Pro Software) (Eric Anderson and Jodi)

Susan Meller of InfoDesigns Inc.

The GNC Dirty Dozen—Steve, Debra, and Dick, prayer does work!

To an anonymous friend who pointed the way and then graciously stepped aside.

UMAX Inc. - Rick Thorp

Throughout this book we will be referring to a wide variety of companies and their products, including those who fall under the category of commercial programs. These programs can be obtained by anyone with a computer from a variety of redundant retail and wholesale sources. However, before we define the significance of each of these types of software, we wish to take a moment to acknowledge the companies who have contributed so much to this book. (Please note that in this book every occurrence of the company name listed below is for *each* of these companies as well as mention of one of their products.) It should be understood that all the ownership, trademark, and rights of property for each of these companies is herein duly noted.

Adobe Inc.™ Adobe PhotoShop®, Adobe Illustrator®

CorelDRAW®/Corel Corp.™

Deneba Canvas™

Gerber Technology™

Grab-it Pro™

Macromedia® FreeHand™

MetaCreations™

Micrografx® Designer

MicroSoft Windows/MicroSoft Inc.™

Ned Graphics, Inc.™

Pantone®, A trademark for Pantone Inc.™

TRUMATCH™

SnapFashion/Bill Glazer®

StyleClick™

Quark, Inc.™, Quark XPress™

SECTION ONE

Skill Level: Elementary

CHAPTER 1

The Design World

Focus: Commercial and Industrial-Based Systems and Software

CHAPTER OBJECTIVES

■ Overview of the role of computers in fashion design in a global environment Introduction to the key players in the business world of fashion design

TERMS TO LOOK FOR

brain center	production
concept-specific	software-specific
connectivity	sourcing
design	vision

First and foremost, we'd like to introduce you to our world, individually and collectively. You are probably wondering why I have said *we*, not *I*. The answer is actually very easy. Writing about designing fashions using computers involves such diverse skills, along with up-to-date knowledge of software that the task simply cannot be handled alone. As I prepared this manuscript I had input and assistance from: leading computer and software firms, graphic designers, photographers, other educators, and industry leaders in both fashion and fabric design. So you can see, I do not consider this a singular effort, but instead it is a collaborative effort, reinforced by the voices of many.

As I begin, let me establish a foundation as to how we all view the world of design—and most importantly the steps we will follow to design on the computer. The design world is one energized by colors; inspirations and dreams meet the world of business, which is focused on deadlines, consumer acceptance, and profitability. There is a central point, a "brain center"—a computer system. Yes, computers, not people, are being relied on to manage all these facets during economic times that demand lightning-quick efficiency. This brain center first connects two very competitive worlds—design and business—and then has the capacity to relate, exchange, and agree on answers that can make changes faster and more economically than ever before.

The global marketplace is without a doubt, connected by technology. Bill Gates, Microsoft Chairman and CEO, predicts that the "PC will be in over 60 percent of U.S. homes by 2001 and the PC and the Internet will become as fundamental tomorrow as the automobile is today" (speech at an event celebrating the launch of Windows 98, San Francisco, June 26, 1998). The Microsoft Web site's home page goes on further to cite Steve Ballmer (another Microsoft executive), who quotes a report by Nathan Associates Inc., about an upcoming industry trend: "1.3 trillion will be spent on information technology, hardware, software, people, labor around the world this year" (speech given at Empowerment 2000, Seattle WA, February 10, 1998). Those are powerful statistics!

It would be so easy if we could write a book about one specific computer system or one specific program that could handle all the business tasks. Unfortunately, there is no one computer system or one software program that does it all, to satisfy everyone. Instead, the computer is simply a hardware system that can today incorporate common programs to assist designers in developing and manufacturing textiles and garments. It would also be so much easier if we could tell you that you should use a specific hardware system and learn only one program. But we can't because there are so many choices—and they are *all* being used in the fashion industry today.

No matter what type of hardware you have, the programs you use are what matter. The bottom line is, what you need to know is how to make your programs work for you most effectively. You also need to understand the fundamentals common to all programs, because you do not know what type of system or programs you will use for the firm that hires you.

Remember, it doesn't matter which computer software program or version you are currently using. You will be learning the basic concepts of designing for fashion on computers. You are not going to learn a specific software package; instead, you are going to master the concepts then apply those concepts to *any* software.

Therefore, the thrust of this book will be on universal computer software features for performing a specific task. This means that the focus will be "concept-specific," not "software-specific." This will keep confusion to a minimum. However, there are other factors we need to acknowledge, the most important being learning style and learning curve. Combine these with technical equipment (computers) and the mix can get very interesting.

Each of us has a different learning style; some styles are auditory, some are visual, some are sequential, and some are global, to name just a few. Many fashion-design students are both visual and global. So, what does that mean for our readers? It means that most of you prefer a textbook to "show you, not just tell you." And for some it means

before we show you, we need to tell you first where you are going, to clearly demonstrate to you the sequence of how to complete the task. Does that sound like you? If it does, you are not alone. We will follow just that sequence in this book.

Our book will incorporate exercises that challenge the cognitive, affective, and psychomotor domains. It will be highly visual and in a sequential format for the global learner.

Remember, almost every business or institution is driven by outcome objectives and budgetary restraints. Therefore, every attempt has been made to bring each topic into focus by concentrating on the features that all computer programs share.

The material this book covers is considerable—to some formidable. Along the way you will learn more about yourself—your learning style and learning curve—and about applying what you have learned to mastering computers. This new knowledge will go a long way after graduation in the real world of business and fashion.

Before you start learning the "how-to's," it is necessary that you learn the importance of each task that the computer can facilitate and the roles of the key users of the computer. The players include the designer and the operations manager, also known as production manager or business manager. These are the people who run this brain center, both working toward success, but traveling different roads to the end result—a successful line.

Before we start working on the computer, we'd like you to meet the players, and take a look at the role they play in our world of design. Each one understands the challenges of tackling a complex subject and wonders if there is some way to break down so much information or material, with the least amount of effort or angst. That is why we have chosen to start with the author's perspective first. Let's see if the worlds of business, fashion and education can mix.

FROM THE AUTHOR'S PERSPECTIVE

Meet M. Kathleen Colussy, Designer

Background

Graduating with a Certificate in Interior Decorating then earning degrees in Fashion Marketing, Business and Psychology certainly prepared Kathy to deal with colors, fabrics, fashion, business and people. However, to some, Kathy's insights come from her career as a knitwear designer. Her first collections were developed under her own label for major specialty boutiques/stores and then later for a misses' label.

During those years of designing knits Kathy was also teaching several design classes at a local college. This set a foundation for her to design "how-to" patterns for many of the top magazines, including *McCall's*, *Vogue Knitting*, and others. She also conducted training seminars, developed audio tapes, and authored numerous "How-to" booklets for other major knitting-related firms in the United States.

Thoughts

To say my background has prepared me to write this book would be an understatement. In recent years I participated in a year-long research and development effort writing curriculum for fashion students. As I began my research I discovered the obvious—not all schools have the same budgets and outcome objectives based on the school's education philosophy, student demographics, and geographical location.

What we all had in common was the need to prepare fashion-design students to enter the new millennium, using all the tools available to create fashion, including the computer. It seemed to me that there was real resistance to this. In some cases, the resistance came from the most unlikely sources—the educational system, other educators, students, and even some in the fashion industry itself. Resistance of any kind usually results from fear of the unknown, time constraints, budget constraints, lack of training, control issues, or other personal agendas. But let's face it, that's life. The challenge was to find a middle ground. The fact remains that computers do save time and money and increase productivity and creativity. Now the question was "How could we work together to prepare the next generation of designers?"

The answer resulted in the birth of this textbook. Trust me, it was quite a "pregnancy" to carry and deliver. Everyone had an opinion on everything—what and who should or should not be included. So when I tell you that I know where you're coming from, trust me. I know how hard it is to learn something new and to attempt to keep "twenty-gazillion" people happy at the same time. Ugh!

However, coming from a creative background I still see life through those eyes. Those experiences and influences, along with personal beliefs, are the filtering system I use even today when meeting challenges. As both a designer and an educator I have a few analogies I would like you to keep in mind as you begin the workbook section of this book.

First, let me share with you an old saying that still applies today—"iron sharpens iron." Think of how a blade is sharpened, by striking up against another equally strong metal surface. Often sparks fly from the process. Many times in your life you will be challenged by strong individuals, who will be determined to sharpen your skills in a manner you may deem unsuitable or uncomfortable. In fact, you may find that you associate these feelings with being "stuck by a knife." From *your* perspective, you may even believe that this was the intention of the confrontation. This may or may not be the case; the point is that you will find that this book is not just about computers, but also about the people who operate them. It is about learning more about you! Are you really in it for the long run? What are your goals, needs, agendas? Only you can answer these questions.

Computers are simply a tool, just like a pencil or paint brush. You will face challenges that will evoke reactions or responses. For example, your boss tells you that Marketing wants you to show them the line in three more colorways by noon. Your response is (here's your first quiz):

a) Shoot the messenger.

b) Run to the restroom and cry.

c) Call your mother or best friend to complain.

d) Change jobs.

I hope you won't do any of the above, but instead remember your training and let the computer do it for you (oh yes, in case you failed this quiz, there will be a retest in Chapter 10).

Begin now to think of the computer as your very own staff of artists, just waiting for your command. So, when the sparks fly, your boss or the marketing department is not the enemy always trying to "stab" you, they are helping you to sharpen the product so that the most important individual is happy—the consumer.

The next old saying (It's great fun to tell stories. Am I showing my age or what?) also applies to the fashion-design business: "Wounds from a friend are better than kisses from an enemy." As a young designer I would go into a buyer's or editor's office with my work and with much pride would proclaim, "Ooh, pretty. I make, you buy." (Actually my communication skills at that point were a little better than that, but you get the idea.) The problem came if they objected for any reason to my creation. My response inside was "How dare they? Just who do they think they are? Murmur, murmur, #@%*!" Acting out these emotions could have been a disaster. Fortunately, here's where some business and marketing training paid off. I would ask myself: "How do you define an objection?" Simply put, an objection is "a question in disguise." Meaning, "Convince me," or "I need more information." OK, but what if it does not sound like a request or a question, but more like a rejection or, even worse, a command for you to change your creation. What do you do? (Remember that quiz you just took?) Let me remind you, some "wounds" really are better than someone telling you "Your work is simply fabulous darling . . . kiss, kiss," and then they don't buy it , or even worse, they go to someone else who *will* make the changes.) So stay flexible.

If it hasn't yet occurred to you, leaning this lesson alone is worth the price of the book. Believe me, I've failed a couple of quizzes along the way too, especially during the process of putting together this book. (Remember, learning is a process, not a destination.) But like you, I had to allow the process to work in me. I learned to incorporate the information that needed to be covered, as validated by my research, along with making it into the kind of book I knew Providence had placed in my heart.

So, when you find yourself about to panic, STOP. Evaluate what is really going on. Is it pride, panic, or fear (of rejection, of the unknown, of feeling inadequate)? My advice is, Don't ever give up.

One last thought—when the computer says "Hit any key to continue," resist the temptation to use your fist. And remember, a prayer or two can't hurt.

Next, let's meet our computer tour guide—Zippy. Zippy will be your personal computer instructor on our journey to the world of fashion on computers, or computer-aided design (CAD) (See Figure 1-1).

WHAT DOES THIS BRAIN CENTER REALLY DO?

Vision

A designer begins with a vision. Most good designers will tell you they spend months just collecting "things." In the fashion industry, you often hear designers talk about clippings and swipes. Clippings, or swatches as they can also be called, are small sections of fabrics.

FIGURE 1-1 The Design World.

Designers may pick up a clipping just because they like a color, the texture, or the print. They may hold onto a thread or fabric finish they find interesting. Swipes are simply collections of pictures, not usually of a specific garment, but instead of colors, shades, trims, details, embellishments—anything a designer finds interesting. Inspiration for a design can come from many influences, even in day-to-day life.

Designers may be stimulated watching a vintage movie with its larger-than-life icons wearing elaborate costumes. Perhaps listening to a song makes them "wanna dance," or maybe they are inspired by the colors of a sunset they saw on their last vacation.

Trust us, it is not unusual for designers to have collections of leaves, rocks, flowers, or other "things" around their office just because something about the color or texture fascinated them. In fact, designers often travel the world to find ideas from different cultures.

All or just one of these diverse examples can be the inspiration for a new collection or line. These visions are then integrated into designs. However, the visions that inspire the designer are not the only criteria for design. Designers must work within the framework of their company objectives and translate these influences into products that the company's

a) Shoot the messenger.

b) Run to the restroom and cry.

c) Call your mother or best friend to complain.

d) Change jobs.

I hope you won't do any of the above, but instead remember your training and let the computer do it for you (oh yes, in case you failed this quiz, there will be a retest in Chapter 10).

Begin now to think of the computer as your very own staff of artists, just waiting for your command. So, when the sparks fly, your boss or the marketing department is not the enemy always trying to "stab" you, they are helping you to sharpen the product so that the most important individual is happy—the consumer.

The next old saying (It's great fun to tell stories. Am I showing my age or what?) also applies to the fashion-design business: "Wounds from a friend are better than kisses from an enemy." As a young designer I would go into a buyer's or editor's office with my work and with much pride would proclaim, "Ooh, pretty. I make, you buy." (Actually my communication skills at that point were a little better than that, but you get the idea.) The problem came if they objected for any reason to my creation. My response inside was "How dare they? Just who do they think they are? Murmur, murmur, #@%*!" Acting out these emotions could have been a disaster. Fortunately, here's where some business and marketing training paid off. I would ask myself: "How do you define an objection?" Simply put, an objection is "a question in disguise." Meaning, "Convince me," or "I need more information." OK, but what if it does not sound like a request or a question, but more like a rejection or, even worse, a command for you to change your creation. What do you do? (Remember that quiz you just took?) Let me remind you, some "wounds" really are better than someone telling you "Your work is simply fabulous darling . . . kiss, kiss," and then they don't buy it , or even worse, they go to someone else who *will* make the changes.) So stay flexible.

If it hasn't yet occurred to you, leaning this lesson alone is worth the price of the book. Believe me, I've failed a couple of quizzes along the way too, especially during the process of putting together this book. (Remember, learning is a process, not a destination.) But like you, I had to allow the process to work in me. I learned to incorporate the information that needed to be covered, as validated by my research, along with making it into the kind of book I knew Providence had placed in my heart.

So, when you find yourself about to panic, STOP. Evaluate what is really going on. Is it pride, panic, or fear (of rejection, of the unknown, of feeling inadequate)? My advice is, Don't ever give up.

One last thought—when the computer says "Hit any key to continue," resist the temptation to use your fist. And remember, a prayer or two can't hurt.

Next, let's meet our computer tour guide—Zippy. Zippy will be your personal computer instructor on our journey to the world of fashion on computers, or computer-aided design (CAD) (See Figure 1-1).

WHAT DOES THIS BRAIN CENTER REALLY DO?

Vision

A designer begins with a vision. Most good designers will tell you they spend months just collecting "things." In the fashion industry, you often hear designers talk about clippings and swipes. Clippings, or swatches as they can also be called, are small sections of fabrics.

FIGURE 1-1 The Design World.

Designers may pick up a clipping just because they like a color, the texture, or the print. They may hold onto a thread or fabric finish they find interesting. Swipes are simply collections of pictures, not usually of a specific garment, but instead of colors, shades, trims, details, embellishments—anything a designer finds interesting. Inspiration for a design can come from many influences, even in day-to-day life.

Designers may be stimulated watching a vintage movie with its larger-than-life icons wearing elaborate costumes. Perhaps listening to a song makes them "wanna dance," or maybe they are inspired by the colors of a sunset they saw on their last vacation.

Trust us, it is not unusual for designers to have collections of leaves, rocks, flowers, or other "things" around their office just because something about the color or texture fascinated them. In fact, designers often travel the world to find ideas from different cultures.

All or just one of these diverse examples can be the inspiration for a new collection or line. These visions are then integrated into designs. However, the visions that inspire the designer are not the only criteria for design. Designers must work within the framework of their company objectives and translate these influences into products that the company's

Skill Level: Elementary

target market will buy and wear. Already you can see it happening—the designer can never have just a pure artistic thought; the business side is starting to inch in, and the creativity is being influenced, or worse yet, stifled. Or is it? Let's see just how designers can convert their artistic ideas into a product.

Design

After a designer has the inspiration to build a line, the computer will take over in ways unheard of before. In fact, in this workbook, after you review the basics, this will also be your starting point. You will work with tools to bring your visions to life, by following an easy-to-understand step-by-step process. You will see how the computer becomes a designer's palette of colors and a tool to change font styles and create or enhance a personal graphic. The computer, and its programs, will serve as your own personal image maker.

Before you think that it will be a smooth transition from vision to design, don't get too comfortable. Remember how the designer was interrupted to think about the consumer while visions and inspirations were first flowing? Well, while a designer is working on the computer to actually create designs, the demands of the business are beginning to penetrate the designer's inner sanctum. The production managers are building a network of sources where they could find the materials and trims and manufacturing facilities for the line being developed. This is called sourcing.

We certainly will cover the influence of sourcing on the design process, but we want you to know that you won't have a slow and easy ride traveling around the world of design. Often you may have to cut straight across "our world" and get some advice (or to be more specific, some prices and availability) before the designs you create can get into the production cycle. Don't worry, it can be done easily. Your "brain center" can log on to the information superhighway and use the Internet to provide answers with lightning speed.

But now, back to the design functions, and how designers can rely on computers to assist them. This list is by no means conclusive, just ask any designer to detail their list of responsibilities or descriptions for a typical day and these will be only part of their job. The following just happen to fall under the design aspect of "our world." The designer, with the help of his or her "brain center," will:

- create logos for labels or hand tags
- select colorways
- render concepts
- transmute the ideas of someone else into a tangible product
- create and illustrate the line
- determine the silhouette
- design or determine the textiles to be used, and reason why
- source fabric, findings, and more
- develop mood boards
- fine-tune work boards
- generate and calculate cost sheets and spec sheets
- make and grade patterns and make markers
- make modifications, including updating lines from season to season
- meet budget requirements and deadlines
- prepare presentation boards, sales sheets, and catalogs

Sourcing

Yes, here's that word again. You've just read the list of skills the computer can help you with in the design process, and this word, *source,* and/or *sourcing,* pops up again. What does it mean? And why can't you just design? Here's a quick explanation: While the

designers are learning the basics, they are also focusing on the trends that will actually help make, or break, a fashion season. In the fashion industry this is called sourcing. Sourcing, in itself, can be overwhelming because it does not focus on just one topic. Seeking out information on (sourcing) consumer lifestyles and attitudes, and knowing the buying power of a target market, can be as important as finding the right sources for raw materials, production, or even sales. Without focused sourcing, both design and business will fail.

We'll help you in Chapter 9 to build a framework on what and how to source, and even more importantly some suggestion on where to find things on the computer. This will serve as a lifeline for designers, making sure they can connect their visions to the right consumers. Our primary focus will be sourcing for fabrics, findings, and manufacturers—crucial for the actual design process. We will also give you a few tips about sourcing data for fashion and consumer trends that will certainly help those working in the marketing and sales segment.

Production

We are not going to cover technical pattern-making, grading, and marker-making to produce a line. Those topics are very technical and deal more with the actual manufacturing/construction phase of the production process. There are many books that cover each of these topics in great detail. Does the computer play a role in those areas? Absolutely! In fact the costs and quality of garment manufacturing continue to improve because of computers.

Although we are not focusing on the machinery/construction and manufacturing of the garments, it is important for you to recognize the financial challenges a designer faces in bringing garments to production. This is where the real tug-of-war often begins. The principle players in production will directly determine the financial success of manufacturing the product at this point. Simply put, these dollars-and-cents people want to know:

- How much it is going to cost to make?
- How long will it take to get to the consumer?
- And most importantly, once it is made, will the consumer be willing to pay the price?

This is not an easy task. A designer can pour one to two years of his or her life into the creation and development of a line. Then when someone comes in with specification and production sheets, topped off with cost sheets that focus only on price, well, the results can often be frustrating! When one person is trying to convey an idea that they feel will revolutionize the way consumers see their clothing, and the other person only cares about the bottom line, who wins? They both do. Remember, "iron sharpens iron."

You will see how the computer can help each side fine-tune and sharpen their decisions by sourcing again for the most competitive production and manufacturing prices. The computer actually will serve as the arbitrator. With this brain center as the source of all the information, both the designer and the production manager can put in suggestions or try out ideas, without wasting materials or incurring any unnecessary labor costs, before making a final decision. With the computer acting as a clearinghouse for ideas, changes and decisions can be made that will both maintain the integrity of the design and maximize profits. This way, both the design and production managers have detailed the problems and both know they are winners.

Sales and Marketing

Now, if you think the designer was done at that point, or if the computer has about been drained of its capacity to do more, fasten your seat belt! You are now entering the marketing and sales wing of the business department. Here it gets a little more crazy, because these number crunchers are expected to relate effectively to the designer's visions in sales presentations, marketing plans, and advertising/promotion vehicles. All we can say

at this point is thank Heaven for the computer! Ultimately, the computer will be able to present the designer's philosophy and vision with:

- presentation boards
- on-line catalogs and Web sites, that are interactive
- three-dimensional simulation of garments (which is the one of the hottest new trends!)

All these tools will assist the sales and marketing team with presentation boards that can sell products to buyers without buyers ever leaving their offices. Just think, if Bill Gates is right, then 60 percent of U.S. homes will be able to shop from the comfort of their homes or offices with the click of a mouse—many are already doing so!

Connectivity

You may never have heard this word used before. Don't worry, it really isn't part of one's daily verbiage; but it is a very special word in the fashion world. *Connectivity* means electronic communication between computers, machinery, business operations, and people. Connectivity prevents chaos and ties it all together.

Often, changes to a line are made right up until the time of production, or even the night before the season's sales launch. We admit that at this point the designer will take a bit of a back seat and the business/production side of the line development will have to take over because it is crucial that all the purchasing, design, production, and sales members know what is going on. With everyone in the design world working on a different aspect of the line, the computer will serve as a tracking system to tie together everyone around the world and to make the necessary design and financial changes that will ensure deliveries, accuracy, and quality products.

Here is an example of what we mean. The fashion world is actually one of the industries to spearhead global integration. Wool from Australia can be woven in Italy, designed in Italy, shipped to Hong Kong for manufacturing, and ultimately be sold in the United States. The design, marketing, and communication can either be a nightmare or a technological dream. Using the computer, you can you modify, change, and adapt a pattern, cost sheets, and spec-sheet forms according to changes in design. Then you can send them electronically to another location on-site or around the world. Once these changes are made, they will be tracked though the product-management flow. This means all workstations will be notified about the updated information or changes through a central communication system— your brain center—no matter where in the world they are located. All the principles— design, marketing, production, manufacturing, and sales people, everyone involved in the product development cycle—will be notified, simply by clicking the computer mouse.

Our "design world" is a wonderful arena—one you should find fascinating. This book is clearly broken down into skill levels, beginning with a quick review of the basics. You will find it helpful to be familiar with the following:

- Foundational computer skills, using a Windows-based program
- Basic design skills: colors, aesthetics, proportion, balance
- Basic research skills: identifying industry trends, consumer trends, and fashion
- Forecasting
- Design evolution: creating a line from the mood board through the work board
- Board preparation and presentation: incorporating elements of design with marketing skills

If you don't feel solid with some of these skills don't feel that you can't get through this book, you can. But we feel it will assist you tremendously if you spend some time brushing up on the basic manual design/production techniques and terminology.

In fact, if you need a bit of a computer review, be sure to spend time in Chapters 3 and 4. We have devoted those chapters to reviewing the terms you will encounter while using the computer, and then give you a quick refresher course on basic computer skills.

We will focus on design and production exercises in later chapters, and will show you:

■ Why: The importance of why you have to learn something, and the role that concept plays in the design process.

■ What: An explanation of what tools and skills you will need. If possible we will also show you how you might approach this task manually. It is important for you to manually think through the process before adapting it to the computer screen.

■ How: Probably the most important. We will walk you through these exercises step by step so you feel confident developing your design skills.

We really believe that you will become, just like us, attached to your computer, because of the ease it affords you in creating your products, knowing your customer, and meeting those deadlines. Once you get comfortable with the skills, you'll wonder just how you ever managed without it!

We have discovered that the well-known designer Tommy Hilfiger produces 12 new apparel lines each year. Can you imagine attempting that without computers? Eric A. Taub of *MacWeek* ("Fashion designers join computer generation," June 29, 1998) points out that this includes evaluating 1000 variations on that season's colors, fabrics, and prints. Taub interviewed Jodi Brown, a computer-design manager at Tommy Hilfiger, who stated: "With our volume, we'd never be able to make a line without using computers. . . . We're not doing the same amount of work in less time, we're doing more work in the same amount of time."

You too will be able to produce more work with better quality in less time as you develop your computer expertise. But before you abandon your pencil and paper for a computer and a disk, in Chapter 2 we are going to give you a brief background about computer systems and programs that are going to help you design.

CHAPTER SUMMARY

The computer is the brain center for designing and producing fashion. Computers and CAD software are an integral part of the fashion world.

Fashion today is a collaborative effort by fashion designers, graphic artists, photographers, and business and marketing professionals, all coming together to produce vital and viable fashion products for today's consumer.

Connectivity is the key to linking computers, people, and machinery.

CHAPTER 2

What Equipment and Programs Should This "Brain Center" Use?

Focus: Commercial and Industrial-Based Systems and Software

CHAPTER OBJECTIVES

- Introduction to computer-aided design/computer-aided manufacturing (CAD/CAM)
- Cultivation of a better understanding of the changing roles of traditional fashion design and designing for fashion on computers (CAD)
- Development of an awareness and appreciation for the relationship of business, marketing, and design
- Overview of the "connectivity" and the role of computers in the global world of fashion
- Distinguishing between industrial and commercial/off-the-shelf software
- Introduction to the difference between vector- and raster-based software

TERMS TO LOOK FOR

application software	DOS	operating system
CAD	global market	platform
CAM	image editing	raster-based
commercial software	industrial software	third-party software
computerese	off-the-shelf software	vector-based

We have only skimmed the surface of what computers can do for you. In this chapter it's time to move on to some specific talk about computers, computer systems (often called platforms), and the programs you may use.

Before we go forward, you're probably wondering why we don't tell you exactly which system and which program you need to know how to use. We can't, they are all important. Face it, you can't tell a new employer they have to purchase a specific computer hardware system or software program because that is what you were trained on. The system a company chooses will depend on their needs and financial resources. Your new employer will be making an investment in your skills; they don't need or want to buy more tools. But don't worry! You'll learn the skills common to most systems and software programs as you work with exercises in this book.

Remember, it doesn't matter which computer software program or version you are currently using. You will be learning the basic concepts of designing for fashion on computers. You are not going to learn a specific software package; instead, you are going to master the concepts then apply those concepts to *any* software.

Let's take a look at how a multiprogram, dual system is used in a real-world scenario. In the article "For Best Color, Designer Mixes Three Platforms" (*MacWeek,* August 3, 1998), Erik Sherman states "Like many corporations Calvin Klein's choice of computer platforms is driven by its choice of applications software. Each department has selected the applications it needs and then picked the appropriate platform." The article continues, "The graphic design department used Adobe Photoshop and Quark Xpress on the Macintosh . . . the product design department relies on the Product Data Management (PDM) from Gerber Technology Inc. of Tolland, Conn. . . . The designers produce garment sketches using Designer from Micrografx Inc.; the textile department used two specialized CAD applications, U4ia by Computer Designing Inc. of Grand Rapids, Mich., for knit fabrics and Design3 Weave CAD by Cis Graphics Inc. of Salem, N.H., for wovens." Here's a quick layperson translation of what Sherman means. The production department uses an industrial PC-based software, the design department uses a third-party/off-the-shelf software on a Mac platform, and the marketing department uses both the Macs and PCs.

As you just read, the system a company chooses will depend on their needs, so you can see why we are not advising you to use one type over another. Our job is to show you how to create textiles, garments, work boards, spec sheets, or cost sheets, no matter which system a company owns. The brain center will simply serve as a tool to allow the design and production process to be implemented successfully.

This chapter will introduce you to the common characteristics of industry systems/platforms using either industrial or commerical software programs. To learn more about specific programs we have developed a quick-reference appendix for you to review that will identify programs, the skills needed to operate them, and the common characteristics. In fact, taking a look at the appendix will give you a strong insight into the many popular programs in the marketplace today. So, don't wait till you get to the end of the book, take a break when you finish this chapter and check it out for a well-rounded overview.

LET'S TALK ABOUT THE COMPUTER

Which platform should you use, a Mac or a PC? (Mac is short for Macintosh and PC is the acronym for personal computer.) The designer's argument about which system (or platform) is better, is as fiercely debated as car owners arguing the benefits of Ford versus Chevy. Our answer is simple—be familiar with both. We know, you probably think we just can't make up our minds, but we prefer to think that we are open-minded. Bear with us, as we show you that in today's design world you cannot stay isolated in a preferred environment. Don't worry about the differences between the systems. You'll learn that the similarities between systems are overwhelming, and a bit of cross-training will certainly improve your worth to the job market.

You're probably thinking, "What do they mean?" So let's take a minute to explain this a bit more. The design department will have to communicate with the marketing department constantly, and so will their computers. What you will discover is that different departments use one computer and its operating system over another. That is what Sherman was pointing out in the Calvin Klein operation.

- The Design Department: The design team will generally use: vector-based-drawing programs and raster-based-image programs to create a line. These software programs can be driven on either Mac or PC systems.
- The Production Department: To maintain the accounting functions and production flow of a collection or line, the production manager relies on database or spreadsheet-style software that will display vector-drawing images of garments or details. These software programs also can be driven on either Mac or PC systems.
- The Sales and Marketing Department: The sales staff depends on presentation software that combines elements of both vector- and raster-based software to create professional publications such as presentation boards, catalogs, or even Web-page design. Again, these software programs can be driven on either Mac or PC systems.

If either system is able to handle all of these operations, owners and users of each system stand firm on the "which is best" argument. However, each system has new reasons for tearing down walls. A joint press release by Apple and Microsoft in July 1998 applauded the success of integrating the Microsoft Internet Explorer Browser in the Apple iMac and Mac OS 8.1 systems. This means that the common ground for Mac and PC systems is the application software a company installs. Actually, many companies first research and purchase the software that will satisfy corporate needs then purchase the hardware.

With that in mind, the leading systems are looking for more avenues to develop cross-platform hardware. No one wants to lose a share of the market, so the leading software companies are responding with software applications that can be successfully run on either platform. Companies are simply responding to industry demands. The Apple Web site: http://www.apple.com discusses how the leading industry experts such as Apple, Microsoft, Citrix, Insignia, and Connectix are providing seminars for creating a "cohesive working environment in organizations using a variety of hardware and software platforms." In fact, they go on to state that "Now organizations using any combination of DOS, Windows, Mac OS, or UNIX can enable any of their users to access centralized company data and applications."

In the fashion world it is not uncommon for some companies to be exclusively Mac or exclusively PC. However, a company may own both.

Don't get confused or let all this talk about different platforms and different systems concern you. Each computer system has unique features and benefits, but they also have a great deal in common. Remember, you are driving the computer with basic skills, common design features, and the principles and fundamentals of design. In fact the steps to designing on the computer are a lot like learning how to drive a car. Every car, no matter what the cost, has many similar features: an ignition, an accelerator, brakes, lights, and forward and reverse gears. You follow the same steps to start and move any car, no matter what the model and no matter how much the car costs. If you do own a luxury car, with extra features, you quickly learn how little things, like automatic headlight shut off, can make your life so much easier. Well, that is what many of the state-of-the-art systems and programs for design are like. But, you don't need a luxury car to travel around town; a basic five-speed can get you home, too. In fact, some families actually own more than one car; possibly one is a luxury car, and the other is the basic family minivan.

Design firms are no different. Many firms operate in what is called a cross-platform environment. This means they are using a computer that can "switch" from Mac to PC and vice versa. They are also using multiple software programs to satisfy specific business needs. Translated, this means the designer can be using two different systems with multiple software programs to satisfy most any business need.

If you are trained (or being trained) on one particular system—Mac or PC—or on one specific program (software), you already are developing the basic skills you will

need to adapt to any other computer system or software. Computer software programs are the tools needed to operate computer systems.

We just slipped in another new term, *software programs,* and you're probably wondering, "OK, first computers, then systems and platforms, and now programs." And, we bet you have the same question for us, which software program should you use? Again, we can't give you a definitive answer, but we will tell you more about some of them.

We do know that you should learn the basic skills in both industry-driven programs and commercial/off-the-shelf software programs. This way you will be comfortable using the tools provided to you on the job, regardless of the system or software available. Software programs, just like computer systems, have many features in common.

INDUSTRIAL SYSTEMS AND SOFTWARE PROGRAMS

The original computer-aided design (CAD) programs were designed for specific hardware systems. Each of these systems, with their own CAD programs were sold directly to the textile and apparel industry. The advantage is that these programs, which can be called a "turnkey" system (for "one turn of the key"), were designed to create, produce, and operate the production end of designing. These systems are the luxury leaders of the industry. Among today's leading state-of-the art systems and programs are Ned Graphics Inc., GT (Gerber Technology), Monarch, Colorado, StyleClick and Lectra, to name just a few.

Commercial/Off-the-Shelf and Third-Party Programs

With technology opening more doors of opportunity than ever before, many computer hardware firms using either the OS/2 (OS stands for operating system) or Windows operating systems have found commercial programs that can achieve the same design results at significantly lower expenses. These "off-the-shelf" programs, which can be purchased by anyone, incorporate many of the key tools and design features a fashion designer will need to complete a task.

SOFTWARE APPLICATION PROGRAMS

Software application programs can fall into different categories, such as drawing programs, image-editing programs, and symbols and images clip art.

A BIT OF HISTORY ON DOS (OS OR WINDOWS)

According to both George McDaniels' *IBM Dictionary of Computing Terms* and the Microsoft Press *Computer Dictionary,* DOS (disk operating system) was the first widely installed operating system in personal computers. Bill Gates and his new Microsoft Corporation developed the first DOS for personal computers, called PC-DOS, for IBM. He retained the rights to market a Microsoft version, called MS-DOS.

The first DOS was not terribly user-friendly, but today it still is the main operating system used, and most of us are familiar and comfortable with an application that runs DOS and Windows.

Apple computers are often argued to be the more user-friendly computer. Mac users recognize OS for their operating system. OS also performs the same functions as the DOS systems—i.e., configuring, networking, file sharing, copying, installing new hardware, and printing commands.

You're probably thinking, "What do they mean?" So let's take a minute to explain this a bit more. The design department will have to communicate with the marketing department constantly, and so will their computers. What you will discover is that different departments use one computer and its operating system over another. That is what Sherman was pointing out in the Calvin Klein operation.

- The Design Department: The design team will generally use: vector-based-drawing programs and raster-based-image programs to create a line. These software programs can be driven on either Mac or PC systems.

- The Production Department: To maintain the accounting functions and production flow of a collection or line, the production manager relies on database or spreadsheet-style software that will display vector-drawing images of garments or details. These software programs also can be driven on either Mac or PC systems.

- The Sales and Marketing Department: The sales staff depends on presentation software that combines elements of both vector- and raster-based software to create professional publications such as presentation boards, catalogs, or even Web-page design. Again, these software programs can be driven on either Mac or PC systems.

If either system is able to handle all of these operations, owners and users of each system stand firm on the "which is best" argument. However, each system has new reasons for tearing down walls. A joint press release by Apple and Microsoft in July 1998 applauded the success of integrating the Microsoft Internet Explorer Browser in the Apple iMac and Mac OS 8.1 systems. This means that the common ground for Mac and PC systems is the application software a company installs. Actually, many companies first research and purchase the software that will satisfy corporate needs then purchase the hardware.

With that in mind, the leading systems are looking for more avenues to develop cross-platform hardware. No one wants to lose a share of the market, so the leading software companies are responding with software applications that can be successfully run on either platform. Companies are simply responding to industry demands. The Apple Web site: http://www.apple.com discusses how the leading industry experts such as Apple, Microsoft, Citrix, Insignia, and Connectix are providing seminars for creating a "cohesive working environment in organizations using a variety of hardware and software platforms." In fact, they go on to state that "Now organizations using any combination of DOS, Windows, Mac OS, or UNIX can enable any of their users to access centralized company data and applications."

In the fashion world it is not uncommon for some companies to be exclusively Mac or exclusively PC. However, a company may own both.

Don't get confused or let all this talk about different platforms and different systems concern you. Each computer system has unique features and benefits, but they also have a great deal in common. Remember, you are driving the computer with basic skills, common design features, and the principles and fundamentals of design. In fact the steps to designing on the computer are a lot like learning how to drive a car. Every car, no matter what the cost, has many similar features: an ignition, an accelerator, brakes, lights, and forward and reverse gears. You follow the same steps to start and move any car, no matter what the model and no matter how much the car costs. If you do own a luxury car, with extra features, you quickly learn how little things, like automatic headlight shut off, can make your life so much easier. Well, that is what many of the state-of-the-art systems and programs for design are like. But, you don't need a luxury car to travel around town; a basic five-speed can get you home, too. In fact, some families actually own more than one car; possibly one is a luxury car, and the other is the basic family minivan.

Design firms are no different. Many firms operate in what is called a cross-platform environment. This means they are using a computer that can "switch" from Mac to PC and vice versa. They are also using multiple software programs to satisfy specific business needs. Translated, this means the designer can be using two different systems with multiple software programs to satisfy most any business need.

If you are trained (or being trained) on one particular system—Mac or PC—or on one specific program (software), you already are developing the basic skills you will

need to adapt to any other computer system or software. Computer software programs are the tools needed to operate computer systems.

We just slipped in another new term, *software programs,* and you're probably wondering, "OK, first computers, then systems and platforms, and now programs." And, we bet you have the same question for us, which software program should you use? Again, we can't give you a definitive answer, but we will tell you more about some of them.

We do know that you should learn the basic skills in both industry-driven programs and commercial/off-the-shelf software programs. This way you will be comfortable using the tools provided to you on the job, regardless of the system or software available. Software programs, just like computer systems, have many features in common.

INDUSTRIAL SYSTEMS AND SOFTWARE PROGRAMS

The original computer-aided design (CAD) programs were designed for specific hardware systems. Each of these systems, with their own CAD programs were sold directly to the textile and apparel industry. The advantage is that these programs, which can be called a "turnkey" system (for "one turn of the key"), were designed to create, produce, and operate the production end of designing. These systems are the luxury leaders of the industry. Among today's leading state-of-the art systems and programs are Ned Graphics Inc., GT (Gerber Technology), Monarch, Colorado, StyleClick and Lectra, to name just a few.

Commercial/Off-the-Shelf and Third-Party Programs

With technology opening more doors of opportunity than ever before, many computer hardware firms using either the OS/2 (OS stands for operating system) or Windows operating systems have found commercial programs that can achieve the same design results at significantly lower expenses. These "off-the-shelf" programs, which can be purchased by anyone, incorporate many of the key tools and design features a fashion designer will need to complete a task.

SOFTWARE APPLICATION PROGRAMS

Software application programs can fall into different categories, such as drawing programs, image-editing programs, and symbols and images clip art.

A BIT OF HISTORY ON DOS (OS OR WINDOWS)

According to both George McDaniels' *IBM Dictionary of Computing Terms* and the Microsoft Press *Computer Dictionary,* DOS (disk operating system) was the first widely installed operating system in personal computers. Bill Gates and his new Microsoft Corporation developed the first DOS for personal computers, called PC-DOS, for IBM. He retained the rights to market a Microsoft version, called MS-DOS.

The first DOS was not terribly user-friendly, but today it still is the main operating system used, and most of us are familiar and comfortable with an application that runs DOS and Windows.

Apple computers are often argued to be the more user-friendly computer. Mac users recognize OS for their operating system. OS also performs the same functions as the DOS systems—i.e., configuring, networking, file sharing, copying, installing new hardware, and printing commands.

Drawing Programs

The fashion designer can trade in paper, pencils, paints, and brushes for vector-based or drawing-style software, which creates free-hand line drawings and object-oriented drawings. These tools can add text, color, and patterns to a design. Some of the more popular drawing programs evaluated in this book are CorelDRAW, Adobe Illustrator, and Micrografx Designer. In addition, we have included painting-style programs such as Fractal Design Painter.

Image-Editing Programs

Frequently, a designer must combine images in their work. We have listed one of the most popular raster, or image style, programs available today, Adobe Photoshop. Without a doubt this program is considered one of the industry leaders and is often referred to as a "third-party program," meaning that many of today's industrial software makers recommend that Adobe Photoshop (a commercial/off-the-shelf program) be used in their own industry system because the program is so complete. The industry attitude is that this program provides so many tools and options, why should they try to reinvent the wheel.

Symbols and Images Clip Art

The last program item to evaluate is clip art. You will find that there are many wonderful designs and images already created for today's designer to use. These can be used in conjunction with most vector- or raster-based software. The best part is that not only are they readily available to use now, most are royalty-free.

If you are being trained on one program, it will provide you with the basic skills. With that foundation you can quickly learn the unique characteristics of other programs. Therefore, we would be remiss to concentrate on just one program. It is important for you to know the features and characteristics common to both industrial and commercial systems, and to acquire the basic skills in both industry-driven software programs and the commercial/off-the-shelf/third-party software programs.

A FEW BRIEF COMMENTS ON SOFTWARE PROGRAMS

There are many industrial and commercial software programs on the market today. To learn more about the products you can search the Web and trade publications, you can go directly to the company, or you can easily gather more information at your local library.

We recommend that you the visit Web sites of these companies to familiarize yourself with the software that is available, especially for the software you do not have access to. Many companies have "demos" you can download. We will go into further detail on how to download in Chapter 9.

Some of the terms we frequently use while explaining industry versus commercial programs are

- application software: specific-use, integrated, suite, extensions
- cross-platform
- operating system
- platform
- software: industrial, commercial, off-the-shelf, third-party, plug-in

Although you learned these terms in your basic computer training classes, as you read more about the industrial and commercial programs, you will reinforce the use of these terms. At first, you might feel a bit unfamiliar with all this "techno-talk," but don't worry, we will give you a quick definition review of these and many other common terms you'll need to know in the next chapter.

STUDENT NOTES

ELEMENTARY

COMPUTER-AIDED DESIGN

In the leading programs on the market today, you have probably noticed that the term CAD showed up several times in the evaluations, and it deserves a bit of attention before we move on. Therefore, we present a brief background on CAD and how these powerful CAD systems control a paperless world in textile and garment manufacturing.

Computer-aided design (CAD) emerged in the 1970s. Its original functions were primarily with drafting and technical ones, with particular emphasis in the pattern-making, grading, and marker-making areas. Actually, it was more an aid to manufacturing, and often you will hear the phrase CAM systems, which actually is the acronym for computer-aided manufacturing. So if someone asks you about your CAM training, you will know it is a term often used interchangeably with CAD.

Today, by incorporating graphic packages, designers can creatively conceptualize, create and modify with the click of a button. This means there is no waste—a designer can change a collection in many ways without ever wasting paints, paper, or materials. The bottom line is, the fewer the expenses, the lower the costs to the consumer. Already, even at the beginning of the process, design and business are connected—the designer is trying to find the "right" look, without compromising the integrity of the design, and the businesspeople are focused on keeping expenses down, in order to maximize profits in the long run.

That is quite a bit of information to absorb, and you may be wondering what does it have to do with you now? The answer is, EVERYTHING! You may be preparing for a new job or already working for a company that is converting to computers, no matter what the situation. The fact is that computers are and will continue to be an inescapable way of life for the fashion designer. The more you know, the more prepared you will be to face daily challenges.

After you move through the exercises in this book, you too will be able to create, render garments, design textiles, generate work boards, or do presentation boards on almost any system, allowing the design and production process to be implemented successfully. We will address these design topics in upcoming chapters. In addition, you will learn how to avoid and often overcome the challenges of working on different programs and different systems in completing these tasks as well as learning the skills common to each.

But we are not quite ready to start the design process. What we are going to work with next is what we call "computerese." Chapters 3 and 4 are going to open the doors to both the basic computer language, technical words, and common buzzwords, along with the fundamental skills you will use to operate any computer system or program. Chapter 5 focuses on the steps you will take to work with the drawing tools, symbols, and text skills that will set the stage as you move from the pencil and sketch pad to a mouse and a computer screen.

CHAPTER SUMMARY

Today's CAD software is available as either industrial or commercial. Industrial software focuses on a specific industry need and often has a higher cost than the commercial software programs, which are also categorized as "off-the-shelf." Commercial software is available and often more affordable to any consumer. Some of the commercial software programs can be further categorized as third-party. This means these programs, such as the very popular Adobe Photoshop, are compatible and work well with other software programs, including those designed for industrial purposes.

The most common factor among the industry or commercial/office-driven systems and programs is you, the designer. It will be your job as designer to apply your finely tuned skills and creativity to create quality products that are acceptable to consumers. And, no matter what the system or the program, it is the innate ability of the designer to effectively use these tools that leads to success.

CHAPTER 3

Computer Lingo

Focus: Commercial and Industrial-Based Systems, Software and Jargon

CHAPTER OBJECTIVES

- Acquaint the designer with relevant computer jargon
- Distinguish basic differences between commercial and industrial-based software
- Begin to elaborate on the different varieties of software used by fashion designers

Words, lingo, slang. Have you heard the expression, "Walk the walk, talk the talk"? Or, if not that one, what about, "When in Rome, do as the Romans do?" This same philosophy holds up in the world of computers. When designers first start working with CAD programs many want to throw up their hands in complete frustration. Their frustration is not because they don't have the design skills or the computer aptitude. They are frustrated because they don't have a clue what is being said. We know most fashion designers think their tools will be charcoals, paints, brown paper, and scissors. We were no different. We could define the tools and clearly understand how to use a pencil, a paintbrush, or a pair of scissors.

But, a firsthand look at the industry today quickly points out that you are working with a whole new set of tools. Most designers as they make the transition from paper to screen do not know how to use the new tools to create and produce a garment design. In fact, the first problem most designers have is just learning the names of the tools.

Our job here is to explain to you what the tools are, and then to move forward and explain how to use them. If we don't, you just can't drive ahead into the design units. Consider this unit as earning your restricted (or temporary) driver's permit. You have to do a whole lot of practicing before you can master driving that car you want to buy. So let's learn the skills to take the road test now, and develop those skills before we send you out onto the superhighway.

Don't think that only computer novices don't know what is being said, seasoned veterans need to review common computer terms too. This chapter reviews the most common terms you will hear, listed in alphabetical order. Some may be familiar to you, but maybe you will be reading/learning other words for the first time. These are terms you really will need to know if you want to work comfortably with CAD programs, because they will replace your pencils, paints, paper and scissors.

You may consider a textbook an odd place to find a "minidictionary," but we thought this might make the road a bit easier to travel. We believe you will find this to be a useful chapter, one that will help shorten the learning curve and make the next chapters a lot clearer.

"When in Rome....."

"When in Rome, do as the Romans do."

Remember, it doesn't matter which computer software program or version you are currently using. You will be learning the basic concepts of designing for fashion on computers. You are not going to learn a specific software package; instead, you are going to master the concepts then apply those concepts to *any* software.

Therefore, beginning with an explanation of some of the basic kinds of software available for the fashion designer should be helpful. You will find that the information below is a great quick reference tool for you to use at any point in the book.

THE BASICS OF GRAPHICS SOFTWARE

The term *graphics* pertains to a program (software) or computer device (monitor or some printers) that enables the computer to display and/or manipulate pictures. It can safely be said that all CAD/CAM systems support graphics.

There are several types of graphic applications, for example:

- **Illustration** (also known as drawing programs) or graphic design programs are vector-based.
- **Image-editing programs,** which are raster-based and generally work with realistic images such as photographs. These are also known as sophisticated paint programs. The image-editing program supports drawing features; however, objects are represented as a bit map versus a vector image.
- **Paint programs** are designed to enhance a bit-mapped real-world image. Typically, you use natural mediums—chalk, pastels, and crayons—that add unique effects to photographs or images.
- **Presentation graphics** software is generally used to create images used in business environments, such as charts and graphs or images for slide show or spreadsheet-related presentations.
- **CAD systems** software enables designers such as those in engineering, interior design, architecture, or industrial design to draft designs. CAD for fashion typically falls under the first three listings, as well as CAM for manufacturing-related directions for producing a line of clothing or accessories. This also includes cost sheets and spec sheets.
- **Desktop publishing** provides a complete package of publishing features used in conjunction with page layout, graphics, and word-processing options.

We will go into even more explicit details on the commonalities of the two major types of software—vector and raster in Chapter 5. For now, take some time to familiarize yourself with the following computer terms before moving on to Chapter 4, which is an introduction to the terms, tools and steps of working with the computer.

Basic Computer Terminology

The A drive: The computer has storage systems. The storage system that is contained inside the computer is typically referred to as the C drive or the hard drive. The A drive is an alternative storage system that you use by inserting a disk into the computer. The data will be stored, but on the disk, not on the internal computer storage system.

Application software (see *Software programs*): Examples include: word processing and graphic design.

Arrow keys: Keypad to the right of your main keyboard that moves the cursor.

Auxiliary storage (also known as a *Secondary storage system*): Devices such as floppy disks.

Backup: Making a copy of your files.

Backup system: Method for storing data in more than one location to prevent its loss.

Booting: Startup; loading an operating system into memory.

Cache (pronounced *cash*): The amount of fast memory that stores information frequently used, which translates into faster processing speeds.

CAD/CAM: Computer-aided designing/computer-aided manufacturing. Sometimes the terms are interchangeable. For example, in fashion designing you can use the computer to both aid you in the design of a garment or a line and set up detailed instructions for the computer to aid in the manufacturing of the garment or line.

Caps lock: Often located on the left of the keyboard, this key permits you to TYPE IN ALL CAPITAL LETTERS without using the shift key.

Carriage return (also known as an *Enter* or *Return key*): Usually located on the right side of the keyboard, when struck, this key takes your text to the next line. It should be noted most word-processing programs have a built in word-wrap feature, which will take your text to the next line automatically. It is recommended you do not use the enter key except to add rows or to intentionally separate rows of text.

Case-sensitive: Some programs are sensitive to the way commands are typed. For example, the word PASSWORD and the word password are different to a case-sensitive program. If you are working with a case-sensitive program, and you do not enter data in the case needed, it may cause frustration when you are entering a program or executing a command.

CD: Compact disk. A circular disk that stores programs and data.

CD-ROM: Compact disk, read-only memory. This is usually a drive on your computer and frequently is labeled by the installation as the D, G, or M drive.

Character: A letter, number, or special symbol on the keyboard.

Click: The action of depressing a button on the mouse to activate or issue a command.

Clipboard: A storage area used by the computer when executing such commands as cut, copy, and paste.

Clone: A generic/no-name brand of computers that imitates another. The clone may or may not be comparable to the original.

Close: To cancel, exit, remove, or shut down a program, window, or application.

Compatible: Computers and/or programs that work together regardless of the manufacturing source. For example, Gerber's Designer Program is compatible with Adobe's Photoshop.

Computer literacy: A degree of awareness of, knowledge about, and competency with computers. You will be computer-literate if you read this book and do all the exercises.

Computer: A machine that receives and processes information. There are a variety of ways for the computer to receive the information, known as input. The computer will then process and display this information; this is known as output.

Connectivity: The new communication buzzword. An instant electronic communication between computers, machinery, business operations, and people.

Control key: The abbreviation on this key is Ctrl. There are usually two control keys on the computer keyboard; they can be found on the right and left of the keyboard. This key is used with other keys to issue commands to the computer software programs.

Copy: This is a frequently used command in computers. The command will copy what you direct it to copy. For example, if you use a phrase over and over, rather than type the phrase each time you use it , you can drag the mouse over the phase, command the computer to copy the phrase, and then you can paste the phrase where you want in the document. This is a real time-saver.

CPU: Central processing unit—the brain of the computer that includes the electronic circuitry that executes stored program information. It is very similar to the human brain, whose function is to issue commands and regulate functions inside and outside itself.

Crash: Breakdown or malfunction of hardware and/or software. This also something you do when you go home after being on a computer all day (just kidding!).

Cursor: The symbol on the monitor that indicates where the user must begin or where the work stopped. The cursor can take the form of an I beam, an arrow, a pointer, a hand, an hourglass, a question mark, or a blinking underscore.

Cut: A process that deletes text/data. If the user doesn't want to eliminate the section of text but, simply wants to move it, the function is often combined with the paste function. This means the user may cut out a section of text and then can paste that text to another area in the document. This is a great time saver and saves the user from retyping data.

Data: Information input into a computer, typically in an unorganized way.

Debug: Process of locating and repairing errors within the computer and/or its software.

Default: Action or assumptions the computer will automatically make, unless you issue other instructions. For example, the default for most workspace is portrait (8.5 inches by 11 inches); you may use the page setup command to change it to landscape (11 inches by 8.5 inches).

Default drive: Sometimes this is known as the area of the computer automatically assigned for storage. Typically it is an area, such as a disk, designated by the designer (user) for storage.

Default settings: When you first start working on a document, the computer has already established where you will start on the page, how far you can type on a line and even how many lines you can enter before moving to a new page. This is because the computer program has preset guidelines for many tasks, such as page layout, background color, and even the setting of a color mode. These default settings can often be changed easily by the designer.

Desktop: This is can be a blank screen, background, or actual workspace. It should be noted that when you open a new file in most graphic programs the actual blank page, not the gray area, will be saved to a disk or printed on a hard copy. The gray area outside the page is great for practicing and then moving that work onto the actual page to be saved or printed.

Desktop publishing: The use of computers and specific software to enable the designer to produce professional-looking and/or commercial documents.

Deselect: Often used as a mouse action or undo command, this feature permits you to change your mind.

Dialog box (see *Menu*).

Digitizer: A graphic input tool that converts images into digital information for the computer to use.

Directory: A group of files stored on a disk or a drive.

Disk drive: Hardware that can read and write information (known as data) from a disk.

Diskette: A magnetic disk used to store data. These disks are available in a standard 3.5-inch size (1.44 MB), a Zip disk (100 MB or 250 MB, for a Zip drive), a CD disk (650 MB, for a CD-ROM drive), a Jaz disk (2 GB, for a Jaz drive), or a DVD disk (up to 4.7 GB, for a DVD drive).

Double-click: Firmly and rapidly depressing the mouse button twice. Used for activating a program icon or any other command that may require a yes, or enter, response.

DOS: Disk operating system. A group of programs that control and manage the computer and disk storage area on a PC.

Download: Transfer of information from one computer to another.

Drag: Mouse motion of depressing the left or right button on the mouse while simultaneously moving the mouse from location to another.

Drag and drop: A click and continuous depression of the mouse on an item, icon, or image enables you to move (drag) that selection and insert (drop) the selection in another location by releasing the mouse.

Driver: Set of instructions between computer, monitor, printer, and other output devices that allows them to communicate with one another.

Editor line: Located at the top or bottom of the screen, this line permits you to edit a command or make a correction. For example: in a spreadsheet or database program in which you can type a new math formula on the editor line and hit the enter key, the corresponding line of the main screen document will make the math correction on every cell that is directly related to this change.

e-mail (also known as *Electronic mail*): The process of sending, storing, and retrieving information between computers regardless of their geographical location.

Enter key (see *Carriage return key*).

Error message: This is displayed on your screen to inform you that you made a mistake. Don't panic. This can be a good message. For example, it might tell you that you forgot to put a disk in the A drive before attempting to save.

Esc: Abbreviation for Escape. This key on the top left of keyboard is used generally to go back one screen or to cancel a command. But, in some industry programs this key actually saves your work. Although this isn't logical, be sure to check the manual for the software program that you are using. (*Hint:* Try using an electronic post-it note to remind you when to use or not to use this command.)

Execute: Computer will respond by implementing a command it has received from the user or the operating system and/or software.

Exit: To quit or shutdown a program.

Export: This features permits you to send your work to another program or computer for viewing, printing, and/or editing.

Extension: Generally a one- to three-letter suffix added to a file name or to a DOS command. Typically it will indicate the program in which the file was generated. For example: WP for word processor or DB for database; or it may indicate further specifics about what kind of graphic it is, such as TIFF.

Facsimile (also known as *Fax*) transmission: The use of computers to transfer information from one fax machine to another.

File: Information, graphics, or images contained on disks, in folders, or on specified drives. A file can be named, saved, opened, copied, retrieved, and modified.

File management: Systematic organization on the computer to manage files and/or directories for easier access.

File extension: The three characters following the name of a file. This identifies what kind of file and the type of program used to generate the file. For example, the program CorelDRAW uses a native extension code of cdr. This means if you save a file in CorelDRAW it will automatically save the file with its name followed by cdr. Designers may not want to use the native extension code because they want/need to use the file in several programs. If that is the case, a designer may create a file and use the extension code TIFF (tagged image file format). This means the designer can later retrieve the file and view it in several software applications. The same holds true in the business world. Often the business-driven software programs will use the extension code of WP for word-processing files, DB for database, or SS for spreadsheet.

File format: This indicates how a file has been set up for retrieval, exporting, or printing.

Filename: Just like each of us has a name for identification, so must a file. Generally, you will assign a name to the data being saved and you will also assign the storage area. It is recommended that you name the file according to what is inside the file for easy identification and use later. For example, if you have a file that says a:motif.tiff, a: indicates the disk drive where the file is saved, motif indicates the filename based on what is in the file, and tiff is the extension indicating what kind of file it was when it was saved.

Floppy: This refers to your disk. You can use this disk to save or back up your work. You will save the work by inserting this disk into the A drive of the computer and commanding the computer program to save the data on this disk by using the A drive storage system.

Fly-out menu (see *Menu*).

Folder: Even on the screen the icon for a folder looks just like the manila folder used for filing physical documents. The function is the same. You can create a document or a file with data or graphics and then store it in a folder.

Font: Text character generated on the computer that can be categorized by typeface, such as Arial or Signature; style, such as bold or italic; and point size, such as 8, 14, or 24.

Function keys: These keys, located at the top of your keyboard, are also called "hot keys." These are shortcuts keys that issue commands such as Select All by merely touching just that one key. Check your computer and/or program for what each key represents.

General-purpose programs: These are commonly known as business-application programs and may include word-processing, database, spreadsheet, and basic drawing programs.

GIGO: Garbage in, garbage out. This is what happens if you put the wrong data into your computer. The computer is only a tool and often is only as smart as the information it receives.

Glitch: This is frequently just a minor problem, not necessarily terminal, that the computer or its software is experiencing.

Groupware: Software that permits several users/machines to swap information via a networking system, regardless of the geographic location of the computers.

Hacker: A person who gains entry into a computer illegally.

Hard copy: Paper printout of your work.

Hard disk: A 3.5-inch disk used for storing data in a location other than on the hard drive of the computer.

Hard drive: The computer filing cabinet that stores all the programs and files on your computer. The hard drive is connected to the mother board, all of which is located in the computer case or tower.

Hardware: The computer and the related equipment it uses.

Help: A menu and/or icon that permits you activate an option for obtaining on screen assistance in a program. Be sure to ask if this assistance has been installed. Believe it or not, sometimes when installing a program the help files are intentionally left off because of the amount of memory they require. Some-

times the help menu is cumbersome to wade through, and you may find it is quicker to ask someone else who knows the program better than you, such as someone on staff or perhaps online technical support.

Hierarchical menu: These menus are sequential, meaning you make one selection and another selection (menu) appears such as in the case of Save As, where your next choice is where to save.

I-beam: (see *Cursor*).

Icon: A small picture or symbol on the screen (see *Cursor*).

Import: Bring data from one program into another.

Inkjet printer: A printer that uses a nozzle device to spray ink onto the paper.

Input devices: Any device for entering data into the computer; for example, keyboard, light pen, mouse, digitizer, or scanner, to name just a few.

Insertion point: (see *Cursor*).

Integrated packages: Programs that contain multiple capabilities, such as a word-processing program, a database program, and a spreadsheet program.

Internal storage: Area allocated by the computer for storing data, such as the C drive.

Internet: Also known as the Net. A connection of computers/modems that can communicate data. (See Chapter 9 for more details.)

Keyboard: A computer input device. The computer keyboard is similar to a typewriter's keyboard, but it has several additional keys useful for computer operations.

Landscape: The orientation (direction) of a document or image. This book is an example of a portrait document. Typically the measurements are 11 inches wide by 8.5 inches high.

Laser printer: A printer that uses a beam of light to transfer information and images from the computer onto paper.

Licensed software: Software that is protected and may not be duplicated or shared without permission of the manufacturer.

List box: A dialog box offering additional selections, such as a list of the names of all the files you have saved on your floppy disk or on the hard drive.

Lower case: These are character keys that type small letters, not CAPITAL or UPPER-CASE text.

Magnetic tape: Secondary storage device used for storing or for making a backup of computer and data files.

Main memory (see Memory): Also known as an *internal storage, primary storage,* or *primary memory* as well as simply *memory.*

Maximize: This option permits you to enlarge a screen or window to full size for viewing and editing purposes. It is typically indicated as a clear block icon on the top right of a screen and/or document. This option is activated by clicking the mouse inside the icon.

Memory: The portion of the CPU that temporarily holds program instructions.

Menu: List of choices or options. There are several versions as well as a variety of different names associated with the term *menu,* including *pull-down, pop-up, fly-out, icon, ? (Help) F4, item, bar, submenu, list box, message box,* and *dialog box.*

Menu bar: On screen (visible) text list or graphic list of options.

Message box: This is a list of choices similar to a *List box* or *Dialog box.*

Minimize: This option permits you to shrink the size of a screen and/or window. This is generally an icon made to look like an underscore or underline located in the top portion of your screen and/or document.

Modem: A device used to transfer and convert digital signals to analog signals (information) over communication lines from computer to computer.

Monitor: TV screen–like device for viewing data on a computer.

Motherboard: A large circuit board containing the CPU, RAM, expansion slots, and microchips.

Mouse: A handheld input device that rolls across a flat surface and is activated by a series of moves, dragging, and clicking operations to input and manipulate data that are viewed simultaneously on the monitor. (Other terms associated with mouse are *Mouse button, Mouse pad,* and *Mouse action.*)

MS-DOS: Type of disk operating system. A system of commands issued by the user and/or software in a language the computer will understand. For example, "a:filename.wps" instructs the computer to save the file on a floppy disk inserted into the A drive as a word-processing file.

Multimedia: A multiple sensory experience, involving sight and sound, available on many of today's computers.

Multitasking: An operating system feature that enables the designer/user to operate several programs concurrently.

Name: The title you are using for your file or folder.

Network: A system of communicating between two or more computers.

Off-the-shelf software: Software commercially produced for use by the general public.

Open: Activate a file on the computer. The file may be new or it may be an existing file saved on either the hard drive (disk) or on a floppy disk.

Orientation: The direction of the workspace/page layout. Landscape orientation means the page is a horizontal layout. Portrait orientation means the page is used vertically.

Output device: Equipment such as printers and plotters used to produce a tangible representation of work generated on the computer.

Packaged software: Software put together for resale.

Password: Unique phrase created by the owner of the computer to restrict access to the computer and/or software and/or storage areas to specific users.

Peripheral equipment: External hardware attached to a computer.

Portrait: The orientation (direction) of a document or image, using a vertical page layout or workspace, typically 8.5 inches wide by 11 inches high.

Presentation graphics program: Professional-looking graphics program used in business.

Printers: Hardware used to output a hard copy of what was viewed on the screen or saved on the computer. Types of printers include dot matrix, bubble jet, inkjet, laser, and drum.

Procedure: Steps necessary to complete a task.

Program: Step-by-step instructions telling the computer to perform specific steps or tasks.

Prompt: A message or signal—such as proceed, perform a task, or make a choice—all given to the user by a computer's operating system.

Pull-down menu: Similar to a window shade, this menu when accessed offers a variety of functions or other options for the user to perform. In many graphics programs these can be left open on the screen when used frequently. In addition, they often offer additional fly-out menus offering additional selections.

QWERTY: Standard keyboard layout (similar to a typewriter) used on most computer keyboards.

RAM: Random-access memory. The computer's primary working memory. This information is stored and accessible but is lost when the computer is shut off, similar to our short-term memory.

Reboot: To restart your computer and/or program when it was already turned on. Sometimes when you are working on the computer, a program may lock up, or even worse, the electricity may go off. If that happens you may need to start the program over. The reason it is called a reboot is because the computer was already turned on and considered warm. When you turn the computer on for the first time each day, that is called a cold start.

Refresh: A computer option/icon that redraws the image and cleans up the screen.

ROM: Read-only memory. Unlike RAM (random-access memory), ROM represents information that is permanently written on a computer chip and will always remember the commands or functions it needs to perform.

Ruler: These guides located at the top and/or sides of the screen enable the designer to render an image that is perfectly aligned and scaled. These can be activated by a simple toggle on-and-off command and then accessed or grabbed to a specific location on screen.

Save: The ability to permanently keep information (see *Storage*). Some suggestions for when, where, and how to save:

- When—As frequently as possible. We suggest you save every 15 minutes. A rule of thumb is how much data can you afford to lose?
- Where—Always back up your work. For example, if you typically save to the hard drive (C) of the computer, also make a copy on 3.5-inch disk. Some companies provide a network for larger files because it is a less expensive way to save files.
- How—This answer is not as obvious as it appears. We suggest that you save complex files in increments, stages, or versions. For example, a designer might save a design to the hard drive as a template to use frequently. The designer will open that file and begin to build the image by garment rendering and save it as Version 1. Next, by adding color, this becomes Version 2. If copies are needed in different color combinations the new color version becomes Version 3. Colors are not the only changes. If a designer wanted to add images such as texture, these also become a new version. This works for modifications of garments too. A designer may have a blouse style that does not change a lot. Maybe the sleeve length or fabrication will be modified because of

seasons. Then the files become versions under the name of the type of modification, such as fall or summer, short-sleeve or long-sleeve. This method is simply working smarter versus working harder. A little planning can go a long way, and the computer really can be your best friend. When the designer is completely satisfied this becomes the final version.

Scanner: Equipment that reads text, photos, or other images directly into the computer to be enhanced, manipulated, or modified by the designer/user. Files can be opened in a word-processing program, graphics program, loaded on the Web or sent electronically via e-mail or fax.

Screen: A device, similar in appearance to a television, that outputs information from the computer.

Scroll: This action or option permits the designer to move through the screen, text, and image, graphic, document, or page layout by using the cursor or keypad. Other terms or icons associated with the term scroll are Page up, Page down, Home, End, the direction arrow keys, Icon, Scroll bar, Scroll box, Select browse object, and Next page.

Secondary storage: Additional storage such as a data disk.

Selection tool: This tool is often in the form of an arrow or a pointer and activates an area by highlighting it with shading, a dotted outline, or a flickering outline. Typically, the mouse is used to activate this tool. Keystrokes can also be used but they are considered cumbersome.

Service bureau: Commercial printing service used to print a variety of files, but typically known for doing camera-ready work.

Shareware: Software available for nominal fee or free of charge.

Shortcut: This can be in the form of using a "Function Key," which does several steps or functions with one keystroke.

Shrink: Make a screen smaller (see *Minimize*). Minimizing does not close the program or window. This feature merely reduces the size so a designer may work on another program.

Soft copy: A visual nontangible display on the screen of the work generated.

Software programs: Applications or instructions that tell a computer what to do. Some types of software programs are Shareware, Public domain, Freeware, Proprietary, Copyrighted, Pirated, Specific-purpose software, and Integrated software.

Status bar: Often located on the top portion of your screen, it indicates everything from the font style selected to the drawing tool used.

Status line: Generally located on the bottom of your screen, it indicates everything from the location of your mouse, the last typed line/character of text, or even the tool you are currently using.

Storage: Areas or devices that are designated for retaining information; they can be temporary or permanent. Examples include Hard drive, Floppy disk, Magnetic tape, Zip, Jaz, and CD.

Style: A typeface alternative such as bold, underline/underscore, or italic, used to enhance font.

Submenu: Additional options that relate to the previous menu.

Terminal: Equipment that will enable the designer to input, output, and communicate information.

Title bar: The name of the program and file at the top of the screen.

Toolbar: In most programs, this is where the tools used by the designer are located.

Tutorial: A demonstration of how the program works. This is usually a mini-exercise using step-by-step instructions that walk you through the operation of a program. Like the *Help menu,* this feature comes with the program, but often is not installed because of the amount of space required on the hard drive to run such an application.

Undo: A great feature of most software that permits the user to go back and delete the last step or series of steps. Check the program and version you are using for the number of times the program will permit you to undo.

Unzip: The decompressing of a file. This means to open a file that was made smaller for reasons of size and then reopened or unzipped to the original size to show complete details of the work. This term is used for very large text files or for large raster-image files.

Update: To keep files and information current.

Upload: Transfer a file from your computer to another computer.

User: You!

Vector image: Term related to most drawing programs and associated with line drawings or images the computer understands as a series of lines done mathematically.

Virus: A series of illicit and illegal instructions that passes from one computer to another via a variety of contact sources.

Warm boot: Restarting the system by hitting Ctrl+Alt+Del keys all at the same time to clear memory or reload program. (See *Reboot.*)

Wingdings: A font with unusual symbols and characters. When this font is selected, ordinary keys such as right parenthesis—)—become a symbol. For example, the number zero = ▢.

Windows: An application software program that works on top of the computer's disk operating system and is used to manipulate and manage your programs, software, and computer functions.

Word processor: A program for generating, arranging, editing, proofreading, and printing text.

Wordwrap: When words automatically move to the next line without manually hitting the enter key or space bar.

Workspace: This can mean the actual size of the printable document; it can also mean the space outside the document that will not print.

Workstation: This includes the area and the equipment the designer will use.

www: World Wide Web. A hypermedia system using the Internet to transport data using a phone line.

WYSIWYG: "What you see is what you get." What is on the screen/monitor is what will print.

ZIP: Usually refers to a Zip disk designed to hold large amounts of data. The term *Zip* can also refer to a type of software used for compressing files, such as PKZip/PKUnzip. It also implies a drive that is either internal or external.

THE MOST FREQUENTLY MISUNDERSTOOD COMPUTER TERMS

This is a brief review of the most frequently misunderstood computer terms for you to incorporate into your vocabulary. Take time to review this list. It will become a valuable resource to you.

CAD: Computer-aided design; or CAM: computer-aided manufacturing. Also known as synthetic art, a technical drawing or illustration created and/or manipulated on the computer.

Commercial: Software that can be purchased by anyone off the shelf. Cost and depth or levels of expertise vary.

Desktop publishing: A complete package of publishing features used in conjunction with page layout, graphics, and word-processing options.

DOS: Disk operating system.

Industrial: Commonly referred to as a turnkey system, related software purchased by companies to perform a variety of sophisticated functions and tasks related to running a business.

Platform: Mac or PC.

Presentation graphics software: Generally used to create images used in a business environment, such as charts and graphs or images for slide show or spreadsheet-related presentations.

Raster-based software: Image-editing program (also known as *Paint program*). Creates raster or bit map or realistic images based on pixels.

Software: Programs and/or applications that are installed on a computer to perform a variety of tasks that can be educational or entertainment- or business-oriented. The type of software used is typically based on the user's need or the job it will be used for. Most software will fall into two basic categories: system software and application software.

System software: Examples include OS, DOS, and NT. These programs manage memory and files and control input and output devices, in addition to managing the actual startup system enabling the user to communicate with the computer and/or operating system. These are also called the booting or supervisor programs. They are typically resident within the computer when purchased.

Vector-based software: Drawing or illustration programs that create vector images based on mathematical curves and lines.

Windows: Application placed on top of DOS to navigate other programs and common file management and other common tasks a computer performs.

ADDITIONAL TYPES OF SOFTWARE

As you can see, with each new program developed often other terms are associated with the software. Below is a list of several of those other names we apply to software. Don't get confused or overwhelmed, just take a few moments to review these titles. Then use it as a quick reference on an as-needed-basis.

Add-ons (see *Modules*).

Application: A specific task such as word processing. Applications can also be special-purpose or general-purpose programs, because they solve a specific problem or meet a specific need.

Copyrighted: Legal ownership of a piece of software protected by copyright laws.

Extensions: Mini-program such as a screen saver or virus program.

Freeware: Free programs that anyone can use without fear of copyright infringement.

Integrated software: Software that performs several different tasks and is in one piece of software. Such a program may have word-processing, database, and spreadsheet programs all in one package.

Modules: Software sold separately that increases the capability of a more sophisticated program.

Pirated: An illegal copy of software.

Plug-Ins (see *Module*).

Proprietary: A specific program and/or company.

Public domain: Available for anyone to use without fear of copyright infringement.

Shareware: Programs readily available for use, often with a small fee attached.

Specific-purpose software: Software designed for one purpose.

Suite of software: This is much more expensive and extensive in scope of actions than integrated software. It is a separate set of programs packaged together and sold as a set. A commercial example is by Micrografx, Corel Corp., and Adobe. An industrial example may be by Monarch or Gerber.

Third-party: A piece of software used with a different manufacturer's software because of its compatibility and usefulness; it is sold separately.

Utility: Frequently, this is software that deals with maintenance of a system or software, such as a virus program.

Oh boy, we bet you are either overwhelmed or bored stiff by now, Sorry. This is like reading the book for your driving test or the owner's manual for your car. Somewhat dry, but oh so important! In subsequent chapters we will bring those terms to life. We'll provide you some insight on how they are applied practically, by showing you the basic steps on how to use the computer/software in fashion designing.

CHAPTER SUMMARY

Jargon plays a vital role in understanding the working of a computer and computer software. It is also the means of relaying information in a universal language that transcends all types of businesses.

This book is concentrating its energy on the commonalities of vector- and raster-based software that can be either commercial or industrial.

CHAPTER 4

The Basics: Introduction to the Terms, Tools, and Steps of Working with the Computer

Focus: Commercial and Industrial-Based Systems, Software, Desktop, and Tool Commonalities

CHAPTER OBJECTIVES

- Recognize and identify that the tools, functions, and vocabulary used in the operation of most vector- and raster-based software are universal computer concepts and not software-specific concepts.
- Locate the primary tools and menus commonly involved in computer-aided design. Identify various input devices/techniques that are used, such as keyboard commands, hot keys, and/or mouse actions such as click, drag, and drop to input designs.

TERMS TO LOOK FOR

cursor	keyboard	program menu
desktop	mouse actions	QWERTY
icon	output device	storage system
input device	program icon	

Y our creative juices are probably fed up with computer systems, programs, and terms, and you are more than ready to get into designing on the computer. We wish we could tell you we're almost there, but sorry, not yet. Consider this as the first day of your job. We want to show you where you will work and give you a quick tour of the equipment you will be using. We want to give you a good look at your desk, your filing cabinets, the copy machine, and your supplies.

You probably wonder why you need this tour, but we have found through years of teaching and on-the-job training, that often people don't really know about the equipment they are working with, and that can cause problems down the road. This is similar to learning about parts of a car and what is needed to keep everything in good working order. You probably know if you forget to change your oil, it can cause severe engine damage, the same concept applies to computers. Learning about the computer's parts and how to use them properly will avoid any unexpected surprises and let you concentrate on your goal to design a line without the interruption of fixing machinery that is broken.

Remember, it doesn't matter which computer software program or version you are currently using. You will be learning the basic concepts of designing for fashion on computers. You are not going to learn a specific software package; instead, you are going to master the concepts then apply those concepts to *any* software.

Figure 4-1 shows a basic computer system. Input devices such as the keyboard, mouse, scanner and pen are tools that you can use to put data into the storage system of the computer. Storage systems such as the hard drive, hard disk, floppy disk, Zip drive, CD, Jaz, and magnetic tape are the tools that you will use to store the data you entered either in the computer, or on disks. Output devices such as a monitor, printer, plotter, and service bureau are tools that you will use to print out the work you have created and stored.

FIGURE 4-1 Parts of a computer: Input Devices (keyboard, mouse, scanner, pen); Storage Systems (hard drive, hard disk, floppy disk, zip drive, CD, other); and Output Devices (monitor, printer, plotter, other).

INPUT TOOLS

Keyboard

The first tool we pointed out was the keyboard (see Figure 4-2). This is the most common tool used when working with the computer. Here, we briefly explain the terms often associated with the keyboard. The most common layout for the keyboard is the QWERTY format. (Notice the first row of letters on the keyboard begins with Q.) Next, you will notice that most keyboards today are also conveniently laid out with a separate number keypad to the right of the main keyboard.

Alt keys: These keys on the bottom right and left of keyboard are typically used in conjunction with other keys to issue commands.

Arrow keys: These keys are typically to the right of the main keyboard. They permit you to scroll around your document in the direction the arrow is pointing.

Backspace: This key erases backward, or to the left of the cursor. It will go back one space every time you hit it.

Caps lock key: This key will permit you to type in ALL CAPITAL LETTERS without hitting the shift key.

Ctrl (control keys): These keys to the bottom right and left on keyboard are typically used in conjunction with other keys to issue a command.

Ctrl+Alt+Delete: The combination of keys depressed simultaneously to warm boot the computer and/or program.

Delete key: This will delete anything directly after where the cursor is located.

Enter: This also known as the return key. It is used to begin a new line, to add a line, or to issue a command.

Function keys: These keys, located at the top of the keyboard, are shortcut or "hot" keys for performing several steps by hitting just one key.

Esc: The escape key typically will terminate the last step used. However, in some programs this key actually enters data. So consult your owner's manual.

Hard carriage return: To hit the enter key intentionally to create a new line or row.

Hot keys: These are shortcut keys that perform several functions by hitting just one key.

Keypad: Keyboard used for typing.

Multiple key functions: Hitting a series of keys at one time to issue a command. For example, Ctrl+Alt+Delete for a warm boot or shift + a character to make a capital letter or symbol.

Number pad: Series of keys on the right side of keyboard laid out similar to a calculator or adding machine.

Num lock: Used to make the keys on the number pad similar to those on a handheld calculator or adding machine.

Option key: Key on a Macintosh computer used to issue a command.

FIGURE 4-2 Computer keyboard.

QWERTY: Style or key layout for most keyboards; similar to a typewriter.

Return key: Also known as enter key, hard carriage return (new line, add lines).

Scroll keys: Arrow keys located on the right of the keyboard. These keys will scroll and/or move around the document. There are four arrow keys—Page Up, Page Down, Home, and End.

Shift keys: When a shift key is depressed in conjunction with a character key a capitalized letters and or a symbol is typed. For example: CAPITALIZED, or !@#$%^&* (? These keys are also useful for constraining objects, text, and graphics when used in conduction with the mouse in many graphic programs.

Space bar: This key located at the bottom center of the keyboard. It adds one space every time it is hit.

Shortcut keys: These keys are just what they sound like—a shortcut to a series of steps accomplished when one key is depressed. For example, F8 to select everything on the screen.

Tab key: This key on the left of the keyboard will move the cursor a set number of spaces to the right every time you hit it.

The Mouse

The mouse (Figure 4-3) is fun to use. It will make many functions easy for you. First, the mouse will move text or objects around the page with efficiency and ease. And, after you've moved all of your data around, point it at the right spot, and with a click the mouse will issue commands and options that will bring your creative work to life. Here's a list of what you have to do so the mouse will move and modify your work based on your commands.

Click: Typically this indicates depressing the left or right button to issue a command.

Drag and click: Depressing the mouse button while moving the mouse at the same time.

Dragging: Moving the mouse across the document and/or screen.

Drag and drop: Depressing the mouse key while highlighting an object or icon and then moving that item before releasing the mouse button.

Double click: Depressing the mouse button twice in rapid succession to issue a command.

Highlight: Using the mouse to select an area.

Left click: The difference between the right and left button in some programs is that each button can issue different commands and/or access different options.

Point: When the mouse is used to indicate or select an area. Frequently, the cursor associated with the mouse actually becomes a pointer.

Pointer (also see *Point*): When the cursor on the screen transforms into an arrow instead of an icon or an I-beam.

Right click: This function typically will result in producing an additional menu or options.

Select (see *Highlight*).

Shift click: Depressing the left mouse key and the shift key at the same time to select an area or issue a command.

FIGURE 4-3 Computer mouse.

DESKTOP SCREEN

The next area to cover is the basic work screen that you see when you first turn the computer on and boot up a software program (Figure 4-4). The screen shown is a standard desktop screen. We know the screen in this book may be a bit different than the one you are working on in the classroom or on the job. No one is working with a better screen, but we might be working with a screen that looks different because a different version (or model) of the software program is being used.

Let us take a moment to explain this in more depth. We knew that before we finished the first chapter of this book that by time it reached your hand, just like fashion itself, the computer systems and programs would already being updated and launching a new season

Again, you could throw up your hands in frustration, or you can look at what you have that works and determine how close the version you own is to the one shown in the book. This situation is a lot like our cars that we keep talking about. You don't go out and buy a new car each year just because the model changed, do you? (If you said yes, I'd like a new convertible sports car in red!) You use what you have because it will get you where you want to go. Computer systems and software programs are no different. You can go through the exercises with the versions of software you have. You don't have to buy a new software program (unless the version you are working with is several years old) because this book is written about how to work with the basic skills, no matter what version you own.

We are going to start with the first working tool common to software programs, and that is the desktop screen, which comes with file folders, filing cabinets, and a variety of tools for you to use, such as pens, brushes, and paints. Common tools of a full screen include a desktop and workspace

The following is an overview of the parts of the actual workspace that you have, including printable document space, and what the program applications, workspace, and desktop have in common. Also, you are going to see visual images of the terms you learned in Chapter 3. For example, in Chapter 3 you read what a cursor was, here you get a chance to see exactly what it looks like in Figure 4-4.

FIGURE 4-4 Desktop screen with an arrow cursor.

First, it is important to identify what elements are common to most of the program applications you will be using in this book. Many of these are accessed by a left click of the mouse on top of the area or icon you wish to access.

Document title bar: This will indicate the current document name and number. If you have not yet named the file the name of document might show as Graphic 1.

Icons: Common to many applications you will be using, these are symbols represent such techniques and tools as: new folder, save, print, zoom, cut, clipboard, and help to name just a few.

Menu bar: This will list the available main menu and give you the option to access other menus that might pull down, pop up, or fly out.

Minimize, maximize: These buttons, typically located at the top right of your screen, enable you to easily reduce or shrink or enlarge or restore the application or document of your choice.

Rulers, grids, and guides: Tools that are accessible for accuracy in drawing, or measuring. In word-processing programs these tools would help you to adjust indents, tabs, margins, and columns.

Scroll bars: Located in several places on the screen. Scroll bars are guides on the screen that you use with the mouse; they will let you move the screen or the document from left to right and top to bottom.

Status bar and status line: These are frequently found at either the bottom of the screen or near the menu or title bars. This bar or line will give you the status of the activity of the application you are working on. For example in a word-processing program it will tell you what page and line you are typing on and how many pages you have typed.

Title bar: Generally located at the top of the screen, this shows the name of the program or application you are using.

Toolbar: A strip of "buttons" that can be accessed by the mouse or keyboard. This bar identifies icons such text, drawing tools, marquee or bounding boxes, pens, and color selections.

Working page: The actual printable area of the screen.

Workspace, or desktop: The entire area outside of the working page that does not print.

X button: Contained in the box at the top right of your screen, this is the close box. It is used literally to close a file or application by a left click of the mouse.

So far you've had a pretty good look at the desktop workspace and you've even had a chance to see how some of the terms covered in Chapter 3 are applied. Now it is time for you to start using these tools and learn how to operate this brain center.

Consider this the road-test practice. Remember you have to have a license before you can buy that car. But, first you have to know how to drive. I know, you can tell I'm a Mom who has experience in what can be called the "car steps." I am not alone, many of the people who have contributed to this book have gone through the same, and we have all talked about car steps. For a moment, reminisce about real life and see if you don't agree.

DRIVING A CAR	DRIVING THE COMPUTER
1. Study for the restricted license	Learn the computer tools and equipment
2. Take the test and pray you don't miss more than 3.	Work with the basic computer tools and pray you save the designs correctly.
3. Practice, practice practice.	Practice, practice practice.
4. Take the road test.	Apply your design skills to create a motif.

Don't forget, through these steps your instructor (or boss) was there to provide direction, advice, and constructive criticism, but as you learn to build your skills you will be able to:

5. Get your license.	Design a garment.
6. Buy your first car.	Develop a complete line or collection.

The Basics: Introduction to the Terms, Tools, and Steps of Working with the Computer

POWERING UP YOUR COMPUTER

We are going to show you how to launch (start) a program from the program menu or from a program icon. Both are common options for a computer user. Simply follow the steps listed below. At the same time refer to Figure 4-5, and probably the most important point we need to make is, Keep notes on what you did and why! The most frustrating study times for students occur when you leave the classroom, go home, review your work, and you don't have a clue how you arrived at the answer. Sure, the instructions are given, but sometimes your own personal notes will be a lot more beneficial.

Launching a Program from the Program Menu (see Figure 4-5)

1. Power up (turn on) your computer and monitor.
2. Using your mouse, left click on the Start button located at the top or bottom of your screen.
4. Using the mouse, scroll to, then left click on Programs.
5. With the left button of mouse, click to select the Program you wish to activate.

Special Notes

Biggest challenge: _____

What you learned that was new, and special notes on what you want to always remember:

Miscellaneous thoughts: _____

FIGURE 4-5 Screen shots of a program icon and a program menu.

Launching a Program from a Program Icon (see Figure 4-6)

1. Power up (turn on) your computer and monitor.
2. Place your mouse directly over the program icon you which to select.
3. Double click the left button to activate, or
4. Click the left button once on program icon and hit the enter key.

Special Notes

Biggest challenge: _____

What you learned that was new, and special notes on what you want to always remember:

Miscellaneous thoughts: _____

 Are you ready to design yet? No, not yet. There's still more to learn. We've discussed cursors and icons, and in fact we even had you work on an exercise where the term *icon*

FIGURE 4-6 Launching CorelDRAW from a Program Icon.

was used. So let's make sure between the definition found in Chapter 3 and the exercise that you just completed that you can identify the common cursor icons and icons associated with specific techniques and tools. In Figures 4-7 through 4-10 show the common icons representing the cursor. With a cursor icon you can always find your place on the screen. You can even ask for help using your cursor. All this is just a mouse click away.

Cursor icons are found in a variety of difference graphics and image-editing programs. In fact, there may be some variations from program to program on the rendering of the icon, but typically you will have no problem recognizing the icon and what it stands for.

CURSOR/ICON WORKSHEET

This is a worksheet for you to identify the common cursors your software application(s) uses. And one last reminder. Don't panic if your version of software and the cursors/icons looks different from the ones in this book. Just as the desktop may look different, so may the cursor icons. For example, if you are using an older version of a CorelDRAW program, you might notice that some of the cursors/icons have been "updated" in the latest version of the software in both form and appearance and even where the icon is located. As we mentioned before, keep good personal notes.

1. Name and version of the software program you are using:

2. Compare the cursor icons from the program you are using to the ones we listed. Identify how they are the same, or even more importantly, how they might be different:

3. Special Notes:

 Biggest challenge: _____

 What you learned that was new, and special notes on what you want to always

 remember: _____

 Miscellaneous thoughts: _____

COMMON ICONS	BRIEF COMMENTS	SCREEN SHOT OF ICON
I beam	text	**FIGURE 4-7** I-beam text cursor.
Arrow	selection/pointer	**FIGURE 4-8** Arrow icon for pointing and selecting.
Hand	selection/pointer	**FIGURE 4-9** Hand icon for pointing and selecting.
? (question mark)	help	**FIGURE 4-10** Question mark icon for obtaining on-screen help.

ICONS, ICONS, AND MORE ICONS

The word *icon* has been used to identify a cursor, but it also can represent a picture or activity, such as drawing or typing. Listed below are the most common icons and their basic task or functions. This list is by no means inclusive and can vary from program to program and platform to platform; however, these are the icons you will most need to know.

Clipboard	Open folder	Save
Color/palette	Paste	Spell check
Cut	Pen	Text
Fill	Picture (clip art)	Trash
Help	Pointer	Undo
Internet	Print	Zoom
New file	Program	
Object drawing	Redo	

Now, using your software program, review the symbols you will use to complete your tasks. Don't just keep personal notes, it's time to show a bit of your designer flair and draw a quick sketch of how yours may differ and note its location.

Clip Art (Figure 4-11)

 FIGURE 4-11 Clip art icon.

Software application (program): _____

Where the icon was located: _____

Comments: _____

Clipboard (Figure 4-12)

 FIGURE 4-12 Clipboard icon.

Software application (program): _____

Where the icon was located: _____

Comments: _____

Color/Palette (Figure 4-13)

FIGURE 4-13 Color/palette icon.

Software application (program): _____

Where the icon was located: _____

Comments: _____

Cut (Figure 4-14)

FIGURE 4-14 Cut icon.

Software application (program): _____

Where the icon was located: _____

Comments: _____

Fill (Figure 4-15)

FIGURE 4-15 Fill icon.

Software application (program): _____

Where the icon was located: _____

Comments: _____

Help (Figure 4-16)

FIGURE 4-16 Help icon.

Software application (program): _____

Where the icon was located: _____

Comments: _____

Internet (Figure 4-17)

FIGURE 4-17 Internet icon.

Software application (program): _____

Where the icon was located: _____

Comments: _____

New File (Figure 4-18)

FIGURE 4-18 New file icon.

Software application (program): _____

Where the icon was located: _____

Comments: _____

Open Folder (Figure 4-19)

FIGURE 4-19 Open folder icon.

Software application (program): _____

Where the icon was located: _____

Comments: _____

Object Drawing (Figure 4-20)

FIGURE 4-20 Object drawing icon.

Software application (program): _____

Where the icon was located: _____

Comments: _____

Paste (Figure 4-21)

FIGURE 4-21 Paste icon.

Software application (program): _____

Where the icon was located: _____

Comments: _____

Pointer (Figure 4-22)

FIGURE 4-22 Pen icon.

Software application (program): _____

Where the icon was located: _____

Comments: _____

Picture (Figure 4-23)

FIGURE 4-23 Picture icon.

Software application (program): _____

Where the icon was located: _____

Comments: _____

Print (Figure 4-24)

FIGURE 4-24 Print icon.

Software application (program): _____

Where the icon was located: _____

Comments: _____

Redo (Figure 4-25)

FIGURE 4-25 Redo icon.

Software application (program): _____

Where the icon was located: _____

Comments: _____

Save (Figure 4-26)

FIGURE 4-26 Save icon.

Software application (program): _____

Where the icon was located: _____

Comments: _____

Spell Check (Figure 4-27)

FIGURE 4-27 Spell check icon.

Software application (program): _____

Where the icon was located: _____

Comments: _____

Text (Figure 4-28)

FIGURE 4-28 Text icon.

Software application (program): _____

Where the icon was located: _____

Comments: _____

Trash (Figure 4-29)

FIGURE 4-29 Trash icon.

Software application (program): _____

Where the icon was located: _____

Comments: _____

Undo (Figure 4-30)

FIGURE 4-30 Undo icon.

Software application (program): _____

Where the icon was located: _____

Comments: _____

Zoom (Figure 4-31)

FIGURE 4-31 Zoom icon.

Software application (program): _____

Where the icon was located: _____

Comments: _____

We know we have given you a lot of words, tools, and steps to consider. And by now you probably are totally fed up with us! We know, just like when you were a kid riding in a car, you keep wondering, are we there yet? No, not yet. We consider all of this information necessary, just like traffic lights, and even though we know all of you would love for us to flash the green light, we still need to proceed with caution to put these tools into action. (But don't get discouraged; you'll make it on time. At least you're still not waiting for the red light to change.)

Even though we are going to proceed with caution, you will learn in Chapter 5 how to work with these tools to manage the data you are going to enter into the computer.

CHAPTER SUMMARY

When working on either industrial or commercial software there will always be universal commonalities. Regardless of whether your are using a vector- or raster-based program, the basic menus, tools, and techniques used are very similar. Even the icon used to represent a given task is as universally recognized as a stop sign or a traffic light.

Locating the basic tools and functions of the computer and software used in designing and rendering fashion can be compared to locating the instruments and operations necessary to drive a car—any car (Figure 4-32), from a compact to a midsize to the most exclusive luxury make and model). Here is an example to "drive" this point home!

Car engine	=	Computer CPU
Transmission	=	File management, open, reopen, exit
Steering wheel	=	Basic drawing tools
Headlights	=	Color and fill palettes
Windshield wipers	=	Viewing options
Turn signals/hazard lights	=	Selection tools, editing tools, and menu options
Radio/CD player	=	Clip art, filters, Internet access
Heater/AC	=	you get the idea!

FIGURE 4-32 Whether using a computer or driving a car, you need to locate all the instruments and learn the operations first.

The basics functions and options are in the same general location, regardless of the relative age of the car (computer or software version) or the brand of car (software/systems—commercial, or industrial) or model (vector or raster).Each vehicle get you from point A to point B, and if you can drive one, you can drive them all. The computer maybe the vehicle but you are still the driver. The real power and creativity is in you!

CHAPTER 5

Special Tools and Skills and Program Applications for Lines, Drawings, and Images

Focus: Commercial and Industrial Vector- and Raster-Based Software Distinctions and Universal File Management Operations

CHAPTER OBJECTIVES

- Compare and contrast the similarities and differences between commercial and industrial vector-based software
- Compare and contrast the similarities and differences between commercial and industrial raster-based software
- Master the basics of file management (files and folders), including New, Open, Reopen, Close, Name, and Save
- Distinguish between vector and raster file formats and file extensions

TERMS TO LOOK FOR

file	main menu
file extension	menu bar
file format	native file format
file management	raster
folder	vector
graphic	

Now that you've walked around the office space for your brain center, we imagine you are more than ready to use your desk tools to design. You're almost there, but we are going to ask that you pay close attention now as you begin to drive the actual design process. Even though you've learned about this brain center and the tools to drive the computer, you are now going to learn how to work with the two different program applications most used by a designer.

You probably are thinking that we have already explained computer programs. Yes, we did explain in Chapter 2 the difference between industry-driven and third-party/commercial/ off-the-shelf programs, but what we are going to discuss now are program applications; the word *applications* is what is key now.

We are going to focus on the differences and the similarities of file management and design basics between vector- and raster-based program applications. This is technical, but if we don't teach you about this now, you could work all quarter long either in school or on the job—and if you don't know how to manage the data you will never be able to merge the components effectively to develop a line. So let's talk about what kind of data you are going to enter.

When a fashion designer uses pens and pencils to sketch, you see lines and shapes merging to create images. As the designer substitutes the pens and pencils for the keyboard and mouse, he or she will be using program applications that will help the him or her to merge the lines and shapes into images that can be used for textile or garment design. These two basic applications are vector-based/drawing/graphic programs and raster-based/ image-editing paint programs.

The best way we know to move you through these application programs is to first explain the features of the applications and identify the concept-specific similarities within both. It does not matter if you are using the most common commercial/third-party/off-the-shelf programs or an industrial-based program application or system. The operation or sequence of managing data of any kind is similar. We will show you how to:

1. Open these programs.
2. Open existing files.
3. Create a folder
4. Name and save these program files.
5. Close and exit the program files.

As we go through these exercises, we are going to give you step-by-step directions on the different skills for each of the program applications.

EXERCISE FORMAT STYLE

We consider this to be a review, because you should all have some basic computer training; however, we know that many of you have only limited training on graphics programs, and this will provide a comfortable review. All of our exercises will be addressed in the following format:

- Identify the activity. We will also indicate the software program shown in the screen shots.
- Explain the reasons why it is being done, and if possible explain who would be doing it and at what point in the process. If possible we will also discuss how it might be executed manually. This will be emphasized in the design exercises.
- The steps to complete the task will be provided.
- Special notes or advice.
- A screen shot of the skills being addressed so you can visually compare your work to the text.

■ A Personal Notes section on what you learned, and/or special notes about the exercise to which you might want to refer later. This will be very helpful as a personal study guide.

Look for this format
for your note taking
in all the remaining
chapters!!!

■ And, a special note from us.

| Stop | Proceed with caution | Go |

■ Be sure to watch for the "traffic lights" under special notes or advice.

We will also caution you about what could be a challenge, and will remind you to stop if you have not mastered the concept. And, of course we will tell you when it is safe to go on to the next topic or section; we will also give you the green light when the way is clear.

THE FILE MANAGEMENT PROCESS (IS THERE MORE THAN ONE WAY TO OUR DESTINATION?)

It is important to stress that in these exercises we are only going to give you one version of how to perform a given task. Let us explain what we mean. When you are heading to work, which road do you take? The interstate, a side road, a back way? Does it matter? Sometimes it does; one route may save you time, money, or even both. However, for the most part, the fact remains that there are still several ways to get to the same destination. The same is true for managing files.

While working on the computer to get to the final goal, we are going to follow the most direct route to reach a given task/destination. We recognize that just like the trip to work, there may be shortcuts. But for the sake of those of you who are not secure in working on a computer, we will take the most familiar route. For those of you who have the computer savvy to go it alone, consider this a review. For example, if you have the expertise to accomplish a task by using a function key or hot keys, go for it! However, even those of you who are computer literate may not have the depth of understanding needed to take all the shortcuts—yet.

So we chose to take the familiar, long road with the exercises in this book. This way you will have a very clear set of verbal and visual directions to accomplish a given task.

One last point: it doesn't matter if you are a seasoned vet or just starting out as a CAD designer, pay attention to the screen. Always note the location of an action and what you did to accomplish that step. Watching the screen and keeping good notes will help you enormously, especially if you are using an unfamiliar computer or software application, either in the classroom or on the job.

If you go through the steps logically, we feel confident that the task you must execute can probably be found in that software and the steps to execute the task are typically in a similar logical location. You will easily find where to locate the action you need to execute the task, it just may take you a moment or two to find it.

Finding where in the program to execute the task is probably no different from looking for a new address. Sometimes you may drive by it the first time or two because it could be covered by foliage, or the number of the address is written too small to be seen from the road. You might drive right past the address a few times, but relax, it is there. Working with different programs is no different—follow the general directions and you too will find the right place in the program.

In fact, persons using these systems according to the Kodak Web site (http://www.kodak.com) can be categorized as one of three types of users:

The **power users**—The pros; a small minority of imaging professionals—highly proficient, using high-powered systems.

The **unsold masses**—Those who view a computer merely as a tool for word-processing and spreadsheets.

The **frazzled few**—Those who have attempted to become power users but have had an expensive and/or unsuccessful frustrating attempt at using computers.

As we begin this section, which focuses on vector- and raster-based programs, our goal is to keep you from becoming one of the frazzled few.

OVERVIEW ON THE DISTINGUISHING CHARACTERISTICS OF A VECTOR-BASED PROGRAM

This introductory overview will include what each of these programs can and cannot do, as well as how and where a fashion designer would use them.

Features

What is a vector drawing program?	A drawing or illustration program
What does a vector drawing program do?	Creates vector images based on mathematical curves and lines
What doesn't a vector drawing program do?	Create realistic images
How and when do you use a vector drawing program?	For flat renderings of garments and some motifs or logos
Who makes a vector drawing program?	Corel Corp. (CorelDRAW), Adobe Corp. (Illustrator), Macromedia (Freehand), Deneba (Canvas), Micrografx (Designer) to name just a few
How do you save a vector drawing program?	Native formats such as cdr in CorelDRAW or as an EPS, PICT, or WMF

Detailed Explanation

Vector drawings are images defined by curves and line or mathematical formulas. Basically, what this means is that a vector program stores each image as a series of instructions on just how to draw the image. These graphical representation of objects—usually consisting of line drawings or other primitive forms such as lines, rectangles, ellipses, arcs, spline curves, and in many cases type—are generally simple and can be highly compressed (made smaller). In the case of a vector program they are also considered an object-oriented system.

In lay terms, a typical vector-based illustration is composed of objects that have one or more paths that have been created by a series of line segments, all of which have anchor points.

These illustrations are actually created in a variety of ways. As you progress in your knowledge of these concepts you will want to continually refer back to this segment before beginning any illustration. Each of the techniques listed below will be covered in more detail in Chapters 7 and 10, the actual "how-to" portion of the book.

Object-oriented drawings

Using freehand drawing tools

Manipulating a scanned image

Using existing clip art

Tracing a bit-mapped image

Importing existing images

Vector-based programs are useful for a fashion designer. We have listed below some of the features, including both the pluses and minuses of using vector-based drawing programs. Figure 5-1 is an example of a vector-based drawing.

The most important feature to note is the resolution or clarity of the drawing. Vector images are also resolution-independent, meaning that they will always render at the highest resolution an output device can produce—the higher the resolution of the monitor or printer, the sharper the object-oriented image will appear. What this means to the fashion designer is that these drawings are easy to:

FIGURE 5-1 A vector-based drawing.

Select

Color

Move

Resize (without degradation of image)

Reorder

Overlap with other images

Use to access individual objects

Reformat, such as with color or fill

Produce smooth-looking graphics (i.e., no jagged lines or stair-step appearance)

Recognize fonts as vectors

Render vector and save as bit-map file format

Output at higher quality

Manipulate objects freely and still access them individually

Vector graphics are much smaller files than raster/bit-map files. A vector file can be resized without degrading the file in anyway; this is not true of its counterpart, a raster file (Figure 5-2).

FIGURE 5-2 Zippy is a vector-based drawing and can be clearly reduced or increased.

STUDENT NOTES

Saving Vector Graphics

The key to any graphic is saving the file correctly. We have included a detailed explanation of the file format extensions when using both vector- and raster-based software. For now, the best formats for saving are Postscript (page-description language, or PDL) and EPS (used to transport files between vector-based-programs). The final output for your project will clearly determine the best format for saving your file. EPS is often the preferred format because it can be used for vector graphics, for type, or for bit-map images. You can also opt to simply use a native file format such as CDR (CorelDRAW).

In Summary

Vector images are best when working with small type and bold, smooth, crisp graphics requiring curves and lines (regardless of what size they will be scaled to). They are considered the most flexible, and they use little memory for storage. The downside is that vector-based images are not realistic. Furthermore, they are known for having a flat versus a three-dimensional appearance as compared with raster-based images.

Now that we have given you a little background on vector-based programs, we're going to walk you through launching a new file, opening an existing file, creating a folder, naming and saving a file, and then closing and exiting the program.

The exercises in this book can be completed with any vector-based program, including Micrografx Designer, Adobe Illustrator, and CorelDRAW.

Special Note: **This section, along with the sections on raster-based software and understanding file formats later in this chapter will be your *two most important referenced sections within this book*. It is critical that you build on a strong foundation. The concepts given here and then built on throughout the book will be a determining factor in your success as a designer.**

FUNDAMENTAL EXERCISES FOR FILE MANAGEMENT FOR VECTOR-BASED SOFTWARE: MAKING THE COMPUTER WORK FOR YOU

As we begin now to put to the test in these practical exercises the basic concepts of file management, don't forget you are not to focus on the program or version of software we use in the exercises. You must focus on accomplishing the same concept or task on your computer using the software you have. Remembering the icons and/or tasks are as common as locating the basics tools and steps to driving a car.

So relax. Sit back. Fasten your seat belt. And let's take a test drive of the basics of file management for vector-based software.

Exercise 5-1: How to Launch a New Graphics Program File

Software Used

CorelDRAW or any off-the-shelf vector-based software
In this exercise we will be showing you the steps in an off-the-shelf vector-based program. If you do not have the exact same software don't panic; as long as you are using a vector-based program you should be able to accomplish the task.

How-to Steps

1. Look at the screen shots in Figure 5-3. Launch the program either through the program listing on Windows, or by double clicking the mouse on the CorelDRAW icon.

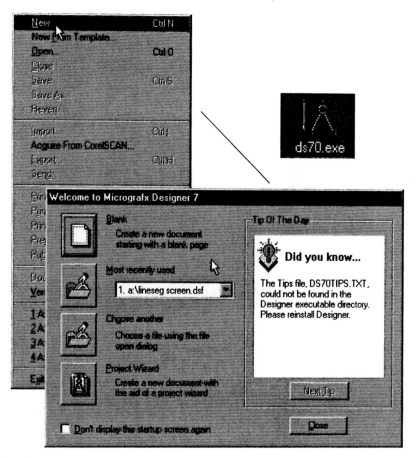

FIGURE 5-3

2. Select New Blank to create a new page, click the mouse or hit the enter key.
3. Go to the File menu and click the mouse.
4. Move down to Page Setup and click the mouse.
5. Make sure you have the page layout you want, portrait or landscape. If you need to change the page layout, click on the selection you want and then click the mouse on OK. If you do not need to make any new changes here, click the mouse on Cancel.

Additional Comments

It is a good habit to use your mouse to select or turn on the Snap to Guides and Rulers. You may also want to display both the clip art and swatches. With these features opened, you are setting up the most common supplies you will use for design.

When you get a blank screen, it is just like a blank piece of paper a designer would pull from a sketchbook. By clicking on clip art it gives you the menu on the screen, and the colors to choose are found in the swatches to use with your tools. Some programs will do this automatically, but we wanted you to know if the program you are using does not do it automatically, it is a good idea to get your desk ready with all your equipment.

Special Notes

Name and version of software used: _____

Additional steps to execute the program that were specific to the software program that you are using: _____

Biggest challenge: _____

What you learned that was new, and special notes on what you want to always remember: _____

Miscellaneous thoughts: _____

Exercise 5-2: Reopening an Existing File in Any Vector-Based Software Program

Software Used

Micrografx Designer

How-to Steps

1. Using the mouse, go to the File menu and click (Figure 5-4).
2. Select Open and click the mouse.
3. At the "look in " box at the top center of screen, click the mouse on the arrow (Figure 5-5).
4. The pull-down menu now offers various locations where you can store your work. If you stored the data on the computer hard drive, you will look for drive C. If you stored the data on a floppy disk, then select the A drive with the mouse and click.
5. Next, use the mouse to select or preview what is on the disk. When you locate the file you want, you may double click with the mouse to open that file.

Additional Comments

Don't get discouraged if you wonder if you ever are going to start designing. You will, but first you have to have a good understanding of your tools.

FIGURE 5-4

Skill Level: Elementary

FIGURE 5-5

Special Notes

Name and version of software used: _____

Additional steps to execute the program that were specific to the software program that you are using: _____

Biggest challenge: _____

What you learned that was new, and special notes on what you want to always remember: _____

Miscellaneous thoughts: _____

Exercise 5-3: Creating a Folder

Software Used

Any vector-based program

How-to Steps

1. Using the mouse, click anywhere on the main New Folder icon (Figure 5-6).
2. From the pop-up menu, select New Folder, and click (Figure 5-7).
3. When the new folder appears, type over the name that is given (default name) for the folder. Perhaps the folder can be named by the collection

FIGURE 5-6

FIGURE 5-7

you are creating or the season you are designing for. Simply strike Enter and the new folder is created.

Additional Comments

Keep your folders organized. The key to success in the design world is managing multiple projects, each with unique features and demanding deadlines. If you can grab your files easily to find the information you need, you create a strong foundation. Possibly you can name each folder for the collection as well as the item being created. For example the folder may be named *panmil*, representing the pants in the collection/line you are working on named Millennium.

Special Notes

Name and version of software used: _____

Additional steps to execute the program that were specific to the software program that you are using: _____

Biggest challenge: _____

What you learned that was new, and special notes on what you want to always remember: _____

Miscellaneous thoughts: _____

Exercise 5-4: Naming and Saving a File to Disk in a Graphics Program

Software Used

Any vector-based program

This exercise will show you the basics of how to save and name a file on a data disk in a graphics program. Failing to understand how and where to name and save a file can be a disaster if you are not paying attention. For this reason we have expanded on this at the end of this section so you can familiarize yourself with saving a file correctly.

How-to Steps

These steps are very important so we have included additional screen shots so that you can follow along and make notes after each screen shot.

1. Go to the File menu, with the mouse.
2. Select "Save."
3. Click on the scroll button in the Save in dialog box for the storage area of your choice.
4. For this exercise, select A then click (Figure 5-8).
5. Go to the File name dialog area and click to highlight the existing document name.
6. Type a name for your file.
7. At this point, after the file has been named, the program will add a special code. This code is called a file extension indicator.

Additional Comments

Each program has a special identifying code, what the computer savvy refer to as the "native format." This code will provide even more details about the file. The name you give the file will indicate what data you have stored in the file. That is followed by a period. After the period is a special code, typically three or four characters (can be letters or numbers or a combination of both), that identifies the type of program the work has been saved in. For now we will use only the native file format extension to save our work.

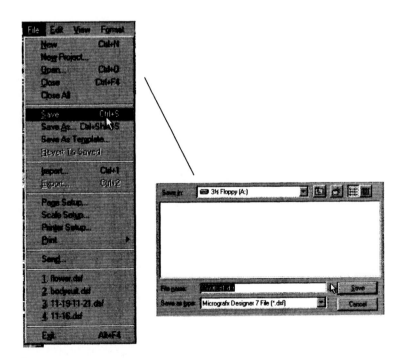

FIGURE 5-8

If you are not sure what your program's native format is, simply name the file and hit the Enter key. The program will automatically add the extension for you.

Special Notes

Name and version of software used: _____

Additional steps to execute the program that were specific to the software program that you are using: _____

Biggest challenge: _____

What you learned that was new, and special notes on what you want to always remember: _____

Miscellaneous thoughts: _____

Special Saving Advice

Probably the best advice we can give you here is to reread the definition of save from the list of basic computer terms in Chapter 3. Beyond that, we want you to pay special attention to which light goes on when you save a file to the A drive.

If you save data on the A drive you will notice actions in two areas of your computer. First, on the screen, usually on the status line, you'll notice the computer will tell you it is saving with a word, a phrase, or a graphic or by numbers and percentages. At the same time this is happening the light located near the mouth of the A drive is on. Notice just how long the light stays on. Frequently, it stays on longer than the status line on the screen indicates. So remember, if you remove your disk while that light is still on, the data will not be saved.

Here are some suggestions for when, where, and how to save.

When—As frequently as possible. We suggest you save every 15 minutes. A rule of thumb is how much data can you afford to lose?

Where—Always back up your work. For example, if you typically save to the hard drive (C) of the computer, also make a copy on a 3.5-inch disk, by using the A drive, on a writeable CD, or on a Zip drive. Some people even save to a "network" (when available) for larger files because it is less expensive than disks.

How—The answer to this is not as obvious as it appears. We suggest that you save complex files in increments, stages, or versions.

- For example, you might save a rendering to the hard drive as a template to use frequently. You open that file and begin to build the image by garment rendering and save it as version 1.
- Next, you experiment by adding color; this becomes version 2.
- If you need copies in different color combinations they become version 3, and so on.
- If you decide to add additional images such as texture, these also take on a version number. This works for modifications of garments, too. For example, a blouse that changes only a sleeve length or fabrication can become versions under the name of the type of modification, such as fall or summer, short-sleeve or long-sleeve. This method is simply working smarter versus working harder.

A little planning can go a long way, and the computer really can be your best friend. When you are completely satisfied this become final version. Typically, the filename will look something like this—A:blousefnl.cdr

Exercise 5-5: Closing a File and Exiting the Program

Software Used

Any vector-based program.

How-to Steps

1. Go to the main File menu; click on left mouse button.
2. Select Close by clicking on it with your mouse button (Figure 5-9).
3. If the computer asks you to save changes, click the mouse on Yes.
4. Go back to the File menu and click on Exit.

Additional Comments

Now that you've reviewed the basics using a vector-based program, it is important to review the same concepts in raster-based programs. So, after you complete this exercise, let's look at image-editing programs in more depth.

Special Notes

Name and version of software used: _____

Additional steps to execute the program that were specific to the software program that you are using: _____

STUDENT NOTES

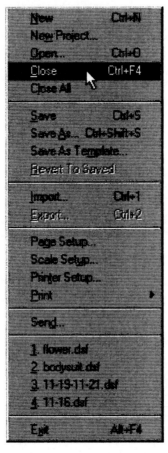

FIGURE 5-9

Biggest challenge: _____

What you learned that was new, and special notes on what you want to always remember: _____

Miscellaneous thoughts: _____

Fundamental Exercises for File Management for Raster-Based Software

Now we are ready to tackle the same tasks on raster-based software that we just finished with for vector-based software. Be sure you look for the commonalities between both vector- and raster-based programs when it comes to file management.

We will begin this section with an explanation of the distinctive qualities and features found in most raster-based programs that can be either commercial or industrial.

Features

What is a raster-based program?	An image-editing program (also known as a paint program)
What does a raster-based program do?	Raster or bit map or REALISTIC images based on pixels
What doesn't a raster-based program do?	Crisp, bold, smooth graphics
How and when to use raster-based programs	Primarily used working with photographs and other realistic images, e.g., clip art
Who makes raster-based programs?	Corel Corp. (CorelPHOTO PAINT), Adobe Corp. (Photoshop), and Fractal (Painter)
How to save a raster-based program	Native formats such as psd for Adobe Photoshop, TIFF, BMP, PCX, JPG, JPEG, and GIF

Detailed Explanation

Raster programs are best known for their realistic or real-world images. These programs allow the designer to refine details, make dramatic changes with special effects, and are noted for providing a greater degree of subtlety than vector-based graphics.

Raster/bit map yields the most realistic images, such as photographs These images can be transformed by using image-editing filters to create a wide range of special effects and natural looks. These programs work with pixels or bit-mapped images, that can be enhanced with vector-style painting options.

Let's take a moment to give you an overview of what a bit map is and what it does. Bit map is a collection of picture elements or dots, also known as pixels. Bit-mapped images are resolution-dependent. Basically this means you must specify a resolution. If you create the image and then change the resolution you degrade the image. Scaling up can be a disaster, scaling the image smaller sometimes yields better results. In fact, the raster image is a referred to as a bit-map image because it contains information that is directly mapped to the display grid of x (horizontal) and y (vertical) coordinates.

In scanned images the computer views 1s and 0s. These bit-map squares can be independently accessed but are difficult to edit. They can be toggled on and off—1 represents on and 0 off.

Figure 5-10 is an example of a raster-based image. Notice the depth and quality of the image.

Bit-map images:

- Are resolution-dependent.
- Are best used with continuous-tone images, such as photographs.
- Can be modified with great detail because you can manipulate each pixel.
- Are generally captured by scanning to be modified digitally.
- Are difficult to modify and to resize.
- Do not lend themselves to freely accessing individual objects.

FIGURE 5-10 A raster-based image.

- Do not enlarge well; their appearance is blurred when they are enlarged.
- Can have a jagged, or stair-step appearance due to the pixels.
- May interpolate or discard pixels indiscriminately when they are being reduced.
- Lend themselves to modifying individual pixels or large groups of pixels.
- Require huge amounts of memory, usually larger than a vector file. This means they must be compressed or zipped to store.
- When the data is compressed.
- Slows down reading, rendering, and printing of files, as well as shrink the amount of original pixel data.

Photoshop is one of the best known and most widely used image-editing programs. Another leading painting program you can use to edit and enhance photos is Metacreations Fractal Design Painter. Fashion designers love Fractal Design Painter because it simulates natural mediums such as charcoals, chalks, oils and acrylics to enhance photographic images.

Interestingly enough, it does not matter which type of application you create your image in; you can convert it to a raster format with Adobe Photoshop.

Saving Raster-Based Images

By far the best way to save a bit-map or raster image is by using the file extension or file type BMP, TIFF, GIF, or JPEG.

In Summary

As a fashion designer, you will be using raster-based images for presentation boards or when you need to have a real-world image. Just as you completed basic exercises using a

vector-based program, we're going to walk you through launching a new file, opening an existing file, creating a folder, naming and saving a file, and then closing and exiting the program using a raster-based/paint program.

Exercise 5-6: Launching a New Image-Editing File

Software Used

Adobe Photoshop

How-to Steps

1. Launch the program either through the program listing on Windows or by double clicking on the Photoshop icon (Figure 5-11).
2. Look at Figure 5-12, where the screen will give you choices.
3. Notice what has been selected—Width: 6 inches; Height: 6 inches; Resolution: 72 pixel/inch; Mode: RGB Color (this can be changed later under the Image menu, Mode fly-out menu); Contents: White.
4. There are several other tools, options, and/or menus you might want to activate (see Figure 5-12). In the Window menu, click to show Tools, Swatches, and Layers.
5. Like Designer you may choose to "turn on" the Snap to Guides and/or Rulers.

Additional Comments

Do you remember reading about file size, format, and resolution? In these exercises we have made the choices for you, but remember to look for arrows that indicated submenus, pull-out menus, or dialog boxes for more choices.

Special Notes

Name and version of software used: _____

FIGURE 5-11

FIGURE 5-12

Additional steps to execute the program that were specific to the software program that you are using: _____

Biggest challenge: _____

What you learned that was new, and special notes on what you want to always remember: _____

Miscellaneous thoughts: _____

Exercise 5-7: Reopening an Existing File in Adobe Photoshop/Raster-Based (An Image-Editing File)

Software Used

Adobe Photoshop

How-to Steps

1. Using the mouse, go to the File menu and click (Figure 5-13).
2. Select Open Existing and click the mouse.
3. At the Look in box at the top center of screen, click the mouse on the scroll arrow.
4. The pull-down menu now offers various storage locations where you can store your work. If you stored the data on the computer hard drive, you will look for drive C. If you stored the data on a floppy disk, select the A drive with the mouse and click.
5. Next use the mouse to select or preview what is on the disk. When you locate the file you want, double click with the mouse to open that file.

Additional Comments

Don't try this on just one file. Open up a couple of files. As you practice the steps will become automatic.

Skill Level: Elementary

FIGURE 5-13

Special Notes

Name and version of software used: _____

Additional steps to execute the program that were specific to the software pro-

gram that you are using: _____

Biggest challenge: _____

What you learned that was new, and special notes on what you want to always

remember: _____

Miscellaneous thoughts: _____

Exercise 5-8: Creating a Folder

Software Used

Any raster-based program

How-to Steps

1. Using the mouse, left click anywhere on the main New Folder icon desktop screen (Figure 5-14).
2. From the pop-up menu, select New/folder and click.
3. When the new folder appears, type over the name that is given (default name) for the folder. (Perhaps you could name the folder for the collection you are creating for the season.) Strike Enter and the new folder is created.

Special Tools and Skills and Program Applications for Lines, Drawings, and Images

FIGURE 5-14

Additional Comments

You've probably noticed by now, the basic steps in opening, reopening, and creating folders is the same in both vector and raster image files. That in itself should make you feel more confident. It simply means that no matter what software program you use, the basic skills will be similar. That is probably the biggest point we hope to drive home. Skills learned using any program can support you in any job situation.

Special Notes

Name and version of software used: _____

Additional steps to execute the program that were specific to the software pro-

gram that you are using: _____

Biggest challenge: _____

What you learned that was new, and special notes on what you want to always

remember: _____

Miscellaneous thoughts: _____

Exercise 5-9: Naming and Saving a File Disk in an Image-Editing, Raster-Based Program

Software Used

Any raster-based program

How-to Steps

1. Go to the File menu and click.
2. Click on Save As (Figure 5-15).
3. Click on the scroll arrow to select a storage area. (For this exercise, click on A.)
4. Go to the File name dialog area and highlight the existing document name.
5. Type a file name.

Skill Level: Elementary

FIGURE 5-15

6. Now it is time to save. You may click scroll to select the three- to four-character suffix or extension for your file format. You may also type in the suffix yourself, following the name of the file. Finally, you may choose to let the software name the file format in its native format (Figure 5-16).

Additional Comments

Saving your information correctly is important. Take a few moments to review the extra notes in Exercise 5-4.

Special Notes

Name and version of software used: _____

FIGURE 5-16

Additional steps to execute the program that were specific to the software program that you are using: _____

Biggest challenge: _____

What you learned that was new, and special notes on what you want to always remember: _____

Miscellaneous thoughts: _____

Exercise 5-10: Closing a File and Exiting the Program

Software Used

Any raster-based program

How-to Steps

1. Go to the main File menu, and click on the right mouse button to select.
2. Click on Close (Figure 5-17).
3. If the computer asks you to save changes, click on Yes.
4. Go back to the File menu and click on Exit.

FIGURE 5-17

Additional Comments

This has been a pretty good overview for you. Soon you will see why it is important to cover all these basics.

Special Notes

Name and version of software used: _____

Additional steps to execute the program that were specific to the software program that you are using: _____

Biggest challenge: _____

What you learned that was new, and special notes on what you want to always remember: _____

Miscellaneous thoughts: _____

Before we put it all together, let's review what you have just done and make several observations that will come in handy later. First, did you notice under the main File menu, regardless of the program software, that several options were common to most of the programs? Notice in Figure 5-18 that under the main File menu you will always have the following choices:

Open a new file
Open an existing file
Save a file
Name and save a file
Page setup options
Print a file
Close a file
Exit the program

You will discover later that these main menus have similar choices just like under the **File menu** (Figure 5-19). For example, most main menus will offer:

Edit (Figure 5-20)—This is a place to undo, cut, copy, and paste to name just a few.

View (Figure 5-21)—Here you can view your work as it would appear on a hard copy or perhaps you wish to zoom in to look at a specific detail of your work.

Window (Figure 5-22)—This menu permits you to see how many projects you are working at one time. In addition, it will permit you to view them simultaneously as well.

Help (Figure 5-23)—Who could live without this menu? Here you will often find answers to questions and solutions to problems, all with the click of a mouse.

File Edit View Layout Arrange Effects Bitmaps Text Tools Window Help

FIGURE 5-18

STUDENT NOTES

FIGURE 5-19

FIGURE 5-20

FIGURE 5-21

Skill Level: Elementary

FIGURE 5-22

FIGURE 5-23

Remember, these menus will usually be repeated in most software programs!

This has been a very technical and dry approach to design, but so very necessary. Now we need to explain how these two can merge. This is very important. Just think, basically vector programs are your pen-and-pencil drawing applications while the raster applications are for photos. Both lines and shapes are needed for design, so you must be able to merge the files effectively. The only way to do that is to learn about common file formats.

UNDERSTANDING COMMON FILE FORMATS

At this point we are going to give a brief explanation of some common file formats mentioned in the description of vector- and raster-based software. They each require a specific file format extension. For example, you might have a file named panmil, which represents the pants for the millennium collection you are designing. But what is most important now is the code will you be putting after the filename. That code, called an extension, identifies the format (program) you need to use to retrieve the data.

You probably wonder why you have to add an extension, since every graphics program defaults automatically to its own proprietary, or native, format. The challenge arises when the native file is not readable in another application. This means that after you name a file, you have to give it a special identifying code that will enable you to open the file, no matter what program you use.

Remember the scenario about switching platforms and programs between departments? Now, if you save a file with a file extension that can be cross-platform, you save yourself a great deal of stress. For this reason we are going to give you the format types, some of which are interapplication and cross-platform compatible. This is by no means an inclusive list. It is merely a description of some of those most commonly used by fashion designers.

COMMON FILE FORMATS

TIFF: Tagged Image Format
Characteristics include:

Versatile
Reliable
Support bit map, including full-color
Can contain multiple images
Great for scanners, frame grabbers, and paint/image-editing programs
Transfer cross-platform (i.e., supports both Mac and IBM formats)
If your pants file was saved in a tiff format, the filename would be something like this: pant.TIF

PICT: Picture Format Native to a Mac
Characteristics include:
- Format used with bit-map images
- Object-oriented drawings
- Great for raster printers

EPS: Encapsulated PostScript
Characteristics include:
- Cross-platform: Mac and PC
- Great for high-resolution PostScript illustrations and vector images
- Files can be imported into other documents.
- Can be scaled and cropped
- May not be editable beyond scale and crop.
- Requires a PostScript printer for output.
- Bit-map images may require tracing to convert images.
- Vector images compress well.

BMP: File Format for Bit-Map Images
Characteristics include:
- Stored in Windows as grid of dots or pixels
- Important for color information: color coded as 1, 4, 8, 16, or 24 bits, which means a 24-bit image can contain more than 16 million different colors.

JPEG: Joint Photographic Experts Group

Characteristics include:

- Interchangeable format is great for photos working with layers.
- Each layer is independent of the others, which means each layer can be edited and individual layers can be preserved for additional editing.
- Designed for compressing up to 1/20 of file's original size.
- Designed to be used for full-color, gray-scale, and real-world images
- For downloads this means smaller files and/or faster downloads.

WMF: Windows MetaFile

Characteristics include:

- Perfect for exchanging graphics between Microsoft Windows applications
- Can even accommodate bit-map images

Native File Formats

The following list includes both commercial and industrial software that is either raster- or vector-based. Some native file formats include:

- Adobe Photoshop = psd
- CorelDRAW = cdr
- Adobe Illustrator = ai
- Macromedia Freehand = ald
- Micrografx Designer = ds7 or mgx
- Metacreations Painter = Rif
- GGT/Ned Graphics/Artworks = tex, (drape texture) msk, (mask) plt (pattern,) ctb, (colorway table)
- GT/PDM = pdm

This topic can be overwhelming. We suggest you consult some computer textbooks to brush up on your basic computer training to help you get started. When it comes to file format, see what your instructor or company recommends. If you are out there alone, without someone to consult, we suggest you talk with a local service bureau. These firms are there to walk you through any problems that may arise.

CONCLUSION

With everything you have just read, you probably want to know how to use vector-based programs and when to use raster-based programs. The following are questions you might need to ask before deciding which program to use:

- **What task do you need to accomplish?** The selection of software such as vector or raster will depend on what you need to create. Ask yourself, Do I want to create simple renderings or enhance real-world images, or a combination of both?
- **What tools would you choose if you were doing this manually?** This is generally the key to which software program you will need: freehand items such as pens, brushes, and other drawing tools = vector-based software; photo images taken by a camera = raster-based software.
- **Who will ultimately view this work?** The production department, the marketing department, or the consumer?
- **What kind of output devices will be used for this work?** Printing in-house or at a service bureau.
- **What constraints must you consider?** Budget and time: You may be sending too much time on an image that can be done for less time and money for in-house use.

Remember, you can either impress or depress yourself and your boss by your choices.

Throughout this book, almost 80% of your work will be vector-based because of file size and because of the types of printer you may have available in the classroom or on the job.

Are you ready to design? We think you are!

Now with your basic computer skills and the refresher on computer "techno-talk," the desktop, and an introduction to graphic design programs, the next step is to apply what you have just read. That is exactly what you are going to do in the Chapter 6.

Are you ready to learn the basics of Vector-Based Software?

CHAPTER SUMMARY

File management is a universal concept that applies to the managing of files and folders and the data they hold. Typically, this task can be accessed under the main File menu in either commercial or industrial software, that is either vector- or raster-based. These menu files, folders, and/or data can be created, reopened, named, saved, printed, imported, or exported.

The way data are named and stored will depend on the type of program you are using and the type of program in which you wish to reopen the data. The three-character file extension will determine not only where, but how a file was created and if it can be reopened and accessed successfully in another program.

The material in this chapter is complex, but foundational. Therefore, the steps to accomplish a given task must be located in the introductory skill level. However, the more-complex specifics of integrating this information in the day-to-day activities of a CAD designer will only come with repeated use and with time and practice.

Incorporating the concepts and the vocabulary is a process. Be prepared to refer back to this chapter and to the vocabulary supplements long after you have finished the course or even your degree.

STUDENT NOTES

ELEMENTARY

CHAPTER 6

Fundamentals of Drawing and Designing on Computers: Visions Become Realities

Focus: Vision Becomes Reality Using Commercial/Industrial/
Vector-Based Drawing Tools and Techniques,
Including Managing Text

CHAPTER OBJECTIVES

- Recognize the basic menu types and their locations in all vector- and raster-based software.
- Identify the basic drawing tools in any vector- or raster-based software.
- Master the basic selection and editing tools and techniques in any vector-based software.
- Become familiar with font families and basic text formatting options in any vector-based software.
- Master the common elementary editing functions of any vector-based software.
- Adapt fundamental design options and features found on any vector-based software to text or objects.

TERMS TO LOOK FOR

axis/pivot point	fill	menu bar	toolbar
blend	font	object-oriented	toolbox
bounding box	formatting	drawing	transform
direct select	gradient	rotate	warp
editing tools	handles	selection tool	
extrude	marquee	shear/skew	

It's Time to Design!

The first thing to do is grab the equipment you need so you will have everything ready as you go through these exercises. To set up your desktop and get your equipment you need to open the toolbox menu. The toolbox menu is a list of options or alternatives you may choose when working with several of your favorite designing tools.

A menu is a list of options and choices. Recall from Chapter 3 that menus themselves have many variations. We will discuss in further detail several types of menus, such as pull-down, pop-up, fly-out, and toolbox. We will also point out some tips for locating the menus you will need and explain how to use the menus most effectively.

If you think about it, a computer program menu is not unlike a menu you might see at a restaurant. You may get one menu with a list of wines when you first arrive. Next, you may be given a larger menu that includes appetizers, main entrees, or even a la carte items. After you've finished your main meal your server may offer you a dessert menu. You will find that the menu selection in your software package is very similar.

Most computer menus are hierarchical, which means that there are lists of selections in sequential order. These subsequent menus are called submenus and often are related. Actually, you have already encountered this situation. When you followed the directions to name and save your file in Chapter 4, first you had to give the file a name and then save it. You could not do that in reverse order.

You may have also noted in Chapter 4 the similarities in the main menus of most programs. Many of today's software packages share the following headings on their main menus:

```
File, Edit, View, Window, and Help
```

In fact, looking at Figure 6-1 you will notice that those main menus not only share the same titles but frequently offer the same choices, which brings us to the logical question: Do the tools in the toolbox vary from program to program? The answer is, very little. When you are working with both vector- and raster-based programs, you will find that they have several tools in common in the toolbox menu. The toolbox itself is considered a main menu and it typically is located to the left of the screen.

Depending on the particular software package you use, you will find a detailed toolbar located just below the main menu bar at the top of the screen. The menu bar will reflect additional choices for the tool you are currently using. And remember, most of the names will be associated with the task or function they perform. For example, in the toolbox, the letter A is in the form of a text icon used to represent text. When you select the A, you may find that the menu bar will present additional options associated with text, such as font family, point size, format, and style. Figures 6-2 through 6-5 show how text can be found in a variety of programs. Now look at the program you are working with and find the tools representing text.

Now, let's look at your drawing tools—what you've been waiting for! The basic tools consist of not only a text icon but also myriad drawing implements you use every day, including pencils, pens, brushes, paints, and rulers. We know those are the tools you are the most anxious to use! Although you will be using both raster- and vector-based programs to design, this chapter will focus on the vector-based programs.

Drawing Tools in Vector-Based Programs

For vector-based drawing programs, the most basic drawing tools are also icons representing pens and brushes and color palettes and/or paint buckets. We will focus on the

FIGURE 6-1 Text tools on the main menu.

FIGURE 6-2 Text tools in the toolbox.

FIGURE 6-3 Text tools as a text icon (usually the letter T or A is used).

FIGURE 6-4 Text tools on the menu bar.

Format Text...	Ctrl T
Edit Text...	Ctrl Shift T
Extrude Text	
Fit Text To Path	
Fit Text To Frame	
Align To Baseline	Alt F12
Straighten Text	
Writing Tools	▶
Change Case...	Shift F3
Make Text HTML Compatible	
Convert	
Show Non-Printing Characters	Ctrl Shift C
Text Statistics...	

FIGURE 6-5 Text tools found under a main text menu.

fundamentals for the most basic drawing tools, such as: drawing objects (also known as object-oriented drawing), adding color and gradient fills, and adding text. You will also discover advanced design-tool icons to enhance your design using fills such as gradient or patterns. These tools will typically be represented as icons symbolizing the function they perform. One feature common to most of these programs is a viewing icon. This icon, which looks like a magnifying glass, lets you view your work by zooming in (+) or zooming out (−) on a particular item. You can view your work full screen or scaled and even without color, wireframe. Using the view icon, you get a real first-hand look at what the final product will look like—a big plus in your own visualization process.

After you move through the basic drawing techniques you will move on to several of the advanced techniques in Chapter 7, including: freehand drawing, editing with pens, brushes, and line segments.

All of these exercises can be done on any vector-based program. As you work with the exercises in this book, most examples will use CorelDRAW, Micrografx Designer, or Adobe Illustrator.

Let's Find Your Tools on Your Desktop

First we'll start with a vector-based toolbox. For most of your fashion drawings you will be using a lot of the line-drawing tools. It really doesn't matter what software you are using, as you will see in these illustrations, because most vector-based software programs share similar tools (Figures 6-6 to 6-8).

FIGURE 6-6 Toolbox in Micrografx Designer.

STUDENT NOTES

FIGURE 6-7 Toolbox in CorelDRAW.

FIGURE 6-8 Toolbox in Adobe Illustrator.

Skill Level: Elementary

Locating Drawing Tools in Raster-Based Programs

It is important to point out that raster-based programs have some tools similar to a vector-based program. However, if you recall, raster-based programs are known as image-editing programs. Although they offer painting tools and other related options, these are used primarily to enhance and edit real-world images. These programs were not created to do line drawings. Figures 6-9 and 6-10 show the toolbars of Adobe Photoshop and Fractal Design Painter, two of the most popular raster-based programs. These tools are accessed and activated in a fashion similar to that of a vector-based program. Fractal Design Painter also has several more tool locations that we learn about later.

Where Do You Look?

Tools are typically represented as an icon, located on a toolbox menu. But sometimes you may need a special feature of that tool. For example, you can locate the pen icon quite easily in the toolbox, but what if you needed a calligraphy pen point? Where do you look? You will discover that there are several logical locations for these additional tools. Below are examples of these locations. But a note of caution, these additional tool option locations vary from program to program and from version to version of the same program. Don't worry, with a little patience and some logic you can locate the additional tools you need. Here are some examples of where additional tools and accessories are located:

- toolbox (typically to the left of the screen) (Figure 6-11)
- toolbar (typically across the top quarter of the screen) (Figure 6-12)
- pull-down menu (frequently the main menu options across the top portion of the screen) (Figure 6-13)
- roll-down menu (also known as scroll-down windows) (Figure 6-14)
- drawer (indicated by an arrow) (Figure 6-15)
- pop-up menu (It literally pops up after making a selection.) (Figure 6-16)
- fly-out menu (Just like the name implies, the menu flies out from a prior selection.
- Sometimes these fly-out menus can also tear off, to be used alone as a version of a floating palette or toolbox on your desktop. (Figure 6-17)

FIGURE 6-9 Toolbar of Adobe Photoshop.

FIGURE 6-10 Toolbar of Fractal Design Painter.

FIGURE 6-11 Toolbox.

FIGURE 6-12 Toolbar.

- list boxes (list of choices within a menu) (Figure 6-18)
- message box (gives user a message that often requires a response) (Figure 6-19)
- dialog boxes (similar to message box, requiring the user to interact with the computer on an action) (Figure 6-20)
- palette menu (Often you will find that logically the tools or colors within a menu will give the name to the menu.) (Figure 6-21)

How Do You Access These Tools?

When it comes to designing, there are many similar design features found in both vector- and raster-based programs. The key is to use these tools and to select the special tools you will need. Choosing the right tool involves a process. In order to use the tools most

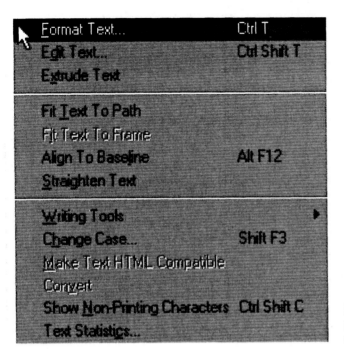

FIGURE 6-13 Pull-down menu.

Ŧ AvantGarde Bk BT
Ŧ AvantGarde Md BT
Ŧ Balloon
Ŧ BankGothic Md BT
Ŧ Bavand
Ŧ Bazooka
Ŧ Beesknees ITC
Ŧ Benguiat Bk BT
Ŧ Benguiat Frisky ATT
 Bernhard Modern Roman
Ŧ BernhardFashion BT
Ŧ BernhardMod BT
Ŧ Boca Raton ICG
Ŧ Boca Raton ICG Solid
Ŧ Bodoni-DTC
Ŧ Bookman Old Style
Ŧ Bookshelf Symbol 1
Ŧ Bookshelf Symbol 2
Ŧ Bookshelf Symbol 3

FIGURE 6-14 Roll-down menu.

effectively, it is important for you to be able to select or activate a specific tool, and/or portions of your desktop, including your design. For example, the mouse helps you to point and say to the computer "I want that pen and that pen point or that color ink." When you have all your tools ready to use, you will be well on your way to creating almost anything you can imagine.

Using the Mouse as a Selection Tool

The mouse is used for tools, images, and selection symbols. Most programs use the mouse to select or deselect. You will use the mouse as you would your finger to point and say "I want this tool," or "I want to draw with that pen." Simply use the mouse to point to where you want the pen to start the drawing.

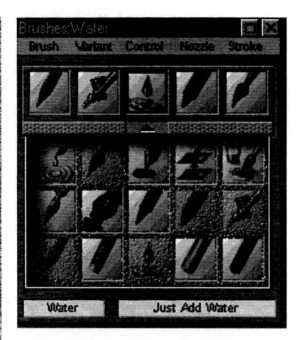

FIGURE 6-15 Drawer.

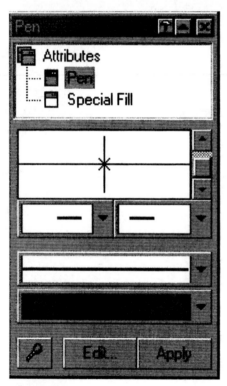

FIGURE 6-16 Pop-up menu.

FIGURE 6-17 Fly-out menu.

Skill Level: Elementary

TrueType AvantGarde Bk BT
TrueType AvantGarde Md BT
TrueType Balloon
TrueType BankGothic Md BT
TrueType Bavand
TrueType Bazooka
TrueType Beesknees ITC
TrueType Benguiat Bk BT
TrueType Benguiat Frisky ATT
Bernhard Modern Roman
TrueType BernhardFashion BT
TrueType BernhardMod BT
Boca Raton ICG
Boca Raton ICG Solid
TrueType Bodoni-DTC
TrueType Bookman Old Style
TrueType Bookshelf Symbol 1
TrueType Bookshelf Symbol 2
TrueType Bookshelf Symbol 3

FIGURE 6-18 List box.

FIGURE 6-19 Message box.

FIGURE 6-20 Dialog box.

Here's what we mean. Do you remember the childhood game of "Simon Says"? The premise of the game was that you could only do what you were instructed to do if your heard the phrase "Simon says." If you did not hear that phrase before the command, you could not perform the task (if you did you were out of the game!). Guess what? The computer loves that game! You will discover that if you don't issue the command the way the computer wants you to, you are "out"—the computer will not do what you want it to.

In Chapter 4 we discussed these mouse commands. Any time you want to perform an action you must be sure that the area or object you want to modify is activated, or selected. The most common mouse action in both vector- and raster-based programs are

- right click
- left click

Simon says

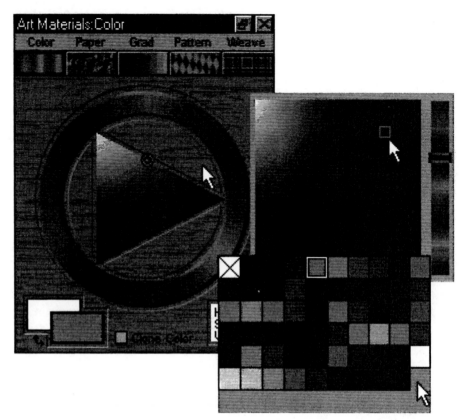

FIGURE 6-21 Palette menu.

- drag and drop actions
- choose (meaning to highlight a menu item to select it)
- select (also meaning to choose or click on an item)
- press (using keys in conjunction with the mouse)

As you continue with the selection process, it is fun to click on the selection symbols to create objects. Therefore, it is critical that you spend time getting acquainted with your toolbox and the tools. In Figures 6-22 through 6-25 you see examples of how to select and activate tools and selection symbols to create images.

Using the Selection Tools to Transform Objects or Images

Frequently, when a double-click action is applied to an object or area, a series of handles will appear, enabling the designer to modify or transform the selected area. For example, the object—in this case a square—may have a bounding box with a series of handles around it. The designer now has several choices to modify the activated area:

- resize
- move (including front to back)
- rotate (including moving axis point)
- skew, also known as shear (vertical and horizontal)
- add color
- constrain (for example, to round corners)
- direct select (an area or specific point)
- add special effects, such as gradients, patterns, and advanced transformations

Here you will see a "visual representation" of several of the common modifications you will be using. This is by no means an inclusive list; however, you must be comfortable using these methods to select and modify in order to proceed.

- Pointer Arrow—Activate the pointer by clicking the mouse on the arrow, which is the selection symbol (Figure 6-22).
- Bounding Box/Marquee/Marching Ants—Click and drag a bounding box (often called a marquee [Figure 6-23] or marching ants [Figure 6-24]) around an area or object to select it.
- Handles used to indicate that the object is activated (Figure 6-25).
- Resize Handles—The handles can be grabbed at any of the four corners to increase the width or height of an object (Figure 6-26).
- Rotate Handles—Usually a double tap of the right mouse button will access an auxiliary set of handles, such as the rotation handles, located at the four corners of the object (Figure 6-27).
- Move—You may also opt to pick up the object and move it from one location to another when this handle or cross-hair is visible (Figure 6-28).
- Shear/Skew—An object can be stretched in a shear or winding fashion by pulling or dragging on this handles (Figure 6-29).
- Direct Select object or node (Figure 6-30).
- Direct Select to Constrain an object such as round a corner (Figure 6-31).
- Move the pivot point or axis location (Figures 6-32 and 6-33).

Here we have provided space for you to make additional notes on these tools.

FIGURE 6-22 Pointer arrow.

FIGURE 6-23 Marquee.

FIGURE 6-24 Marching ants.

Fundamentals of Drawing and Designing on Computers: Visions Become Realities

ELEMENTARY

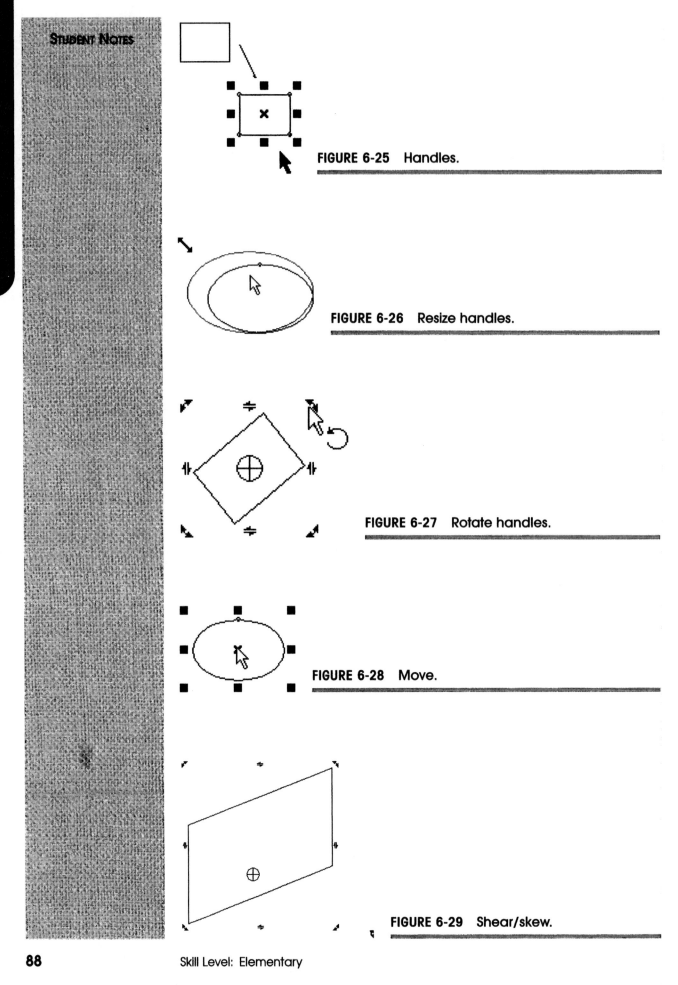

STUDENT NOTES

FIGURE 6-25 Handles.

FIGURE 6-26 Resize handles.

FIGURE 6-27 Rotate handles.

FIGURE 6-28 Move.

FIGURE 6-29 Shear/skew.

FIGURE 6-30 Direct select.

FIGURE 6-31 Direct select to constrain an object.

FIGURE 6-32 Move pivot point.

FIGURE 6-33 Move axis location.

STUDENT NOTES

Now, you try it!

CURSOR TYPE	YOUR NOTES HERE
Rotation handles	
Resize	
Move (cross hairs in center)	
Skew or Shear (corner arrows)	
Edit (note handles on one object and not the others)	
Constrain (using mouse and shift key together)	
Direct Select	
Move Axis/Edit	

DRAWING WITH VECTOR-BASED SOFTWARE

Here are some common functions you will be perform with your mouse, selection tools, and basic drawing tools. These exercises are not software-specific. They can be accomplished on any vector-based program. Drawing with any vector-based software program will always include object-oriented icons such as squares or circles. Many programs will offer additional geometric shapes or simple directions to modify the basic geometric shapes, such as modifying a square into a rectangle. Most will have features that will permit you to round the corners of your shape as well. These shapes are the building blocks you will use to make to render a garment. In most vector-based drawing programs some of the common object drawings include squares (Figure 6-34), rectangles (Figure 6-35), circles (Figure 6-36), ellipses (Figure 6-37), polygons (Figure 6-38), twirls (Figure 6-39), and stars (Figure 6-40).

Now it is time for you to use these design tools. The following exercises will give you a chance to work with the most common design tools. Take your time, keep good notes, and just have fun!

FIGURE 6-34

FIGURE 6-35

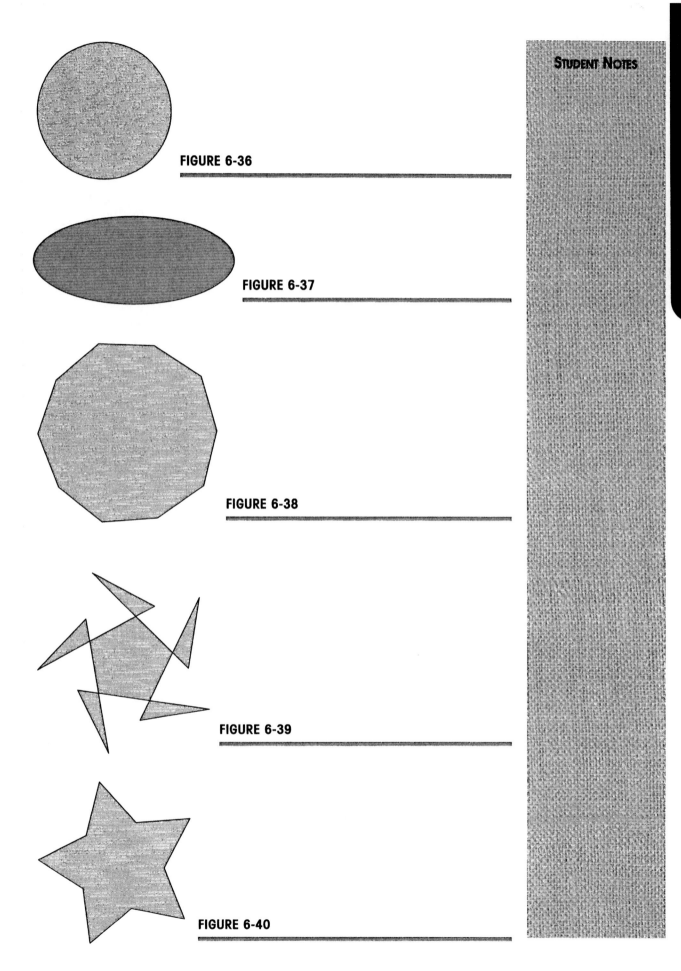

FIGURE 6-36

FIGURE 6-37

FIGURE 6-38

FIGURE 6-39

FIGURE 6-40

STUDENT NOTES

Exercise 6-1: Modifying and Transforming Objects Using Selection Tools

Software Used

Any vector-based software program

How-to Steps

1. Open a new file in any vector-based software program.
2. Using the mouse, click on the object-oriented icon shaped like a square (Figure 6-41).
3. Drag the mouse to the blank page and click and drag to form a square.
4. Click the mouse on the selection tool icon. (*Hint:* This is usually an arrow icon on the toolbox.)
5. Click and drag to draw a larger box around the square you just created. This is known as a bounding box or marquee (Figure 6-42).

Experiment with click and drag use of the mouse to play with the modifying options we just described. Make notes below.

Special Notes

Name and version of software used: _____

Additional steps to execute the program that were specific to the software program that you are using: _____

FIGURE 6-41

Skill Level: Elementary

FIGURE 6-42

Biggest challenge: _____

What you learned that was new, and special notes on what you want to always

remember: _____

Miscellaneous thoughts: _____

Exercise 6-2: Drawing a Square and a Circle Using Object-Oriented Icons

Software Used

Any vector-based software program

How-to Steps

1. Using the mouse, go to the toolbox for the object-oriented square icon.
2. Drag the mouse onto the document portion of your desktop and click and drag to create a square.
3. Using the mouse, go to the toolbox for the object-oriented circle icon.
4. Drag the mouse onto the document portion of your desktop and click and drag to create a circle on top of the square (Figure 6-43).

Special Notes

Name and version of software used: _____

Additional steps to execute the program that were specific to the software pro-

gram that you are using: _____

Biggest challenge: _____

FIGURE 6-43

What you learned that was new, and special notes on what you want to always remember: _____

Miscellaneous thoughts: _____

Exercise 6-3: Adding Color to Objects

Software Used

Any vector-based software program

How-to Steps

1. Using the same file you just created, go to the pointer or selection tool and make a marquee around any object. This is done by dragging and clicking a bounding box around one of the two shapes (Figure 6-44).
2. Go to the paint bucket icon or click on any color from the color palette menu. This will select a solid color. The color should fill automatically. If the color does not fill automatically, try dragging the mouse to the object and click the mouse to fill object with the color.

Repeat steps 1 and 2 on the second object.

FIGURE 6-44

Additional Comments

You can color all objects at the same time using the same color by drawing a marquee/bounding box around all the objects at the same time. You can also choose to change the outline color of the object and make it different from the interior fill.

Special Notes

Name and version of software used: _____

Additional steps to execute the program that were specific to the software program that you are using: _____

Biggest challenge: _____

What you learned that was new, and special notes on what you want to always

remember: _____

Miscellaneous thoughts: _____

Exercise 6-4: Changing the Order of Objects

Sometimes you may design an image and want to try it in another position, closer to another object on the same page. If these objects have an area that is overlapping you may simply flip them from back to front or front to back; this is known as changing the order of objects.

Software Used

Any vector-based software program

How-to Steps

1. Using the mouse, draw a square with the square object-oriented icon.
2. Using the circle object-oriented icon, draw a circle to the lower left of the box as in Figure 6-45.
3. You will find that the tool for moving objects on the screen is found in several locations. Sometimes the switch location option is an icon. Often, moving objects is accomplished by accessing a pull-down menu, such as the Change menu on the main toolbar and selecting "Order" (Figure 6-46).

FIGURE 6-45

FIGURE 6-46

Additional Comments

Experiment by sending the circle you just made from front to back. Remember to keep notes on the steps you take, so you can follow the software and version you are using. These notes will be very helpful later when you are drawing details on garments or working with text and objects.

Special Notes

Name and version of software used: _____

Additional steps to execute the program that were specific to the software pro-

gram that you are using: _____

Biggest challenge: _____

What you learned that was new, and special notes on what you want to always

remember: _____

Miscellaneous thoughts: _____

Exercise 6-5: Transform Objects by Blending

Software Used

CorelDRAW

How-to Steps

1. With the object-oriented icon, draw a square.
2. With the object-oriented icon, draw a circle.
3. Place a marquee or bounding box around the circle and square.
4. Locate the transform or blend option or menu (frequently you will find this under the Change menu, where you will select "Blend") (Figure 6-47).

Additional Comments

You can select the number of steps in the process if you desire or use the default number, and select to apply. You may also opt to transform the colors to form a rainbow (Figure 6-48).

Special Notes

Name and version of software used: _____

FIGURE 6-47

FIGURE 6-48

Additional steps to execute the program that were specific to the software program that you are using: _____

Biggest challenge: _____

What you learned that was new, and special notes on what you want to always remember: _____

Miscellaneous thoughts: _____

FONT SELECTION

Conveying attitude in an image is everything. Remember you are turning visions into realities.

Presenting the right image to the marketplace is fundamental for success. One of the first places to begin with image selection is in selecting the right text or lettering to market your ideas. Fonts convey image as well as attitude. The designer who takes this into consideration when creating icons or logos or enhancing and explaining any concept set themselves apart. Frequently, a designer uses hand-printed letters to label a design, rendering, or storyboard. This is wrong; use the computer to spell out success in conveying your ideas and sit back and watch the difference in response.

Font selection will confirm that you know and understand your particular market's psychographics, which include the customers' lifestyles by taste and price point. Choosing the correct font will reinforce the image or attitude of your designs as they are meant to convey (Figure 6-49).

Old West *Jerusalem*

Paris *Florida* 𝔚𝔢𝔡𝔡𝔦𝔫𝔤

Renaissance

Medieval FUN Kids

NEW YORK Dance *Funky*

ROME *Romance*

FIGURE 6-49 A selection of fonts.

Managing Text

Font is another name for a *type* of text. Unfortunately, unlike graphic artists, who invests many years learning their craft, fashion designers do not spend a great deal of time training in the concepts, elements, and application of using text. Most of the programs you use will include many of the basic elements of text you will need as a fashion designer. You will discover that managing text in graphics programs, both vector- and raster-based, are similar to that of a basic word-processing program. Similarities among the programs include:

■ Variety of font family types to choose
■ Variety of point sizes
■ Some of the basic style choices, such as **bold,** <u>underline</u>, and *italic*
■ Word wrap
■ Spell check
■ Format options, such as left, center, and right indents; tabs; borders; color choices; and even special effects.

Although we have already talked about the importance of expressing image, we cannot emphasize enough the important role played by text selection and application in your line/marketing and sales presentations. The use of fonts is very important in conveying an image or attitude. For this reason we have included a section on text for you to locate and evaluate the fonts available on the software program you are using.

Examples of Font Families

Garamond
Jansen Text
Times New Roman
Shelley Volante

Examples of Point Sizes

Size 8

Size 12

Size 18

Additional Format Options

Left

Centered

Right

Style Options

Bold

Underscore/underline

Italic

Text can be found in several menu locations on most vector- and raster-based software programs, such as fly-out (Figure 6-50), pop-up (Figure 6-51), pull-down (Figure 6-52), dialog (Figure 6-53), and list boxes (Figure 6-54).

A few exercises follow to let you experiment with types of fonts and font families. This will give you an opportunity to familiarize yourself with how a fashion designer applies text basics and how you use text options with your software program. These skills will let you see how the fashion designer will use options to create logos, labels, and storyboards. And don't forget, be sure to make any notes about your software.

Exercise 6-6: How to Locate Text

Software Used

Any vector-based software program

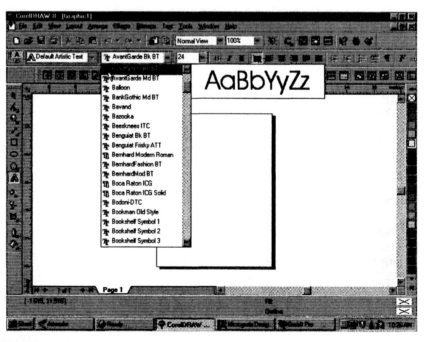

FIGURE 6-50

Skill Level: Elementary

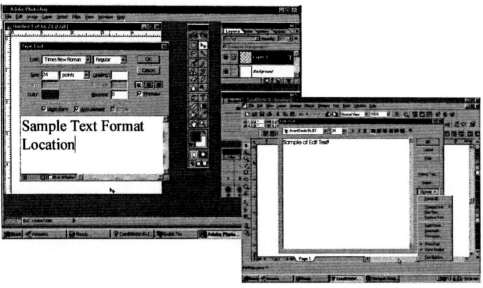

FIGURE 6-51

FIGURE 6-52

FIGURE 6-53

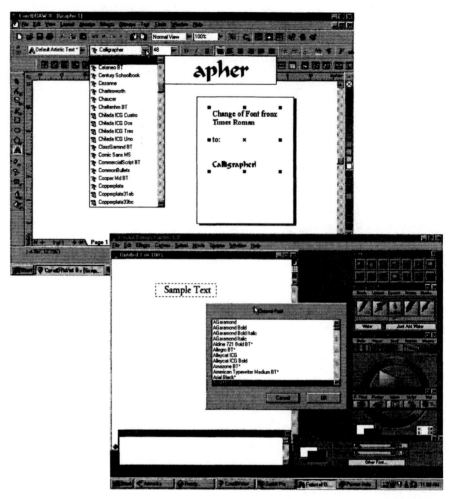

FIGURE 6-54

How-to Steps

1. Look for the text icon; usually the icon letter is A or T. Double click on it (Figure 6-55).
2. Click on the I-beam cursor and type a word.
3. Locate the text option menu in your software. Your text menu may produce a text dialog box or a pull-down or roll-down menu. Text may also appear across the top of your screen on a menu bar or from a text main pull-down menu also at the top of the screen (Figures 6-56 and 6-57).

Additional Comments

Experiment with the font families you have available. Check to see if you have any ZapfDingBats, Wingdings, or Critters (Figure 6-58). These font families will be comprised of icons or images that will correspond to every stroke on your keyboard and can be useful for enhancing a document.

Special Notes

Name and version of software used: _____

Additional steps to execute the program that were specific to the software pro-

gram that you are using: _____

Skill Level: Elementary

FIGURE 6-55

File Edit View Layout Arrange Effects Bitmaps Text Tools Window Help

FIGURE 6-56

Format Text...	Ctrl T
Edit Text...	Ctrl Shift T
Extrude Text	
Fit Text To Path	
Fit Text To Frame	
Align To Baseline	Alt F12
Straighten Text	
Writing Tools	▶
Change Case...	Shift F3
Make Text HTML Compatible	
Convert	
Show Non-Printing Characters	Ctrl Shift C
Text Statistics...	

FIGURE 6-57

Biggest challenge: _____

What you learned that was new, and special notes on what you want to always

remember: _____

Miscellaneous thoughts: _____

STUDENT NOTES

Example of Critters

Wingdings

FIGURE 6-58

Exercise 6-7: How to Format Text

Software Used

Any vector-based software program

How-to Steps

1. Locate the text icon on the main toolbox. Click to activate this icon (usually a letter A or T) and move the mouse on to the main blank page.
2. Click the mouse again, the cursor should turn into an I-beam.
3. Type some sample text.
4. Add a bounding box to select or activate your text.
5. Now begin to format text by changing font family and even point size by using the mouse to click and select (Figure 6-59).

Additional Comments

One thing worth mentioning is that some programs afford you the luxury of pre-viewing font family alternatives. This is a great time-saving device, so check to see if your software provides this option. If not, you will have to select the font style and then review it after the change has been made.

Special Notes

Name and version of software used: _____

Additional steps to execute the program that were specific to the software pro-gram that you are using: _____

Biggest challenge: _____

What you learned that was new, and special notes on what you want to always remember: _____

Miscellaneous thoughts: _____

Skill Level: Elementary

T Times New Roman 45.00 p **B** *I* U

Tr AvantGarde Bk BT
Tr AvantGarde Md BT
Tr Balloon
Tr BankGothic Md BT
Tr Bavand
Tr Bazooka
Tr Beesknees ITC
Tr Benguiat Bk BT
Tr Benguiat Frisky ATT
Bernhard Modern Roman
Tr BernhardFashion BT
Tr BernhardMod BT
Tr Boca Raton ICG
Tr Boca Raton ICG Solid
Tr Bodoni-DTC
Tr Bookman Old Style
Tr Bookshelf Symbol 1
Tr Bookshelf Symbol 2
Tr Bookshelf Symbol 3

FIGURE 6-59

Exercise 6-8: How to Position Text

Software Used

Any vector-based software program

How-to Steps

1. Using the text icon to activate the text, type a word or a phrase.
2. Select text with a bounding box.
3. From the menu bar or main text menu, select format options such as bold, italic, and underline (also known as underscore).
4. You can experiment with formatting options such as alignment and style. Frequently, these are also icons that will indicate right, center, or left.

Special Notes

Name and version of software used: _____

Additional steps to execute the program that were specific to the software pro-

gram that you are using: _____

Biggest challenge: _____

What you learned that was new, and special notes on what you want to always remember: _____

Miscellaneous thoughts: _____

Exercise 6-9: How to Check Spelling

Software Used

Most any vector-based software program

How-to Steps

1. Using an existing file, activate the spell check by looking for the ABC icon (Figure 6-60).
2. A dialog box will pop up, giving you several options for the misspelled word, such as Change, Ignore, Add, and Cancel. You will find some obvious choices for you to change, or correct, your spelling—the computer will suggest several possible alternatives (Figure 6-61).
3. Click on the new word of your choice, if it is on the list, or type in the correct spelling.
4. Click on the change or replace button.

Additional Comments

Often the spell check will not include the most common fashion terms or names used often in the world of fashion design. For example, the name of your company may come up as a spelling error, because the computer does not recognize the name. You can eliminate this inconvenience by "Adding" the name of your company directly to the spell check program (Figure 6-62).

Special Notes

Name and version of software used: _____

 FIGURE 6-60

FIGURE 6-61

Skill Level: Elementary

FIGURE 6-62

Additional steps to execute the program that were specific to the software program that you are using: _____

Biggest challenge: _____

What you learned that was new, and special notes on what you want to always remember: _____

Miscellaneous thoughts: _____

Exercise 6-10: Adding Color to Most Text

Software Used

Almost any vector-based software program

How-to Steps

1. Type text.
2. Locate the text format menu options.
3. Select Interior Fill to add color.
4. With the mouse, select a color.
5. Select Outline Fill to add an outline color (Figure 6-63).
6. Select a color, and click.

Additional Comments

To apply the above choice in some programs you must literally choose Apply. Also, the location for color can vary from program to program. Frequently, it is located on the menu bar after you have selected to work with the text icon. It can also be found on roll-up menus, a main pull-down menu or even a fly-out menu.

Special Notes

Name and version of software used: _____

FIGURE 6-63

Additional steps to execute the program that were specific to the software program that you are using: _____

Biggest challenge: _____

What you learned that was new, and special notes on what you want to always remember: _____

Miscellaneous thoughts: _____

Exercise 6-11: Drop Shadow

Software Used

Any vector-based software program

How-to Steps

1. Type text using a medium gray color.
2. Retype the same text using the color black.
3. Place a bounding box around the black text.
4. Move the black text directly to the bottom right of the gray text to simulate a drop shadow effect (Figure 6-64).

Drop Shadow

FIGURE 6-64

Additional Comments

Many times you may have to place a bounding box or otherwise direct select the text you wish to format before the text can be edited or formatted in any way.

Special Notes

Name and version of software used: _____

Additional steps to execute the program that were specific to the software program that you are using: _____

Biggest challenge: _____

What you learned that was new, and special notes on what you want to always remember: _____

Miscellaneous thoughts: _____

Exercise 6-12: Fit Text to Path

Software Used

Micrografx Designer or any vector-based software program

How-to Steps

1. Type text.
2. With the object-oriented drawing icon, make a circle just below your line of text; this will be used as a path.
3. With your mouse, place a bounding box around the object as well as the text.
4. Select the change menu, by clicking it with the mouse.
5. Use the mouse to select the option Align, then Text to Path (Figure 6-65).
6. Move the handle to place the text on the exact location of path desired.

FIGURE 6-65

Special Notes

Name and version of software used: _____

Additional steps to execute the program that were specific to the software program that you are using: _____

Biggest challenge: _____

What you learned that was new, and special notes on what you want to always remember: _____

Miscellaneous thoughts: _____

Exercise 6-13: Copy/Paste Text

Software Used

Any vector-based software program

How-to Steps

1. Type text.
2. Place a bounding box to select text.
3. Go to the Edit menu for your program to select the Copy command.
4. Using the mouse, click on the new location where you wish to place the text.
5. Click the right mouse button to give you the pop-up menu offering the paste option; click on Paste (Figure 6-66). If you do not have a paste option here, try going back to the Main Edit menu to select Paste.

FIGURE 6-66

Skill Level: Elementary

Additional Comments

The copy and paste options are great features for saving time by not having to retype frequently used text. This feature is also useful for copying objects or renderings. Also note there is an option to cut rather than copy, which removes the text or object from its original location.

Special Notes

Name and version of software used: _____

Additional steps to execute the program that were specific to the software program that you are using: _____

Biggest challenge: _____

What you learned that was new, and special notes on what you want to always remember: _____

Miscellaneous thoughts: _____

ADVANCED TEXT TECHNIQUES

Adding Special Effects to Text

So far you've had a chance to experiment with some of the most basic text functions. In the fashion industry, there will be many times when you really need to add punch to a presentation, and text is just the tool for the task. In this section you will explore additional special effects in both vector- and raster-based programs. We will show you how to work with:

- Gradient fills
- Filters
- Two-dimensional and three-dimensional illusions

What you will quickly see is how these special effects will literally bring to life any rendering, storyboard, or logo. The first exercise will show you how to extrude an object. This can be an effective selling technique as items are presented on a designer's presentation board.

Exercise 6-14: Extrude

Software Used

Micrografx Designer or any vector-based software program

How-to Steps

1. Type text.
2. Place a bounding box around text.
3. Using the mouse, select the change menu.
4. Select Extrusion Options (Figure 6-67).

Extrude
Warp

Blend...
Combine ▶
Modify ▶
Transform ▶
Reset Transform

Extrusion Options...
Reduce Points...
Convert To Curves Ctrl+R
Convert To Image...

Align ▶
Order ▶
Text ▶

FIGURE 6-67

5. Experiment to suit your needs, such as with Sunlit. Don't forget to preview your work before you select Apply (Figure 6-68).
6. Click Apply when you are satisfied with your changes.

Special Notes

Name and version of software used: _____

FIGURE 6-68

Skill Level: Elementary

Additional steps to execute the program that were specific to the software program that you are using: _____

Biggest challenge: _____

What you learned that was new, and special notes on what you want to always remember: _____

Miscellaneous thoughts: _____

Exercise 6-15: Warp

Software Used

Micrografx Designer

How-to Steps

1. Type text.
2. Place a bounding box around the text.
3. Using the mouse, select the Change menu.
4. Select Warp (Figure 6-69).
5. Place the mouse on the corner handles and drag.
6. Experiment, and see what you can create.

FIGURE 6-69

Special Notes

Name and version of software used: _____

Additional steps to execute the program that were specific to the software program that you are using: _____

Biggest challenge: _____

What you learned that was new, and special notes on what you want to always remember: _____

Miscellaneous thoughts: _____

Exercise 6-16: Gradient Fill

Software Used

Most any vector-based software

How-to Steps

1. Type text.
2. With the selection tool, make a bounding box around the text.
3. Using the mouse, click on the paint bucket icon.
4. From the fly-out menu, select either Radial, Linear, Conical or Square fill (Figure 6-70).
5. Click OK to apply.

Additional Comments

Notice under the gradient menu that there are additional options for lighting and shadowing effects. Experiment with these to see the different effects and make any notes you will need for future reference.

 FIGURE 6-70

FIGURE 6-71

Skill Level: Elementary

Special Notes

Name and version of software used: _____

Additional steps to execute the program that were specific to the software program that you are using: _____

Biggest challenge: _____

What you learned that was new, and special notes on what you want to always remember: _____

Miscellaneous thoughts: _____

Exercise 6-17: Converting Text to Outlines/Convert to Curves

Software Used

Most any vector-based software, including CorelDRAW

How-to Steps

1. Type text.
2. Using the selection tool, select any section of text you wish to break apart.
3. Go to the Arrange menu (Figure 6-72).
4. Select the Create Outlines option from the main text menu.
5. Using the select tool, select the last letter of your word to modify.
6. Now apply a color from the color palette to the letter, by clicking the left mouse button on the color of your choice (this should add color to your selected letter).
7. You should now be able to apply other advanced techniques to the text.

FIGURE 6-72

Special Notes

Name and version of software used: _____

Additional steps to execute the program that were specific to the software program that you are using: _____

Biggest challenge: _____

What you learned that was new, and special notes on what you want to always remember: _____

Miscellaneous thoughts: _____

Exercise 6-18: Rotate/Drop Letter

Software Used

Almost any vector-based software

How-to Steps

1. Type text.
2. Using the selection tool, select text.
3. Go to the main arrange menu.
4. Select the Create Outlines option from the main text menu.
5. Using the select tool, select the last letter of your word to modify.
6. Apply a color from the color palette to the letter by clicking the left mouse button on the color of your choice (this should add color to your selected letter).
7. Using the copy and paste commands, make at least two copies of the letter.
8. Go to the Arrange menu and select Transform, then Rotate (Figure 6-73). You may opt to select each letter one at a time and experiment with the rotation option you just learned to modify your letters, or you may follow the screen shown in Figure 6-74.
9. When you are finished experimenting be sure you go to the Arrange menu and select Group (Figure 6-75).

ROTATE A LETTE R R R R

FIGURE 6-73

Skill Level: Elementary

Special Notes

Name and version of software used: _____

Additional steps to execute the program that were specific to the software program that you are using: _____

Biggest challenge: _____

What you learned that was new, and special notes on what you want to always remember: _____

Miscellaneous thoughts: _____

Exercise 6-17: Converting Text to Outlines/Convert to Curves

Software Used

Most any vector-based software, including CorelDRAW

How-to Steps

1. Type text.
2. Using the selection tool, select any section of text you wish to break apart.
3. Go to the Arrange menu (Figure 6-72).
4. Select the Create Outlines option from the main text menu.
5. Using the select tool, select the last letter of your word to modify.
6. Now apply a color from the color palette to the letter, by clicking the left mouse button on the color of your choice (this should add color to your selected letter).
7. You should now be able to apply other advanced techniques to the text.

FIGURE 6-72

Special Notes

Name and version of software used: _____

Additional steps to execute the program that were specific to the software program that you are using: _____

Biggest challenge: _____

What you learned that was new, and special notes on what you want to always remember: _____

Miscellaneous thoughts: _____

Exercise 6-18: Rotate/Drop Letter

Software Used

Almost any vector-based software

How-to Steps

1. Type text.
2. Using the selection tool, select text.
3. Go to the main arrange menu.
4. Select the Create Outlines option from the main text menu.
5. Using the select tool, select the last letter of your word to modify.
6. Apply a color from the color palette to the letter by clicking the left mouse button on the color of your choice (this should add color to your selected letter).
7. Using the copy and paste commands, make at least two copies of the letter.
8. Go to the Arrange menu and select Transform, then Rotate (Figure 6-73). You may opt to select each letter one at a time and experiment with the rotation option you just learned to modify your letters, or you may follow the screen shown in Figure 6-74.
9. When you are finished experimenting be sure you go to the Arrange menu and select Group (Figure 6-75).

FIGURE 6-73

Skill Level: Elementary

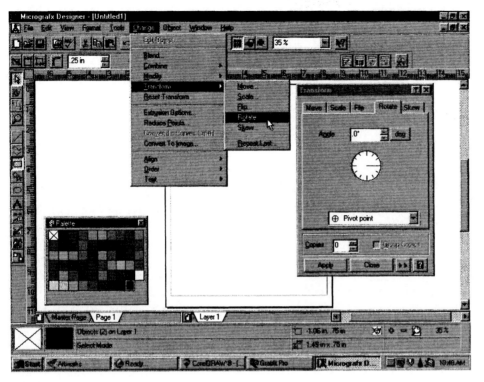

FIGURE 6-74

FIGURE 6-75

Special Notes

Name and version of software used: _____

Additional steps to execute the program that were specific to the software pro-

gram that you are using: _____

Biggest challenge: _____

What you learned that was new, and special notes on what you want to always remember: _____

Miscellaneous thoughts: _____

Exercise 6-19: Capital Letter in a Box

Software Used

Almost any vector-based software

How-to Steps

1. Type the capital letter O, choose point size 72 using any Gothic-style font.
2. Using the mouse, go to the square object-oriented icon.
3. Draw a square a little larger than your letter.
4. Using the selection tool, select a lighter shade to fill the square/box with color.
5. Using the selection tool, move the letter O inside the box.
6. From the Arrange menu, select Bring to Front; this should place your letter on top of the square/box.
7. Using the selection tool, select the text icon.
8. Move the text I-beam next to the square box, and complete the word "once."
9. Using selection tool, make a bounding box around the text and the object.
10. Go to the Arrange menu and select Group.

Special Notes

Name and version of software used: _____

Additional steps to execute the program that were specific to the software program that you are using: _____

Biggest challenge: _____

What you learned that was new, and special notes on what you want to always remember: _____

Miscellaneous thoughts: _____

nce Upon A Time

FIGURE 6-76

Skill Level: Elementary

Exercise 6-20: Liquid Text/H2O/Convert Text to Curves

Software Used

Almost any vector-based software

How-to Steps

1. Type H2O, using no color fill and only the text outlined in the color blue.
2. To begin to convert your text to curves or outlines go to the Arrange menu and select Convert to curves to break apart the letter O (Figure 6-77).
3. Using the selection tool, select the letter O and fill it using the texture fill menu on the fly-out from the main toolbox menu.
4. Select the Blue Lava option from the list box and apply it (Figure 6-78). You may want to experiment with the range of blues from the color palette to make the colors monochromatic. You may also wish to go to the pen outline fill tool and make Hairline in a darker shade of blue for emphasis (Figure 6-79).
5. Place a bounding box around all text and objects.
6. Go to the Arrange menu and select Group.

Special Notes

Name and version of software used: _____

Additional steps to execute the program that were specific to the software program that you are using: _____

Biggest challenge: _____

What you learned that was new, and special notes on what you want to always remember: _____

Miscellaneous thoughts: _____

FIGURE 6-77

FIGURE 6-78

Lava Fill, H2⬤

FIGURE 6-79

Exercise 6-21: Mirror Version Number One

Software Used

Almost any vector-based software

How-to Steps

1. Type one of your initials (Figure 6-80).
2. Using the selection tool, select the letter you just typed.
3. From the Edit menu, select Copy, then click just to the left of the original letter and select Paste (from the Edit menu, or click the left mouse button).
4. From the Arrange menu, select Transform, then Scale-Mirror. From this menu select Scale & Mirror (Figure 6-81).
5. Keep the height at 100% and select Apply to Duplicate, using your mouse.
6. Select Duplicate.
7. Using the mouse to position the letter to suit your needs.

Additional Comments

Understanding the concept of a mirror version will be useful in Chapter 14, where you will be designing actual logos and hand tags. We are just practicing the concepts in this chapter. So be sure to take good notes for reference later.

Special Notes

Name and version of software used: _____

Additional steps to execute the program that were specific to the software program that you are using: _____

Skill Level: Elementary

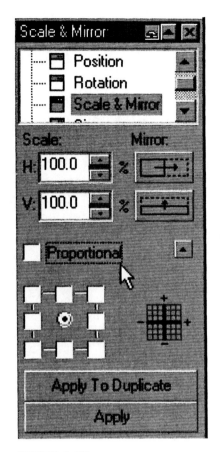

FIGURE 6-80

FIGURE 6-81

Biggest challenge: _____

What you learned that was new, and special notes on what you want to always

remember: _____

Miscellaneous thoughts: _____

Additional Comments

Notice in Figure 6-82 how the text can progress and in Figure 6-83 what your initials can look like.

Special Notes

Name and version of software used: _____

Additional steps to execute the program that were specific to the software program that you are using: _____

Biggest challenge: _____

FIGURE 6-82

K

K K

K

FIGURE 6-83

What you learned that was new, and special notes on what you want to always remember: _____

Miscellaneous thoughts: _____

Exercise 6-22: Design a Logo Using Your Initials

Software Used

Almost any vector-based software

How-to Steps

1. Type one of your initials.
2. Using the selection tool, select the letter.
3. From the Edit menu, select Copy.
4. From the Edit menu (or click the right mouse button), select Paste.
5. From the Change menu, select Transform.
6. Experiment with the options you used in Exercise 6-21.

Additional Comments

You may also find in your version of software an option such as Mirror.

Special Notes

Name and version of software used: _____

Additional steps to execute the program that were specific to the software program that you are using: _____

Biggest challenge: _____

What you learned that was new, and special notes on what you want to always remember: _____

Miscellaneous thoughts: _____

Exercise 6-23: Placing Text in a Box

Software Used

Adobe Illustrator or almost any vector-based software

How-to Steps

1. Type text using any font family or color.
2. Make the point size approximately 36.
3. Using the selection tool, go to object-oriented drawing and select a square.
4. Draw a box or rectangle that is more narrow and longer than your original text.
5. Using the selection tool, place a bounding box around the text.
6. Go to the Text menu and select Convert Text to Paragraph.
7. Notice the new handles around the text. These handles allow you to manipulate text. Also, the handles will toggle from open to filled and will convert to a horizontal arrow when you begin to place the text over the object in which you want to place it (Figure 6-84).

This is an example of creating text that will fit inside a box or any other created object!

You can type vertically

FIGURE 6-84

Additional Comments

Begin to experiment with this option by placing the text in the box once the bottom center handle is toggled to show that the text has been accessed. Don't forget, to access handles you will rapidly click the right mouse button to toggle between types of handles.

Special Notes

Name and version of software used: _____

Additional steps to execute the program that were specific to the software program that you are using: _____

Biggest challenge: _____

What you learned that was new, and special notes on what you want to always remember: _____

Miscellaneous thoughts: _____

Exercise 6-24: Making a Banner

Software Used

Adobe Illustrator Version 8 or almost any vector-based software

How-to Steps

1. Type a word or phrase for a banner, using any font family and a point size of at least 42 points. Also, select a medium shade of blue for your text.
2. Place a bounding box around the text.
3. From the Type menu, select Create Outline.
4. On the toolbar, use the selection tool to select the square object-oriented drawing icon.
5. On the page below your text, draw a rectangle a little longer than the text.
6. Using the selection tool, fill the rectangle with a light color.
7. Using the selection tool, place the text on top of the new rectangle. Don't forget to move text to the front.
8. Using the selection tool (or go to Edit, Select All), select object and text with a bounding box.
9. From the Filter menu, select the first option of Distort.
10. From the Distort fly-out menu, select Twirl (Figure 6-85).
11. Choose any option.
12. With all the items still in the bounding box, go back to the Filter menu and select the first Stylize menu.
13. Under the Stylize menu, select Drop Shadow (you may leave options at the default).
14. From the Edit menu, Select All.
15. Leave all the items in the bounding box, and from the Object menu, select the Group option.

FIGURE 6-85

Additional Comments

As you are working with different software programs you will discover that some vector programs have the banner option. However, many vector-based programs require you to build your banner, following the same logical thought process as you followed in this exercise. You might find minor variations in the steps of the different programs, so you may not be able to follow the steps exactly as the exercise demonstrated; that's OK. Remember, the point is to use the software and version you have and to logically locate the techniques and apply them to the program you are with which you are working.

Special Notes

Name and version of software used: _____

Additional steps to execute the program that were specific to the software pro-

gram that you are using: _____

Biggest challenge: _____

What you learned that was new, and special notes on what you want to always

remember: _____

Miscellaneous thoughts: _____

Putting It All Together

Here you get to put all of these techniques into practice. In this exercise you will find that using different text styles will convey different attitudes or expressions. Don't forget, fashion designers strive to create an image, and every detail will count, including the details on the logo, the advertising campaigns, the presentation boards, and even the sales materials. Use the computer as a tool to present that image.

In this exercise look for a Font Family that will convey the following:

Time Period

Gothic
Neo-Classic
Art Deco
1960s

Special Notes

Name and version of software used: _____

Additional steps to execute the program that were specific to the software program that you are using: _____

Biggest challenge: _____

What you learned that was new, and special notes on what you want to always remember: _____

Miscellaneous thoughts: _____

Image
 Classic
 Modern
 Fashion forward
 Professional/business

Special Notes

Name and version of software used: _____

Additional steps to execute the program that were specific to the software program that you are using: _____

Biggest challenge: _____

What you learned that was new, and special notes on what you want to always remember: _____

Miscellaneous thoughts: _____

Attitude
 Bold
 Strong
 Fun
 Romantic
 Athletic

Skill Level: Elementary

Special Notes

Name and version of software used: _____

Additional steps to execute the program that were specific to the software program that you are using: _____

Biggest challenge: _____

What you learned that was new, and special notes on what you want to always remember: _____

Miscellaneous thoughts: _____

Market Segment

Children
Petites
Men's
Juniors
Bridal

Special Notes

Name and version of software used: _____

Additional steps to execute the program that were specific to the software program that you are using: _____

Biggest challenge: _____

What you learned that was new, and special notes on what you want to always remember: _____

Miscellaneous thoughts: _____

Geographic Location

California
New York
Paris
Milan
The Orient

Special Notes

Name and version of software used: _____

Additional steps to execute the program that were specific to the software program that you are using: _____

Biggest challenge: _____

What you learned that was new, and special notes on what you want to always remember: _____

Miscellaneous thoughts: _____

Special Effects
 Fills
 Your choice

Special Notes

Name and version of software used: _____

Additional steps to execute the program that were specific to the software program that you are using: _____

Biggest challenge: _____

What you learned that was new, and special notes on what you want to always remember: _____

Miscellaneous thoughts: _____

Well, you have done great! We hope you have enjoyed learning a little bit about how text can enhance your designs. As with anything else, you will need to continue to practice these new techniques.

You will find that the notes you have made will be a real time-saver later, especially when you are searching for just the right font to show your intentions. Before we begin Chapter 7, we have included a list of many of the fundamental terms that are associated with computer graphics designing. This will be helpful in developing your understanding of computer-aided-designing.

Begin now to review these additional terms, and feel free to jot notes in the margin to refer back to for use in later chapters.

GRAPHIC DESIGN TERMS

The following are the most common terms used when talking about the design tools and techniques being applied when you are using the computer. That doesn't mean you won't be using the terms covered in Chapter 3—you will be working with both.

Computer Graphics Terminology

Aliasing: Also known as "jagged edges." The appearance of a stair-step or jagged edges on a bit-map image or text. In a drawing program, try drawing a diagonal line in a fairly wide pen point and you will notice the jagged stair steps. (See *Bit map* and *Dithering*.)

Anchor point: Also known as end points. This point can represent the beginning or end of a line segment. These can appear hollow when not selected or shaded when activated.

Application: A set of programs used to accomplish a specific task.

Bezier: This can refer to a pen/tool or a curved line. This tool option is found in most drawing programs. It permits the designer to create a line segment, that when activated can convert into a curved line.

Bit: Basic unit of measurement for data in a computer.

Bit map: A pixel-by-pixel image created in a raster-based program. This can also be associated with file extension used for bit map images such as TIFF, PICT, GIF, and some EPS files. The bit-map images often have gritty, grainy, or jagged outlines because these images are created on a fine grid system. A fine grid system is necessary to depict all aspects of the image, including hue, color (RGB, CMYK), intensity, and saturation. (See also, *Aliasing*.) Fonts may also be bit-mapped. When the font is enlarged you can clearly see the jagged edges on the lettering.

Blend: The progression of shapes, objects, or colors often associated with terms like *Gradient* or *Fountain fill*.

Clip art: Figures included with a software package or sold separately, often stored on a CD or floppy disk. Clip art can often be modified in a variety of ways to enhance a document or graph. Clip art can also be created by the designer and stored.

Colorbook: A hard copy of your colors calibrated for your printer—useful in color matching.

Colorway: A series of color choices made by the designer to indicate the season's color selection for the line.

Closed path (see *Shape*).

CMYK: Cyan, magenta, yellow, and black. This is an example of a type of color mode available. We will give more detailed explanation in Chapter 10.

Cross hair: X-like cursor symbol on the screen when drawing objects (see *Cursor*).

Direction handles: Used to reshape curves or curved points. These handles can be activated by clicking the mouse on the object/line you wish to rotate position.

Direction points: These indicate the end on direction handles when reshaping curve segments.

Dithering: Smoothing the pixel dots in a black-and-white image to smooth out the appearance of jagged edges. (See also, *Aliasing* and *Bit map*.)

DPI: Dots per inch. This is a term for scanners and printers; the higher the number, the clearer the resolution. Examples are 300 DPI and 600 DPI.

Ellipse: Oval shape created with a graphics program. Also a dialog box choice such as Save As.

End Points (see *Anchor points*).

Export: Sending a file from one program, system, and/or computer to another.

Fill: Associated with an open or closed path (shape), frequently used to indicate filling with paint, color, or pattern.

Filter: A term associated with special effects in Adobe products. These can be text or graphics used to overlap objects.

Foreground: In the case of multitasking or multiple windows open, this indicates the window that is activated. In a graphics program, it can indicate an image, object, text, or fill.

Frame: In desktop publishing, this indicates the isolating of text and/or objects from each other.

Gradient: A type of fill of two or more colors which can be graduated linear or radial.

Graphics: Pictures or charts.

Greeking: Filling an area with text that is for the purpose of showing text, not showing text for its content.

Grid: A series of dots that enable the designer to align or measure objects, images, or text. These options maybe toggled on or off to lay out a design.

Group: Two or more objects that can be combined to form one object or one idea.

Guide: Lines or rulers that can be toggled on and off to view on the screen to assist the designer in aligning, positioning, or even measuring distances between objects. They are invisible on hard copy.

Halftone: Usually this is a term associated with a black-and-white image.

Handles: These aids are activated by the selection icon. They are small black-filled boxes that outline an image, object, or text and can be activated for editing purposes.

Hue: The name of a color such as red, blue, or green.

Join: The process of connecting end points in lines within an object.

Kerning: Adding or deleting space between text characters.

KISS: Keep it simple and straight. Loosely translated: Don't overdesign.

Layer: Computer concept comparable to a designer using acetate sheets to distinguish layers of a design that has been created in a series of steps. This feature can be edited, removed, or printed.

Light pen: A graphic device that permits the designer/user to interface directly with the computer.

Line art: Drawings created without halftones for the purpose of printing on low-resolution printers.

Line: An open path between two end points.

Marquee: This option, also known as a bounding box, is typically found by using the mouse to activate the selection tool or pointer, then dragging the cursor over and around the area, object, image, or text you wish to isolate for editing purposes.

Mask: To cover or drape an object or character with an overlapping pattern.

Object: A shape or line that can be manipulated and/or isolated to manipulate independently within the design.

Open path: A line or path with two end points.

Paint program: Drawing created by switching pixels off and on.

Path: A single line segment or a series of segments.

Pattern: A repeat motif or design that can be computer generated used in filling objects.

Pixel: Smallest portion of the image. Similar to a dot or point of light.

PMS: Pantone Matching System. This is an industry standard system for defining and matching color.

Pointer (see also, *Cursor*): This tool can be used to activate an area. It is often referred to as the selection tool.

Raster: Type of computer image (see also, *Bit map*).

Resolution: The clarity and quality of the viewing monitor, actual screen image display, or printer output; can be categorized as high or low.

RGB: The primary colors red, blue, and green.

Rotate: The ability to tilt an object or line a specified number of degrees either by inputting a number such 45 degrees or by manually adjusting.

Scale: The ability to resize an object, line, or group of objects.

Shear: The skewing of an object. These handles permit you to slant the object a variety of different directions.

Skew: Alter the appearance of an image in diagonal or horizontal directions.

Template: In graphics this can be an image you create, trace, or duplicate as a model. In the context of word processing, database, or spreadsheet applications, this refers to a previously generated form/format in which you can overlay your data. It saves you from creating a document from scratch. You will use templates in spreadsheet applications if you are developing company cost or spec sheets.

TIFF: Tagged image file format (see also, *bit map*). This is a file format that is used for bit map images. This format is used for larger file sizes based on resolution. They easily lose quality if resized up or down. Scans up to 300 DPI.

Tweak: To clean up, edit, modify, and adjust settings, images, and files.

Vector images: Object-oriented images that are either basic geometric shapes or objects created with a Bezier tool/curve. The result is objects or images that are clear regardless of resizing or other editing functions performed on them. (*Note:* Typically we contrast bit-map images with vector images. Each has a different function and purpose, but often we attempt to make them do something they are not designed to do or are not best suited for.)

White space: The area of the document left blank to enhance the image by adding focal emphasis.

X axis: Object width.

Undo: This function can be your best friend, and is done in most programs by selecting the Undo command to undo your last step, command, or function. Several graphics programs permit you to go back several steps.

Ungroup: To break apart an image or collection of objects in order to work with them individually.

Y axis: Object height.

Zoom: The ability to view artwork up close to clean up details. This tool appears as an icon that resembles a magnifying glass because it magnifies the work. This icon has a function that permits you to do the zoom out, or reduce the magnification. Using this tool is similar to looking through the other end of a pair of binoculars to see the work as a whole versus the magnification that emphasizes the part.

In Chapter 7 you are going to take a firsthand look at more of your computer's design tools and how you will use them to build shapes and objects. As you know from sketching class, shapes are the building blocks for rendering. In this next section we will lay the groundwork for you to better understand the components the computer uses to render fashion.

CHAPTER SUMMARY

All vector-based software will have similar features that are used in the design process. Frequently these features will share similar locations within the program. Some of the most common features are main menu, menu bar, toolbar, and/or toolbox.

The selection, editing, and other toolbox-related options and features are easily accessed in a universal manner in order to perform any computer-aided-designing tasks.

In every vector-based program, the text or typing functions share similar icons and formatting menu options or functions.

The drawing tools, specifically the object-oriented drawing tools share similar characteristics and functions in any vector-based program application. For example, the ability to create perfect squares, rectangles, oval, and circles.

Even the more sophisticated choices of color selection, fill type, and other enhancements such as blend, extrude, and warp can be found in almost any vector-based application.

When it comes to text and object-oriented drawing, these features are available and perform almost identically for raster-based programs whether the programs are commercial or industrial-based.

Familiar editing features and techniques such as font family options; text formatting such as bold, underline, and italic; editing features such as cut, copy, paste, select, and select all are also universal to most types of software.

SECTION TWO

Skill Level: Intermediate

CHAPTER 7

Working with Free-Hand and Line Drawing, Using Pens, Brushes, Filters, and More

Focus: Commercial/Industrial/Vector- and Raster-Based Drawing Tools and Editing Techniques, Specifically, Free-Hand (Fashion Designing Essentials on the Computer)

CHAPTER OBJECTIVES

- Identify and become familiar with the location and function of the most common auxiliary desktop tools such as rulers, guides, and grids.
- Locate and evaluate the common drawing tools (such as pens and brushes) used in the rendering of fashion in both vector and raster-based software.
- Recognize and distinguish the advantages for using different software alternatives (vector versus raster) for rendering fashion.
- Develop a better understanding of how fashion is rendered and modified on computers.
- Begin to master the universal editing features of adding, removing, or modifying points, lines, and shapes used in computer-aided fashion rendering.
- Apply the knowledge of how the computer is used to draw simple fashion renderings.
- Locate and apply raster-based filters to simple vector- or raster-created drawings or images.

TERMS TO LOOK FOR

background	free-hand drawing	point
Bezier pen	grid	Poly-Laso
compound lines	guides	portrait
desktop layout	landscape	rubber stamp
edit mode	line drawing	rulers
filter	magic wand	
foreground	noise	

As you begin to design, using more complex computer techniques, you will pack up your charcoals, paint brushes, and illustration boards for computer pens and brushes to be used with many of the exciting design vector-based programs, such as CorelDRAW, Adobe Illustrator, and Micrografx Designer, to name just a few. Each of these great programs offers a wide range of brushes, pens, and pen points and an exciting range of colors and fills for you to use as you design.

You will also compare and contrast tools such as felt tip pens, airbrush, crayons, charcoal, and pastels as you move through the exercises in this chapter, using widely recognized raster-based programs such as Metacreations' Painter, and Adobe Photoshop. All of these are a delight to the eye for a fashion designer! Literally almost anything you can do by hand is possible to do on the computer. We will walk you through a visual tour of each of the techniques and tools and where they are located.

You're going to start by locating the toolboxes in vector-based, then in later exercises, in raster-based programs. This will give you a chance to familiarize yourself with the similarities and differences between the two kinds of programs. In fact you will be amazed by the similarities and overwhelmed by the choices you will now have.

The most noticeable differences among the programs is the degree of sophisticated alternatives you have among the pens and line drawings found in vector-based programs. And, in the raster-based programs you will discover myriad colors and filters to captivate your imagination and fuel your passion for design.

These exercises will show the subtle nuances of many of the drawing tools you will use for fashion rendering. This will provide you with experience on several advanced techniques that will challenge your thinking and stimulate your imagination.

As you master each new technique, you will have a better insight into just how the computer thinks and how to best use the building components to make your designs on the computer flow as naturally as they did when you did them by hand. By mastering these new skills you will learn to create, edit, and modify your fashions like a pro in no time. That is why in this section like never before we encourage you to really experiment with the tools and explore the boundaries of what you can make the computer do for you.

Just imagine, always having a brand new pen, brush, or chalk in almost every color you can imagine right in front of you. Well now you do, so enjoy.

Here's a brief look at the vector and raster-based techniques and tools we will be using and what they can do.

In Chapter 4 we had you locate your toolbox and toolbar. Well, as we promised then, in this chapter we will begin to tackle those tools and master the techniques associated with them. Each tool you select will offer a wide assortment of additional choices, options, and accessories for you to use in your renderings. We will begin by having you open any vector-based software. We will be using Micrografx Designer.

Once you have opened a new file, there are several features associated with your tools you have to locate and access. Go to the main view menu; notice the list of items that are checked off in Figure 7-2. A check mark indicates that the items are toggled on for viewing. Each of these choices represents additional tools, toolbars, or other relevant

FIGURE 7-1 Samples from Corbis stock images.

options you will frequently use when designing. In addition we recommend that you always activate other useful icons, such as:

- Under the view menu (Figure 7-2)
 Show Images
 Show Object Fills
 Show Hatch Fills
 Show Image Fills

- Under the view menu, Workspace (Figures 7-3 and 7-4)
 Show Guides
 Show Printer Page Titles
 Show Rulers
 Show Ruler Position

FIGURE 7-2

FIGURE 7-3 View menu options.

FIGURE 7-4

Skill Level: Intermediate

■ Under the View menu, choose Toolbars, and in the pop-up menu that appears, toggle on (Figure 7-5)

> Standard
> Drawing
> Toolbox
> Ribbon
> Style
> Status
> Hint
> Palette
> Color Buttons
> Show ToolTips
> Display Shortcuts

FIGURE 7-5 Toolbar options.

Next, on the main menu bar we toggled on the following (Figure 7-6):

■ Color Palette (Figure 7-7)
■ Snap to Rulers (Figure 7-8)
■ Snap to Guides (Figure 7-9)

Note in Figures 7-6 and 7-9, we have also toggled on the clip art icon and the color palette icon from the menu bar.

To access the object format menu, go to the main format menu and select Line Fill. The object format menu will automatically bring up this pull-down menu.

FIGURE 7-6

FIGURE 7-7

FIGURE 7-8

FIGURE 7-9

Skill Level: Intermediate

Special Notes

Name and version of software used: _____

Additional steps to execute the program that were specific to the software program that you are using: _____

Biggest challenge: _____

What you learned that was new, and special notes on what you want to always remember: _____

Miscellaneous thoughts: _____

 In Chapter 4 you were introduced to several other useful icons; now you will see the benefits of activating these tools. One tool in particular is the snap-to option, which acts like a magnet to pull your line to a grid, guide, or ruler. It also will join open-ended segments or close an area for the purpose of adding color or fill. Take some time to familiarize yourself with these features and begin to experiment with them. You will really enjoy using these in conjunction with other techniques to create and add interest in your designs. Each of these options will merely duplicate what you would have traditionally done by hand. As always, remember to make any additional notes for your own use later.

Tool:	Grids (Figure 7-10)
Where they are located:	Typically these can be accessed by going to the main menu under View and toggle on the Grids option.
Additional Comments:	The blue lines and grids are movable with the mouse and will not be visible on a hard copy of your work.

Special Notes

Tool:	Rulers (Figure 7-11)
Where they are located:	View menu. Note that the rulers are both horizontal and vertical.
Additional Comments:	These are helpful for precise spacing or scaling of an object.

INTERMEDIATE

INTERMEDIATE

FIGURE 7-10 Grids.

FIGURE 7-11 Rulers.

Special Notes

Tool:	Guides (Figure 7-12)
Where they are located:	In the top left section of your screen.
Additional Comments:	When the rulers are toggled on for viewing, merely point your mouse to the top left side of the workspace and click and drag the reference rulers (they are both horizontal and vertical) onto the desktop.

FIGURE 7-12 Guides.

Special Notes

Tool:	Snap to
Where they are located:	Many times there is an individual icon. Check under the main menu: View or Tools to toggle on this option.
Additional Comments:	If this option is not turned on when you are drawing line segments or freehand the objects may not be considered closed and will not fill with color.

Special Notes

Tool:	Undo
Where they are located:	Frequently the undo task can be an icon, but most often you will find this action located under the edit menu.
Additional Comments:	Be sure you know how many times your program will permit you to undo an action. Don't forget that even hitting the space bar by accident constitutes an action.

Special Notes

Now we will look at those special options and what they do. You will quickly see how they will benefit the fashion designer to simplify tasks to create a single garment or to render a complete line.

Look at the icons below (Figure 7-13) and you can see that today's fashion designer can utilize a system of grids, guides, rulers and X and Y coordinates that will allow you to handle many different tasks such as:

- Align
- Constrain
- Proportion
- Reverse direction
- Duplicate
- Join segments
- Group

FIGURE 7-13 Snap to.

Special Notes

PENS AND PEN POINT OPTIONS

Go to your main toolbox and activate the pen drawing icon (Figure 7-14). In this example we are using CorelDRAW 8.

Although the location for pens and pen points can vary we have shown you several logical places to find pens, pen points, attributes, and other related options. Finding these options is similar to looking for the headlights, windshield wipers, and hazard lights on a car. You know they are there, but sometimes they are not where you are used to finding them; the location may vary from model to model. Several of the most common locations where you might find these tools and options are:

- icon on toolbox
- icon on toolbar

Skill Level: Intermediate

- fly-out menu
- pull-down menu
- pop-up menu
- list box/dialog box

Take a moment to locate these options in your software package. Figure 7-15 is a full screen shot showing several of those locations in CorelDRAW.

FIGURE 7-14 Toolbox with fly-out pen icon.

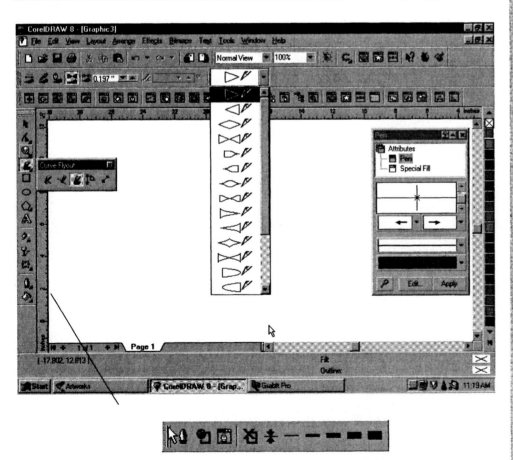

FIGURE 7-15 Locations for pens and pen points in CorelDRAW.

Special Notes

Name and version of software used: _____

Additional steps to execute the program that were specific to the software

program that you are using: _____

Biggest challenge: _____

What you learned that was new, and special notes on what you want to

always remember:

Miscellaneous thoughts: _____

While you were locating the actual drawing pen you may have noticed that you could select the pen style and several other related options such as:

- Natural (Figure 7-16)
- Calligraphic (Figure 7-17)
- Pen point outline width (Figure 7-17)
- Pen attributes (including line types, color, and ends) (Figure 7-18)

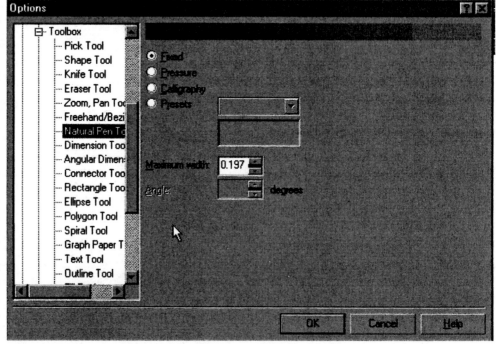

FIGURE 7-16

Skill Level: Intermediate

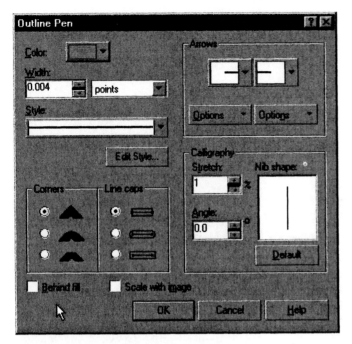

FIGURE 7-17

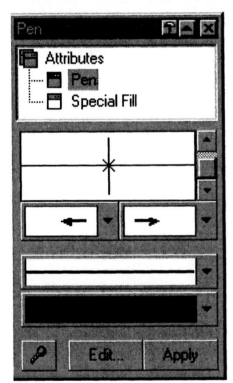

FIGURE 7-18

Special Notes

Name and version of software used: _____

Additional steps to execute the program that were specific to the software pro-

gram that you are using: _____

Biggest challenge: _____

What you learned that was new, and special notes on what you want to always

remember: _____

Miscellaneous thoughts: _____

FREEHAND DRAWING: PENS AND LINES

Now you are ready to explore the location and use of freehand drawing pens and lines. We will be using Micrografx Designer 7 for our examples, but these tools are included in most vector-based software.

These tools and techniques are the foundational mathematical building blocks for any drawing. Every drawing is constructed with a series of logical, mathematical measurements based on either: object-oriented drawings, lines or line segments, or freehand drawing lines and curves.

We will walk you through the most basic to the more sophisticated freehand drawing and line drawing tools, beginning with simple lines. The primary location for this tool is on the toolbox menu, which will pop up additional related alternatives. These new options are found on the toolbar located at the top of the screen (Figures 7-19 and 7-20).

FIGURE 7-19 Main location for tools—toolbox.

FIGURE 7-20 Main location for tools—toolbar.

Simple Lines

Lines are considered either simple or compound. We will start with a close-up look at each of the simple line icons on the main toolbar (Figure 7-21). They are:

- Parallel lines
- Perpendicular lines
- ¼ Arc
- Parabola

These tools are found in Micrografx Designer and are very useful for rendering a garment. But, it is important to point out that not all vector-based programs offer each of these. You should always consult your owner's manual or look under the Help menu to find out what your program offers.

FIGURE 7-21 Simple line icons.

Special Notes

Compound Lines

Another drawing technique for designers is the use of compound lines. These line styles will help you accomplish mathematically precise compound complex lines to create your fashions (Figures 7-22 and 7-23). These lines are the advanced building blocks for any vector-based illustration.

Special Notes

Use Caution... these tools take time to master....

Additional Comments

These tools take time to master. At first they feel awkward to handle—very similar to how it feels to learn to drive a stick shift. So be patient with yourself. Using these tools takes time and practice. You are learning to think like the computer brain center as you learn to construct your designs. You will have to learn to communicate with your hand and mouse to make the transition from designing manually to designing using the computer.

FIGURE 7-22

 FIGURE 7-23

But don't worry, in no time you will begin to flow with the computer's way of drawing and, like driving a stick shift, it will become second nature to you. Best of all, like a stick shift, the computer will let you experience a newfound control to your drawings. Before you know it you will feel like a pro.

Listed below are several of these compound lines, and their icons that are found on most vector-based software. The lines and icons shown are from the Micrografx Designer located on the main menu bar. We suggest that you open a new file and review these tools using your software program. Please, make sure to keep good notes and jot down any thoughts you might have to assist you in mastering these tools. Also don't forget to refer to the quick reference on vector-based graphics in Chapter 5.

The different types of compound lines are:

- Jointed lines
- Curved lines
- B-splines
- Bezier curves
- Freehand lines
- Irregular polygons

We have provided additional space for each of these tools. There you might want to note where these tools and their accessories where located. Remember, mastering these tools will take a great deal of time and practice. In later chapters you will see the advantage to taking the time to master these tools now.

FIGURE 7-24 Location of compound lines on the main menu bar.

Jointed Line (Figure 7-25)

 FIGURE 7-25 Jointed line icon.

Special Notes

Name and version of software used: _____

Additional steps to execute the program that were specific to the software

program that you are using: _____

INTERMEDIATE

Biggest challenge: _____

What you learned that was new, and special notes on what you want to always remember: _____

Miscellaneous thoughts: _____

Curved Line (Figure 7-26)

FIGURE 7-26 Curved line icon.

Special Notes

Name and version of software used: _____

Additional steps to execute the program that were specific to the software program that you are using: _____

Biggest challenge: _____

What you learned that was new, and special notes on what you want to always remember: _____

Miscellaneous thoughts: _____

B-Spline (Figure 7-27)

FIGURE 7-27 B-spline icon.

Special Notes

Name and version of software used: _____

Additional steps to execute the program that were specific to the software program that you are using: _____

Skill Level: Intermediate

Biggest challenge: _____

What you learned that was new, and special notes on what you want to always

remember: _____

_____|_____

Miscellaneous thoughts: _____

Bezier Curve (Figure 7-28)

FIGURE 7-28 Bezier curve icon.

Special Notes

Name and version of software used: _____

Additional steps to execute the program that were specific to the software pro-

gram that you are using: _____

Biggest challenge: _____

What you learned that was new, and special notes on what you want to always

remember: _____

Miscellaneous thoughts: _____

Freehand (Figure 7-29)

FIGURE 7-29 Freehand line drawing icon.

Special Notes

Name and version of software used: _____

Additional steps to execute the program that were specific to the software pro-

gram that you are using: _____

Biggest challenge: _____

What you learned that was new, and special notes on what you want to always

remember: _____

Miscellaneous thoughts: _____

Irregular Polygon (Figure 7-30)

FIGURE 7-30 Irregular polygon icon.

Special Notes

Name and version of software used: _____

Additional steps to execute the program that were specific to the software pro-

gram that you are using: _____

Biggest challenge: _____

What you learned that was new, and special notes on what you want to always

remember: _____

Miscellaneous thoughts: _____

COMBINING YOUR SKILLS

Now it is time to show you how to combine the object-oriented fundamentals you learned
in Chapter 6 with several freehand drawing skills. As you combine these skills you will
also work with advanced editing of object-oriented drawings using advanced drawing
techniques you have just reviewed.

Exercise 7-1: Select a Simple Line Drawing Icon (using Micrografx Designer)

Software Used

Almost any vector-based program

Skill Level: Intermediate

How-to Steps

1. Use any vector-based software and open a new file.
2. Select the simple line drawing icon.
3. Create a line segment.
4. Select the line segment you just drew.
5. Click the right mouse button to access the edit fly-out menu.
6. Select Reshape Points from the fly-out menu (Figure 7-31).
7. Touch either point with the mouse, and note the results.

FIGURE 7-31

Additional Comments

Whenever you create a new line segment, note that when you select this line the handles take on a different appearance than that of an object-oriented drawing. One of the handles is open while the other is solid to indicate it is activated. These are known as open or closed paths (Figure 7-32).

FIGURE 7-32

Special Notes

Name and version of software used: _____

Additional steps to execute the program that were specific to the software program that you are using: _____

Biggest challenge: _____

What you learned that was new, and special notes on what you want to always remember: _____

Miscellaneous thoughts: _____

Exercise 7-2: Connecting a Drawing Using the Snap-To Icon

Software Used

Micrografx Designer or almost any vector-based program
Let's begin by comparing to different images. Look at Figure 7-33. The clear handles indicate open paths and the solid handle is the ending point and a closed path.

FIGURE 7-33

Special Notes

Name and version of software used: _____

Additional steps to execute the program that were specific to the software program that you are using: _____

Biggest challenge: _____

What you learned that was new, and special notes on what you want to always remember: _____

Miscellaneous thoughts: _____

Exercise 7-3: Using a Simple Line Tool

Software Used

Almost any vector-based program

How-to Steps

1. Open a new file.
2. Using the simple line tool, begin to duplicate the lines in Figure 7-34.
3. Activate the snap-to icon and experiment with how to connect and close. (*Hint:* The closer you come to the original point the easier the "snap-to" option will work.)

Additional Comments

Now you can see the advantage of having the snap-to icon activated. Any drawing not connected or closed will not fill. Now you can also see the benefit of having the snap-to icon activated to be sure your drawings connect and close. Take a moment to experiment with this concept and make your notes in the space provided.

FIGURE 7-34

Skill Level: Intermediate

Special Notes

Name and version of software used: _____

Additional steps to execute the program that were specific to the software program that you are using: _____

Biggest challenge: _____

What you learned that was new, and special notes on what you want to always remember: _____

Miscellaneous thoughts: _____

DIFFERENCES BETWEEN SIMPLE AND COMPOUND LINES

The concepts we will cover next can be considered Exercise 7-4, so be sure to jot down good notes as you practice, along with the explanation of what the tool is, where it is located, and how to use it.

Editing Simple and Compound Lines

After you locate the simple and compound line tools on your toolbox, you can also begin to edit your drawings using the Edit Mode icon (see Figure 7-35).

Now look at Figure 7-36, here you will notice you have the simple line tool icon and the edit mode icon activated simultaneously, with a corresponding edit fly-out menu with additional choices.

In Figure 7-37, the compound tool icon and the Edit Mode icon are also activated from the fly-out menu on the main toolbox.

FIGURE 7-35 Edit tool icon on toolbox.

FIGURE 7-36 Edit fly-out menu.

INTERMEDIATE

FIGURE 7-37 The compound tool icon and the edit mode icon are also activated from the fly-out menu on the main toolbox.

Take a moment to locate the fly-out menu associated with the Edit Mode icon and jot down any special notes in the space provided below.

Special Notes

CALL-OUT A POINT OR A LINE SEGMENT

One other special editing function you may wish to explore is call-out. The call-out a point or a line segment is an extremely useful function for editing a drawing or clip art. There are several possible locations for it. Frequently, it is a right button function (Figure 7-38).

FIGURE 7-38 Call-out a point or a line segment.

This option will permit you to isolate and edit up to three line segments of a drawing. This action permits the designer to modify a design with ease.

ADDING A POINT AND/OR ADDING A LINE SEGMENT

Another useful editing technique is adding a point and/or adding a line segment. The best way to understand the use of this option is to follow the steps listed in Exercise 7-5.

Exercise 7-5: Adding a Point.

Software Used

Micrografx Designer

How-to Steps

1. Draw a line segment.
2. Add handles by selecting the line.
3. Click the right mouse button (or double click on the object) to select the line.
4. Click on the right mouse button and select Point Reshape (Figure 7-39).
5. Click on the right mouse button again and a new menu appears. Select Add Point (Figure 7-40).
6. Click anywhere on the line to add a new point.

Additional Comments

Just as in the previous exercises, you will activate this option with the right mouse button. This action permits the designer to modify a design with ease. You will really need to be able to adapt this technique in the next chapter when you are working with clip art.

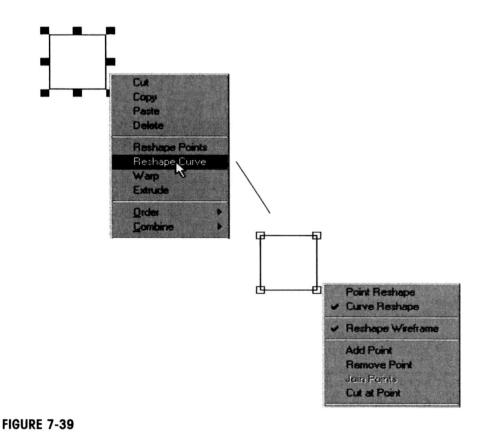

FIGURE 7-39

| Add Point |
| Remove Point |
| Join Points |
| Cut at Point |

FIGURE 7-40

Special Notes

Name and version of software used: _____

Additional steps to execute the program that were specific to the software pro-

gram that you are using: _____

Biggest challenge: _____

What you learned that was new, and special notes on what you want to always

remember: _____

Miscellaneous thoughts: _____

Exercise 7-6: Delete a Point or a Line Segment

Software Used

Almost any vector-based program

How-to Steps

1. Draw a square with the square object-oriented icon.
2. Place handles to select the object.
3. Click the right mouse button (or double click on the object).
4. Select Reshape Point.
5. Click on the right mouse button and select Reshape Curve (Figure 7-41).
6. Select Delete a Point or Line segment

Additional Comments

Typically, the point that you highlight is the point that will be deleted.

Special Notes

Name and version of software used: _____

Additional steps to execute the program that were specific to the software pro-

gram that you are using: _____

Biggest challenge: _____

INTERMEDIATE

FIGURE 7-41

What you learned that was new, and special notes on what you want to always remember: _____

Miscellaneous thoughts: _____

Up to this point we have been showing you several complex techniques and the associated tools that are very useful for rendering fashion. Now, let's tie all of this information together.

Challenge Exercises

Each of these Challenge Exercises will build on each of the concepts covered thus far. The exercises begin slowly and culminate in a sample real-world fashion. These are exercises you may be required to do in the industry.

Challenge Exercise 7-7: Object-Specific Reshaping

It is important to note that the way you perform object-specific reshaping will depend on the type of object you create as well as which software you are using to duplicate this exercise. The concept is a universal concept for any vector-based application.

Software Used

Micrografx Designer or any vector-based program

How-to Steps

1. Open a new file.
2. Using the square object-oriented icon, draw a box.
3. Double click on the solid handle.
4. Drag to the center of the rectangle. This will permit you to sharpen or round the corners (Figure 7-42).
5. Now try this same technique on an ellipse and a circle.

FIGURE 7-42

Additional Comments

An ellipse converts to a cone shape, a circle converts to a pie-wedge shape, and polygons convert to stars as well as to many-sided polygons or curved polygons. Also experiment with the right-button options immediately after object-oriented drawing and after placing handles around an object-oriented drawing. Note the two different pop-up menu selections.

Special Notes

Name and version of software used: _____

Additional steps to execute the program that were specific to the software program that you are using: _____

Biggest challenge: _____

What you learned that was new, and special notes on what you want to always remember: _____

Miscellaneous thoughts: _____

Challenge Exercise 7-8: Convert an Ellipse into a Pie Wedge Using the Edit Tool Icon

Software Used

Micrografx Designer

How-to Steps

1. Select the ellipse icon and draw an ellipse.
2. Click on the edit tool icon in the main toolbox. (Note that the menu bar selection changes.)
3. Double click on the ellipse. The top of the ellipse now has a single blue handle.
4. Click on the solid blue handle.
5. Drag the pointer in a circular fashion inside the ellipse (Figure 7-43). (Note that if the pointer is inadvertently dragged outside of the ellipse it transforms into an arc.)
6. From the inside of the ellipse, drag the mouse and release the button when you are finished and make note of the results.

Additional Comments

You will know you are in the editing mode when you have the solid blue handle. Also make note of what occurs if you double click on the ellipse during the converting process.

Skill Level: Intermediate

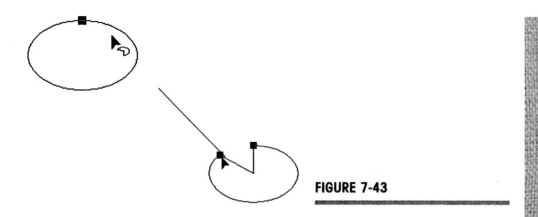

FIGURE 7-43

Special Notes

Name and version of software used: _____

Additional steps to execute the program that were specific to the software program that you are using: _____

Biggest challenge: _____

What you learned that was new, and special notes on what you want to always remember: _____

Miscellaneous thoughts: _____

Challenge Exercise 7-9: Select an Object for Reshaping Using Anchor Points

Software Used

Any vector-based program

How-to Steps

1. Using the object-oriented Star icon, make a star (Figure 7-44).
2. From the menu bar, select star. Note that using the shift key in conjunction with the mouse will constrain the shape to your liking.
3. Select the object with the pointer.
4. Double click on the object.
5. Right click the mouse and select Convert to Curves.
6. Drag on any anchor point to reshape.

Additional Comments

Here is where using the wire-frame option comes in handy. Selecting wire-frame enables the computer to redraw the object faster, especially if the object contains fills.

FIGURE 7-44

INTERMEDIATE

Special Notes

Name and version of software used: _____

Additional steps to execute the program that were specific to the software program that you are using: _____

Biggest challenge: _____

What you learned that was new, and special notes on what you want to always remember: _____

Miscellaneous thoughts: _____

Challenge Exercise 7-10: Add or Delete an Anchor Point

Software Used

Micrografx Designer

How-to Steps

1. Using the object-oriented Star icon, draw a star, as seen in Figure 7-44.
2. From the menu bar, select star. Note that using the shift key in conjunction with the mouse will constrain the shape to your liking.
3. Select the object.
4. Click on the Edit Mode icon on the main toolbox. (When you do this, hollow handles appear around the object.)
5. Click the Reshape Points option on the menu bar at the top of screen, or simply click the right mouse button on any empty box and select Add Point (Figure 7-45).
6. Point where you wish to add a point and begin to edit to suit your needs.
7. When you are finished editing the new point, presses Esc to cancel Edit Mode. To delete a point, follow steps 5 to 7, but select Remove Point rather than Add Point.

Additional Comments

Holding the control key for Editing Mode works the same as in object-oriented drawing mode to constrain. Your star might look like Figure 7-46.

FIGURE 7-45

Skill Level: Intermediate

FIGURE 7-46

Special Notes

Name and version of software used: _____

Additional steps to execute the program that were specific to the software program that you are using: _____

Biggest challenge: _____

What you learned that was new, and special notes on what you want to always remember: _____

Miscellaneous thoughts: _____

DESIGNING

Now it's time to start practicing all that you have been learning and to start designing.

Fashion Exercise 7-11: Converting a Star into a Flower

Software Used

Any vector-based program

How-to Steps

1. Choose a polygon to corner, then Star.
2. Select the number of sides you would like. Don't forget to click and drag back inside of the shape to create your star and work with handles before entering the edit mode to curve and reshape. You can also make a duplicate and add color or other details. (*Hint:* Be sure you choose Symmetrical Curve to twist or lengthen the flower petals. This is found when you right click the mouse. When you are done your flower should look something like Figure 7-47.)

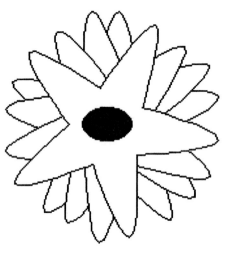

FIGURE 7-47

Special Notes

Name and version of software used: _____

Additional steps to execute the program that were specific to the software program that you are using: _____

Biggest challenge: _____

What you learned that was new, and special notes on what you want to always remember: _____

Miscellaneous thoughts: _____

Well now that you are feeling pretty confident, let's try your hand at designing a simple blouse.

Fashion Exercise 7-12: Drawing a Basic Sleeveless Summer Blouse

Software Used

Micrografx Designer

How-to Steps

1. Using the guides, make a reference line in the center of your screen.
2. Draw only half of the sleeveless garment using the parabola and line segment tools. Be sure not to make any detail on the garment just yet.

Skill Level: Intermediate

3. Use the mirror/duplicate/connect technique you learned in Exercises 6-21 and 6-22.
4. Complete the blouse (Figure 7-48).
5. Fill the blouse with a solid color or a gradient fill.
6. Name and save the blouse.

FIGURE 7-48

Additional Comments

If you had any problems completing this blouse, go back now and practice the exercises in this chapter.

Special Notes

Name and version of software used: _____

Additional steps to execute the program that were specific to the software program that you are using: _____

Biggest challenge: _____

What you learned that was new, and special notes on what you want to always

remember: _____

Miscellaneous thoughts: _____

But wait, there's more! You are not done just yet. Your boss just came in and informed you that sleeveless blouses are out—body suits with sleeves are in. What are you going to do?

Let's take a retest to see if you remember what to do when you're faced with a computer challenge. Here are your choices:

a) Shoot the messenger.
b) Run to the restroom and cry.
c) Call your mother or best friend to complain.
d) Change jobs.
e) Pull out this book and remember your training.

Well, did the choices sound familiar? Try not to react but to respond to computer-related challenges.

Universal (Vector-Based) Tools and Intermediate Skills You Will Need

- Using basic editing and shaping modes
- Using a variety of selection methods, including direct select, accessing the tool-box menu items, including right-button submenus
- Adding anchor points or segments
- Familiarity with use of rulers or measurements for proportion
- Using guides and snap-to (including viewing, accessing, locking, and hiding grids or guides)
- Using preview mode or zoom tool
- Using pens and other related drawing techniques
- Working with basic and advanced object-oriented drawings
- Using simple and compound line segments
- Working with open and closed paths, points, or line segments
- Using parabolas
- Using mirror/duplicate
- Connecting segments and points
- Adding color or fill
- Naming and saving a file

Fashion Exercise 7-13: Converting Your Sleeveless Blouse into a Body Suit

Software Used

Any vector-based program

How-to Steps

Make the following changes to your blouse.

1. Add a point to the right and left sides of the waist line.
2. Direct select the points to convert the blouse into an hourglass shape.
3. Add a point to the hem of the blouse.
4. Using the skills you just mastered, transform the blouse into a body suit. And, don't forget to add some sleeves.
5. Name and save the body suit under a native file format. Your garment should look something like Figure 7-49.

FIGURE 7-49

Special Notes

Name and version of software used: _____

Additional steps to execute the program that were specific to the software program that you are using: _____

Skill Level: Intermediate

Biggest challenge: _____

What you learned that was new, and special notes on what you want to always
remember: _____

Miscellaneous thoughts: _____

You did great. You really are on the road to success. Give yourself a pat on the back!

FREEHAND DRAWING REVIEW

Let's do a quick review of what you have learned. Almost all illustrations created in
vector-based software are created by any combination of object-oriented drawing or objects
having one or more paths. These paths are composed of one or more line segments. Each
line segment has anchor points at each end. You also discovered that anchor points are
available with no handles or one or more handles. Finally, you learned to edit curves that
are controlled by the handles that extend from anchor points. Mastering each of these
techniques took time, grace, and patience.

Before we complete this chapter, we need to make one more very important stop—
raster-based programs. In this section we will begin to compare the raster-based drawing
and editing tools with the ones you have been using in vector-based software. We can
safely say that here is where you will really have some fun! And you've earned it!

RASTER-BASED TECHNIQUES AND TOOLS

Next we will take a look at some raster-based techniques, which will include the use of
filters. Also, we will show you how to prepare the vector-based file you just created to
be opened in a raster-based program. This is important, because now, using the raster
techniques you will learn how to add surface interest to your blouse!

First, let's take a look at the drawing tools in raster-based software for comparison.
The thing to keep in mind is that these tools are most frequently used for enhancing an
image. The drawing tools identified in these illustrations are found in Adobe Photoshop
and Metacreations' Painter.

NAME	ICON	
Brushes:		FIGURE 7-50
Pens (including felt-tipped)		FIGURE 7-51
(look for other selections in the drawer) Crayons		FIGURE 7-52

INTERMEDIATE

Pencils

FIGURE 7-53

Chalk

FIGURE 7-54

Trowel

FIGURE 7-55

Water

FIGURE 7-56

Hoses

FIGURE 7-57

These are just of few of the many tools you have available. So be sure to pay close attention, watch for your other choices, and take good notes!

Now is a good time to compare the differences and the similarities of the drawing tools in a raster-based program with those in a vector-based program. Up to now we have been using only tools in a vector-based program. By opening your raster-based software and experimenting with the tools, you will begin to discover for yourself just what these tools have in common. Be sure to jot down your observations. Again, take some time to locate these tools on your software and take good notes.

Special Notes

Name and version of software used: _____

Additional steps to execute the program that were specific to the software pro-

gram that you are using: _____

Biggest challenge: _____

What you learned that was new, and special notes on what you want to always

remember: _____

Miscellaneous thoughts: _____

As you can see the raster-based programs are very similar in some ways to the vector-based programs. However, we need to spend some time showing you several of the unique nuances found in many raster-based programs.

Selection and Editing Tools Found in Most Raster-Based Software

It is time to introduce you to the location and use of several of the basic concepts associated with raster-based software, including the different types of selection and editing tools. We will begin with accessing the tools and describing briefly the function of each. Naturally the best way to become acquainted is to spend time experimenting with them.

It is important for you to understand at this point that the concepts we are about to share are only the basics. These programs are very sophisticated and can be a class or textbook unto themselves.

In fact there many great books out there you may wish to acquire to help you bridge the information gap if you find you require more software-specific help. In this chapter we are merely exposing you to a small portion of what most raster-based programs can do.

Raster-based software has several unique advanced features that can be used to enhance your renderings. Each of these has practical applications that will readily adapt to any fashion illustration.

Perhaps one of the most critical things to keep in mind when using a raster-based fill or filter is the amount of disk space needed. The difference is dramatically different from vector-based drawings, so be sure you have the disk space before you save anything.

As we mentioned earlier, the purpose of this section is to introduce you to tools and techniques common to raster-based programs. In later chapters will explore how to apply these additional concepts and techniques to fashion.

If you have access to Metacreations' Painter, open a new file and feel free to follow along. If you do not have the program, you can still visually walk yourself through the exercise with us. The tour is fairly self-explanatory.

Exercise 7-14: Opening a New File in Metacreations' Painter

How-to Steps

1. Open Metacreations' Painter by double clicking on its icon.
2. Click on file, then new.
3. Enter the dimensions, resolution, image type, and paper color to match Figure 7-58.
4. Click OK when complete.

Additional Comments

The dimensions and the paper color are located in list boxes you click on to activate (Figure 7-59). Later you may change the numbers we have selected to suit the needs of your particular file.

Special Notes

Name and version of software used: _____

Additional steps to execute the program that were specific to the software program that you are using: _____

Biggest challenge: _____

INTERMEDIATE

FIGURE 7-58

FIGURE 7-59

Skill Level: Intermediate

What you learned that was new, and special notes on what you want to always

remember: _____

Miscellaneous thoughts: _____

Viewing Tools in Metacreations' Painter

Go to the Window menu and toggle between Hide Tools and Show Tools and Hide Palette and Show Palette (Figure 7-60). In Figure 7-61 you can see your Tools Palette, which contains all of your tools. The red outline will indicate which tool is currently activated. To access a particular tool, all you need to do is click on it.

FIGURE 7-60

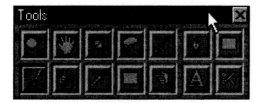

FIGURE 7-61

Selecting Brush Size

If you select the brush tool, you will notice the options to control the size of the brush. You may also control the opacity (how heavy or light the paint will be), as well as what grain of paper you will use (Figure 7-62).

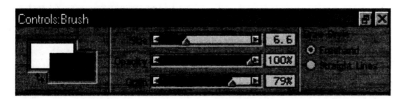

FIGURE 7-62

Additional Comments

The dials next to each of the names will slide for you to control the size or percentage desired.

Special Notes

Choosing Color

Another important feature in Metacreations' Painter is the location of color. If your color is not showing when you open your new file, go to Art Materials and click on Color now.

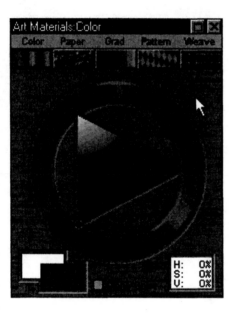

FIGURE 7-63

In Figure 7-63, you will notice you have the ability to change saturation and/or color value by clicking in the color triangle. The color you selected will be located in the color triangle and is indicated by a circle within the triangle. We will go more in depth on color choices in Chapter 10.

Note the two colored boxes in the lower left corner in Figure 7-64 indicates the foreground and background color selection. These color selections also can be toggled back and forth as you choose. Note that the color selected in the color triangle directly corresponds to the color choice for the foreground.

Special Notes

Choosing Paper

Let's move on to changing paper or texture. In the art materials palette, click on Paper, then, to access your additional choices, click on the small purple triangle to open the drawer to view the paper selections (Figure 7-64). From here you can access a selection by using the mouse to click on your choice.

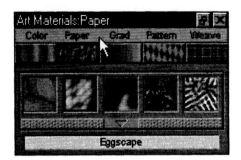

FIGURE 7-64

Special Notes

Tools and Brushes in Metacreations' Painter

Note in the main brush menu shown in Figure 7-65, just as before you can view the different selections by opening the drawer via clicking on the small purple arrow. Also note the additional list boxes in Figure 7-66. These choices correspond to the tool you have chosen, and every tool has its own set of choices. On the brushes palette, you also have the option to control your brush size (Figure 7-67).

We suggest you take a few moments to access and experiment with each of these before moving any further in this section. We have provided space for you to jot down your thoughts as you try each of these tools.

FIGURE 7-65

FIGURE 7-66

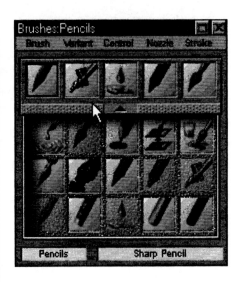

Brushes:Pencils

Brush Variant Control Nozzle Stroke

Pencils Sharp Pencil

FIGURE 7-67

Exercise 7-15: Experimenting with the Basic Tools and Menus in Metacreations' Painter

How-to Steps

1. Open a new 6-inch-by-6-inch file.
2. Access the brushes palette and make any additional notes you feel you might need.
3. Feel free to scribble and play as you experiment with each of the tools.

Special Notes

Tool Name:	Your Comments:
Pencils	
Eraser	
Water	
Chalk	
Charcoal	
Pens	
Felt Pens	
Crayons	
Airbrush	
Liquid	
Artists	
Water Color	

Adobe Photoshop

We told you that you would really begin to enjoy your computer and we hope you especially enjoyed the great tools in Metacreations' Painter. We now want to move on to show several of the basics in the image-editing program Adobe Photoshop.

Earlier we introduced you briefly to how to open a New file, as well as where the main toolbox was located. A brief review wouldn't hurt, so begin by following along as we cover some of the basics of image editing.

Skill Level: Intermediate

Exercise 7-16: Introduction to Using the Basic Tools in Adobe Photoshop

How-to Steps

1. Open a new 6-inch-by-6-inch RGB file.
2. Click on the brush icon in the main toolbox.
3. Under the view menu, be sure you have all the tools and palettes toggled on.
4. Now, go to the corresponding brushes palette and select a brush size (Figure 7-68).
5. Select a color from the color palette and practice using the pencil tool.
6. Select the pencil tool from the toolbox and select a new color from the color palette.
7. Practice with the pencil tool and make note of the difference between the brush and the pencil tools.

Additional Comments

You should notice a difference between the brush and the pencil. The pencil draws more of a flat, one-color while the brush uses many colors.

Special Notes

Name and version of software used: _____

Additional steps to execute the program that were specific to the software program that you are using: _____

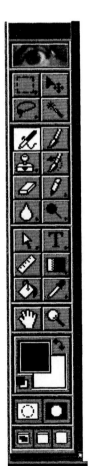
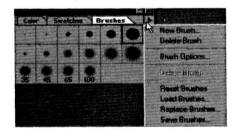

FIGURE 7-68

Biggest challenge: _____

What you learned that was new, and special notes on what you want to always remember: _____

Miscellaneous thoughts: _____

Additional Editing and Selection Tools Found in Most Raster-Based Software

In most raster-based software, the selection process is a little different from the selection process in a vector-based program. Making a selection on a raster-based image or photograph is *very* different from making a selection on a vector-based drawing. You will need a wide variety of selection tools in order to isolate and select a given portion of a photograph.

The lines, curves, and colors all play a part in how to isolate and select a portion of a raster-based image, and Photoshop and Painter both give you special selection tools for each job. Therefore we recommend that you take a few moments to become familiar with the most frequently used tools and write a brief explanation of your findings next to each tool.

Practice Using the Basic Adobe Photoshop Tools

The Marquee Tool

FIGURE 7-69

This tool permits you to select either a rectangle or elliptical area. This is accomplished by selecting the marquee icon from the main toolbox (Figure 7-69) and dragging it over an image.

Additional Comments

The marquee tool has an arrow to indicate a fly-out menu for you to choose between the different marquee tools. One other feature of this important tool is your ability to constrain the shape of the marquee. This is accomplished by holding down the shift key as you drag your marquee to make it a circle or a square (Figure 7-70).

FIGURE 7-70 Marquee tool.

Special Notes

The Lasso Tool

FIGURE 7-71 Lasso tool.

The lasso tool is used to make a freehand selection over an area. To use this tool, select the lasso tool Icon from the main toolbox (Figure 7-71) and click and drag over an irregular shaped area, including straight-edge segments.

Special Notes

Polygon Lasso Tool

FIGURE 7-72 Polygon lasso tool.

The polygon lasso tool is used when making a selection over a straight-edge segment. This tool is also used to draw freehand segments or over a specific area or image by holding the alt key while dragging the mouse. This is known as alt-dragging (Figure 7-72). This action is used in conjunction with double clicking the mouse to close the selected section.

Special Notes

Magic Wand Tool

FIGURE 7-73 Magic wand tool.

The magic wand is different from the other selection tools in that it will permit you to select or isolate a section based on color. The magic wand icon is found in the main toolbox (Figure 7-73).

Additional Comments

One great feature you will find useful is the ability to command the tool to choose the image or background for applying special effects. This is accomplished by accessing the edit menu, then choosing Select, then Similar for choosing one particular color. Or to isolate an image from the background you can go to the edit menu and choose Select, then Inverse to accomplish this task.

Adding, Subtracting, or Copying from a Section of an Image Using the Magic Wand Tool

- To add to a section of an image, hold down the shift key.
- To subtract or take away from your selection, hold down the alt key.
- To copy a selection within the existing document, hold down the alt key and click and drag to new location. This may also be accomplished using the cloning tool.

We have exercises later where you can actually apply these techniques. This technique will be useful in creating and rendering fabric in the Fabric Design segment of this book.

Special Notes

STUDENT NOTES

Rubber Stamp Tool

The rubber stamp tool is a tool used to paint, copy, or modify an image or color to another image. The rubber stamp tool icon is located in the main toolbox (Figure 7-74). This tool also has a related menu box for you to make specific selection such as Mode or Opacity (Figure 7-75).

FIGURE 7-74 Rubber stamp tool.

FIGURE 7-75 Rubber stamp options.

Additional Comments

We will explore this option later in the chapters on designing fabric.

Special Notes

We certainly have covered a lot of new ground!

Fun with Filters

Now you are ready to have some fun with filters. Filters are basically an image-editing application used to create or simulate a wide array of surface interest for your image. Filters can be applied to an image that has been generated in either a vector- or a raster-based program. Filters can transform a basic thumbnail rendering into a comprehensive final work of art.

As you are progressing in your knowledge and skills on computer-aided designing, you are beginning to discover that the computer really is your friend. Working with and applying filters to any design or image is just downright fun!

Filters simulate a variety of surface interests that can be applied to a digital image or to a vector rendering. These filters represent a wide range of textures types and styles such as:

- Fabric-related surface textures—knits, brushed, puckered
- Embossed surface
- Tiled effects, including mosaics and pixels
- Motion/directional effects, including wind-swept
- Distortion and stylized effects
- Perspective effects
- Lighting effects
- Degree of intensity
- Shine—finishes from glossy to mat
- Grain effects

- Glass effects, including opaque and stained glass
- Artistic Effects to make your work resemble different artistic styles or movements such as Van Gogh, Impressionist, Fresco
- Ink pen and outlined effects

Each of these filters or textures can be applied to lines, shapes, objects, images, or edges.

There are filters created especially for vector-based renderings as well as raster or real-world images. In this section we will introduce you to both and let you experiment.

The key to mastering these is experimentation. You do virtually nothing; the computer does everything.

When you see that different versions of a design that would have taken hours to create by hand are done literally in seconds by the computer, you will fall passionately in love with your computer.

Up to this point it has probably felt more like a battle of the wills. Now you will discover that each of you has a significant contribution to make to any creation. You are the designer or artist, the computer merely executes your ideas for you. In this section, like never before you will finally see just how the computer will go to work for you!

We have included a sampling of raster-based filter menu options found in Adobe Photoshop. The screen shots are examples of several of the filters that have been applied to a file similar to the one you just created. In Figure 7-76 we show you the full-screen location of the Filters menu.

Exercise 7-17: Using Filter Options in Adobe Photoshop

How-to Steps

1. Open a 5-inch-by-5-inch file in RGB color mode with a resolution of 72 dpi (dots per inch).
2. Using a brush found in the main toolbox, make several swirls and strokes in five different colors (Figure 7-77).
3. From the Edit menu, choose Select All.
4. From the Filter menu, select Artistic (Figure 7-78), Fresco, and hit OK.

Additional Comments

These filters can easily be adjusted. Some filters will permit you to preview the work before you apply it.

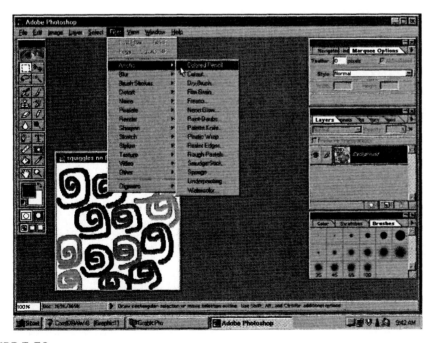

FIGURE 7-76

INTERMEDIATE

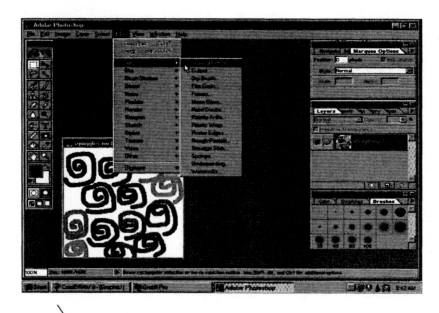

FIGURE 7-77

Special Notes

Name and version of software used: _____

Additional steps to execute the program that were specific to the software pro-

gram that you are using: _____

Biggest challenge: _____

Skill Level: Intermediate

FIGURE 7-78

What you learned that was new, and special notes on what you want to always remember: _____

Miscellaneous thoughts: _____

Now that you have tried one of the filters, why not take a few minutes to experiment with each and make notes below on the ones you feel may have apparel applications. In later chapters we will make reference to the notes you take now. For example, when we have to render a denim-looking fabric you will find that filters will do most of the work for you.

Don't forget if you apply a filter you don't like you can always select Undo to cancel you selection (Figure 7-79).

NAME OF FILTER:	YOUR COMMENTS HERE:
Artistic	
Blur	
Distort	
Noise	
Pixelate	
Render	
Sharpen	
Sketch	
Stylize	
Texture	

INTERMEDIATE

INTERMEDIATE

FIGURE 7-79

Skill Level: Intermediate

Additional Comments

Remember, each of these options activates an accompanying fly-out menu of more choices, so be sure to take great care in making your comments. These notes will be very helpful in the Fabric Design segment of this book.

Now let's put to good use what you have just practiced. We will reopen the basic blouse you created and apply a filter to enhance your garment.

Fashion Exercise 7-18: Applying a Raster Filter to a Vector-Based Image

Software Used

Adobe Photoshop

How-to Steps

For demonstration purposes you will be copying a file created in a vector-based program into a raster-based program to practice this technique. Or you may opt to make just a simple object-oriented box to practice filling with color, then applying a filter.

1. Open the basic blouse you created in Exercise 7-12.
2. If you haven't already added a light blue color to your blouse, do so now.
3. Select your blouse and go to the edit menu, and select Copy.
4. Open a raster-based program such as Adobe Photoshop. Note that the file will automatically open to the same size as your blouse, so select OK to Open.
5. Go to the Edit menu and select Paste.
6. Choose the Magic Wand icon from the toolbox and make a selection around your blouse. The new selection will appear in the form of "marching ants."
7. Go to the Filter Menu and begin to experiment with the filters.

Additional Comments

By using the filters you can convert a simple drawing you filled with the color blue into the look of denim in seconds.

Special Notes

Name and version of software used: _____

Additional steps to execute the program that were specific to the software program that you are using: _____

Biggest challenge: _____

What you learned that was new, and special notes on what you want to always remember: _____

Miscellaneous thoughts: _____

Wow! It seems like that was quite a road you just traveled! We have been to a number of exciting places in our journey. We hope you have enjoyed discovering the similarities and differences between vector- and raster-based software.

THE LAST WORD IN FONTS—WYSIWYG: IS WHAT YOU SEE WHAT YOU WILL GET?

Many times throughout this book you will hear us ask that question "Is what you see what you will get when you print your project?" In these early stages of your discovery of how to use the computer we have steered clear of some of the challenges you may encounter later in your journey as a designer. One such place is in fonts—the fonts you have access to when labeling your creations may not convert the same when they go to press.

For example, you may have selected one font that suggested "Bridal," but when it was printed by marketing, instead it conveyed "Boring." When this occurs, don't panic. Recall from Chapter 5 that we mentioned a lot about how to save a file and file formats. Well, here's where paying attention pays off. Instead of saving your file as a native file format, try saving and/or exporting it as an EPS file. Remember, EPS is like a document of instructions within a document—telling the file to properly interpret your font instructions. So, don't forget to refer back to Chapter 5 when selecting a program for your on-the-job projects. The helpful breakdown of each of these program types, as well as knowing their specialty will be critical when choosing the best way to import, export, or save your files. Stop and take a quick look back at the charts found in Chapter 5; in no time you will realize that they are an invaluable tool in designing. Later in Chapter 10, we will show you how to check with a service bureau to ensure correct font selection.

Now we are ready to move on to the basic of designing for your line. Come with us now to Chapter 8 as we see what the experts have to say as you discover their secrets to creating a successful line.

CHAPTER SUMMARY

All fashion begins with an idea that can be created on a computer as easily as it can be created by hand. In Chapter 6, you observed that the building blocks of any fashion rendering are geometric shapes. The first drawing tools used in that process were the object-oriented drawing tools. These are found on any vector- or raster-based software.

In this chapter you began to explore the next phase of the process, using the additional drawing tools such as pens and brushes that can form renderings that range from straight and compound lines to curves. Each of these tools and techniques can be edited at any stage of development.

The location of the tools and the function of the tools are universal. Accessing the options may vary from program to program, but they are always performed in the same manner. In fact, within any given piece of software the same function can typically be performed in a multiple ways—i.e., by menu, mouse, or function keys.

We then further investigated the use and nature of raster-based software as it differs from the use and nature of vector-based software. Although the tools share the same general location, the use and function frequently differ.

The nature of the work that is typically performed in raster-based software is image editing. Therefore, the selection tools must reflect the need for more sophisticated alternatives for the designer to choose from when performing these types of tasks. This fact will become more and more apparent to the designer in later chapters and in continued use and practice of the techniques demonstrated in this chapter.

Finally you discovered the secret of applying filters to a renderings. Filters have the ability to transform the ordinary into the extraordinary with just a click of the mouse!

CHAPTER 8

Designing a Line: The Elements for Creating a Successful Line

Focus: The Principles and Secrets of Fashion Design and Fashion Marketing to Design a Successful Line

CHAPTER OBJECTIVES

- Identify the fundamental principles of marketing to designing for fashion.
- Prepare to apply the secrets of the "marketing mix" to creating a successful line.
- Correlate the demographics and psychographics of consumers to the fashion-design process.
- Review factors pivotal to stimulating consumer buying motivation.
- Investigate the secrets from some of the fashion experts for creating a successful line.

TERMS TO LOOK FOR

category	group	presentation boards	style
classification	key item		swipe
collection	line	price point	taste level
concept board	marketing	related separates	theme board
division	marketing mix	season	trans-seasonal
flats	mood board	signature look	worksheets

WHERE DO YOU START?

You've spent a great deal of time working with your tools. But now, a very important concept begins to surface. You can develop the most extraordinary design skills; you can master the tools of the computer; you can be part techno (by that we mean, you are able to sit down at almost any computer station and within minutes begin to design). But, and this is very important, what are you going to design?

Believe it or not, probably anyone can design just one piece! However, having the ability to create exciting multiple-piece lines season after season is truly a talent. So now you face a new challenge, applying the technical skills to develop concepts. These concepts will then set the foundation for creating your line. Below is a bit more detailed focus on what this all means.

Many of today's designers have spent years developing their signature look or trademark style. Some designers are driven by style, while others are motivated by color, patterns, fabrications, or fit.

Think of yourself when you are creating a garment. What inspires and motivates you? Sometimes you may find a fabric that sends your imagination soaring. Maybe on other occasions your designs are driven purely by color.

Finding something to fit comfortably can send most of us back to the cutting room! It is easy for most of us to remember a disappointing shopping experience searching for a garment that not only fits well but also camouflages figure flaws. If finding the right fit wasn't hard enough, what about trying to find an outfit that "comfortably" went from day wear to evening wear?

If you have found the fit—and the perfect multipurpose garment—did price ever stop you from buying? Don't worry you're not alone.

All of these factors and more, are the same influences that today's fashion designer must face daily. If they don't, or you don't, the designs will never leave the sample room. If you do address these concepts while you develop your lines, you will be responsible for setting the foundation for your fashion success.

So, it's time to put down the computer tools, grab that business hat we talked about in Chapter 1, and spend some time in the business wing of the fashion world.

MARKETING AND ITS IMPACT ON DESIGNERS

There is in the language of marketing today's fashion, a term you use to describe what we have been discussing: it is called the marketing mix. This mix is made up of product, price, place, and promotion. Simply put, it is understanding your customer inside and out. Quite frankly, the designer who stays true to this information can never go wrong.

Let us explain what we mean. These are important questions a designer must consider when creating a line. The answers to these questions will define the consumers and detail their needs, wants, and ability to pay for a given garment.

Time to put on your business hat!

Product

How will this product be made? What role will quality play? What are the benefits and features?

Does this product satisfy a consumer need or a consumer want? Or, interestingly enough in fashion, does it satisfy both? For example you may go shopping for a winter coat because you need one, but among all the products offered, what are the features that you find most interesting and that encourage you to want to buy a certain coat? Image? Value? Quality?

Place

What kinds of outlets for purchasing this product are there? Where are these products available for sale? Where are the stores located? Is the product available in retail stores, specialty retail stores, specialty stores, boutiques (including in-store boutiques), catalogs, factory stores, and/or on-line?

Promotion

How will the product be displayed, merchandised, and advertised? How are consumers informed about the products? What types of salespersons are available to showcase or explain the product? What concepts are conveyed to the consumer? How and where is the information about the product channeled to the target market? Whose name is on the product—Yours? Or the company you design for, including private labeling? And don't forget packaging; that alone sets unique product standards.

Price

What is the price range "acceptable" to this group or target market? What is important to the company producing and promoting the product—profit margins, advertising, production costs, competitors?

People

Finally, all of these components are reinforced by people. This includes everyone involved, from the designer who creates the idea to the company's decision makers to the consumer, as well as everyone in between.

What motivates a consumer to buy a garment?

- Source?
- Status or image?
- Aesthetics?
- Function or performance?
- Quality?
- Brand loyalty?
- Price?
- Fabric?
- Hand?
- Figure requirements?

The key is communication! Feedback and reflection all play an important role in the marketing mix. The designer or firm who listens to as well as attempts to anticipate the consumer wants and needs has the real secret to success.

The successful designer frequently not only knows their customer, but is their customer. A classic example was Coco Chanel, she had a theme or signature look; she defined a taste level; she anticipated trends while keeping an eye on the past (i.e., she knew what worked); and finally, she had a great sense of timing.

While every designer will not go down in history as a Chanel, the designer who stays current and develops that internal instinct, and stays true to their customer needs and desires, will go along way in making their mark on their individual niche of fashion.

RELEVANT FASHION MARKETING TERMS

When it comes to categorizing and describing fashion, there are several terms that frequently are misunderstood or misrepresented. It is important for you to cover these terms specifically. You will find that they are relevant to the exercises included in Chapter 14, where you will generate your own marketing and promotion tools.

Classification

Classification is a grouping of items similar in nature and use. In a retail sense, this is a related assortment or category of items.

To further explain, here is sample of several classifications followed by detailed examples.

EXAMPLES OF CLASSIFICATIONS
- Shorts
- Pants
- Sweaters
- Dresses
- Skirts
- Coats

Now, let's take a closer look inside one of these classifications. For our example we will use the classification, Coats.

PARTIAL LIST OF COATS CLASSIFICATIONS
- Reefer
- Chesterfield
- Trench
- Princess
- Pea coat

Line

Line is typically used to describe American fashion. Frequently, "a line" represents a collection of styles by trims or details. In most cases, however, a line is a seasonal representation of a collection of garment groupings or styles by a designer.

Lines can be referred to as *item lines* (lines specializing in one or more specific items) or *group lines* (lines grouped around fabric, styles, or silhouettes). From there, a line can be divided by groups of garments, usually between six and eight groups are called a division. These each have their own theme, fabric, color, and trend.

Often, American designers will call their line a collection. However, the term *collection* is generally associated with high-end European fashion.

When it comes to designing a line, most U.S. companies or designers produce up to five to six lines per year. The name of the line will correlate to the season in which it is sold.

- Spring
- Summer
- Transitional
- Fall I & II
- Winter
- Holiday
- Resort

Style

Another misunderstood term is style. *Style* has several meanings associated with it. For instance, it can mean the basic characteristics or distinguishing features of a design and its presentation; or it can refer to a period or point in time used as the inspiration for a design. For example, an item might be said to be in the Greco-Roman style.

You can also categorize styles by one of the following terms: classic, sporty, retro, ethnic, career, high fashion, trendy, contemporary, active wear, after-five, bridal, formal or black tie, or minimal.

Another use of the term *style* is in qualifying a specific garment within a particular style. For example, we all know that styles of pants are described by their length, such as running shorts, hot pants, shorts, Jamaica shorts, Bermuda shorts, clam diggers, Capris, slacks, stirrup pants, and so on.

We know that designers are primarily visual, so let's look at a compilation of this information in an easy-to-read flow chart of the design process. The following chart is divided by how the consumer might process fashion choices and in the second column the factors or choices you are faced with as a designer so that you both can arrive at the same point—the cash register.

THE DESIGN PROCESS

Today's designer's responsibility goes beyond creations that reflect their personal whims for fabrics or colors. Frequently, a designer is motivated to consider other critical elements of design. Part of the design process involves research that is based on facts pertaining to several market influences such as: consumer psychographics/demographics, current fashion trends, economic indicators, past sales, and other regional geographic or global considerations.

Frequently, however, a design is driven by the personal inspiration of the designer as they relate to the push–pull of these influences.

Regardless of the influences, most designs follow a simple flow-chart like the one below.

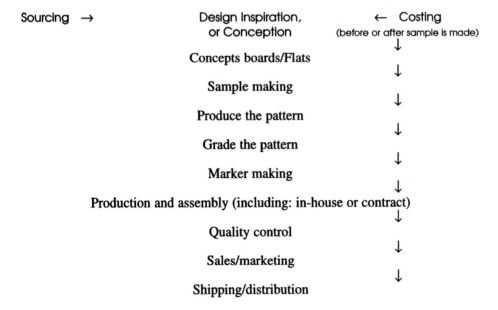

Sourcing → Design Inspiration, ← Costing
 or Conception (before or after sample is made)
 ↓

Concepts boards/Flats

↓

Sample making

↓

Produce the pattern

↓

Grade the pattern

↓

Marker making

↓

Production and assembly (including: in-house or contract)

↓

Quality control

↓

Sales/marketing

↓

Shipping/distribution

THE DECISION PROCESS

The following chart depicts on the left the thought processes a typical customer might go through in a matter of minutes or even seconds when viewing a garment. Are you prepared

to get their attention with just one glance? (Sometimes that's all you have.) The column on the right is your series of decisions; as you can see, if the process is similar then hopefully the outcome is the same—a sale!

CUSTOMER CHOICES:	FASHION DESIGNER DECISIONS:
Status/image	Company image
Aesthetics/style	Styling
Retail source	Sourcing for fabric/findings, also included is the actual retail outlet that will ultimately carry the line.
Category example: dresses	Category example: dresses
a) Need	Season
b) Want	
c) Impulse	
Size/figure requirements	Size
Price point	Cost to produce/profit margins
Other factors/motivators:	Other factors:
a) Quality	Quality
b) Performance	Performance
c) Hand of fabric	Hand of fabric
d) Color/print	Color/print
e) Impulse purchase	Inspiration

When it comes to fashion decisions, both the fashion designer and the consumer are driven by internal and external motivators that affect the choices they made—one to design, the other to buy or not to buy.

As a designer you must know everything about the company you are working for and the consumer it represents. Let's review the following questions you must always ask yourself as you begin the design process:

Who is the ultimate customer? Demographics as well as psychographics come into play here. What is he or she like and what are their shopping patterns? What is their customer's taste level?

 a) Conservative

 b) Updated

 c) Fashion forward

What about styling?

 a) High end/designer style—unique

 b) Better or bridge

 c) Adaptation for misses/petites

 d) Contemporary or trendy

 e) Junior/youthful trendy chic

What retail sources will carry the line?

 a) Traditional department stores

 b) Specialty department stores

 c) Boutiques

 d) Specialty stores

 e) Off-price stores

 f) Outlet stores

 g) Direct mail/catalogs

 h) On-line shopping

What will be the price point?

 a) Popular ($)

 b) Moderate ($$)

 c) Better ($$$)

 d) Designer ($$$$)

 e) Couture ($$$$$+)

All of these factors and more play a vital role in designing a line that will sell. Why not take a moment and step outside your role and look at your designs through the eyes of the consumer.

FASHION DESIGN TERMINOLOGY

Now that your are familiar with the flow of fashion we will move on to the terminology often associated with the rendering of fashion. The way a line is assembled can vary from company to company. However, most designer and firms start out with a visual representation of the progress of a line.

The process typically begins with mood boards, theme boards, or concept boards. Just like their name, each is a compilation of visual and or tangible artifacts used to describe the line. These artifacts are often called swipes. The term *swipe* refers to an item or object that has been "swiped" for inspiration, evaluation, and observation. This can be a leaf that was a great example of just the right shade of red that a designer had in mind. Maybe it's a swatch of fabric that has a yarn that would be perfect inspiration for a boucle suit. Or maybe it was a photograph of a model wearing an interesting detail or trim that the designer wants to incorporate into his or her creation.

From the swipe comes the actual work boards. These show shapes/silhouettes and actual flat work sketches that are represented in groupings. Finally, there are the presentation boards. Just as the name implies, these boards frequently consist of more than one board depicting the full line. These boards are used to convey a complete story. Presentation boards might include:

- Inspiration and theme
- The name of line and season
- The designer company name and/or logo
- Garment fronts and backs
- Fabric swatches
- Colorways/color story
- Patterns, prints, or motifs used
- Styles
- Silhouettes
- Details, including trims, embellishments, or other findings

The secret to designing these boards is planning and organization. Everything should be well organized, concise, and clearly labeled and done in draftsman-like quality. The text, lettering, and fonts should reinforce the concepts as well as the company's image. Several of the exercises you have been doing up to this point have been preparing you to create a visual representation of your ideas.

An additional key to creating great boards is that they must have continuity, appropriateness, timing, and most important, simplicity. You do not want to send any mixed messages. Remember, whoever will be viewing your boards or your line must be able to get your message the first time. Therefore, the goal of each of these boards is to visually convey your collection with accuracy, interest and simplicity.

From here we will take a closer look at the real world.

And now, it is time to drive into the real world and meet two of today's top designers. This will give you a chance to hear how they are applying what you are learning. As you meet our two featured designers, we thought it would be inspirational to know a bit about their background and how they got into the world of fashion. Each of these women will discuss their design philosophy, trends in fashion, their consumers, and how the computer is used in helping them meet today's challenges.

MEET KAREN KANE

One of today's most salable clothing designers is Karen Kane. For those of you unfamiliar with the Karen Kane line, here are a few facts about Karen and her line.

Like many of you, Karen Kane has had a love affair with clothes since she was a young girl. While growing up in Santa Barbara, California, her sister taught her to sew at the age of 11. Like many of us, Karen began sewing for her dolls then mastered sewing for herself.

When she completed high school, Karen went on to study fashion design for 2 years in Los Angeles. On graduation, she was hired as a pattern maker and later worked as a designer for a junior sportswear company. This is where she met her future husband and business partner, Lonnie.

In 1979, after much thought, Karen, decided there was a void in the fashion world. She wanted to design the things she wasn't finding for herself in the stores. She wanted comfortable, stylish clothing that didn't require a lot of fuss. This thought became Karen Kane, Inc. Karen and Lonnie began their business under one roof—their garage. With just a handful of employees, they were well on their way to success.

Today, Karen Kane, Inc., is still located under one roof—a 130,000-square-foot, state-of-the-art facility with over 250 employees. The Karen Kane line enjoys wide distribution at many of today's top department stores, such as Bloomingdale's, Nordstrom, Lord & Taylor, Macy's, and Dillard's to name just a few.

The success of the line has prompted retailers to allocate coveted floor space for the Karen Kane line to have its own department.

Karen Kane customers maybe described as fiercely brand loyal. The age range of her customers is between 30 and 50 years old; although, a woman of almost any age can find an item or look they can adapt to suit their needs.

Karen Kane customers have a confident sense of personal style. They are often professionals who want clothing that is comfortable and represents quality investment dressing. The line is available in Misses and Petite sizes, and includes stand-alone items and items known as related separates. These items not only go from day to night but are often trans-seasonal.

The fabrics often include many of the natural fibers, such as cotton or linen. However, you will also find other cellulose-based fibers, such as rayon, because of its natural shine and "breathable" qualities. Every garment has been designed to fulfill the lifestyle requirements of the Karen Kane client.

Our interview with Karen started with the following questions: What is her primary source of inspiration? For Karen that was easy, without hesitation she said "fabric, then color."

When asked to describe the breakdown of her line, Karen said her line can be divided by groupings. Within any given line there are approximately 18 essentials. These essentials are the key items usually found in every season. Some of these essentials are T-shirts, twill pants, and denim jeans. Frequently, these are available in a traditional color palette of black, white, navy, and cream.

To summarize, Karen Kane's signature look is one of comfort, quality, and ease, with a sophisticated and fashion forward color story.

But how does this design process flow? According to Karen, she begins by sourcing fabrics, then she sketches the garments inspired by the fabrics and colors.

Naturally the next question was, where does she source? Karen describes herself as very hands-on. She personally shops in several markets, those within the continental United States as well as the international markets. In fact, Karen has one key staff member whose sole responsibility is shopping places like Turkey, Spain, Germany, India, and many other major countries in Europe and the Orient. (We know what you are thinking: "Where do I sign up for that job?")

Skill Level: Intermediate

One favorite of Karen's is that she personally sources for antique fabrics, such as linens. From this point Karen frequently will have an artist design a print to be placed on the new fabric.

The actual printing process is done at one of several print houses or printing mills. These prints can then be modified for pitch, color, repeat, and for layout. Traditionally, this step is computer-generated for preview before actual application of the print to the fabric.

The next stage the Karen Kane line goes through is the actual rendering of items potentially to be included in the line. Once these sketches are made, they are reviewed and a final determination is made on which pieces will be adopted into the line. According to Karen, she does all the designing herself, by hand. Once the items have been accepted, however, the computer takes over. The drawings are scanned and flats are made for work sheets.

Figure 8-1 shows examples of Karen's actual sketches. Figure 8-2 shows the final sketches that be adapted for work sheets used by Karen Kane, Inc., sales representatives in taking orders for the line.

Like many of today's firms, the next step is for samples to be made in-house. A final preproduction inspection is made before the remaining design team takes over. These designs are handed off to her expert staff for pattern making, marker making, and grading. All of this is done on computers, specifically on PDS (Product Data System) and PDM (Production Data Management) (Gerber Garment Technology).

Karen is highly motivated to hire the best staff available. Her staff typically comes in already trained in the basics aspects of design we have mentioned. However, Karen takes things a step further and provides additional computer training for the actual production process of the line on the Gerber System.

Finally, Karen has her own in-house marketing team, who create on software programs such as CorelDRAW, Adobe PhotoShop, and PageMaker to assemble all the marketing and promotional tools she will need to enhance and promote the Karen Kane line to the buyers. This aspect of computers will be covered more in Chapter 14, where you will meet Karen Kane's sales representative for the Southeast U.S. territory, John Linsk.

As you can see from the early vision through the design process to the consumer, the computer plays a vital role for Karen Kane, Inc. Oh yes, Karen was asked for her final comments and advice for young designers. Her advice to young designers: "Enjoy what you choose to do, work really hard, and never give up!"

So for now, we hope we've given you some insight into the design process and the role computers play. And the next time you go into your favorite department store, check out the Karen Kane Department. (And oh yes, if you find you have a little extra to spend, I happen to know one author who would not mind at all divulging her dress size!)

Let's take a look at another of today's most bankable designers, Pamela Dennis. Just like Karen Kane, she too has an inspiring success story that will encourage you in your pursuit of excellence in designing.

MEET PAMELA DENNIS

Pamela Dennis is one of today's most sought-after designers. All you have to do is tune in to any major award show, including the Oscars, and you will find someone who is wearing a Pamela Dennis gown (Figure 8-3).

The fashion and press are forever dropping names of who is wearing what. Even back in March 1995, for an interview for *People* magazine, Pamela was noted as saying "Suddenly my gowns are as famous as the stars who wear them."

You can't help but be impressed and inspired by the list of who's who, all wearing one of Pamela's creations. Jamie Lee Curtis, Drew Barrymore, the Duchess of York, Cindy Crawford, Geena Davis, Daisy Fuentes, and the list goes

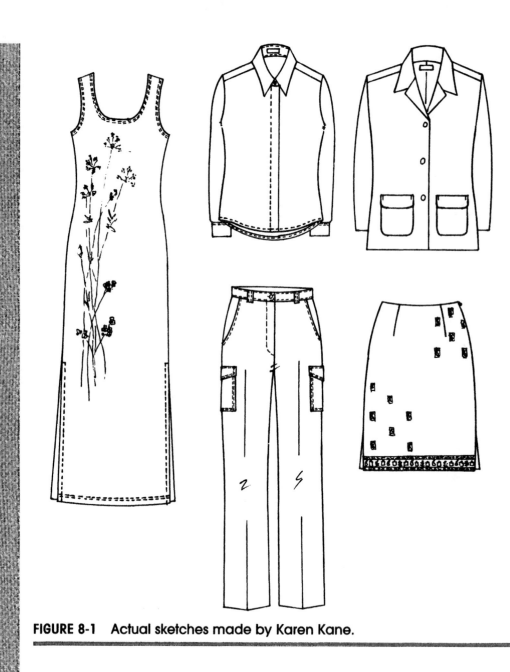

FIGURE 8-1 Actual sketches made by Karen Kane.

on, all have something in common—each has at least one design by Pamela Dennis in her wardrobe. You will find all the top stores, like Neiman Marcus, Bergdorf Goodman, Barney's New York, Saks Fifth Avenue, and Nordstrom, to specialty stores around the globe all showcasing the talents of Pamela Dennis.

Pamela is just as recognized for her efforts among her peers. Pamela Dennis has been honored with the Gold Coast Fashion Award and has twice been a finalist for the Mouton-Cadet's Young Designer Award.

The reason is simple, Pamela knows what women want: eveningwear that is at once glamorous, sexy, and wearable. Having met her on several occasions, that perfectly describes Pamela Dennis. We found her to be not only one of the most gifted designers but also one of the most delightful and gracious.

Several of Pamela's most striking qualities are that she is very down to earth, very witty, and very caring. By her own admission, she hardly ever says no, especially when it comes to making time for fashion-design students.

As we spoke more specifically to Pamela about her background, you can't help but be touched by her fairy-tale beginnings. Her fashion roots began, like

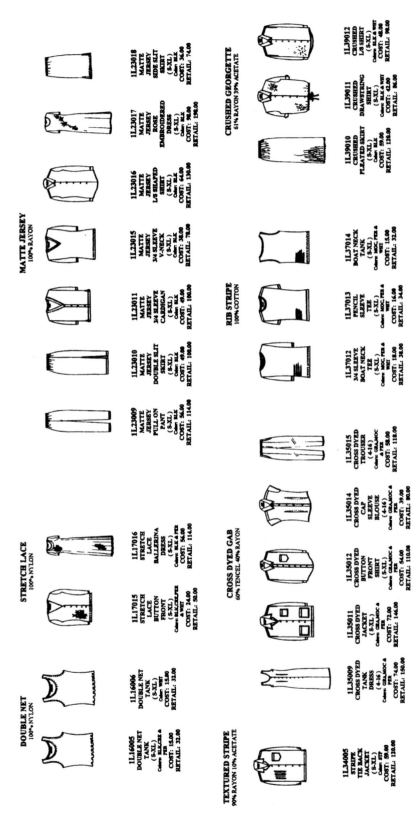

KAREN KANE LIFESTYLE
TWILIGHT 12/31/98

FIGURE 8-2 Work sheets for the Karen Kane line.

INTERMEDIATE

FIGURE 8-3 A Pamela Dennis gown, front and back.

most young women, during her middle-school and high-school years. Pamela tells of being sent of to school in one outfit and somehow coming home in another.

She laughed as she explained about her and her mother's difference of opinion on color: "I always loved black, while mom preferred the more traditional colors for young girls. . . . My poor mother would come to pick me up from school and could never find me because I had changed or modified my outfit. . . . It drove her nuts. . . . She would never recognize me!"

This passion for fashion waned ever so slightly, as it does for many, when it comes time to make the "college quest." Fashion became more of a hobby while she made college and career choices based more on her admiration and emulation of an older brother, an attorney. Somehow, her interest in fashion took a back seat. Before long, Pamela found herself a long way from Fashion Avenue, having earned a degree in Political Science and preparing to pursue a career in law.

Then providence took over her destiny. Pamela was invited to a black-tie event and discovered she couldn't find anything she liked to wear for the party. So she set off to do what came naturally—design her own gown. The result was a truly amazing divine appointment. At the event, her gown caught the eye of a photographer, who wanted to use the gown in an advertisement for DeBeers. Like any good Cinderella tale, the story ends with an advertisement showcasing Pamela's dress right in the middle of dazzling jewelry, a Chanel gown, and a Valentino gown As they say, the rest is history.

As she related this story, I could not help but be reminded of an old proverb that says "A man's gifts make room for him." Well, for Pamela this couldn't be more true. Her designs are still catching the eyes of today's arbiters of style.

Today, Pamela Dennis has her headquarters and showroom in New York. As the head designer, Pamela is still inspired by her fashion roots. According to Pamela, the secret to good designing is "I always remember I am in the service business, computers are a big factor in helping my business run smoothly. . . . But one thing I always remember, I am not any different than anyone else, yes I might have many celebrity friends. But it is not uncommon for me to frequently dine with and even exchange holiday gifts with the head of my parking garage as well. I always consider myself a servant to those I design for. . . . If you keep that in mind you will be able to live with yourself and sleep at night."

As we concluded our interview, Pamela expressed encouragement and best wishes for anyone pursuing a career in fashion design. In fact, she stressed "being persistent and staying true to what you believe." However, for our purposes, we felt her best advice came from her heart and actions, not her words.

Observing Pamela, you can't help but see that one of the best-kept secrets of fashion design is that "apron of humility" Pamela wears. The way up is actually down—that is, choosing to have a servant's heart. Remember, when you meet the clients needs, you will meet yours too.

INTERMEDIATE

After meeting both of these women, you are probably ready to see your name on a label too. However, one thing is for certain, you cannot keep your head in the clouds for long. Remember, these women are businesswomen as well as designers. So, while you may daydream about being the next great designer hold on tight to that business hat as we move on to the next important component of fashion design—sourcing. In Chapter 9 we will put into practice some of the secrets you have just discovered.

Each of these designers talked about colors and fabrics, because truly it is the fabric that sets the designs apart, and often it is the component that causes the most challenges. Fabric represents about 60% of the cost of a garment. Making sure you get the best quality fabric for the best price can often be an exercise that challenges the best of the best.

Let's take another look at our road map so we see how much further we have to go. Our next stop, Chapter 9, is about sourcing. This simply means finding all the materials, supplies, and sources you will need to design and produce your line. Then we move on to Chapter 10, where we will lay the foundation to help you keep the glamour and remove the mystery of working with color on computer. Chapter 11 is about fabric designs and prints. Take a look at the extraordinary designs. Typically what sets them apart is not the silhouette, but rather the fabrication—both color and texture. This chapter will not only provide the fundamentals, but it will also give you exercises to turn your computer into a fabric designer.

Chapters 12 and 13 are driven by several renowned textile industry firms. From them you will get a firsthand look at how to create woven and knit fabrics. Then Chapter 14 will culminate with you creating the promotion and marketing tools you will need to promote yourself or your line. With this information, if a designer has to modify a design to meet the criteria for a successful marketing mix, then he or she will have the tools and the information to make the changes. So, your design hat may be peeking out, but keep that business cap on, these chapters will lay the foundation to effectively market your own lines.

Before you go on, here's a miniglossary of more fashion marketing terms you will encounter as you move through this exciting industry!

Fashion Marketing/Design Terms

Adaptation: A fashion design or concept that has been modified from an original concept or design.

Apparel: In the broadest sense it means clothing, what we wear (not necessarily fashionable).

Assortment: Refers to clothing/garments within a classification according to such things as price, color, size, style, etc.

Avant garde: A fashion or design concept that is considered ahead of its time.

Balance: In design, this is determined by dividing a garment down the center to determine if the design is formal/symmetrical or informal/asymmetrical.

Better: The industry refers to this market segmentation as the "upper end" in price point or structure and quality.

Bottom weight: Fabrics that are traditionally heavier in weight or texture to create skirts, pants, etc.

Brand: This term can refer to a name and/or trademark that can identify a product with regard to quality, integrity, fashion value, or signature look.

Bridge fashion: Typically, this is a line of clothing priced between designer and better.

Category: Segmentation of clothing by use. For example, shirts, sweaters, blouses, jackets.

Chic: Fashion that is considered currently stylish.

Classic: A style that remains year after year with slow/minimal updates. Examples are items such as jeans, cardigan sweaters, a "little black dress," a man's Oxford dress shirt.

Classification: A grouping of items similar in nature and use. In a retail sense, this is a related assortment of items.

Collection: Also known as a group or a special line of clothing. This term is usually associated with Europe when describing high-end clothing.

Color card: A seasonal representation of yarns, fibers, fabrics, or garments that are produced.

Colorway: The name for the variety of colors chosen for a design and/or line. For example, typically the range of numbers of colors selected for a line might be three to five or five to seven.

Contractor: Firms who provide cutting, sewing, finishing or other relevant services in apparel production.

Coordinates: Items that relate and harmonize with one another by pattern, fabric, color, and/or print. These items can stand alone or be worn together.

Companion print: This term is frequently used for a line of related separates. These are often variations of patterns or prints that can be mixed and matched within the line to not only make coordinating easier for the consumer but to encourage the consumer to purchase multiple pieces from the line.

Concept board: Here is where a designer commits to paper the ideas for the next season or line.

Coordinates: Two or more separates that are made from matching and/or coordinating colors or fabrics.

Couture: The highest expression of fashion design. Literally translated, it means "high sewing." These designs are frequently considered a form of art of museum caliber and quality.

Croquis: Often a template or outline silhouette of a human figure used by designers to render. This can be an original line drawing made by the designer or a template.

Demographics: This marketing term surely belongs under fashion design. These statistics are the underpinning of any marketable design creation. These facts or statistics include the following information about a given segment of the market: age, gender, sex, race, income, education level, occupation, and housing, to name just a few. (The term *psychographics* refers to the lifestyle and shopping habits of a consumer market segment.)

Design: A unique and/or individualistic interpretation and/or version of a style.

Designer: In the world of fashion a designer can be responsible for the creation of fabric, patterns, and/or a line of apparel.

Detail: Parts of a silhouette. For example: a particular collar, sleeve, or hem.

Draping: A method of making a pattern by draping the fabric across a form or mannequin (model).

Dress form: A form in the shape of a human body. This form is often an adjustable padded shape that permits a designer to pin and drape fabric around it.

Emphasis: The focal point of a design.

Ethnic (also known as *folk*): This is a type of design or inspiration from a traditional national or regional costume.

Fabrication: How a design is made (knit, woven, other) and whether a design is made of natural or synthetic fibers.

Fad: A design or style that gains favor quickly but the duration of the favor is short lived.

Fashion: The current prevailing style used by a given segment of society.

Findings (also known as *notions*): Details including buttons and zippers.

Flat-line rendering: A one-dimensional sketch that shows specific details used in construction. This also known as a *Flat, Work Sketch, or Technical Drawing.*

Form: Acronym for Family, Occupation, Recreation, and Motivation. A simple way to keep in mind your consumers; demographics and psychographics. If you know these influences in your customers, you will always create designs that will sell.

Grading: A process of making a sample size pattern then making the pattern larger or smaller to include the complete range of sizes for a market segment; for example, misses, petites, plus size.

Griege goods: Fabric that has no finishing treatment; for example, unbleached muslin.

Hand: The feel of a fabric.

Harmony: The unity of all the elements of a design.

High fashion: (see *Couture,* also known as *Haute Couture*).

Hot items: Quick sellers, frequently reordered. They can be determined by demand in a given geographical area over another; for example, winter boots.

Jobber: The individual who buys fabric, usually in small quantities, from converters, mills, or other manufacturing sources then resells the fabric to companies who cannot afford minimums or do not need larger quantities of cloth.

Key items: Designs with high sales potential that can be driven by demand, price, geographical location of outlet, and prevailing market conditions. These items generally represent consistent sales volume from season to season. They frequently vary by color and/or fabrication.

Key resource: This can be your vendor or supplier of Griege goods or findings. Hopefully you and your product will be a key resource of a majority of retail stores.

Label: Identifying tag that may indicate the designer and manufacturer and/or the fiber content by percentage, care, and country of construction origin.

Licensing: Contracts between firms, manufacturers, and designers. For the designer, this means authorizing his or her name to be used on a product.

Line: This is the term we use to represent most of today's American fashion. Frequently, a line is a collection of styles by trims or details. In addition, this a seasonal representation of a collection of garment groupings or styles by a designer.

Line-for-line copy: Exact representation of a design.

Logo: Brand name or symbol that is identified with a designer and/or product.

Knitting: The interlooping of yarn to form fabric.

Knock-off: An industry term referring to a copy of a higher-priced design made typically with less costly fabric and/or findings and for a less expensive price.

Marker: A pattern layout placed on top of the fabric for the cutter to follow.

Market: The target customer and place in the industry that a designer will design for.

Marketing: The buying, distributing, and selling of merchandise to the consumer.

Market segment: The primary target market a line is designed to capture.

Mood board: The boards used to visually describe the mood for the line and/or season.

Off-shore producers: Companies outside the continental United States.

PDM: Product data management.

Piece goods: Fabric sold by the yard.

Primary market: The consumers to whom your design, line, or idea is marketed. This also means a supplier of raw materials such as fabric, findings, furs, leathers and plastics.

Price point: The price range indicates items and how they are priced. For example, popular (also known as budget), moderate, better, and designer.

Private label: A design produced by manufacturers for another company, which will place their name or label in it.

Production sample: A sample submitted to buyers for approval. Today, this can be accomplished by computer simulation.

Psychographics: The factors that influence a company's primary target market. Some of these factors might be attitudes, hobbies, shopping patterns, taste level, and spending habits.

Ready-to-wear: This term comes from the French *pret àa porter*. It is often associated with the higher echelon of fabrics and workmanship found in designer clothing, such as by Bill Blass or Oscar de la Renta. These items are not one-of-a-kind but are designs that do come off-the-rack, but are recognized for their style, status, quality, and fashion value.

Resource: A vendor, supplier, distributor, or manufacturer that supplies essential items.

Retro: Designs that reflect an era of the past for inspiration.

Rhythm: The repeating of lines, colors, trims, and details to create a pattern motion that the eye can follow.

Sample: A first or trial garment made from muslin or pattern paper. This may also be a computer-aided simulation.

Silhouette: The overall shape of a garment. Frequently, this is described in either geometric shapes or in alphanumeric references. Examples are the elongated silhouette, an A line or S silhouette, and a figure-8 or hourglass shape.

Sourcing: Worldwide search for the best available fabrics, findings, garment manufacturers, and production at the best prices and delivery schedules.

Specification sheet: Used by designers and firms to include detailed information about a particular item and/or line.

Sportswear: This category was made popular in the 1930s, and includes such items as sweaters, jackets, T-shirts, and skirts, to name just a few.

Style: This term has several meanings. First, it is the basic characteristics or distinguishing features of a design and its presentation. Second, it refers to a period or point in time used as the inspiration for a design. For example, an item might be said to be in the Greco-Roman Style.

Swipe: Any picture, color swatch, trim . . . anything that has given you inspiration and that you might to add to your design boards.

Target market: Consumers are segmented by their wants and needs as well as their purchasing power.

Textile: Fabric, cloth, goods, and/or stuff, but excluding findings. This term is from the Latin term for "to weave."

Theme board: Board used to convey the theme, mood, or inspiration for a product/line and/or season.

Trend: The direction in which fashion is moving.

Toile: A muslin or linen sample of a garment.

Vendor: Supplier of goods used or sold.

Weaving: The interlacing of two yarns at right angles to make cloth.

Wholesale: The selling of goods and services at list prices, which may include a trade discount. Typically, this is business-to-business buying and selling, as opposed to *retail,* which is business-to-consumer selling.

Zeitgeist: "Spirit of the Times." All designs typically reflect or mirror the times in which they were created. Just look in your closet. If you have any "remnants" of the 1980s, you'll discover a time of designs that showcased oversized opulence and/or larger-than-life shoulders.

CHAPTER SUMMARY

A good fundamental understanding of the key elements and jargon associated with sales and marketing, promotion, and merchandising are vitally important to the designer in the fashion-design process.

Successful designers will reflect on past trends, sales records, and research in order to source and satisfy the needs and desires of their ultimate retail customer.

Obviously, most designers are first motivated or inspired by color and/or by fabric. However, every successful line is based on researchable facts and business savvy, not just an instinct for the direction fashion is taking for their target market consumer. This includes taking into consideration the marketing mix: (product, price, place, and promotion) within the design process. This means taking into consideration not just consumer demographics but also consumers' lifestyles and shopping patterns and/or spending habits (psychographics).

The fashion-design process can also be driven by several other critical factors, including the availability and/or quantity or quality of the resources needed to produce the line.

Often the overall business philosophy of a design firm, especially the budget or time constraints they place on the designer, will have an impact on the design process. Successful designers are cognizant of each of these relevant considerations within the complete process of taking fashion from concept to consumer.

CHAPTER 9

Re-"Sourcing" the Net: Locating the Right Fabrics, Findings, and More

Focus: The Business Side of Fashion (Sourcing and Researching Data via the Internet as Well as Using Other Traditional Resources)

CHAPTER OBJECTIVES

- Understand the role of sourcing in today's global fashion world
- Comprehend the basic operations of the Internet, including related jargon
- Obtain an on-line e-mail account
- Access and utilize the Internet to research and source for fashion
- Conduct a basic Boolean search on the Internet
- Compare and contrast the Internet to traditional research or other sourcing methods
- Examine the basics of downloading files

TERMS TO LOOK FOR

boolean	forecasting	nesting	sourcing
bot	home page	network	stop words
browser	hyperlink	path name	URL
channels	hypertext	protocol	virus
domain	Internet	search engine	www
download	Intranet	search engine math	zipped or compressed files
e-mail	ISP	server	
e-tailing	meta search engine	spiders	

So, are you ready to send your designs to the manufacturer? By now you've had a pretty good look at what the computer can do, and you probably are developing a nice line. But, even though a collection looks exciting on the designer's work board, you still are not ready to move to production. In fact, you actually now need slow down the design process and take a few minutes to put on your business hat.

Often as designers are creating lines, they find a need to make adjustments to a design. The reasons can vary, but changes are always made to ensure the ultimate goal—to produce a product that consumers will buy. That means the designer needs to know:

- How much is the consumer able to spend?
- Even more important, how much is the consumer willing to spend (this will include a bird's eye view of what is happening in the economy)?
- What are the key fashion trends, including, but not limited to, fabrics, colors, silhouettes, and trims?
- How can all of this be produced competitively?

This is all done by a process known as sourcing. Sourcing is finding the right materials, colors, and manufacturing centers and learning about consumer habits (this aspect of the design process has always been a part of a designer's job). Even though a designer would love to just create, the most successful designers realize the role merchandising plays in their success. From a sales and marketing point of view, this means that a designer should know about the overall healthiness of the economy, including the lifestyles and buying power of their consumers. From a production point of view, designers need to be able find the right textile mills to work with, the key trade shows to attend to search for well-priced findings, as well as choosing the right manufacturers to produce the line. A successful designer knows that finding the right sources has to go hand in hand with the keen eye of design.

Most designers don't try to handle this alone. They look for help from both technology and their design-team members. With the challenges inherent in competing in today's global marketplace, computer technology has made sourcing quicker, sharper, and accessible to all. With the help of production managers, findings buyers, and fabric buyers, designers must don their business hats, roll up their sleeves, and work quickly with their design team to gather the information they need.

The key here is knowing how to access the information. Since the information is already available to everyone at lightning speed, sharp decisions have to be made to maintain a competitive edge. The bottom line is that everyone on the design team will need their computer to quickly gather the data that will aid the decision-making process.

You'll soon realize that the computer will provide you with information that at one time could be gathered only through long hours poring over books and publications, expensive consultants selling competitive intelligence, and costly buying trips overseas. In this case, the brain center single-handedly has created global integration, and made us all research analysts.

LET'S DIG A LITTLE DEEPER TO UNDERSTAND THE CONCEPT OF SOURCING

In the fashion industry you will often hear the word *sourcing,* which means finding the raw materials and manufacturing facilities to develop lines and promote effective selling techniques that are in line with the consumer market being targeted. If you spend time talking with a designer, you will find that their focus—the visions and designs—are strictly on the materials and findings. They are always looking for unique fibers, textures, colors, and trims. If you talk to the production/business manager in the firm, you will hear about finding the most productive manufacturing facilities and targeting in to the consumer. If you

talk to the sales and marketing department, their focus is on the most effective tools to sell to both the wholesale and consumer customers. Understanding and incorporating all of these concerns via the computer and the Internet is the key to success.

The fact is, marketing is already thinking *Internet*—one of the hottest buzz words in e-tailing (also referred to as e-commerce) for marketing and retailing to customers online. So believe us when we tell you that you can't avoid using this as another tool for sourcing. It is only natural that we now concentrate on this topic of sourcing and explain why it is so important at this stage of the game for a designer.

Is Sourcing Used Only after the Designer Has Created a Line?

No! Sourcing is a technique that is applied in all facets and stages of design. Once you enter the design industry and are exploring fields of interest, you will find that you can go in many directions. Your focus can be on

Textile design
Garment design
Production
Marketing and sales

Do All Companies Source?

Yes! Frankly, it does not really matter where your expertise lies, because your creative skills and abilities will land you in one of the following places:

- You may be working as an independent. That means your own name is on the label, just like Tommy Hilfiger or Donna Karan. Although being an independent designer may be your dream, getting some on-the-job experience is very important when you are starting out, so it is more than likely that you will be working with a design team.
- You may work for a major manufacturer, like Levi's or Vanity Fair. Here you will work with a number of design-team members, together creating a product line that is representative of the company image.
- Design opportunities may surface with the leading retail teams, developing and designing national brands such as INC for Macy's or The Arizona Jean company for JC Penney. Or you may ultimately work to develop products for a well-known private label company such as the Gap or Victoria's Secret.

It doesn't matter where you hang your design hat. It is important for us to emphasize that the business/operations teams is going to be consumed with finding materials that are competitively priced so that the design firm can offer the customer the best value at the most competitive price. Everyone in the design world knows fabrics generally are the most costly factor in the total cost of a garment. And designers want to make sure you have found the best fabrics and trims to use—best in terms of both quality and price.

Who Will Be Doing the Sourcing?

You will! No matter where you work in the design cycle, expect to be a contributor. Everyone in the fashion industry today will tell you that at some time in their career they have to get information—maybe on fabrics and trims; maybe on quotes for manufacturing; or maybe on the consumer. The subject doesn't matter, you just need to know how to do it, and even more importantly, you need to do it as quickly as possible.

How Is Sourcing Done?

Even though the Internet has been around for about twenty years or so, it has been only in the past decade, with advances in technology systems, that the Internet has been useful to businesses. Until that time, did designers source? Of course they did, but it was all done manually. That meant a great deal of time was spent researching books and periodicals at the libraries, relying heavily on trade publications and industry-driven trade shows.

Further information was also gathered by conducting surveys, working with consulting firms to learn about economic and consumer trends, and taking costly overseas trips to find textile companies and manufacturing facilities.

Did Sourcing Work?

Of course it did, because everyone was conducting their own searches in the same way. Designers were producing lines three to five times a year, with everyone contributing. Today, however, with the brain center acting as a survey center, a consulting firm, and even an overseas travel agency, the time to gather the data has decreased dramatically. Not only are designers able to react more quickly and more accurately to their consumer demands, they are also able to do so with fewer and less costly expenses.

The bottom line is that with the computer, a designer can produce up to 6 to 10 lines a year, and achieve the true basic principle of marketing, which is to create customer satisfaction that will generate repeat business.

Let us explain that a bit more. The principles of marketing generally focus on the four P's—price, place, product, and promotion. But, true marketers will tell you that the real emphasis is not on the four P's, but instead on the ability to create exchange (dollars for product) with customer satisfaction. That means not only have the customers bought the goods or services, but they are satisfied and will return for more. If a designer can consistently satisfy a consumer and give them new product lines each time they return to purchase, this will increase sales.

In the past, even though designers and manufacturers provided the consumer with satisfaction, they didn't always have something new or a bit different when the consumer came back to shop. Although consumers were disappointed because there wasn't anything new, they returned to the store later because every designer was working on the same time frame.

However, with the technology of the 21st century, which enables designers to produce twice as fast as before, the consumer does not have to leave a store empty-handed or throw a catalog away, because there is always something new. Competition has become fierce, and the computer has been the reason. So let's take a look at the role the computer plays in sourcing.

SOURCING AND THE COMPUTER

It is probably important to start off by saying that the computer does not do the sourcing. People do. People are using the Internet services that need to be accessed through computer terminals. To know exactly what the Internet does and how it works is a topic that fills countless books in the marketplace today, and those books will continue to change as the technology of the 21st century continues to develop. We are not here to teach you everything about the Internet. Instead we want you to understand the basics, as well as how the computer and the Internet can help you meet the demands in the fashion cycle.

What Is the Internet?

The Internet, often referred to as the Net, is a worldwide network of computers. Consider it like a giant telephone system that allows people to communicate no matter

where they live. How effectively you can speak to someone else will depend on the equipment you own. But, generally speaking, whether your computer is a state-of-the-art high-speed system or even a few years old, the results will be the same. You can be connected to the global marketplace and communicate with people worldwide using a common language.

Is there a difference between the Internet and Intranet? Yes, Intranet typically refers to a network of computer users within an organization who exchange messages internally.

What Is the World Wide Web?

The World Wide Web, which you see often abbreviated as www or even referred to as the Net, is a huge interconnected library. What the Web does is connect all the people who are on the Internet and provide an easy way for users to gather information.

The Internet offers a variety of services to the consumer (including you, the fashion designer), such as discussion groups, file transfer, database resources, and e-mail. As you move around this Web, often you will hear the term *surfing*. This means moving around from spot to spot talking to people, gathering data, and generally exploring new areas of interest. The information you find can be intense (economic news, stock quotes, company profiles) or entertaining (game rooms or chat rooms, where you just sit back and talk to someone, with the computer keyboard serving as your input device). Or you may even find the Web to be a great substitute for Uncle Sam's postal service if you sign yourself up with an e-mail address, which allows you to talk back and forth to people and to even send people files of information of data.

You may wonder why would e-mail (electronic mail) be important to a designer? Believe it or not, as manufacturing firms tend to spring up in developing nations worldwide, e-mail is the most cost- and time-efficient method to transfer information. With the click of a mouse, a pattern can be e-mailed from a U.S. design firm to their Costa Rican manufacturing facility. That one click saved someone from packing the patterns in a tube, running to the mailbox, paying for the shipping costs, and waiting for the pattern to arrive in Costa Rica!

What Kinds of Information Should the Designer Have?

Gathering information to develop a line can be overwhelming. In order to keep this simple, we are going to break this discussion into two basic areas.

1. We are going to provide you with a snapshot of what you need to research. Along with a brief overview, we will give you some suggestions and starting points on where to find this information both in electronic format and hard copy if possible.
2. We will give you some practical steps on how you can access and/or download the information you gather from the Net. Yes, this is a technique unto itself. Sometimes there is so much data, and such good data, that you might want to keep the files on your own computer's hard drive rather than searching each time you need the information.

One last tip before we start this process. People often ask, where do I start? A quick hint is to always look at the past. Even though new and exciting data are available every day, look at what made past lines successful—what fabric mills you have worked with, what companies you know, or what trade shows offer you the best buying/selling opportunities. Conversely, learning what caused problems can often be the best data you can gather, so don't be shy about digging into past sales or product lines. Learning about successes and failures often will serve well as a starting point for a designer. So, let's drive forward to determine how the brain center can focus your research.

INTERMEDIATE

HOW THE BRAIN CENTER CAN PROVIDE RESEARCH TO CONNECT VISIONS, DESIGN, PRODUCTION, AND SALES/MARKETING

Visions

You learned in Chapter 1 that designers begin with a vision. Specifically, they want to target a special consumer group, focusing on their likes, needs, and buying power with colors, textiles, and products that are exciting and new. Although you think of visions in terms of colors, fabrics, and trends, it really starts out with the healthiness of one's pocketbook. Simply put, a designer has to know what is going on in the world. So first we are going to address the economy and the role the consumer plays in the economy.

Economic Research and Consumer Buying Power

Why Researching for Data in This Area Can Help You

- As a designer you really need to know about the economic healthiness of the world. You need to know how people are doing financially as they make decisions on purchases, whether they are purchasing homes, cars, or clothing. From a design viewpoint, if economic times are on a downturn, the garments you create should reflect that. Your ideas and visions may focus on simple lines and durable fabrics during practical times. When economic times are booming, colors, shapes, and textiles may reflect bolder and more exciting attitudes.

- From a production viewpoint, finding the most technically appropriate and economical manufacturing facilities can help make or break a line. If a line is produced at the best price, you give it to your customer at a smart price for the economic times. Ultimately, the consumer is satisfied. Therefore, you need to have a good look at what is going on in both the domestic economy and the international economy, because they will let you know where is best to produce your lines. Manufacturing facilities are popping up in emerging economies every day, as technology creates greater shifts from hand needlework and automated production.

- From a sales and marketing point of view, simply put, you need to know how people are spending their money and on what. The economics of the world can best be interpreted by consumers' daily buying habits. And before you even think about designing a line, you have to think about the consumer and what and where they want to spend their money. Here is a list of the best places to start to find that information. Before you complete this chapter you will be accessing many of these resources on-line.

SUGGESTED SOURCES FOR INFORMATION	WHY
Standard & Poor's Trends and Projections	Strong economic overview
Standard & Poor's Industry Surveys	Identifies industry growth/concerns
Consumer Buying Guide	Shows how and where consumers are spending their money
Government resources	Numerous resources provide information, such as economics, tax and tariff information as well as statistics on companies, banking, and consumers.
Daily newspapers (e.g., the Wall Street Journal)	Illustrate consumer spending habits

Skill Level: Intermediate

| Business periodicals (e.g., *Newsweek, Time, Fortune*) | Discusses economic shifts and issues worldwide |
| Featured authors/consultants/books (e.g., *Faith Popcorn's Clicking*) | Provide researched concepts on consumer attitudes |

Design

Why Researching for Data in This Area Can Help You

- As a designer, fashion trends and textile research are vital for creativity. Once the designer really gets to know the consumer, the next step is probably the most exciting. It is at this time that designers start to gather their visions and inspirations and match them with sources that will provide colors, fabrics, and design tools such as graphics, clip art, and color services that will enable them to produce exciting and innovative products that the consumer will appreciate 18 to 24 months in the future.

- From a production point of view, the production manager has to be sure that the fabrics and findings the designer is targeting are available within guidelines of quota restrictions, during the time the materials are needed, and even more importantly, to know the landed costs of materials.

- From a sales and marketing point of view, this team must clearly understand the designer's vision and be able to develop a strong strategic marketing plan that will be unique and exciting for the consumer. This marketing team has one of the most difficult jobs—they have to build the bridge between the designer and customer. And, if the sales and marketing team does not clearly understand the colors, the fabrics, or the silhouettes, they will never successfully pave the road for the consumer to buy. The line will have no direction or excitement, and it will simply blend in with every other competing product. Ultimately, sales will occur by chance rather than by the consumers' demand for the new styles and trends the designer has just presented. So it is only natural that you and the design and marketing team will be looking to the following sources for help.

SUGGESTED SOURCES FOR INFORMATION	WHY
Leading trade publications (e.g., *Women's Wear Daily, Daily News Record (DNR), Bobbin, Knitting Times*)	Identify key trends, textile reports
Leading fabric councils and firms (e.g., Cotton Council, Wool Bureau, Burlington Industries, The Fiber Society, The Textile Institute, American Apparel Manufacturers Association (AAMA), Computer Integrated Textile Design Association)	Identify fabrications and their use, care, and innovations
International Trade Show Directory	Locate domestic and international trade shows for textiles and findings
Leading fashion and color services (e.g., Promostyl, Tobe, Hue Point, Bill Glazer, wgsn-edu and Associates)	Focus on color projections, fabric, and fibers
Leading books on costume and costume history	Details, fabrications, and silhouettes from the past often provide inspiration for lines in the future.
Leading industry magazines/publications (e.g., *Bobbin, Textile Suisse, Knitting Times*)	Provide trend projections
The Arts, including libraries, theatre, and museums	Provide a plethora of inspiration for the designer.
Seminars and workshops	These are frequently a great place to mine for information.

Production

Why Researching for Data in This Area Can Help You

- As a designer, even though the focus is on creating garments that make men, women, and children look attractive, a designer also wants to be sure that the way the garment is mass-produced maintains the integrity, fit, and durability of the original design and sample. Therefore, good designers confer with the production department to ensure the quality production of a line.

- From a production point of view, sourcing for information is vital in two areas: equipment and manufacturing. It is essential for the production manager to know about the state-of-the-art equipment for both design and garment construction. From a business point of view, the production manager knows that a well-thought-out investment in technology will produce a much more profitable garment in the long term. Therefore, they must be up to date on the latest computer systems and programs so they can maximize pattern making/grading and marker making output. In addition, they will take a firsthand look at the type of equipment needed to produce an item. Specific industrial machines cut construction time in half, and time saved is money earned. Therefore, the production manager must be on top of all new equipment and changes.

- Along with knowing equipment needs, a production manager needs to focus on the actual manufacturing facility. With manufacturing centers worldwide, the production manager must assume the role of an international trader, identifying overseas taxes and tariffs, quotas and customs processes, and shipping times and freight-forwarding companies.

- From a sales and marketing point of view, with the U.S. government cracking down on unsafe labor practices, it is so important to focus on where the product is being manufactured, and to emphasize quality of construction in the sales literature and marketing campaigns. Going hand in hand with promoting quality construction and care, the sales and marketing teams will want to promote the products that meet U.S. marketing regulations, which enables consumers to identify fibers, country of origin, a legal identification code (which helps consumers identify the manufacturer), and the international care symbols.

This part of the process can seem intimidating to the beginner. However, when determining the direction fashion is moving in, management will not always buy into your gut-instinct; several well-researched facts will help support your insights, and below are listed some of the best places to start.

Suggested Sources for Information	Why
Women's Wear Daily Buyers Guide	To identify manufacturing companies
Brands and Companies by Gale	Title is self-explanatory
Dunn and Bradstreet	Leading source on companies
World Trade Center	To connect international suppliers and manufacturers.
U.S. government (e.g., GIDC— Garment Industry Development Corp., Department of Commerce Office of Textiles and Apparel, The International Trade Administration, BEM/Big Emerging Markets, the World Bank, Global Export Market Information System, ITC (International Trade Commission))	All the latest statistics and policies for trade and tariff information, as well as labor information/regulations.
Thomas Registry	List of many of the leading small and large manufacturers.

Skill Level: Intermediate

Leading industry magazines/ trade publications	To read about leading equipment and manufacturing firms.
Press kits, annual reports, sales materials	To learn about new technology from leading equipment manufacturers' systems.

Sales and Marketing

Why Researching for Data in This Area Can Help You

- As a designer you know that the consumer is buying more than a product—they are also buying an image. Therefore, it is up to the designer/design team to not only know when the key designer markets, fashion shows, and industry releases occur, but to make sure that you as the designer are accessible to your consumer. You and your firm must promote print/broadcast ads, special events, and support public-relations activities that will reinforce the image of your collection/line.

- From a production point of view, the focus is strictly on deadlines, deadlines, deadlines. The last thing a production manager needs, as he or she juggles material and product shipments around the world, is not being able to deliver on time. A designer may have spent 2 years in the development of a line; if the production manager cannot ensure the prompt and timely delivery of a product, the line is a failure because it did not get to the consumer at the right time. Continuing to research tariffs, quotas, and shipping, just as the production manager began in the production process prevails as the production manager's key responsibility.

- From a sales and marketing point of view, this research is essential for effective promotion. Members of the sales team will need to research the development of strong sales tools; advertising strategies, including Web page and catalog design; companies to sell and promote products; key brand competitors and key retail store competitors. Finding insights or strategies for the best way to promote the line can be crucial. Below is a list of where you should consider starting this research.

Suggested Sources for Information	Why
Leading trade publications (e.g., *Women's Wear Daily, Daily News Records (DNR)*)	Identify key competitors; advertising and promotion techniques
Leading advertising publications (e.g., *Advertising Age*)	Review advertising campaigns and leading advertising/public relations firms
World Trade Center	Appropriate freight-forwarding companies, international sources and affiliations.
Sheldon's	Locate retail stores and buyers and resident buying offices. This is a list of useful US retail stores (state-by-state).
Ward's	This is a directory of companies and product lines.
Hoover's	Index guide to leading companies. *Hoover's* publishes several books each year Ex. top 500 companies, top private companies. Both are in capsule format on the Web.
Thomas Registry	List of both small and large manufacturers

Now, where do you find all of these resources? As we already said, these data are available in hard-copy format, but let your brain center take over and make your life a bit easier. Finding these data on the computer gives the designer an instant library right in their own offices. It is as easy as clicking the mouse.

Re-"Sourcing" the Net: Locating the Right Fabrics, Findings, and More

An Internet Primer

There are a variety of ways to search for the same information using the Net. However, in order to access this information you will need to understand a few pertinent terms associated with surfing the Web. These terms and phrases will enable you to search more effectively and efficiently for information. We have included several visual aids to help you make your way around.

This is by no means the definitive explanation of how to do research on the Web. It is just some terms and a quick tour followed by a list of some great Web sites you should check out as you begin your journey on the information superhighway.

To start, you will need a modem on your computer attached to a phone line. From there, you will need a Web browser (i.e., a software tool to enable you to look at the Web) and/or server (also known as a ISP [Internet service provider]) to connect you to the Internet.

There are two important features to keep in mind when selecting an ISP. The first is rates—Do you have access to local numbers, or will you be using long-distant charges to go-online to surf the Web (which translates into more money spent)? The second consideration is accessing speed and modem speed. You probably want your ISP to support at least 56 kilobytes per second.

Once you log on to the Internet, you will be able to locate a potential source for fabric or finding by typing in the correct Web address. Frequently, you will find that you must follow a particular protocol for typing in the address. For example, you will be expected to type into the Web-site address line the following information—http://www.thecompanyaddress.com.

Frequently, you maybe given an address that looks something like this: http://www.seflin.org/aifl/aifl.edu.htm. What does all that mean? Well, the first portion of the address or the http:// is the protocol of the site. The next segment of the address (www.seflin.org) is the domain portion of the address. The remaining information (/aifl/aifl.edu.htm) represents the path name of the address.

Simply put, have you ever dialed an international phone number? Think of how you go about dialing your family in Mexico or Japan or wherever. All those numbers you dial represent the country, the city, and even the street they live on as well as their specific apartment. It is very similar for using the Internet.

The information at the beginning of our example is also referred to as the URL (uniform resource locator), followed by the name of the Web site and or company, which is followed by a period and the initials *org*.

Sometimes when you type in the address you will discover that the address for the company is case sensitive. This means you will be required to avoid spaces, and/or to use capital letters. Other times, the last three characters of the Web site might not be org (which stands for organization). There are several other frequently found extensions, such as *com*, which represents the largest number of extensions, designates a commercial site. The letters *edu* are used for educational institutions, *net* for network, and *gov* for the U.S. government. There are also extensions that represent a specific country, for example *fr* for France, *jp* for Japan, and *uk* for the United Kingdom.

Several changes have been proposed, including the use of several proposed new extensions:

firm = business
shop = goods for sale
web = Web-related information
arts = cultural/entertainment
rec = recreation
nom = individuals
info = information

Once you have typed the correct address, you will be taken to the home page (or starting point) of a company's Web site. The layout and contents of a given company's home

page may vary. Most sites are multimedia (sight and/or sound as well as some with animations), with interactive hypertext and/or hyperlinks. (This is when the cursor changes to indicate more information on that subject and often links you to either another part of the company's Web site or to a related Web site of another company.) In many Web pages there are also items called hypermedia, which are embedded graphics.

The best way to get the feel for a site is to move your mouse around the screen and look for either a change in the cursor (for example, from an arrow to a hand) or to look for text that is a different color from the rest of the document. Many sites are very user-friendly, while other sites will clearly instruct you to simply click here to get more information.

Screen Layout Commonalities

The actual layout for your Internet provider or carrier is very similar to the main menu bar options with which you have been working. Figure 9-1 is a sample of an America Online menu bar. Note the familiar-looking title bars, menu bars, scroll bars, and navigational toolbars or icons.

In fact a close-up of the main menu options such as file, window, select or edit, view, help, print, and font, as well as navigational aids in the form of icons called browser buttons such as arrows for going back or forward a page or site are very similar to the screens you have been using up to this point.

Before we move on to another practical aspect of having Internet access, let's review the elements of the Net:

- Most sites will include title, menu, status, and scroll bars
- Common universal icons
- Actual Web page
- Hypertext and/or hyperlinks
- May or may not have advertising banners, multimedia functions
- E-mail (electronic mail)

E-Mail, or Electronic Mail

As we stated earlier, the Internet is about sharing information; and the most popular way to connect people and computers is through electronic mail. E-mail is the fastest-growing method of sending information in today's fast-paced world of fashion. This kind of connectivity is changing the way we do business. Using e-mail beats the more traditional means of sending interoffice or other business-to-business communication. The advantages of e-mail are:

1. No more miscommunications—everything is in writing
2. No more waiting or phone tag
3. Immediacy
4. No costly phone interruptions, which diminish productivity
5. Less expensive to send files, graphics, or other types of correspondence

Frequently, you will be provided with an e-mail account either by your school or the by the company where you work. E-mail is like a cross between a telephone, an answering machine, and a mailbox all in one. You can send and receive a variety of messages. You can have multimedia-style capabilities within your system—you can construct and

FIGURE 9-1 America Online menu bar.

send everything from a message or letter to an entire file that could include text, graphics, or digital images.

Often your browser will also provide you with free e-mail. To access e-mail accounts and related options is simple. In Figure 9-2 is a basic blank page for sending an electronic letter as well as what typed information looks like using a basic e-mail account on one of the more popular ISPs, America Online (AOL).

Figure 9-3 is a typical screen for adding attachment files. Attachments are files that you send from your computer to another computer. This process is referred to as uploading. When you receive an attached file, it is called downloading. Downloading is not exclusive to e-mail. Therefore, we will go into greater detail on this concept and the process of how to perform it later in this chapter.

But what if you don't have an e-mail account? Obtaining an e-mail account and sending e-mail to another computer is easier than you think. We will begin by helping you to obtain a free e-mail account.

How to Obtain a Free E-Mail Account

"Did someone say free? *Free* is my favorite four-letter word! If you are a student who already has Internet access, try logging on to one of the larger search engines that provides free e-mail accounts, such as Yahoo.com, Hotmail.com or BIRDMAIL.com. There are plenty of search engines and other sites that offer free e-mail accounts. Try going to http://www.birdmail.com and follow the directions on your screen for opening a free e-mail account. (We strongly suggest that you have two e-mail accounts, one for business purposes and one for personal.) When you request your e-mail account, be sure to follow all the directions completely, fill in every box completely. That old "Simon Says" rule is really in force here—if you don't fill in the information properly, the site will not respond and grant your request.

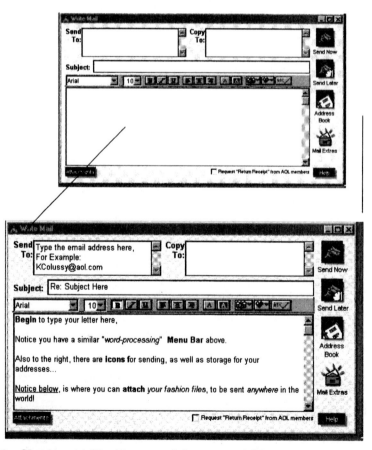

FIGURE 9-2 Blank and filled-in e-mail forms on AOL.

FIGURE 9-3 Form for attaching files to an e-mail in AOL.

When selecting a log-in name, keep it professional for business. We recommend that you use your name or a professional name that will be recognizable to your clients. Trust us, your client will not know who X-69 is, so keep the funky names for your personal account.

Make your password one you can easily recall, perhaps the name of your pet. (We suggest you avoid using your Social Security number for security reasons.) When you get to the field or empty text box that asks for the name of who referred you, feel free to tell them you were referred to them by us. In fact why not make your first e-mail to me? Write me at kcolussy@birdmail.com or KColussy@aol.com. Be sure to tell me who you are, where are you studying, and whether the book is helping. Just like you, I love getting mail.

Finally, don't forget to use you "net-iquette" when sending e-mails for business. Net-iquette is slang for corresponding properly on-line. This means showing some prudence and discretion when writing and sending e-mail. Never send anything you may regret later. Also, what you send can be considered contractual in nature, so please beware. You never know who has access to what you send. E-mail can truly make your life much easier if you use it wisely. (In addition, you may wish to consider making a file folder for storing e-mail for which you wish to keep a record.)

Net-iquette can also involve showing emotion in your correspondences. When sending e-mail, sometimes you may wish to convey to your reader excitement or emotion about a particular subject. One way to show enthusiasm or more of your personality within your correspondences is with symbols. Naturally we have included several of the favorite symbols used in e-mails just for fun.

Net-iquette

Symbol	Meaning
:)	I am smiling.
8)	Wearing glasses while smiling
0:)	Wearing a halo while smiling
;)	Winking and smiling
(^-^)	Chuckle
:(Unhappy
:0	Really unhappy
:O	Shouting
I - o	Snoring
:-D	Laughing
>:-(Really mad
%-)	I think I have looked at my computer too long!
:-&	I am tongue-tied or speechless!

Re-"Sourcing" the Net: Locating the Right Fabrics, Findings, and More

INTERMEDIATE

:-/	Huh?	
:"(Crying	
*<:-{)	Ho Ho Ho	
=):-)	I'm so cool in my top hat!	
:1	Undecided	
	\0/\0/\0/	Hurrah!
:-X	My lips are sealed.	
=:-)	Cool hair	
{:-)	Bad hair	
:-()	Mustache	
<'}}}><	Blessings	
----<----<--<({@ ----<----<--<({@ ----<----<--<({@	Roses	
*(\ *** /)* *(\ ⌣ /)* *(_/11_)* */___*	Little Angel	
(****/) (__/) (\()/) (/ \) (/\ /\) / \ () ~~~~	Really big angel!	
:-#	Braces, but still smiling! (Or, my lips are sealed!)	
^^	Chuckle	
BTW	By the way	
FYI	For your information	
FWIW	For what it's worth	
TT	TaTa (bye)	
IMHP	In my humble opinion	
TY	Thank you	
CU	See you!	
FAQ	Frequently asked questions	
ALL CAPITAL LETTERS	means "shouting!"	
Spam	Junk mail	

These are fun and really add life to your e-mails.

Channel Surfing and More on the Net

Now you are asking, where can we go from here? The alternatives are amazing. You can shop for fabric and findings, read up on the latest in fashion trends, send your ideas to the producer in Hong Kong, or maybe book a flight for a trade show you wish to attend. You can even send a friend a free animated greeting card, all with a click of your mouse. How? By logging on to your Internet browser.

216

Skill Level: Intermediate

FIGURE 9-4 Channel selections on AOL.

Your browser may provide you with a variety of channels from which to choose. Channels are sites that are categorized by topics such as shopping, sports, weather, and travel (Figure 9-4). However, most channels are geared to the retail consumer. So, what about wholesale shopping alternatives?

We will be showing you other ways to access this information as well as how to do other types of research either from your computer at home, at school, or at work. Most new fashion designers don't know where to begin. They may not even know a list of fabric companies, let alone their Web-site addresses. So where do you look? Or better yet, how do you look on-line?

Search Engines

There are a number of different vehicles we will be using for your research. These vehicles are called search engines or databases. Search engines are designed to help you on your quest for the perfect fabric.

There are several types of search engines. Most are directories or databases of information broken into categories. Most search engines have dual functions of database and advertising medium. According to the Microsoft home page, search engines can be categorized as

- Premier providers, such as the more popular Web search engines: AltaVista, GoTo, Infoseek, Lycos, and MSN Web Search.
- People and business, for names, e-mail addresses, phone numbers, mailing addresses for people and businesses: BigFoot, InfoSpace, MSN White Pages, and WorldPages.
- Full-web search engines that search every word on every page: Excite and Northern Lights.
- Directories and guides that categorize and review indexes to Web sites: LookSmart, NetGuide, Yahoo, and MiningCo. (now known as About.com).
- Newsgroups that search and participate in usenet newsgroups on the Web: DejaNews.
- Specialty, which specialize in services and reference information on the Web: Encarta, Euroseek, Yack, Corbis, MapQuest, Roget's Thesaurus, and Dictionary.com. (The above information was obtained directly from the Microsoft home page on

June 8, 1999 (http://home.microsoft.com/search/lobby/searchsetup.htm). Later in this section we will provide you with a more complete list of all the major search engines for you to review, preview, and add to your favorites.

We highly suggest you add the Microsoft Web site as a bookmark or favorite Web address for future reference.

When it comes to searching for the location of where and how to add a bookmark or favorite Web site, you will discover that this option is typically located on the toolbar of your ISP. For example, in the case of AOL every time you go on-line to a specific Web address, you will find a small icon of a red heart at the top right of you screen. This red heart can be dragged and dropped into area referred to as Favorites.

Once you have logged on to a particular Web-site address, you will soon discover that there are other portions of your screen you will want a better understanding of. As you begin to navigate around the screen there are several items that are optically vying for you attention. Often, the first thing to grab your attention will be headlines or banners. Some of these banners will be directly corresponding to the site you have logged on to, such as the title of the company or the company's distinguishing logo. In fact, many newcomers doing research on the Web often confuse an advertising banner as part of the research process, when it is not. Frequently, the ad will appear in a text box or banner format instructing you to "click here." But do not get sidetracked. When locating and navigating any search engine, you must be familiar with the terms and formats used in order to access the information you want.

Let's begin to explore this process a little closer. Obtaining information is often posed in the form of a query (question). Here, more than ever GIGO (garbage in garbage out) is what you will get if you are not paying attention. For example, as you begin to navigate the layout of the home page of a given search engine, keep in mind that some fields are actually advertising banners or hyperlinks trying sell you something. If you select one of these by accident try using the back button or home page icon. This is similar to using the undo icon—it will simply get you back to the previous step (or in this case, the previous screen).

Another consideration when using a search engine is that some are case-sensitive. Many search engines require you to phrase your request in a particular fashion, such as a group or word string. Often a search engine's queries can differ in the way you are required to input your request. The secret is don't panic or become frustrated and overwhelmed. The entire search process can be similar to having a conversation with the computer. You may sometimes find that you must rephrase your question in order to obtain the information you want.

In fact on several search engines we noticed a great option that will help you to conduct your search—the ability to use different foreign languages. This is a blessing if your native language is not English.

It may be the case for you or your client that English is not your primary language. This can really be a stumbling block when attempting to use even the simplest word to express what you mean. Let me give you an example: Imagine using the English word *dress,* when what you meant in Spanish was *traje* or perhaps, *vestido de noche,* or *de gala* and not *vestido* or *bata.* For those of you who speak Spanish there is a big difference right?

Believe me, you can have trouble even if you *are* speaking English. Here is the same example in English. Perhaps you are using the word *dress* when what you really meant was an evening gown (or eveningwear) or perhaps the term *after-five.*

It can be very confusing, but it doesn't have to be. Just like you would take the time to find another way to convey your message with the spoken word, you may be required to take some time to request your information using several different methods in order to get the results you desire. Now you can see what we mean, you may need to think before you form your query.

There are several other methods used to conduct Internet research. The first is called doing a Boolean search or using logical search operators. The second method of research method employs the use of symbols and is called Search Engine Math.

We can just imagine what you are thinking, "Oh great now they expect us to be librarians too!" Not, really. But we will be taking some advice from one.

A Boolean search incorporates a logical inclusion or exclusion of words between other words to assist in conducting your search. You will be using words such as AND, OR, NOT, AND ALL, OR ANY, and NOT EXCLUDING and wild cards (*) to broaden or narrow your search on a particular subject or topic. Simply put, there are several ways for you to use these operators to search for answers on a given subject.

Perhaps you need to do research on costumes from the Italian Renaissance for your Spring bridal collection. How would you use Boolean operators to begin your research? You might start by asking the search engine to begin with Italian OR Renaissance.

The example in Figure 9-5 is a set of Venn diagrams representing the Boolean operator "OR." Circle "A" represents Italian and circle "B" represents Renaissance. By using the word OR in our query the results would give us literally everything that had the words Italian or Renaissance in it.

Obviously the use of the word OR in our query would make our topic far too broad in scope. In Figure 9-6 you will clearly see by using the term "AND" the results would be far more useful.

Next, Figure 9-7 shows the results of using the Boolean operator "NOT." The term NOT further excludes results.

Another Boolean term useful in conducting research is the term "NEAR." Near implies that the word-string used in a given query will be near one another with a document.

Typically the nearness of the words used are found within 10 to 25 words of each other depending on the search engine used. Nesting is another method of refining your search, this is accomplished by the use of parentheses around your word-string. This will ensure the words are used in conjunction with one another and will be found near one another within the same document.

Finally, in Search Engine Math the terms AND, OR, and NOT are replaced with symbols of plus signs (+), used to broaden your search, minus signs (–) to narrow your search, or quotation marks(" ") to refine your research.

The number of results from a given search engine are then ranked by several methods. The first is by Keyword or Key Phrase. This refers to the amount of unique terms of phrases within a document used to describe it's content. Depending on the search engine you use the results may vary. A Meta (many) search represents a search engine that utilizes several search engines simultaneously to conduct your query. There are several search engines which are called Bots or Spiders in short because the search was conducted by a robot for keywords and phrases. All search engines compile, sort and analyze data.

While results will vary, I have found that typically when using a Meta Search engine sometimes more—is just more. The quality of the results is not necessarily better. Frequently it is not just "how" you conduct your research but "where." It will not take long for you to discover some of the best databases for information are located within web sites that share similar interest or topics.

Don't forget when using the Boolean operators be sure to type the words, AND, OR, NOT in all capital letters to ensure the best results. In addition when it comes to proper nouns, always capitalize them and check your spelling. You may have wanted information on a Chanel suit, but a misspelled word gets you Channel. Ugh!

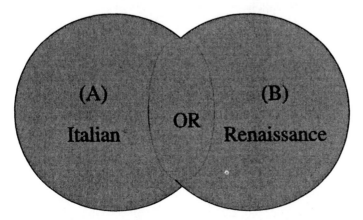

FIGURE 9-5 Venn diagram, "OR." Results will be everything in A and B.

I N T E R M E D I A T E

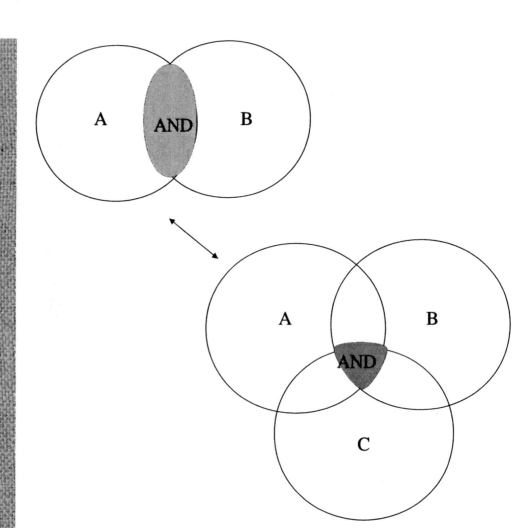

FIGURE 9-6 Venn diagram, "AND." Results are very specific from A and B or from A, B, and C.

Using the same example, you could also type: Chanel, Coco. This will result in any-thing with the name Chanel and with the name Coco. You will soon discover using these operators takes time and patience.

Also, do not panic when you encounter difficulty because you inadvertently used several stop words. Stop words are words that your search engine chooses to ignore be-cause they find them meaningless. For example, you may wish to avoid using conjunc-tions, prepositions, adverbs, and slang when asking for information. Honestly, your search engine will not understand when you want to "ax it a question." Instead, try to use nouns and verbs when requesting information.

We promise in no time you will be surfing the Web like a real computer geek!

FIGURE 9-7 Venn diagram, "NOT."

The following was adapted from a handout "Searching the Web" by Roberto C. Ferrari for The Art Institute of Fort Lauderdale, Summer 1998. This is a list of questions you should ask yourself before your begin your research on the Internet.

1. What is the reputation of the Web site? And its parent organization?
2. Who has created this Web site and provided this information?
3. Are these people considered experts in their field? For example, when looking for an article on the retail economy, are you searching the *Wall Street Journal* or the *National Enquirer*?
4. Cross-reference and make every attempt to verify your data.
5. The Web is only one source and it doesn't replace all traditional sources.
6. The Web has its drawbacks too. Great photos never replace the touch or hand of a fabric. So verify sizes, weights, yardage, and fiber content or even quality of construction.
7. Don't forget that Web sites need updating, so be sure your information is current. And like anything else, sources found on the Web can be here today and gone tomorrow. So have several comparable backup sources.

Before we introduce you to several great search engines and some really awesome Web sites, we want to offer you a few insights from a real-life librarian webmaster.

Now we will look at some of the search engines you might be using. You may wish to compare and contrast the different sites as they apply to your personal needs. We will start you off with a simple compare and contrast exercise that we will do together. And remember, getting to these addresses is simple. Just type http://www.Addressname.Com

Search Engine Research Savvy: Basic How-to Steps

1. Go to the search engine of your choice, for example: http://www.AltaVista.com.
2. Look for the language you are most comfortable speaking in to do your research; for example, Spanish.
3. Look for the blinking cursor or for a search box.
4. Type your request as concisely as possible; for example, denim fabric.
5. Select the Start, Go, Enter, Go to, Submit, or Ask button.
6. Review the list and evaluate your results. (Follow the suggested links to determine your results.) The results are typically ranked numerically in order of relevance, with the best choices listed at the top.
7. Don't panic if the results are not at all relevant to what you requested. Just try again.
8. Begin to experiment. Try to narrow your search by using word strings; for example, wholesale denim fabric.
9. If you find that the responses you get are too vague or too broad, what do you do?
10. Be sure you spelled everything correctly and use appropriate capitalization for proper nouns.
11. To narrow your search using similar words or multiple words, use key words, concepts, or phrases; also use commas, quotation marks, and/or plus signs to separate the words.
12. Another frequently used operator is the minus sign, to indicate that something is of less (or no) importance. (Avoid leaving spaces between the operator and the search term.)
13. Also try nesting your request within parentheses, experiment with the *, or wild card truncation. You may find this helpful. For example, if you are looking for an import firm, and you type import, this technique will recognize related words such as importer, importers, and importing, which can be very helpful in the search.

I
N
T
E
R
M
E
D
I
A
T
E

14. Compare and contrast your results with those from another search engine. We suggest that you try http://www.ask.com, ask for the same exact information, and jot down the results.

Additional Comments

The harvesting value of research varies from search engine to search engine. As you will soon see, many specialize. Many sites offer help for refining your search, as well as the opportunity to select advanced search options. This is typically a button icon or pull-down option located within one of the frames of the search engine screen.

One last word of advice: be sure to read your screen for how and where the search engines ask for your information. Often a significant portion of the screen is taken up with advertisements. In other cases, hypertext or a hyperlink will lead you to a fee-based answer. In this instance, you will be required to prepay for a response. Frequently, this information can be obtained for free on-line, perhaps at another Web site, or it may be available free at your local library.

Some sites will permit you to preview the sites and the information they provide for a free trial period. But remember, you are in control. Should you find yourself zooming off to another Web address you did not plan on, do not panic; hit the back button located on the top half of your screen.

Lastly, we discovered some interesting trivia found in an article on "The Best Search Engines" by Fred Langa for the *Langa Newsletter* in July 1999. The article rated search engines, specifically ranking the best search engine used for its ability to cover the complete Web in a given search. The winner was Northern Lights, followed by AltaVista. According to a recent Associated Press article, Langa says that "Northern Lights covered only 16% of the Web." Langa goes on to say "Despite these obvious shortcomings, search engines are still essential for serious research. . . . You gotta use them." However, in his August 6, 1999, issue Mr. Langa relates "Last week, I saw a press release that caught my eye: World's Largest search Engine. . . . With over 2,000,000,00 unique URLs are in Fast search database. . . . that's twice the size of HOTBOT and YAHOO!"

"FAST Search comes from Fast Search & Transfer, with R&D facilities in Norway and over 10+ years research in algorithms and software." Located at http://www.alltheweb.com, Fast Search, according to Langa "seems pretty good." Langa goes on to say "FAST seems promising. I'm not quite ready to abandon AltaVista, but I like what I have seen so far."

So, what does all that mean to you? There is much more information available out there, and it is up to you to find it. So be adventurous and creative. And you be the judge!

Special Notes

Web sites you used: _____

Data you found:

What you learned that was new, and special notes on what you want to always remember.

Miscellaneous thoughts: _____

Using Search Engines for Locating a Variety of Fashion-Related-Research

Well how did you do? That wasn't so bad was it? Now we are ready to continue exploring the Web. We have listed several of the more popular search engines and meta search

engines. Several search engines will provide you with the ability to do advanced search option. Feel free to experiment and make notes as you go along.

This section is followed by some great Web business, marketing, and fashion-related sites you will want to visit. Many you will want to add to your favorites. Please note that all site listed end with the extension ".com" unless otherwise noted.

Not all the sites listed below are exclusively a single database. Many will connect you directly to several databases for information. The trick is to find the site that specializes in a specific types of information. You will notice that some sites are more user-friendly than others.

As we all know, fashion is always changing, so most companies are forever updating and upgrading their Web sites to keep information current and the site more user-friendly. Trust us, researching and sourcing on-line is not some exclusive club designed to increase your blood pressure or frustration level or to make your self-esteem bottom out. Companies really do want you to find and use their sites.

We recommend that you visit every site listed. Check out the potential advantages to your particular research needs and jot down in the margins what you discover for future reference!

Suggested Search Engine/Site	Harvesting Significance
Alltheweb	FAST Search
AOL	America Online
AltaVista	Focuses on specific search areas; fine-tunes. This large index contains over 30 million pages! It can also be searched by category. It is very user-friendly, and is multilingual.
ASK	This one is also a sure bet, so go ahead ASK Jeeves.
About (Formerly known as the MiningCo.)	This one is really a five-star best bet.
Beaucoup!	Uses a variety of search engines to research.
BigHub	A search engine specializing in classified specialties.
Cyber411	A great multiparellel search engine that will search up to 15 different single engines.
Dogpile	Yes, the name is real, it's not a joke. This is a common meta-search engine. We really recommend it.
Eldarco	This site specializes in listing all the latest search engines in almost every category, including fashion and art.
Excite	Great source to summaries an idea— i.e., consumer spending habits.
Geocities	This site has many terrific links useful for fashion.
GoTo	This does simple searches as well as uses other databases.
GoToTheWorld	One of the latest search sites of choice.
Hitbox	Searches multiple search engines simultaneously.
HotBot	Fast engine that ranks results on topics searched. A great tool when there are common words in search ideas.

Re-"Sourcing" the Net: Locating the Right Fabrics, Findings, and More

Infoseek	The Web's largest database with an integrated subject directory. Also look under UltraSeek and express.infoseek.
iTools	For reference and research.
iWon	Sort of like "gamble as you search"; each time you use the site you become eligible for a drawing.
LookSmart	Search engine with great image formats and over 24,000 categories!
Lycos	This search engine can do a search in 20 seconds and is very comprehensive.
Magellan.excite	In-depth research found here.
Megago	Multidatabase searching capabilities.
Metacrawler	Strong multiparallel engine search by topic.
Metasearch	Considered a very useful site.
Netscape	Not just a browser; it also aids in conducting searches.
Northern Lights	Strong multiparallel engine search by topic.
Opentext	Information-seeking site.
PlanetSearch	Searches multiple search engines simultaneously.
Profusion	This site doesn't repeat hits when searching.
SearchKing	Searches multiple search engines simultaneously.
SearchEngineWatch	Helps you keep up to date with all the latest search engines.
Searchpower	Over 2000 major searches in over 80 categories and in 301 languages.
Snap	Searches multiple search engines simultaneously.
Surffast	Searches multiple search engines simultaneously.
Symantec	This is a good site especially for looking in other countries' languages.
37.com	A spider which searches 37 different search engines simultaneously.
Yahoo	Good source for general information to specific categories; builds/connects like branches on a tree.
WhatUSeek	Why not give this one a try?
WebSeek	Image-specific search engine—over 660,000 images!

We are also including here three sites for finding an ISP (Internet service provider): http://www.ispfinder.com, thelist.Internet.com, and ispcheck.com.

Remember how we mentioned all those great business, marketing, and fashion resources? Well, now it is time to give you a list of several of those sites for you to try.

Skill Level: Intermediate

INTERMEDIATE

SEARCH ENGINE COMMENT PAGE

Jot down here which search engines you found useful, user-friendly. or not-so-user-friendly. Make any additional notes on how you conducted your research, what worked, and what didn't.

Business, Marketing, and Other Related Research Sites You Will Not Want to Miss, Including the Net-How-to's

SITE ADDRESS	HARVESTING SIGNIFICANCE
AmericanBusiness	This has the jargon you will need to understand all the latest business buzzwords.
BEA.gov	Bureau of Economic Analysis
Beyond	Software and newsletters
Braintrack	This lists colleges and universities and their specialties
Browsertune	One of the top 100 Web sites. A real favorite of ours.
Businesswire	Cost of living analysis and more
CareerPath	While you are looking up companies on Comfind, you can always go to this site for the latest job listings. This is by no means the only site or the best site for fashion; but it is a starting point.
CareerMosaic	Locates jobs in wide range of fields, not just fashion.
Census.gov/foreign-trade/	Also try Irs.ustreas.gov and usitc.gov; latest statistics and information on trade, tariffs, and taxes.
Ceoexpress	The best business tool on the Web today. Every needed business source can be found on this one site. For example, newspapers, television news, Standard and Poors, you name it, it's there.
Clearinghouse.net	Great for topic-related research.
Clickit	This is great for Internet information and related resources.
Comfind	Global company find.
CorpTech	Great CEO people finder for over 160,000 executives.
Cyberschoolbus	Type: un.org/Pubs/CyberSchoolBus/infonation/e information.htm. This site is from the United nations and covers statistical and narrative information

INTERMEDIATE

Datamasters	Type in the following: /survey.html to locate a site to compare-salary information. http://www.datamasters.com/cgi-bin/col.pl This is the same web site but showing the cost of living analysis
dictionaries.travalang	This will obtain a free language translator
Eboz	Very helpful site on anything to do with the Web and the Net. Tons of success tips and more.
Echo	Language translator
Encarta	The encyclopedia on-line; great for a quick review on a topic.
Encyberpedia	Helpful database of Internet information, jargon, and navigation.
Fax4Free	Just like the name says. Such a deal!
FactFinder.census.gov	Wow! Need we say more? Also try Ifla.inist.fr//11/natlibs.htm.
Fedworld.gov	U.S. federal government information. Go to: http://www.sec.gov/edgarhp.htm for the Securities and Exchange Commission with information on businesses. Also try: http://stats.bls.gov/ocohome.htm Occupational outlook online...also great career /job info
Headcount	Terrific site for Internet statistics.
Home.sprintmail	Type in the following to an amazing site we discovered: http://home.sprintmail.com/ ~debflanagan/index.html A great tutorial on researching businesses online, everything this woman has online is outstanding!
Ilo.org	International Labor Organization
IMF.org	International Monetary Fund Organization
InfoSpace	One of the best global people finders.
Infomine.ucr.edu	Great Internet information.
Internow also Internet	Up-to-the-minute information about the Net.
IOMA	Marketing and Internet-related topics.
Ipl.org/ref/	The Internet Library.
Learnthenet	Need help? More tutorials on the Internet? Try here.
Lib.berkeley.edu	Type in http://www.lib.berkeley.edu/ TeachingLib/Guides/Internet/FindInfo.html This site is helpful with information literacy as well as using the internet-complete with tutorials. We also suggest you try: http://www.mit.edu:8001/people/cdemello/ univ-full.html This is an awesome site for research colleges/universities research
Liszt	List of e-mail newsletters and the like available on-line.
Local.gov/	The Library of Congress–site with historical tours and archived collections
Kodak	The best Web site available for color information.
Kweb.com/fil	This site offers everything a freelance individual could want such as free clipart, emails and other free internet stuff
Microsoft and Apple	Provide up-to-date hardware information and keep the designer tuned in with the

Skill Level: Intermediate

	state-of-the-art technology and software demands. And don't forget to look up the Web sites of the software companies found in this book. Many provide free trial downloads.
MindSpring.net	Offers a search engine as well as other Internet-related information.
Mit.edu.8001/	Go online and research colleges.
NewJour	Articles and links to thousands of journals and newsletters.
NRF	Nation Retailing Federation—great information and links.
Otexa.ita.doc.gov	US office of textiles and apparel.
Prenhall	Why not check out the latest books? We suggest you also go to: Prenhall.com/biz.infosearch.com.

Phone-Directory-Style Sites:

a) Infoplease	d) infospace	g) att.net
b) 555-1212	e) companies.whowhere	h) companies on line
c) big yellow	f) bigbook	i) switchboard.com

sec.gov	Securities and Exchange commission, also try: sec.gov/edgarhp.htm
Sgi	Silicon Graphics; exciting art and freeware on-line.
Shareware or Freeware, FreeShare or Download	Yes free, and almost free, downloads—software including clip art. We especially recommend you visit SEBD.com (Software Excellence by Design). They offer award-wining screen capture software as well as Web services. All of the screen shots shown in this book were done in Grab-it Pro by SEBD. This can be very helpful for training in software programs—a picture is worth a thousand words.
SoftSeek	Find related computer software and more, etc.
Thepaperboy	Newspapers available from around the world.
TheNetWork	Who's who in the Internet economy.
TheTimeZone	Look up the current date and time internationally!
TSCentral	Trade Show Central, listed by topic, and region, not by company.
UN.org/Pubs	This site is from the United Nations.
USData	Site specifically for statistics, etc.
Ussal.com/~ibnet	International Business network
Way.net/omnivore	Terrific Net stuff
Webmuseum	Yes, one of many electronic museum sites.
Wiredsource	Internet topic and source
Whatis	A great Web link to over 1500 topics, 3000 links, and 5000 hyperlinks about the Internet.
Worldbank.org	Information on latest banking trends and other relevant issue to textiles and apparel marketing
WorldPages	Great for searching for businesses.
WTO.org	World Trade Organization–locating the most

INTERMEDIATE

Zdnet

current information on international trade
policy as it pertains to fashion and apparel
We really suggest this Internet site.

Additional Comments

One last suggestion, if you are looking for a quick demographic overview on a specific city or town, check out the local Real Estate sites. For example, if I wanted a quick snapshot of the greater Ft. Lauderdale area, specifically Weston, I could log on to the site: http:www.HomeSpot.com. This site provides me with the opportunity to select the county and city in South Florida I wish to review. This is very useful information and a great starting place for the designer who also desires to own their own retail outlet (boutique) to sell their creations.

One last tip, check with your school librarian to see if she or he has available for you other resources on-line. Sometimes you may be pleasantly surprised at what is available; for example, often your school may subscribe to many of the fee-based sites we have mentioned. Today's libraries are truly without walls, thanks to the Internet.

One of our favorite picks for you to recommend to your librarian is http://www.groveart.com.

Groves Art is an amazing resource that makes available a wide collection of art, paintings etc. useful in doing costume period research.

InterNet, Marketing, and Business-Related Web Site Comments Page

Jot down here which search engines you found useful, user-friendly, or not-so-user-friendly. Make any additional notes on how you conducted your research, what worked, and what didn't.

Some Favorite Fashion-Related Sites

SITE ADDRESS	HARVESTING SIGNIFICANCE
AMC	Yes, the cable channel. But who can deny the fashion connection with Hollywood? (This one is an author favorite pick!)
Access Business Online	Fashion news directories, classifieds, and many buyer–seller connections.
AmericanApparel	The AAMA (American Apparel and Manufacturing) website
Askmag	*American Sportswear and Knitting Times* on-line. This trade publication publishes a yearly

	review of industrial software that is outstanding!
Apparel Exchange	Lists fashion companies and trade associations.
Apparel.net	Connects to 50 or more related fashion Web sites featuring everything from British fashion to sources for manufacturers, trade shows, and links to the hottest fashion tips in the industry today.
ApparelTech	Affiliated with Amarante Consulting to provide management and technology resources for fashion firms. *Bobbin Magazine* as well as ShowLink and ShowNet.
At-net	The apparel and textile network.
Biography	This is the site for the cable channel, but has several great biography resources on retailers, fashion designers, and other arbiters of style.
Bobbin On-Line	The on-line version of *Bobbin Magazine* as well as ShowLink and ShowNet; includes Bobbin Live.
Catalogsite	Also see, CatalogCentral and Catalogdirect for signing up for free catalogs. These can be great for information or for spotting trends. We especially love Neiman Marcus, Pottery Barn, and Lands End.
Citda.org	Association and Web address for textile designers.
Clothes-Care	Just like the name says, helpful advice for caring for fabrics.
CNN	Look for news and fashion/STYLE
Costume.org	Costume research and links. Be sure to also try: costumes.org/pages/ethnolnk.htm For ethnic time links type: costumes.org/pages/timelinepages/timeline.htm For timeline links try: costumes.org/pages/histlink.htm Finally we discovered the following additional private sites for costume: http:// dc.infi.net/~gunther/tl001.html. http://www.geocities.com/Paris/Metro/2549/mode.html http://milieux.com/costume/ http://users.aol.com/nebula5/costume.html
Costumegallery	Great site for costume history
Culturefinder	Very inspiring for the location of information on a given culture.
Designercity	Can there ever be enough sites to get fashion inspiration?
DavidsonBlueBook	A fee-based site with the final word for related textile sourcing.
Einstein.human.cornell.edu *or try* Human.cornell.edu/txa/related.cfm	While searching for more sites we stumbled upon this site, assembled by another professor as a service to his students. A good example of what you might have at your school. Don't despair if there aren't any Webmasters, gather your findings and offer them to your college's librarian and ask them to include them on the library's home page. If the sites are valid, most will be delighted to include your suggestions.

INTERMEDIATE

Elle	One of many of the top magazines to have Web sites. Why not try your favorite magazine?
Fabricad	Consulting resource for sourcing, jobs, trends, and more (fee-based).
Fashionangel	This site is for the locating the best of the Web for fashion.
Fashionbiz	The business of fashion and other related information.
Fashion Central	Up-to-the-minute fashion trends.
FashionCenter	The New York Market on-line
Fabriclink	Awesome site with links for fabric.
FashionFirst	See the latest collections and trends.
FashionInternet	Filled with links and fashion-related resources.
FashionLink	Great site for contacts.
Fashion Live	Fashion shows from Paris in English, Japanese, and French.
FashionMarketing	Terrific site for jobber, production, and more.
Fashion.Net	Guide to fashion apparel designer, beauty, and fashion magazines.
FashionPlanet	Can there ever be enough uses for the word *fashion*? Another site with other great links to explore.
FashionSolution	Filled with fashion sources; very user-friendly.
FashionSource	The site for fiber products and their links. Great fabric/fiber tutorial.
FashionTelevision	Catch the latest on fashion from that other medium.
Fabric University	This site is fabric information heaven! It is found at fabric.com.
Fibersource	Fiber resource research links
Firstview	On-line previews of designers' current collections—current collections for a fee; past collections are free.
Fgi	The Fashion Group International
Gerber Technology	State-of-the-art, complete systems for the fashion industry.
Geocities.co/paris/4432	This is a wonderful fashion-related site.
Global Textile Network	International trading center for sourcing and distribution of textiles.
Griffindesigns	Wow! This site is a real sleeper. It's loaded with over 500 links for fashion!
HOT Couture	Web site for the Hot Couture line by Grace Grinnel.
Lectra	State-of-the-art, complete systems for the fashion industry.
Library.unt.edu	Wow! Talk about a great research site! Located at the University of North Texas.
Marquise.de/	While surfing with Geocities at Geocities.com/paris/4432, look what we found—a very cool site and hot links!
Megago	Very useful site to link to museums and more for fashion.
ModaCad, now known as StyleClick	State-of-the-art information and systems for the fashion industry.
ModaMilano	Italian fashion trade show dates and great designer links.
Model-Online	This site has search capabilities also known as "Fashion Navigator."

230 Skill Level: Intermediate

Monarch	One of the knitting maven's sites of the industry.
MrBlackwell	This site is just for fun!
NedGraphics	One of the top software companies featured in this book.
NGA	National Gallery of Art, a virtual tour of exhibits, filled with information and inspiration!
Paris.org/Musses/Louvre	Did you know you can visit libraries and museums around the world too? Here's just one example.
Pathfinder	Great site for locating insight on culture with links to Musicseek, Movieseek, Artlink, and more!
PBS.org	Extremely helpful and informative site filled with surprises and topics relevant to research, the arts, and more. Be sure to follow some of the links such as NOVA.
Pretparis	Pret-a-Porter Paris
Ragnet	The name is so-o-o appropriate!
Ragtime	Great for art and culture research
Sourcingweb	Fabric and findings to equipment and more.
Snapfashun	Home of Bill Glazer and Associates for forecasting and more.
StyleTagMag	More links and more fashion graphic images to search.
Techexchange	Consider this site "sourcing heaven."
Texi.org	Textile Institute Organization
Textile.org	Great site on textiles, also try textilesweb.com.
Unicate	This site is the home of the Textile Industry Business Center, where you can buy, sell, display, etc.
WGSN-edu.com	A great site for trends, sourcing and networking-specifically designed for students—over 200 colleges use this site!
WWD	Why not visit the "holy grail" of fashion for yourself!

Check out the latest at the colleges and university sites who offer or specialize in fashion or art history. What a wealth of harvesting open to the general public, or at least to those with some Internet savvy, like you. Why? Don't forget a number of universities are involved in research and development; therefore, surfing the Net to these campus giants is often worth the trip. We especially enjoyed the University of Texas and North Texas and the great example from Cornell University Web site we mentioned earlier. Definitely follow all the links they provide.

We also found http://www.Mileux.com/costume/index.html to be a very useful costume site. And one final campus we recommend you try—Project 2000 located at siue.edu/COSTUMES/COSTUME1/INDEX.html

Finally we came across some additional fashion sites that may be of interest. They are listed in random order

Char.txa.cornell.edu/zbs/webdocs/art/dress/historic/historic.htm	You have to see this site to believe it!... historic costume and more!
costumes.org/pages/ethnolnk.htm	Ethnic time links

Re-"Sourcing" the Net: Locating the Right Fabrics, Findings, and More

231

costumes.org/pages/histlink.htm dc.infi.net/~gunther/tl001.html	Timeline history links
costumes.org/pages/ timelinepages/timeline.htm	Christy's Garden of History of timeline links
Dir.yahoo.com/Arts/ Design_Arts/Fashion/Designers/	List of biographies and more including alphabetical links to some of your favorite designers.
er.uqam.ca/nobel/ r14310/Lists/AHW-Members.html	Art history timeline and links
Geocities.com/ Paris/Metro/2549/mode.html	The links are wonderful. . .a costume and fashion dream. . .especially follow the one on hats!
Lib.udel.edu/subj/	Arranges the web site by topic and subtopic to links ... this was a real find at the Univ. of Delaware!
Milieux	Costume link site
moas.atlantia.sca.org/ topics/clot.htm	Every time I think it doesn't get any better, I find another amazing costume site like this!
Ragtime objectwarehouse.com/ACSniffer/	Terrific site for art and culture research
Users.aol.com/nebula5/ costume.html	A private web site with great links to costume-related information

FASHION-RELATED WEB SITES COMMENTS PAGE

Jot down here which search engines you found useful, user-friendly. or not-so-user-friendly. Make any additional notes on how you conducted your research, what worked, and what didn't.

What you probably have discovered by now is that the new frontier for designers is the Web. The trend of retailing transforming into "e-tailing" is a no longer a fringe idea but a fast-growing fact of doing business. The challenge for the fashion designer to take hold of the future in "Inter"-niche marketing is almost boundless.

Remember part of your job as a fashion designer is to spot trends and adapt them to your niche of the market. Today's fashion designers must consider themselves as the new breed of "Net-preneurs." That means checking out all of the sites that relate to the research and business end of designing, not just the fashion-related sites.

Remember new sites are added daily, and keeping up is almost a full-time job. So be sure to network with other designers and update your favorites/bookmarks regularly. And please, don't forget to e-mail us any great finds.

What about Other Sourcing Options, Specifically, Researching Fashion Trends?

There are additional resources you may wish to consider. One is the use of a professional company that specializes in research and trend analysis. We spoke with one such company that really understands the ever-changing demands of today's junior market.

232 Skill Level: Intermediate

Bill Glazer is the Creative Director of BGA/LA. Bill began his career as a textile stylist who traveled extensively. This opportunity helped him understand how to research color, fashion, and print direction. While on one business trip to California, he was convinced that L.A.'s vibrant street scene was literally alive with the lifestyle trends that would become the driving force in young attitude fashion. No one was reporting on the L.A. street scene, so BGA/LA was born.

BGA/LA's clients are leading-edge retailers and wholesalers such as Liz Claiborne, Planet Hollywood, Matel, Nordstrom, JC Penney, and Wal-Mart, to name just a few.

We spoke directly with one of Bill's top associates: Wendy Carmona. Wendy's job includes traveling to 10 different cities approximately four times per year to determine the latest fashion directions. As the European correspondent, she tracks trends and translates those into electronic and hard-copy publications called SnapWest and Report West.

Wendy noted that many fashion students may already be familiar with the textbook SnapFashun, which Bill coauthored with Sharon Lee Tate. The "Snap-Fashun" concept is both a book and digital library available to the industry and/or educational client.

We asked Wendy to explain the basic premise of SnapFashun for those of you who are unfamiliar with the concept. According to Wendy, the "SnapFashun library contains thousands of details that can combine with vector-based flat sketches for basic garments. . . . The results are simple to use and manipulate designs that can be understood by every level of the fashion industry, regardless of the designer's level of ability in illustration" (see Figure 9-8).

"A designer can scan prints into the computer using off-the-shelf software" (including the ones used in this book). "Then prints can then be placed directly inside the sketch."

"Imagine what this means . . . the speed of a design and the production process as a whole enable the designer greater freedom to research their market and spend more time creating profitable lines that fit their customer's profile."

In Figure 9-9, all the elements of a design can be easily manipulated to add a detail, color, or print with a click of the mouse.

Wendy also shared with us that "today's designer is free to utilize almost any off-the-shelf vector- and raster-based software to create storyboards, line sheets, flats, store cost sheets, create a design database and reference "pictionary" and more! All of which can also be sent electronically to any part of the globe!" (Does this sound familiar, or what?) This concept is an extremely important one in the creating and rendering of fashion design. Therefore, we will be exploring this industry concept in much greater detail in our Chapter 10.

INTERMEDIATE

Report West Europe

5 issues a year covering the best of European sportswear and dress trends. The following are samples from Report West Europe.

"geo" detailing

off the shoulder

hidden plackets

occasional dressing

pleating

"volume" skirts

See "Design Strategies" on reverse side.

"geo" cuts

zippered cuffs

cut work

DESIGN STRATEGIES

These are our ideas on how to take current and forward trends and add them to your line. Design Strategies comes in every issue of Report West Europe.

FIGURE 9-8 Flats of Report West Europe Design Strategies.

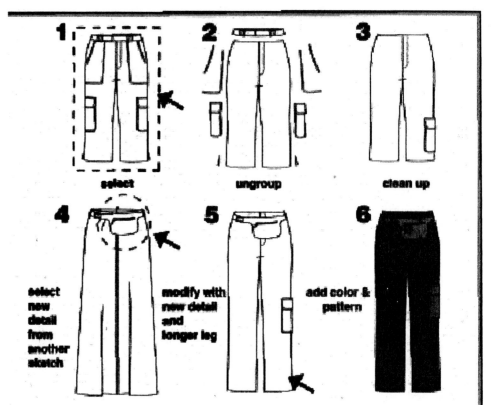

1 select

2 ungroup

3 clean up

4 select new detail from another sketch

5 modify with new detail and longer leg

6 add color & pattern

FIGURE 9-9 In SnapFashun, all the elements of a design can be easily manipulated to add a detail, color, or print with a click of the mouse.

As you can see, even the experts are creating reports that are electronically created as well as very user-friendly.

As we move on to our final stages of preparing you to try your hand at sourcing, or mining, the Net, we have to mention one last obvious resource—your local library.

Sourcing Using Traditional Researching Sources, Including the Library

At this point we strongly suggest you go to your local library and get yourself a copy of your local inter-library card. For example, here in South Florida we have available to us an inter-library card known as a SEFLIN card. This card provides access into a network of local public and university libraries. Frequently, you will be amazed at the links that your local library provides via Seflin. You can now easily access other libraries or institutions of higher learning from any computer with a modem and Internet access.

There is another advantage to visiting your local library. Sometimes it is really great to talk with a real person and not just a computer—someone you can pose your research questions to and get some practical advice from. We realized this while researching for this book; several of our library gurus noted some significant changes taking place. For example, searching the Library of Congress Catalog reveals that it is currently undergoing several significant changes. In fact most librarians we spoke with recommended that you visit the Web site and read about Z39.50 Gateway. The Web address is http://www. 1cweb.loc.gov/lib.congresslinkz3950.

The Z39.50 is the standard defining a protocol for computer-to-computer information retrieval. Z39.50 makes it possible for one user in one system to search and retrieve information from another computer system.

Stay informed and stay tuned. Remember that the library walls are really coming down and the access you have from your computer is unprecedented, so take advantage of this when doing your research.

We could fill a book on the Internet itself, other fashion-related sources, and additional Web sites. So we can only hope the sites we have provided you with will be a blessing to you as you begin your research journey. And don't forget, if you find a great site you would like to share in future editions of this book, drop us an e-mail.

WELL, ARE YOU READY TO SURF THE WEB?

Let's Take a Quick Review before You Log On

- Always make a bookmark or mark your favorites for easy access.
- Don't panic when you can't go to your site; consider that sometimes the sites are "busy" or "down" for maintenance or updating. (Night owls will discover this will especially be the case!)
- When searching for information, always ask the same question several different ways.
- Try searching in your native language first, then convert to English.
- Don't believe everything you find on the Web. (Remember GIGO and "buyer beware.")
- Don't panic if you end up somewhere you didn't mean to visit. . .just hit the Back button.
- Trust us, when we went searching for sites about specific costume periods, you'd be amazed at the garbage we found that had little to do with factual-research-based information. Some sites could make even a streetwise sailor blush.
- Remember, like anything else computer-related, this is just a tool. Be sure to use several sources for your research. And always cross-reference your results.
- For hard-to-find sites, don't forget to use trade publications and journals to see how a company may be abbreviating their name. There are even Web sites that assist you in locating acronyms.

INTERMEDIATE

So, with all of this as a foundation, why don't you try "mining the Web" for information? Be sure to make a list of your favorite Web sites in the space provided at the end of this chapter.

SOURCING EXCERCISES

Exercise 9-1

Find a leading wholesale textile firm offering velvets and/or corduroy fabric.

Special Notes

Web sites you used: _____

Data you found: _____

What you learned that was new, and special notes on what you want to always remember. _____

Miscellaneous thoughts: _____

Exercise 9-2

Find a leading wholesale supplier of novelty buttons.

Special Notes

Web sites you used: _____

Data you found: _____

What you learned that was new, and special notes on what you want to always remember. _____

Miscellaneous thoughts: _____

Exercise 9-3

Find a wholesale supplier of lace for women's lingerie

Special Notes

Web sites you used: _____

INTERMEDIATE

Data you found: _____

What you learned that was new, and special notes on what you want to always

remember. _____

Miscellaneous thoughts: _____

Exercise 9-4

Find a leading wholesale jersey manufacturer and/or supply company.

Special Notes

Web sites you used: _____

Data you found: _____

What you learned that was new, and special notes on what you want to always

remember. _____

Miscellaneous thoughts: _____

Exercise 9-5

Find the addresses of five different stores and the locations of their buying offices. These companies should carry upscale women's sportswear and/or related separates.

Special Notes

Web sites you used: _____

Data you found: _____

What you learned that was new, and special notes on what you want to always

remember. _____

Miscellaneous thoughts: _____

INTERMEDIATE

Exercise 9-6

Get information from a leading retail store about trends in women's apparel for the next year.

Special Notes

Web sites you used: _____

Data you found: _____

What you learned that was new, and special notes on what you want to always remember. _____

Miscellaneous thoughts: _____

Exercise 9-7

Use two different trade sources to identify the names of several leading menswear manufacturers.

Special Notes

Web sites you used: _____

Data you found: _____

What you learned that was new, and special notes on what you want to always remember. _____

Miscellaneous thoughts: _____

Exercise 9-8

Make a list of five different trade shows in the next 90 days. For each, identify the location, the major focus of the show, and how to submit an application to show or market merchandise.

Special Notes

Web sites you used: _____

Data you found: _____

Skill Level: Intermediate

What you learned that was new, and special notes on what you want to always remember. _____

Miscellaneous thoughts: _____

Exercise 9-9

Find a scheduled upcoming annual trade show that specifically relates to yarns and/or knitting equipment.

Special Notes

Web sites you used: _____

Data you found: _____

What you learned that was new, and special notes on what you want to always remember. _____

Miscellaneous thoughts: _____

Exercise 9-10

Find a Web site about computer systems that specialize in vector-based software used in fashion design. (*Hint:* Why not try going to the Web site of one of the companies listed in our exercises?)

Special Notes

Web sites you used: _____

Data you found: _____

What you learned that was new, and special notes on what you want to always remember. _____

Miscellaneous thoughts: _____

Exercise 9-11

Find a Web site that will show you what your favorite fashion designer is currently showing on the runway.

Special Notes

Web sites you used: _____

Data you found: _____

What you learned that was new, and special notes on what you want to always remember. _____

Miscellaneous thoughts: _____

Exercise 9-12

Find a Web site that will give you information on ethnic prints or embroideries from Africa, South America, or even Bulgaria.

Special Notes

Web sites you used: _____

Data you found: _____

What you learned that was new, and special notes on what you want to always remember. _____

Miscellaneous thoughts: _____

Exercise 9-13

Find information on women's after-five dress designs from one of the following periods: 1920s, 1930s, or 1950s. Compare your results in terms of whether you were able to find the following information:

- The signature look of the period
- Who were the major players (not just in fashion)?
- The dominating silhouette
- The major focal points (e.g., hourglass figure or waistline emphasis)
- The significant textiles, fibers, details, and color stories
- Did the length of the hemline have any significant role or relevance?

Special Notes

Web sites you used: _____

Data you found: _____

Skill Level: Intermediate

What you learned that was new, and special notes on what you want to always remember. _____

Miscellaneous thoughts: _____

Exercise 9-14

Find specific information on women's gowns from the Italian Renaissance period and contrast them with the changes during the French Renaissance period.

Special Notes

Web sites you used: _____

Data you found: _____

What you learned that was new, and special notes on what you want to always remember. _____

Miscellaneous thoughts: _____

Exercise 9-15

Find current information on one of the natural and/or one of the synthetic fibers.

Special Notes

Web sites you used: _____

Data you found: _____

What you learned that was new, and special notes on what you want to always remember. _____

Miscellaneous thoughts: _____

Exercise 9-16

Now that you are getting the feel for research, let's step things up a bit. Go to the search engine of your choice and list Websites that contain the following information:

1. Information on the difference between vector- and raster-based software:

2. The difference between the Internet and the Intranet: _____

3. Where you can find free clip art for fashion: _____

4. A biography of your favorite fashion designer: _____

5. An on-line retailer who sells only private-label merchandise:

6. A Web site that has information about 16th century fashions:

7. A list of fabric stores in your area: _____

8. A street map showing the location of your favorite fabric store: _____

9. A full text article on the latest in trade relations with the United States and Mexico: _____

10. Locate as much information as possible on three different businesses in your area hiring in your field. Are you able to find enough information about the company and its principles in order to sound knowledgeable in an interview situation? Can you also find enough information to determine who their target customer is?

Download Basics

As you did the exercises above, did you notice how many companies on-line offered you the advantage of downloading information, demos, or other offers? As we noted in our section on electronic mail, downloads can be considered an integral part of doing business on-line.

In this section we will provide you with a brief overview of what you need to look for as well as a thought or two on some of the best resources for downloading. Without getting too technical, we will talk to you about how to download your data.

Sometimes you maybe able to simply print out the data you want, while other times you might want to send (or receive) large amounts of information. When you desire to receive a large file from a Web site or another computer often the only way to access it is by downloading. This brings us to the next question. . . .

What Is a "Download"?

A download is what the name implies: a file you "bring-down" from another source to "load" it onto your hard drive for use later. The following is a brief explanation of where to store the file you are downloading, and what to do with it once you download it.

Where to Store the Download

Before you begin to download, you need to have a place to put the file you are downloading. Suggestions include:

A floppy disk using the A drive. The advantage to the A drive is that you are not taking up space on your computer. You can use a standard 3.5-inch disk. Or you could download to a specialized Zip drive onto a Zip disk.

The computer C drive. Should you choose to put the file on your hard drive, we suggest you create a folder to store the file, to make it easier to access at a later date. We suggest you name the folder "Internet Downloads."

Special Notes

How Much Can You Download and Store?

The majority of the files you download from the Internet will be quite large, and in order for the computer to receive the data efficiently and quickly, the files may need to be compressed. That means when you get ready to use the data, the file has to be decompressed. Decompressing a file will enable you to access the data from your disk.

This process is a lot like what you might go through when you are getting ready to take a trip on an airplane for a 2-week vacation. Most airlines have baggage restrictions. But of course you "need" to bring a lot of extra clothes, so you begin to pack, unpack, and repack your entire wardrobe into a suitcase size that is acceptable to the airline.

But like having the "right-sized" suitcase, you may find you need the "right" software and/or hardware to assist you in making these files "fit" properly. As we mentioned many files come zipped, or compressed. (Zipped files typically have been reduced in size to shorten the transfer time.)

How to Unzip a File That You Have Downloaded

Some files can be easily unzipped. After you downloaded the file, if the computer defaulted and saved the file the file format as "exe," this means the file has been downloaded and saved in a self-extracting program. Next you must go to the file, folder, or drive where you saved the data and double click on the "exe" file. This will open the file, which will be ready for you to use.

However, if the file you downloaded was saved with the zip file extension, you will need a special key to unlock the file. The key you will need is an unzip program, such as WINZIP, which is an example of a copyrighted program. This program will extract any files with a zip (.zip) extension.

We suggest you be sure to always create a storage area for your downloads. You may want to begin by practicing with some of the great offers you find on your Internet search for freeware.

One last thing, be sure to run a virus check on everything you download, just to be sure. As always we have left you some space to make any additional notes on your findings. (Remember, a virus is a destructive computer program or series of commands that can harm or destroy your computer. Be sure you are comfortable with where you are obtaining the files from. Especially suspect are e-mail files received from unreliable sources.)

Special Notes

Name and version of software used: _____

List of additional steps you needed to take to execute the program that was specific to the

software program that you are using: _____

Biggest challenge: _____

What you learned that was new, and special notes on what you want to always remember:

Miscellaneous thoughts: _____

Well how did you do? It is essential that you become familiar with the jargon and techniques, then you will become comfortable with the process. Becoming a research expert on the Internet is not an overnight event. It takes time and practice and patience! Remember there is no way around it, everybody sources!

INTERMEDIATE

Did you enjoy your Internet global tour?

Finally, we have provided you with a place to make a list of your favorite Web sites:

NAME	WEB ADDRESS	AREA OF SPECIALIZATION	ADDITIONAL COMMENTS
1.			
2.			
3.			
4.			
5.			
6.			
7.			
8.			
9.			
10.			

Not wanting to leave anything out, we have provided you with a list of names and addresses in case you need a "Plan B." Below is a list of additional sources for you to contact the good-old fashioned way—by mail or by phone.

Allied-Signal, Inc.
Fibers Division
1411 Broadway
New York, NY 10018

American Association for Textile Technology, Inc.
P.O. Box 99
Gastonia, NC 28053
704-824-3522

American Cyanamid Co.
Fibers Division
One Cyanamid Plaza
Wayne, NJ 07470

American Fiber Manufacturers Association, Inc.
1150 17th St. NW
Suite 310
Washington, DC 20026
202-296-6508

American Fur Industry
855 Ave. of the Americas
New York, NY 10036
or
363 7th Ave.
New York, NY 10001
212-564-5133

American Apparel Manufacturers Association
2500 Wilson Blvd.
Suite 301
Arlington, VA 22201

American Printed Fabrics Council
45 West 36th St.
3rd Floor
New York, NY 10018
212-695-2254

American Textile Manufacturers Institute
1801 K St.
Suite 900
Washington, DC 22037
202-862-0500

American Wool Council
200 Clayton St.
Denver, CO 80206

Apparel Guild
450 7th Ave.
Suite 1807
New York, NY 10123
516-735-0823

Associated Corset and Brasserie Manufacturers, Inc.
1430 Broadway
Suite 1603
New York, NY 10018
212-354-0707

BASF Corp.
Fibers Division
P.O. Box Drawer D
Williamsburg, VA 23187

Burlington Industries
1345 Ave. of the Americas
New York, NY 10021

Cashmere and Camel Hair Manufacturing Institute
230 Congress St.
Boston, MA 02110
617-542-7481

Celanese Inc.
Consumer Education Dept.
522 5th Ave.
New York, NY 10036

Chemstrand Company
PR Dept.
350 5th Ave.
New York, NY 10001

Clothing Manufacturing Association
730 Broadway Ave.
9th Floor
New York, NY 10003
212-529-0823

Color Association of the United States
24 East 38th St.
New York, NY 10016

Cotton Inc.
1370 Ave. of the Americas
New York, NY 10019
212-586-1070

Council of Fashion Designers of America
1412 Broadway
New York, NY 10018
212-302-1821

INTERMEDIATE

INTERMEDIATE

Custom Tailors and Designer's Association of America
17 East 45th St.
Suite 401
New York, NY 10017
212-387-7220

Dan River Inc.
111 W. 40th St.
New York, NY 10036

Education Foundation for the Fashion Industry
7th Ave. and 27th St.
Room C204
New York, NY 10001
212-760-7820

E.I. du Pont de Nemours & Company, Inc.
Textile Fibers Dept.
Wilmington, DE 19898

Eastman Chemical Products, Inc.
Kingsport, TN 37662

Fur Information Council of America
655 15th St. NW No. 320
Washington, DC 20036

Fashion Association of America
475 Park Ave. S.
17th Floor
New York, NY 10016
212-683-5663

Fashion Editors and Reporters Association
1720 Arch St.
Little Rock, AR 72206
501-267-1740

Fashion Group
597 Fifth Ave.
New York, NY 10019
212-593-1715

Fibers Industries Inc.
1211 Ave. of the Americas
New York, NY 10036

Hoechst Celanese Corp.
1211 Ave. of the Americas
New York, NY 10036

Infants', Children's, Girls Sportswear & Coat Association
500 7th Ave.
New York, NY 10018
212-819-1011

International Linen Promotion Commission
200 Lexington Ave.
Suite 225
New York, NY 10016
212-685-0424

International Silk Association
41 Madison Ave.
41st Floor
New York, NY 10017
212-213-1919

Knitted Textile Association
386 Park Ave. S.
New York, NY 10010
212-689-3807

Leather Apparel Association
19 W. 21st St.
Suite 403
New York, NY 10010
212-924-8845

Leather Industries
1000 Thomas Jefferson St. NW
Suite 515
Washington, DC 20007
202-342-8086

Men's Apparel Guild of California-MAGIC
100 Wiltshire Blvd.
Suite 1850
Santa Monica, CA 90401
310-393-7757

Mohair Council of America
516 Central National Bank
San Angelo, TX 76903
or
1412 Broadway
New York, NY 10036
915-655-3161

Monsanto Chemical Co.
Fibers Division
800 N. Lindbergh Blvd.
St. Louis, MO 63367
or
1114 Ave. of the Americas
New York, NY 10036

National Cotton Council
PO BOX 12285
Memphis, TN 38182

National Knitwear and Sportswear Association
307 Seventh Ave.
Suite 1601
New York, NY 10001
212-366-9008

National Retail Federation
325 7th St. NW
Suite 1000
Washington, DC 20004
202-783-7971

New England Knitwear and Sportswear Association
451 Pine St.
Lowell, MA 01851
508-453-5993

New York Fashion Council
153 E. 87th St.
Suite 6A
New York, NY 10128
212-289-0420

New York Skirt and Sportswear Association
225 W. 34th St.
Room 1403
New York, NY 10122
212-564-0040

Textile Distributors Association
45 W. 36th St.
17th Floor
New York, NY 10018
212-563-0400

Textile Fibers Dept./Advert.
270 Park Ave.
New York, NY 10017

Union Carbide Chemicals
2501 M. St. NW
Suite 350
Washington, DC 20037

United Infants and Children's Wear Association
1430 Broadway
Suite 1603
New York, NY 10018
212-244-2953

Wool Bureau
330 Madison Ave.
19th Floor
New York, NY 10017
or
360 Lexington Ave.
New York, NY 10017
212-986-6222

Wool Council
6911 S. Yosemite St.
Englewood CA 80112

Woolknit Associates
267 E. 58th Ave.
Suite 806
New York, NY 10016
212-683-7785

Young Menswear Association
47 W. 34th St.
New York, NY 10001
212-594-6422

Please note that the above listings are merely a sample representation. There are many other fine companies that provide relevant information and services to the designer. An inclusion or exclusion of any company is not an endorsement for or against any company.

To get the names and addresses of companies not listed above, please check the recommended Web sites or library resources to obtain that information. Also, please consider that the addresses given were the most recent at the time of writing.

Well, did you enjoy surfing the Web? It wasn't that difficult, was it? You went to India for cotton, Hong Kong for buttons, New York for forecasting, and Milan for inspiration from your favorite designer, or into the past for insight from the Renaissance, all without leaving your desk. Is it any wonder that in this increasingly cost-conscious world, sourcing will be done more and more on-line?

Designers often find themselves looking for ways to cut costs, particularly after gathering some strong solid research. Since fabric is the most costly single expense in producing a garment, finding the right fabrics at the right costs is crucial.

So naturally, in our remaining chapters we are going to zero in on fabric. Here you will see firsthand how your fabric choices will be crucial in both costs and creativity. You will soon discover that the computer will enable you to design and/or simulate both woven and knitted fabric and prints.

CHAPTER SUMMARY

The World Wide Web is a network of computers. The Internet permits access to today's fashion designer by use of an Internet service provider (ISP or browser). A browser is also a software tool that let's you look at the Web.

In addition, computers connect the fashion design world electronically via e-mail in a matter of minutes and with minimal cost.

The Internet has a plethora of Web sites that are suitable for researching and sourcing. This is also extremely cost effective. Research and sourcing for facts, fabrics, findings, or trends can be done by traditional methods or on-line. Sourcing for fabrics or researching a competitor can now be done from the designer's own desktop computer.

Frequently, a fashion designer will use a search engine or database of information in order to locate this orother data relevant to trend analysis, forecasting, demographics, company profiles, and the like.

The greatest challenge for conducting a search on the Internet is locating the best verifiable and most-qualified site for your particular needs from such a vast quantity of sites available.

Often a designer will conduct a Boolean search for information. Research for trends, fabrics, findings, and more can be done in English or in many other languages. Information can be searched in the form of a query that can be narrowed or expanded in nature with the use of Boolean operators or Search Engine Math. Connectivity and computer savvy are the keys to the ever-changing fast-paced world of fashion.

INTERMEDIATE

CHAPTER 10

Color and Computers: Is What You See What You Get?

Focus: The Principles and Secrets of Working with Color and Design

CHAPTER OBJECTIVES

- Apply the basic theories of color and design to computer-aided designs.
- Explore the commonalities of reproducing color on vector- and raster-based software.
- Achieve accurate color reproduction on either vector- or raster-based software.
- Create, customize, and calibrate color palettes and colorways on the computer.
- Compare and contrast working with color on commercial and industrial software.
- Explore and evaluate the advantages and/or disadvantages to replicating color on computer.
- Weigh the alternatives of printing in-house versus using a service bureau.

TERMS TO LOOK FOR

calibrate color	colorway	opacity	shade
channel	color wheel	palette	source profile
chroma	DPI	perceptual	tint
color	file compression	matching	value
color mapping	file conversion	resolution	WYSIWYG
color mode	gamut	saturation	
color model	KISS	service bureau	

COLOR

Color is typically defined as the presence or absence of light as it is reflected or not reflected from a surface. Color is basically wavelengths of light. As we describe color we refer to it by its hue, which is merely another name for color. Color is also described by chroma or intensity, which signifies the degree of saturation. The term *value* is the range of grays from white to black. Those closest to white are called tints; those closest to black are called shades.

Everyone remembers from any basic drawing class that we frequently categorize color by placing colors on a color wheel. From there we divide them by the primary colors also known as chromatic colors. These colors—red, blue, and yellow—are those from which all other colors come. We refer to the achromatic hues as the essence of neutrals such as black, white, and gray. We further break hues into secondary colors, monochromatic, analogous, triadic, and so on.

We have included basic color-wheel information at the conclusion of this chapter to which you can refer. If necessary, take a moment now to refresh your memory about the color wheel and the basic color schemes.

The psychological image of color is undisputed. And when it comes to the selection and matching of colors in computer-aided design, it becomes essential that we continue with our discussion of relevant terminology. A basic understanding as an artist-designer is not sufficient. Selecting colors for your designs on computers can be as challenging as when you first learn to mix colors. From your first attempts, what you wanted isn't always what you got. The same holds true for the computer. Selecting color in most vector- and raster-based programs can be described as image modes.

There are eight basic image modes:

Bitmap	=	pixels are 100% black or white
Grayscale	=	pixels are black, white or up to 255 shades of gray
Duotone	=	printing method using two or more plates to add depth to grayscale
Indexed color	=	one channel and a color table up to 256 colors
RGB	=	most widely used
CMYK	=	used for PostScript printers, professional quality in-house
Lab color	=	three-channel mode that can be known for WYSIWYG (what you see is what you get)
Multichannel	=	256 multiple-level grayscale channels

What this means to you the designer is the term you learned earlier—WYSIWYG. In the case of color, WYSIWYG—not! You cannot assume that what you select and view on the screen is what you will get when you produce a hard copy of the design.

The goal then, when it comes to color, is to reproduce colors as accurately as possible. Color matching and color reproduction are the processes of transforming color values or information generated from one device to another. For example, a designer may desire to showcase colors found on an original (such as film, print, illustration, painting, swatch, or various other types of images) to the colors visible on the computer monitor and ultimately to a printed page or other final output device.

Designers use a variety of imaging devices to accomplish this, such as scanners, displays, and printers that are only capable of using a subset of all visible colors. The color subset that a device is capable of handling is called its color gamut (range of color).

You will find that the colors you typically view on your output profile (your monitor or printed hard copy) do not always match your original or source profile. Here is where you might encounter the terms *color gamut* and *color mapping*. *Color gamut* refers to imaging devices, such as scanners, monitors, and printers, that can only display a subset of all visible colors. *Color mapping*, on the other hand, is the technology that permits the best match in appearance to the source image. Therefore, the challenge is to

INTERMEDIATE

convert color from a source device to a destination device with as little loss of color as possible.

Further frustration arises for designers who are driven by color, as they try to match the colors they see. The fact is, the human eye can detect a wider color gamut than the computer, so no wonder some designers go prematurely gray in the attempt!

There are several organizations that specifically deal with the challenge of color. One such organization is CITDA (Computer Integrated Textile Design Association). In an article entitled "CITDA Strives to Craft A Color Language" in the September 1999 issue of *Executive Technology*, Jeanette Hye quotes CITDA chairwoman Katy Chapman's comment that "one of the most important issues facing its members is color." According to Ms. Chapman, a color committee has been formed with the express goal of "identifying color or standards that will make it possible for designers, mills, manufacturers, and buyers to speak the same 'color language.' " Later in the article, Chapman goes on to say that "the industry's goal is to identify specific standards and practices for the communication of color across multiple CAD/CAM programs and devices" and that "CITDA will encourage developers to adopt these standards as a way to streamline color matching issues for users and others."

What does that mean to you? Obviously, as a fashion designer you need to stay informed in terms of the changes within the industry. As we mentioned earlier, you need to keep on that business hat and keep up with the trade and with the trends in all aspects of our business, including color.

The trend for the future seems to be as processing time increases and cost to digitally print decreases, more and more companies will turn to color printing digitally in-house. Up until now, companies have opted to print digitally in-house only for samples; the remaining production would be sent out and completed by engraving. Today, this can be accomplished directly to the cloth with the use of inkjets and heat transfer.

Many of the companies who produce software solutions for these challenges are included in several exercises later in this chapter.

According to the ColorSync2 Color Management Glossary, "Color mapping is when two or more devices such as a scanner plus printer or monitor plus printer when used together will have a gamut match."

As we said before, matching color for a fashion designer can be everything. Matching real-world images such photographic reproductions is known as perceptual matching. Colorimetric is most often associated with logo design and when color plays a critical role in a design. Finally, saturation matching is for business presentation and graphics. For our purposes, most of our exercises have been limited to grayscale or RGB.

You will discover as a designer that you can choose from a premixed swatch on the computer, or you can mix your own percentage of gray or mix process color using cyan, magenta, yellow, black, and red. Finally, you may need to select your colors based on a matching system, such as Pantone or TRUMATCH for process printing. In the last case this involves matching color by a numbering system and not trusting your eye to what you see on the screen. Each of these systems is a trademark representing ownership; each is the property of the respective company mentioned. Finally these systems also represent a color matched by number that is based on a hue, brightness, and/or value.

In Figures 10-1 and 10-2 CorelDRAW shows the different options you might find in your software to match numerically the color you really want with the corresponding numeric value. When you select your colors in this fashion or something similar, this is also known as calibrating color.

Working between vector- and raster-based software also requires some consideration. If you have forgotten some of the distinctions, take a moment to go back and review the differences in Chapter 5 before moving on in this section.

Before we go any further, we need to define several terms that we have been throwing around that may sound familiar to you from your classes in color theory or design basics. When it comes to depicting color on the computer, the following is a list of choices of color palettes available, along with a brief explanation of each. These color choices are frequently referred to as color modes or color models.

FIGURE 10-1 Pantone Process Colors in CorelDRAW.

FIGURE 10-2 Pantone Matching System in CorelDRAW.

COLOR MODELS

HLS Hue, light, saturation color model. For example, if you start with
 black, you can choose grayscale by leaving the saturation at
 zero and change the degree of lightness. The hue value for the
 primary colors are: red = 0, yellow = 60, green = 120, cyan = 180,
 blue = 240, magenta = 300. The standard setting for a hue is 50%
 lightness and 100% saturation.

Color and Computers: Is What You See What You Get? **253**

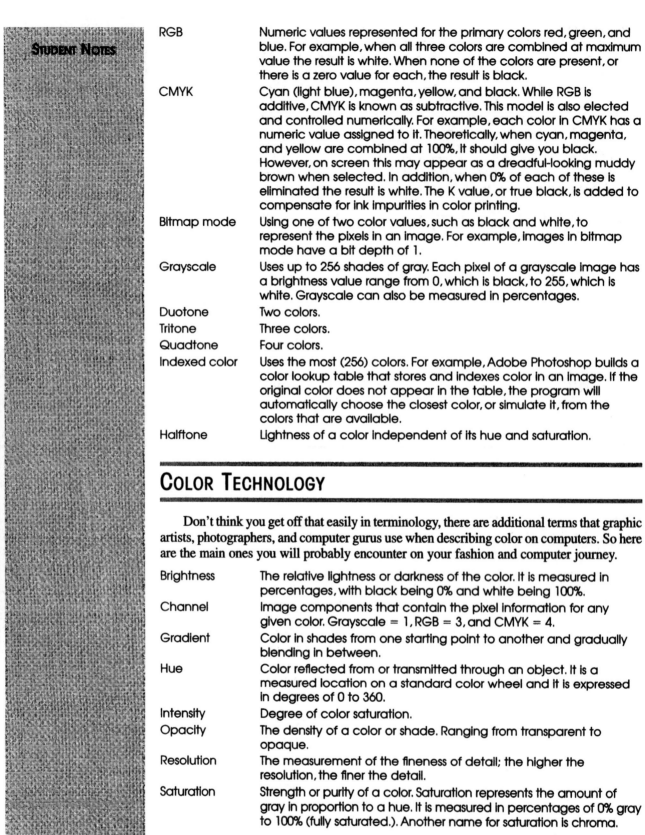
RGB	Numeric values represented for the primary colors red, green, and blue. For example, when all three colors are combined at maximum value the result is white. When none of the colors are present, or there is a zero value for each, the result is black.
CMYK	Cyan (light blue), magenta, yellow, and black. While RGB is additive, CMYK is known as subtractive. This model is also elected and controlled numerically. For example, each color in CMYK has a numeric value assigned to it. Theoretically, when cyan, magenta, and yellow are combined at 100%, it should give you black. However, on screen this may appear as a dreadful-looking muddy brown when selected. In addition, when 0% of each of these is eliminated the result is white. The K value, or true black, is added to compensate for ink impurities in color printing.
Bitmap mode	Using one of two color values, such as black and white, to represent the pixels in an image. For example, images in bitmap mode have a bit depth of 1.
Grayscale	Uses up to 256 shades of gray. Each pixel of a grayscale image has a brightness value range from 0, which is black, to 255, which is white. Grayscale can also be measured in percentages.
Duotone	Two colors.
Tritone	Three colors.
Quadtone	Four colors.
Indexed color	Uses the most (256) colors. For example, Adobe Photoshop builds a color lookup table that stores and indexes color in an image. If the original color does not appear in the table, the program will automatically choose the closest color, or simulate it, from the colors that are available.
Halftone	Lightness of a color independent of its hue and saturation.

COLOR TECHNOLOGY

Don't think you get off that easily in terminology, there are additional terms that graphic artists, photographers, and computer gurus use when describing color on computers. So here are the main ones you will probably encounter on your fashion and computer journey.

Brightness	The relative lightness or darkness of the color. It is measured in percentages, with black being 0% and white being 100%.
Channel	Image components that contain the pixel information for any given color. Grayscale = 1, RGB = 3, and CMYK = 4.
Gradient	Color in shades from one starting point to another and gradually blending in between.
Hue	Color reflected from or transmitted through an object. It is a measured location on a standard color wheel and it is expressed in degrees of 0 to 360.
Intensity	Degree of color saturation.
Opacity	The density of a color or shade. Ranging from transparent to opaque.
Resolution	The measurement of the fineness of detail; the higher the resolution, the finer the detail.
Saturation	Strength or purity of a color. Saturation represents the amount of gray in proportion to a hue. It is measured in percentages of 0% gray to 100% (fully saturated.). Another name for saturation is chroma.

Ok, so you are still thinking, "What does all of this mean to the fashion designer?" As you must have realized by now, you have many choices when it comes to color. As we said earlier, the input and output devices, software, and end use will dictate the choices you make. The bottom line is that all of the programs we have included in this book give you the ability to:

1. Select a color model
2. Convert color to a numeric values

Skill Level: Intermediate

3. Mix color, for example, 2- or 4-color
4. Manage color, such as
 a. Arrange and make new color palettes
 b. Import or export a color palette for use in another program
 c. Sort color, add color, subtract color, name colors, and merge palettes

One last term before we move on—resolution.

Resolution

The term *resolution* was used over and over in the explanation of the two major program types we are using, raster- and vector-based software. Resolution is a broad term that refers to the amount of detailed information contained in a graphic image. It also implies the level of capabilities in output or input of an image.

Vector-based images are resolution-independent, which means you can manipulate the image input and not worry about the output resolution quality of the image. Basically, what you see is what you will get with vector image resolution. It is not that simple with raster or bitmap images.

A great amount of preplanning is required when working with raster-based programs and images. Generally, this means you have to set up the file right the first time when you begin to use a raster-based program and/or image.

Resolution of a bitmap image affects the file size and the quality of the output. Translation: what you see on the screen is not what you will get unless you give specific instructions to your computer and/or printer. These files typically are very detailed and therefore are very large, and they can be complex to save and edit. We recognize that this can be overwhelming to a designer who is new to this aspect of image editing. In fact the most common users of this program are photographers and graphic designers who have studied these concepts long and hard.

Therefore, we have two suggestions. First, take a specific course on just image editing, preferably using Adobe Photoshop, before you tackle any complex concepts for your projects. If you don't, you will have the natural tendency to overdesign with the software. Second, read your handbook carefully. Each software package or system will give you detailed directions for overcoming color-related challenges as well as how to get the best color results from the computer, monitor, and printer with which you are working. If you don't, this translates into headaches for you if you are not very familiar with file size, format, and conversion and printing requirements and restrictions. For this reason, we have simplified what you will do with this software—keeping simple the applications as they pertain to fashion design. We have also included some interviews with some experts in the field of graphic design and photography.

For most exercises, we will be using CorelDRAW and Ned Graphics/Gerber Artworks. These programs deal with color issues very well. They are versatile and powerful, but for the fashion designer, they can seem like the equivalent of trying to drive a 747 on a highway. So relax, we will get you off the ground and take you up for a spin.

Again, we strongly suggest you take an additional course in image editing. Like anything else, it will go a long way in making you much more valuable on the job. Besides learning is a lifelong pursuit; you don't finish when your last class in school ends.

For our readers who do not have the luxury of going back to school full-time because they are working full-time, why not tap into your local college or community school? Many times they will have available short-term courses at times that are more suitable to your needs.

PLANNING

When it comes to fashion designing on computers, by now your realize that planning is the key. Here are several tips you may wish to follow when it comes to preparing your work to be handled or printed by someone other than yourself:

INTERMEDIATE

"LOOK, I CAN FLY"

"KEEP IT SWEET & SIMPLE"

- Don't over design, keep it [your files] sweet [clean] and simple (KISS).
- To save processing time, and disk space, keep files as small as possible.
- Be sure you save versions of your files.
- Make a backup of whatever you give to someone else.
- Don't cover mistakes or changes with white boxes or anything else; this increases the file size. Instead, delete the items you don't want.
- Pay attention to the file format so that others can reopen the file easily. In fact, ask the person who will be printing the file what file format and version they want you to save in.
- Don't forget that vector images can be scaled easily, raster or bitmap images cannot.
- Check the page layout, color mode, and font selection. Include a note with the file with these specifications to avoid any unnecessary surprises.
- EPS file font should be converted to outlines.
- Send a preliminary hard copy with the file.
- Check, double-check, and check again that you have done all of the above!

The following tips are very helpful when you know who will be working on your files. If you don't know who will be working with them, what should you do?

Here's a list of things you may wish to consider and do when searching for the right place (typically a service bureau) to print your files.

- Don't be shy, ask for references, and then check on them.
- Ask to see samples of the work they have done.
- Be sure to discuss the hardware/cross-platform issues.
- Don't forget software-compatibility challenges.
- Ask about color matching, file conversion, and file size.
- Especially, ask about fonts. Don't assume they have what you selected.
- Solicit their advice on cost-effective ways to handle your design needs.
- Shop around for quality, quality, quality . . . then price. Remember, it's your name and career on the line.

Service bureaus can be your best friends. They can make you look very good or really bad. Don't walk, run, if they don't want to give you the customer service you need. And one more thing, there is no such thing as a dumb question They're the experts, and you will be paying for their work as well as their advice. So don't be afraid to ask questions.

ADOBE PHOTOSHOP TECHNIQUES FROM A PHOTOGRAPHER:

MEET DIANE BLAZY

Here we have included a brief interview with photographer Diane Blazy; she will offer the fashion designer some insight into the use of color, file formats, and general Adobe Photoshop know-how. Diane also provided some great insight into how a photographer uses Adobe Photoshop and how this knowledge could benefit you, the fashion designer.

Diane Blazy received a Master of Fine Arts Degree in Photography from Rochester Institute of Technology in Rochester, New York. While in school, Diane began to shoot photographic assignments for magazines. She moved to New York City in 1985 to further her career as a photographer, but after a vacation in Florida, she decided to relocate there.

Diane's photographs have been published in *Newsweek, Palm Beach Life, Boca Magazine, South Florida Magazine, Health Magazine, The Miami Herald, Black Enterprize Magazine, The Philadelphia Inquirer, Sunshine Magazine,* and the *Sun Sentinel* to name just a few. Her work is represented by Index Stock Imagery in New York City.

Currently, Diane is also teaching photography for several South Florida colleges and universities in addition to her freelance career. The following advice

comes from an interview where she shares her insight with you as seen through the "lens" of a photographer and educator.

When we spoke with Diane she kept her insight very concise and to the point. They are geared to both the novice and the expert fashion designer using Adobe Photoshop. According to Diane, this is one of the premier tools used by the experts in the world of photography today. Her thoughts have been paraphrased because the subject matter is technical. We did not want you to get bogged down in a narrative on subject matter that may be new to you. In fact, as your progress in your designing skills on the computer, this will be an easy format for you to make reference to at a later date. For this reason, we have left space for you to go back and jot down your notes and even the steps you needed to take when applying this advice.

File Size, Compression, and Conversion

- Remember only Adobe Photoshop native file format will allow you to save a file with all the layers open.
- EPS is a file format that is useful for sharing files between Photoshop, Illustrator, PageMaker, and Quark Xpress. This file can also be used to save a clipping path in Adobe Photoshop.
- The most common file format is TIFF. TIFF is great for RGB and CMYK and is supported by both the MAC and PC. One additional thought: If you save your file as a TIFF and the file has layers, TIFF will flatten the layers.
- When you convert a psd (the Photoshop native file format) to another file format, you will have to flatten the layers. Translation: you can no longer work on those layers.
- According to Diane, Why not try to save the individual layers separately?
- JPEG is great file format for saving disk space.
- For viewing on screen, use 72-DPI resolution; for desktop printer or scanner, use 300-DPI.

Special Notes

Service Bureaus

Like all professionals, Diane has a practical idea for interviewing the company or individual who will be responsible for the printing process:

- Get a sample slide from the printer/service bureau to scan into your computer for color-balance and gamma control.

Special Notes

INTERMEDIATE

According to Diane, any Fashion Designer who is working in Photoshop should use the following advice to add mystery and savvy to their creations.

When Working with Layers

■ Try experimenting with the opacity of a layer to reveal other layers above and below. This technique can be used to create depth, texture, and intrigue to your work. One great trick is to add a layer mask to a layer. Then cut though to reveal the layer below.

Special Notes

When Using Filters and Masks

Diane's favorite filter is the "unsharp mask." This really allows you to sharpen an image.

■ Playing with the Mask feature is very useful for fashion designers.

Special Notes

"LOOK FOR ME AGAIN IN CHAPTER 14"

When Using Fills

Here, Diane's choice is the gradient tool for adding color to a background or transforming a particular area of a photograph. Here you can use the premixed choices; but Diane recommends mixing your own colors for blending, then changing the opacity of that gradient layer to allow the photographic image to show through the gradient.

Special Notes

Final Words of Wisdom

- Did you know that you can take a photograph of a garment, then edit the length of the hem, change the color of the dress, duplicate the model, and then show it in several variations?
- When you open the Photoshop program, be sure you have toggled on all the tools you will be using.
- Don't forget the computer is just a tool, like the camera is to the photographer. You must have a vision or idea first. Then use the tool to give life to your ideas.

Special Notes

"Finally, as a fashion designer, if you can dream it, you can create it in Adobe Photoshop . . . so enjoy!"

WORKING WITH COLOR

Let's put all this information and great advice to work for you in several exercises designed to show you the basics, as well as make you look like a pro when it comes to working with color. In the first few exercises, we are using an off-the-shelf vector-based program to demonstrate several basic choices you may be required to make. Just as before, the location for these choices may vary from one software package to another and from one version to another. Don't panic, use your common sense and search the main menu. When all else fails you can always search in the help menu or in your owner's manual.

We have chosen to start with CorelDRAW. Figures 10-3 to 10-9 are screen shots of what the color palette and the numeric values might look like. The basic fly-out color menu shown in Figure 10-3 was accessed by double clicking on the paint bucket icon from the main toolbox, then selecting the color menu icon. Figure 10-4 shows the palette editor menu, where you can make the following choices:

1. Color model (CMYK is highlighted)
2. Palette name
3. Edit options—Open, New, Save, Save As, Replace, Add, Remove, and Sort

Special Notes

INTERMEDIATE

INTERMEDIATE

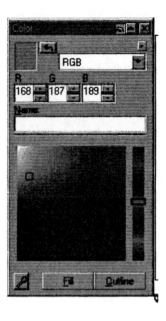

FIGURE 10-3 Basic fly-out Color menu in CorelDRAW.

FIGURE 10-4 Palette Editor menu in CorelDRAW.

FIGURE 10-5 Additional menu bar choices in CorelDRAW.

Skill Level: Intermediate

Figure 10-5 shows additional choices on the menu bar just to the left of the palette editor:

1. Color viewers are usually pulldown menus (Figure 10-6) for more choices.
2. Color mixers include a mixing area (Figure 10-7).
3. Fixed palettes (Figure 10-8) are for color matching.
4. Custom palette (Figure 10-9).

FIGURE 10-6 Color viewers.

FIGURE 10-7 Color mixers.

INTERMEDIATE

FIGURE 10-8 Fixed palettes for color matching.

FIGURE 10-9 Custom palette.

Special Notes

Skill Level: Intermediate

If you have learned anything from this overview on color, it's that you have choices! So, let's go try out some of those choices.

Exercise 10-1 Create and Save a Color Palette

Software Used

CorelDRAW

How-to Steps

1. From the Tool Menu select Palette Editor (Figure 10-10).
2. Click on the button to select new.
3. Specify a folder location for the new palette (your choice).
4. Select a relevant name for the palette, such as Fall 2001.
5. To save the palette before you exit the program, go back to Tool Menu, Palette Editor (Figure 10-11).
6. Select Save As, specify the name and the folder, and select OK (Figure 10-12).

Additional Comments

If you don't name and save this palette you will lose it when you exit.

Special Notes

Name and version of software used: _____

List of additional steps you needed to take to execute the program that was specific to the software program that you are using: _____

Biggest challenge: _____

What you learned that was new, and special notes on what you want to always remember: _____

Miscellaneous thoughts: _____

FIGURE 10-10

FIGURE 10-11

```
New Palette                                          [?] [X]

Save in:  [📁 Custom          ▼]  [🔼] [📁] [▦] [▤]

  📁 Canvas        📁 Profiles       📄 corelpnt.cpl
  📁 Displace      📁 Shearmap       📄 Crayon Colors.cpl
  📁 Duotone       📁 Tiles
  📁 MeshWarp      📁 Tonecrve
  📁 Palettes      📁 Userdef
  📁 Patterns      📄 coreldrw.cpl

File name:    [                        ]    [  Save  ]

Save as type: [Custom palette  (*.cpl)  ▼]   [ Cancel ]

Description:  [                        ]
```

FIGURE 10-12

Perhaps you are wondering about working with color and color palettes using industrial software. Surprisingly, it is not much different from most of the available vector-based commercial software, such as CorelDRAW, which we just used.

WORKING WITH INDUSTRIAL-BASED SOFTWARE

As we move on to the next exercise you will find that industrial-based software, such as Artworks by Gerber, also has similar familiar features for color selection and matching. So be sure to keep in mind the big picture within the process of using this kind of software.

Exercise 10-2 Adding Color to a Color Palette or Mixing Custom Colors

Software Used

Artworks Color Palette

How-to Steps

1. Go to the Tool menu and select Palette Editor.
2. Choose any color in the color selection area.
3. Click to select a color swatch in the palette area to specify the position of the new color you chose.
4. Click on the Add button.
5. To mix a custom color, go to the Custom Color Mode button, which is also located under the main View menu.
6. From here you may select your color mode and mix your colors numerically.

Additional Comments

You may also opt to name your colors by typing in the name box (Figure 10-13).

Skill Level: Intermediate

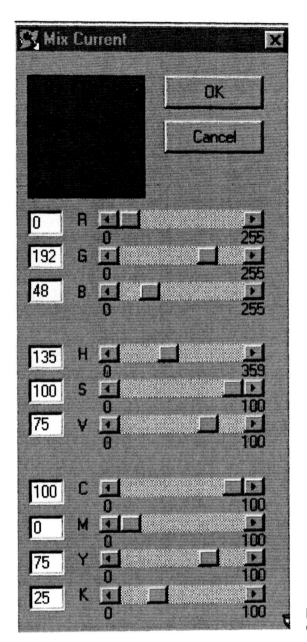

FIGURE 10-13

INTERMEDIATE

Special Notes

Name and version of software used: _____

List of additional steps you needed to take to execute the program that was specific to the software program that you are using: _____

Biggest challenge: _____

What you learned that was new, and special notes on what you want to always

remember: _____

Miscellaneous thoughts: _____

Exercise 10-3 Create a Color New Palette

Software Used

Artworks

How-to Steps

1. From the main Palette icon, double click on the Artworks toolbox palette (Figure 10-14).
2. Click on New Palette or select, File, New Palette.

FIGURE 10-14

Additional Comments

From this point you are ready to begin to store, name, and save color palettes. We will take you sequentially through the most obvious choices you would be making.

Special Notes

Name and version of software used: _____

List of additional steps you needed to take to execute the program that was specific to the software program that you are using: _____

Biggest challenge: _____

What you learned that was new, and special notes on what you want to always remember: _____

Miscellaneous thoughts: _____

Exercise 10-4 Choosing Colors to Store and Save

Software Used

Artworks

Skill Level: Intermediate

How-to Steps

1. Follow the steps to open a new color palette listed in Exercise 10-3 (Figure 10-15).
2. Double click on a color to begin your current color selection. The rainbow icon located on the toolbar offers a wide range of colors from which to choose (Figure 10-16). Or you may opt to use the colorbook software icon from the Artworks main menu.
3. Name the color in the name box; for example, Bahama Blue.
4. Select a palette square where you wish to store this new color, then click on the store icon (Figure 10-17).
5. Continue to repeat steps 2 through 4 until you are satisfied with the selection.
6. To name the file, click File, Save As. You may wish to name this palette by the season or line it will represent; for example, Spring.
7. The file format will default to Artworks native format (PLT).

New Palette	Ctrl+N
Open Palette...	Ctrl+O
Save	Ctrl+S
Save As...	Shft+Ctrl+S
Save Palette to Image...	
Import Palette...	
Export Palette...	
Page Setup...	
Print Preview	
Print...	Ctrl+P
1 A:\sample color.PLT	
2 C:\Artworks\...\Default.plt	
Exit	

FIGURE 10-15

Additional Comments

You will need to update the palette each time you use it. This is done by selecting File, Save. To print is just as easy to do, select File, Page Setup, and set the number of rows and or columns you desire to print and click OK. Finally, select File, Print.

Special Notes

Name and version of software used: _____

List of additional steps you needed to take to execute the program that was specific to the software program that you are using: _____

Biggest challenge: _____

What you learned that was new, and special notes on what you want to always remember: _____

INTERMEDIATE

FIGURE 10-16

Miscellaneous thoughts: _____

FIGURE 10-17

Exporting

At times you may wish to export (send the file to another program) your color palettes into other programs. This is accomplished in basically the same fashion regardless of the

268 Skill Level: Intermediate

software. We have given you the steps to export your color palette for both vector- and raster-based software.

Exercise 10-5 Export a Color Palette from Artworks into a Vector-Based Program and a Raster-Based Program

Software Used

Artworks or Micrografx Designer and/or Adobe Photoshop or Metacreations' Painter

How-to Steps

1. From the artwork palette select File, Export Palette (Figure 10-18).
2. Select a directory where you wish to place the new palette.
3. In the dialog box for Save As, make sure All Palette Formats has been selected. This will automatically save your palette for Micrografx Designer, Adobe Photoshop, and Metacreations' Painter.
4. After you name your palette, select Save.

New Palette	Ctrl+N
Open Palette...	Ctrl+O
Save	Ctrl+S
Save As...	Shft+Ctrl+S
Save Palette to Image...	
Import Palette...	
Export Palette...	
Page Setup...	
Print Preview	
Print...	Ctrl+P
1 The Honey Hunt.PCS	
2 A:\sample color.PLT	
3 C:\Artworks\...\Default.plt	
Exit	

FIGURE 10-18

Special Notes

Name and version of software used: _____

List of additional steps you needed to take to execute the program that was specific to the software program that you are using: _____

Biggest challenge: _____

What you learned that was new, and special notes on what you want to always

remember: _____

Miscellaneous thoughts: _____

Exercise 10-6 Opening Your Color Palette

(You may also opt to open color palettes created in one program and use them in another.)

INTERMEDIATE

Software Used

Artworks Color Palette

How-to Steps

1. Open a new file.
2. On the floating palette, click on the square icon button in the upper left corner.
3. From the pop-up menu, choose Palette Manager (Figure 10-19).
4. Select Import (Figure 10-20).
5. Go to the directory in which you originally stored your color palette. Select your color palette and click OK.
6. Toggle on the button next to the name of your color palette. Click OK.

FIGURE 10-19

FIGURE 10-20

Special Notes

Name and version of software used: _____

List of additional steps you needed to take to execute the program that was specific to the software program that you are using: _____

Biggest challenge: _____

What you learned that was new, and special notes on what you want to always

remember: _____

Miscellaneous thoughts: _____

Exercise 10-7 Opening Your Color Palette in Raster-Based Software

Software Used

Metacreations' Painter

How-to Steps

1. Open a new file.
2. Go to the Window menu, and select Art Materials.
3. Click on the word Color and select Adjust Color Set from the pulldown menu (Figure 10-21).
4. Select Library on the Art Materials palette.
5. Change directories to where you stored your color palette.
6. Select your color palette and click OK.

Special Notes

Name and version of software used: _____

List of additional steps you needed to take to execute the program that was spe-

cific to the software program that you are using: _____

Biggest challenge: _____

What you learned that was new, and special notes on what you want to always

remember: _____

Miscellaneous thoughts: _____

WORKING WITH COLORWAYS

OK, it's 11:45, almost lunchtime. You have exactly 1 hour, and today is your favorite store's one-day sale. You are ready. You've made your plans. Those shoes you have been eyeing for weeks are finally on sale at your favorite department store, and you made sure the last pair of size 6 is on hold with your name on them, when in comes your boss, announcing that she did not like the original colorways you selected, and she wants to see the design in her choice of colors . . . before you go to lunch!

Ok, what are you going do? Fake fainting from a lack of food? Argue with her over how great your color selection is? Or worse yet, tell her how stupid her choice would look?

FIGURE 10-21

Instead of panicking, how about letting the computer create several different colorways at one time, including yours, the boss's, and maybe even a third compromise combination?

This is just another example of a fashion challenge you will be able to meet using the computer. Imagine looking like a hero to the boss and getting to the one-day sale. Wow! It doesn't get any better than that!

To demonstrate this we have selected the Artworks program. You will discover how easy and quick it is for designers to change and view their work in a matter of minutes in several different colorways. Later on you will be able to refer back to this section and follow along when you have created your own pattern for viewing in several alternate colorways. The Colorways Program will allow you to view the same design in alternate color stories.

Skill Level: Intermediate

We want you to briefly review the toolbars and menu options in both the Color Palette and Colorways software or programs. If you do not have the software, as we have said many times before, relax: the techniques are easy to understand and follow. As always, we have included several screen shots for you to better understand the concepts.

We introduced you briefly to the Artworks Color Palette in our last series of exercises on creating a color palette to be used in your line in Artworks for use in another program. Figure 10-22 shows the Artworks Icon Palette. Color Palette is where you select the new colors to be used with the Colorways Program.

In Figure 10-23, the main menu across the top of your screen has many familiar options you have seen before such as:

<p style="text-align:center">File, Edit, View, Windows, and Help.</p>

Figure 10-24 shows the main menu bar for Colorways. As you move your mouse slowly across the menu bar the name of each icon is displayed.

Now let's move on to the Artworks Color Palette window. These two programs will be used together in our "fashion colorways challenge." Be sure to pay close attention to the instructions and screen shots. Remember, the steps provided will enable you to follow along and grasp the concepts even if you don't have the software, or if the software or system you have is from another company. In Figure 10-25 you can see the main window, and again, you will notice as you move your mouse slowly around the screen specific areas will activate the names associated with icons.

FIGURE 10-22 Artworks icon palette.

FIGURE 10-23 Main menu in Artworks.

INTERMEDIATE

FIGURE 10-24 Main menu bar for colorways.

FIGURE 10-25

Skill Level: Intermediate

Exercise 10-8 Working with Colorways

Software Used

Artworks Colorways Palette

How-to Steps

1. Open the Artworks Colorways icon (Figure 10-26).
2. From the file menu, select from the samples file, Gridgreen.tif (Figure 10-27). You now have two screens in view.
3. From the Gridgreen.tif window make a marquee around the Gridgreen motif. This action will capture for you to see all the colors from the motif by color mode and percentage (Figure 10-28).
4. Keeping the cursor on the actual print screen, go to the Edit menu and select Copy.
5. Now, place your cursor on the top of column two, next to the original color list (Figure 10-29).
6. Open the color palette from the main menu (Figure 10-30).
7. Click on the Paste Swatch button (Figure 10-31).
8. Click on the Rainbow icon from the menu bar (Figures 10-32 and 10-33). Or you may select directly from the Colorbook software from the Artworks main icon menu.
9. Begin to double click on the colors you wish to substitute for your new colorway. Be sure you select the same number of colors as the original. In this case you will need to select seven new colors.
10. As you proceed to select the colors by double clicking, they will be added to your color palette. You also have the option to name those colors if you prefer in the name dialog box at the top of the screen (Figure 10-34).
11. When you are done selecting your colors, go back to the Colorways main menu bar and select the Apply icon (Figure 10-35).

FIGURE 10-26

FIGURE 10-27

FIGURE 10-28

FIGURE 10-29

FIGURE 10-30

Skill Level: Intermediate

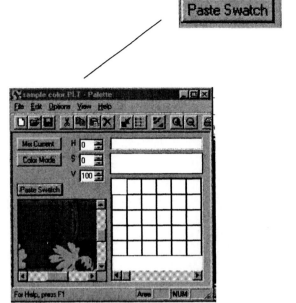

FIGURE 10-31

FIGURE 10-32

FIGURE 10-33

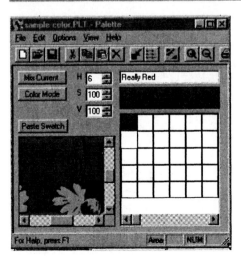

FIGURE 10-34

Color and Computers: Is What You See What You Get?

12. You may continue to repeat the last four steps as many times as you wish, to create as many colorways as you wish. However, now we have two suggestions: 1) Always make sure your cursor for each new colorway is on the top row of the column to start a fresh colorway (Figure 10-36). 2) After you have created your first variation of color, go to the Colorways view menu and select Multiple Colorways (Figure 10-37). By doing this after you have created all the different colorways you need, you will now be able to go to the Colorways window menu and select Multiple Colorways to view all of the choices at one time (Figure 10-38).

 FIGURE 10-35

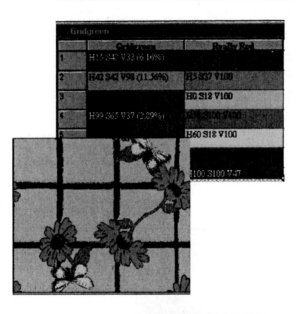

FIGURE 10-36

FIGURE 10-37

Skill Level: Intermediate

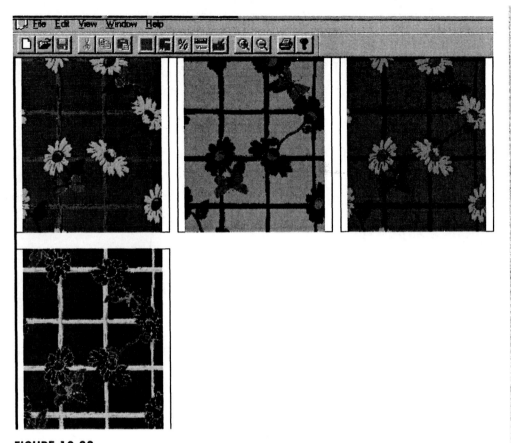

FIGURE 10-38

Additional Comments

When you have selected View All Colorways from the windows main menu, you may opt to go to the main file menu and select print to make a hard copy for you or your boss to view.

Special Notes

Name and version of software used: _____

List of additional steps you needed to take to execute the program that was specific to the software program that you are using: _____

Biggest challenge: _____

What you learned that was new, and special notes on what you want to always remember: _____

Miscellaneous thoughts: _____

Hey you did great!

Need some help on what colors work best together? Why not take a moment to review the basics of a color wheel?

INTERMEDIATE

COLOR WHEEL

Figure 10-39 is an example of a basic color wheel. Starting at the center top and going clockwise, the colors are yellow, yellow-green, green, blue-green, blue, blue-violet, purple, red violet, red, red-orange, orange, and yellow-orange.

Triadic Colors

This scheme of colors involves any three colors that are an equal distance from one another on the color wheel. Figure 10-40 is an example of triadic colors.

Complementary Colors

This is a color scheme made up of any two colors that are directly opposite each other on the color wheel. Figure 10-41 is an example of complementary colors.

Split Complementary Colors

This scheme consists of three hues: a basic hue and the two hues on either side of the basic hue. Figure 10-42 is an example of split complementary colors.

FIGURE 10-39 Basic color wheel.

FIGURE 10-40 Triadic colors.

FIGURE 10-41 Complementary colors.

FIGURE 10-42 Split complentary colors.

FIGURE 10-43 Monochromatic colors.

Monochromatic Colors

This is a popular combination of one pure color (hue) that ranges from light to dark or a combination of the hue and its tints (adding white), tones (adding gray), and shades (adding black). Figure 10-43 is an example of monochromatic colors.

Well, you did great, you are well on your way to becoming a color expert. Now you are ready to try your hand or (mouse!) at designing fabric.

We are going to start with surface prints in the next chapter and move on to the actual designing and rendering of both knitted and woven fabrics in our remaining chapters.

So fasten your seat belts as we head for our next destination, designing prints for fabric!

CHAPTER SUMMARY

When it comes to reproducing color on computer, what you see is not exactly what you get.

Designers will be required to use standard universal color calibrating and/or matching systems in order to obtain perceptual color matching from the computer, output devices, and ultimately the final product.

At first glance, working with color in either vector- or raster-based software is virtually the same. The sequence for discriminating between colors is also very similar for commercial and industrial software.

The greatest challenge when attempting to match color is the number of colors the human eye perceives and the computer's ability to duplicate that information.

As the designer prepares to calibrate color, the outcome objective of the project is what drives the choices.

It is highly recommended that the designer consult with other color experts, such as service bureaus, to help determine matching or reducing color, file size, and/or compression, as well as file exchange and file format. Why? Remember, it is often the outcome objective of each project that will dictate the best choice.

Within the framework of industrial-based systems and/or software are additional features and tools designed to afford the designer myriad alternatives for achieving and previewing color accuracy.

Working with color, especially using raster-based images, can require a significant amount of additional storage space for the file. Therefore, a designer must consider using a larger storage disk to deal with this challenge, instead of the traditional 3.5. Zip drives and compressing files are just two of the alternatives.

Today's designers can also preview designs in alternative colorways within minutes on the computer. This factor and others have streamlined the design process, allowing a designer to be more creative and more prolific than ever before.

SECTION THREE

Skill Level: Advanced

FIGURE 10-40 Triadic colors.

FIGURE 10-41 Complementary colors.

Color and Computers: Is What You See What You Get?

FIGURE 10-42 Split complentary colors.

Monochromatic Colors

This is a popular combination of one pure color (hue) that ranges from light to dark or a combination of the hue and its tints (adding white), tones (adding gray), and shades (adding black). Figure 10-43 is an example of monochromatic colors.

Well, you did great, you are well on your way to becoming a color expert. Now you are ready to try your hand or (mouse!) at designing fabric.

We are going to start with surface prints in the next chapter and move on to the actual designing and rendering of both knitted and woven fabrics in our remaining chapters.

So fasten your seat belts as we head for our next destination, designing prints for fabric!

CHAPTER SUMMARY

When it comes to reproducing color on computer, what you see is not exactly what you get.

Designers will be required to use standard universal color calibrating and/or matching systems in order to obtain perceptual color matching from the computer, output devices, and ultimately the final product.

At first glance, working with color in either vector- or raster-based software is virtually the same. The sequence for discriminating between colors is also very similar for commercial and industrial software.

FIGURE 10-43 Monochromatic colors.

The greatest challenge when attempting to match color is the number of colors the human eye perceives and the computer's ability to duplicate that information.

As the designer prepares to calibrate color, the outcome objective of the project is what drives the choices.

It is highly recommended that the designer consult with other color experts, such as service bureaus, to help determine matching or reducing color, file size, and/or compression, as well as file exchange and file format. Why? Remember, it is often the outcome objective of each project that will dictate the best choice.

Within the framework of industrial-based systems and/or software are additional features and tools designed to afford the designer myriad alternatives for achieving and previewing color accuracy.

Working with color, especially using raster-based images, can require a significant amount of additional storage space for the file. Therefore, a designer must consider using a larger storage disk to deal with this challenge, instead of the traditional 3.5. Zip drives and compressing files are just two of the alternatives.

Today's designers can also preview designs in alternative colorways within minutes on the computer. This factor and others have streamlined the design process, allowing a designer to be more creative and more prolific than ever before.

SECTION THREE

Skill Level: Advanced

CHAPTER 11

Advanced Fashion Design Rendering Fabrics, Flats, and Prints

Focus: The Principles of Surface Design-Prints for Fabric or Flats on Vector- and Raster-based Software

CHAPTER OBJECTIVES

- Manipulating and editing clip art
- Applying and editing pattern fills
- Applying line and design principles to flats and prints
- Creating and modifying a single motif
- Converting a single motif into a repeat motif
- Generating repeat variations for prints
- Mastering and applying advanced CAD techniques to render fashion

TERMS TO LOOK FOR

balance	layers	proportion
clip art	line types	rhythm
complex image	mirror	scanning
continuous	motif	trace
emphasis	print	tracing
half-drop	print house	
harmony	printing mill	

ADVANCED

For many of you, this is the chapter you have been waiting for. At last you can really begin to design! This chapter promises to be both exciting and rewarding, but before we move on to the how-to's we need to start this part of our journey with a brief refresher on textiles and terms as they relate to the designing of prints.

Most of today's fabrics incorporate applying surface prints directly to the fabric. Prints can draw inspiration from a variety of different designs, patterns, or motifs, all of which can be rendered on the computer.

The term *print* implies a design or pattern applied to the surface of the fabric. You may recall from the study of textiles that there are a variety of different methods or styles in which prints are actually applied to the surface of the cloth. As we mentioned in Chapter 8, this process of applying a design to fabric is done by a print house or a printing mill. For our purposes later in this chapter, we will focus on the basics of how you can begin to create and modify, using your computer, designs that can be used as prints for fabric.

A print can be a single design or motif. Prints are also often in the form of a repeat.

CATEGORIZING PRINTS

Prints can often be categorized by subject matter (some of these categories are according to Susan Meller, co-author of *Textile Designs*), such as:

- Nature: flora and fauna
- Animals and insects
- Geometric shapes and objects
- Abstract
- Historical representations, known as styles or periods of Time (these often coincide with art movements)
- Geographical, including regional designs and symbols known as ethnic or cultural
- Unique realistic or stylized.

Frequently a print can be a simple two-color choice, such as black and white, or a print can explode with color.

As a fashion designer, you maybe wondering, Where do I start? How do I begin? One of the best ways to start is by exploring the library of clip art your software has made available to you. Remember, time is money, and sometimes the most obvious place to begin is right in front of you.

Clip art can be found in several of the following locations:

- pattern fill option
- clip art icon
- hard drive, import, export, or download
- Separate CD or disk

WORKING WITH CLIP ART

Up to this point you have been learning how to create art from scratch, but as you will see there are several other ways to create images. Some of the more popular ways is using ready-made clip art. Clip art is one of the fastest way to "create" fashion.

You will discover that clip art is a very exciting tool used by most fashion designers. In fact most vector-based software comes with clip art. Clip art can also be installed along with the software, and may be available on a separate CD or disk. Clip art is available in vector (EPS) files or raster or bitmap files (TIF, BMP, GIF). These files can be resident or they can be imported.

Another source for clip art is the Internet. In Chapter 9 you learned how to download from the Internet. This means you can now put that knowledge to use by downloading or importing and exporting clip art to suit your needs.

One of the best features of using existing or ready-made clip art is that it is available now. Most software programs we have been using in this book already include clip art that is ready for you to use. As the owner of the software you have the right to use the clip art without fear of copyright infringement. Always be sure to check to see what liability or restrictions are specified with your clip art. Unfortunately, the only drawback is that some clip art can look "canned." Here we will teach you to modify clip art to look like your own creation. In addition to using basic modifying techniques, clip art may also be scanned or traced.

Other reasons for using clip art are that it will save you time and money, and it is easy to use.

Clip art is organized in several ways. For example in Figure 11-1 you will see the location and hierarchical structure of the clip art found in Micrografx Designer. They are separated by

- Collections (Figure 11-2)
- Subject matter (Figure 11-3)
- Files (Figure 11-4)

The clip art we will introduce you to first is clip art that represents flats or work sketches. This clip art can later be filled with your pattern or motif. For now we have chosen to use this black-and-white vector-based clip art to demonstrate the basic concepts of manipulating most clip art, including the concepts of:

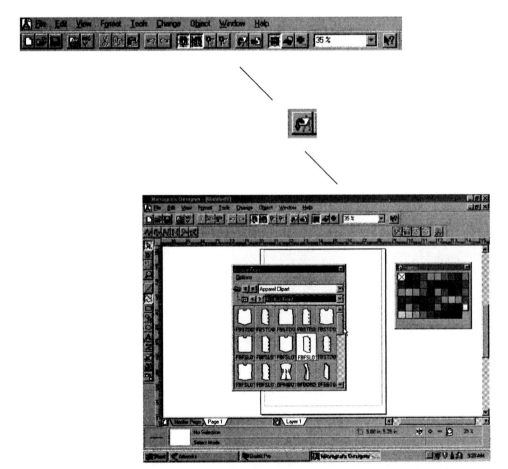

FIGURE 11-1 Location and hierarchical structure of the clip art found in Micrografx Designer.

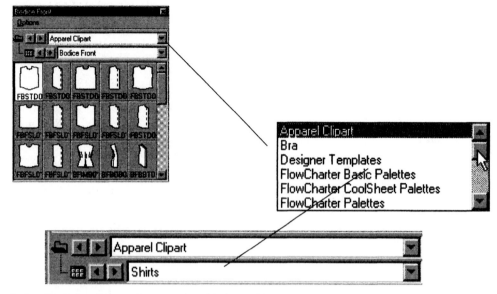

FIGURE 11-2 Clip art organized into collections.

FIGURE 11-3 Clip art organized by subject matter.

FIGURE 11-4 Clip art organized into files.

- Location of files
- Basic editing, i.e., select, resize, etc.
- Advanced editing (ungroup and direct select)
- Manipulating of nodes
- Miscellaneous thoughts on cut, add points, reshape curves, and more

ADVANCED

Skill Level: Advanced

Let's begin with several exercises designed to show you not only how to access clip art but how to modify it. The clip art we have chosen for this next section comes from the Gerber PDM program. This clip art can be used with a third-party program such as Micrografx Designer. These are great flats that are just perfect for a fashion designer. In fact, they are some of the most fashion-appropriate we have found. This clip art is great for creating worksheets similar to the ones you saw in Chapter 8 by Karen Kane Inc.

If you do not have access to this clip art, you may opt to follow along using any vector-based program and using vector-based clip art. Don't worry if your clip art is not fashion-related. The trick is to learn how to manipulate clip art, any clip art. Remember, these are exercises on clip-art concepts, not on how to use a specific piece of clip art.

These individual files are very easy to locate, access, and use.

Exercise 11-1 Locating and Accessing Clip Art

Software Used

Micrografx Designer and Gerber's PDM clip art

How-to Steps

1. Open a new file.
2. Click on the clip art icon (Figure 11-5) on the main toolbar.
3. Note that there are two different pull-down list boxes. The first is the main list of clip art; the second will have a sublist describing what is in the main list (Figure 11-6).
4. To select from each box, use the mouse to highlight and click.
5. To select clip art, click and drag (Figure 11-7) your selection from the list box directly to the blank document. You can then place handles or a bounding box to do basic modifications such as resize, rotate, and skew (Figure 11-8).

FIGURE 11-5 Clip art icon on main toolbar in Micrografx Designer.

FIGURE 11-6 Sublist describing what is in the main list.

ADVANCED

FIGURE 11-7 Click and drag your clip-art selection from the list box directly to the blank document.

FIGURE 11-8 Add handles or a bounding box to the clip art you have dragged to your document.

Special Notes

Name and version of software used: _____

List of additional steps you needed to take to execute the program that was specific to the software program that you are using: _____

Biggest challenge: _____

What you learned that was new, and special notes on what you want to always remember: _____

Miscellaneous thoughts: _____

Exercise 11-2 Editing Clip Art

Software Used

Micrografx Designer and Gerber (Ned Graphics) Artworks, PDM's clip art

How-to Steps

1. Make a clip art selection from the clip art list box.
2. Place a bounding box or handles around the clip art.
3. Begin to experiment by double clicking on various sections of the clip art.
4. You will begin to notice the different modes the handles take on. Up to this point you have only seen a series of eight solid color boxes around an object or the modify handles for resize, skew and rotate. As you now notice, the handles can take on several other forms (Figure 11-9).
5. When using this technique you may find that how this is accomplished varies from one software package to another. Frequently, you may need to break apart or ungroup the image. Be sure to check the handbook or help menu for your software.

Skill Level: Advanced

FIGURE 11-9 Different forms for handles.

More Handles

In this section we are going to introduce you to several new sets of handles. When using Micrografx Designer, you will find that additional handles are available for the fashion designer to use in the manipulating and editing process. If you are using any other program you may need to check your owner's manual or on-line help to check out their method of editing clip art. One simple generic method may be to try locating the options that will ungroup or break apart the clip art to isolate specific areas of the design.

In Micrografx Designer the handle transformations range from:

1. Solid line box (no handles) (Figure 11-10). This function isolates a specific portion of the clip art.
2. Solid line box with handles inside the perimeter of the box (Figure 11-11). This further isolates a portion of the clip art to add color or fills.
3. Series of open boxes. This will activate the individual nodes to reshape a specific section of the clip art (Figure 11-12). When you right click your mouse, additional menus will appear that offer you the ability to add, cut, or delete points, as well as to reshape points and curves.

Begin now to experiment with your clip art and make any additional notes you may require. You may opt to make notes on each transformation.

Additional Comments

Transforming these handles for the first time can be frustrating. It may remind you of how you felt the first time you learned how to drive a stick shift . . . ugh! Do you remember looking like a jackrabbit while driving? Or maybe you were the queen of stall. It doesn't matter, the secret is don't panic and get yourself all frustrated, or worse yet, think you are stupid, because you are not. It just takes some practice. These handles are accessed by a double click as well as by where you click your mouse on the object.

So take a few minutes to simply practice accessing the handles before you actually make any changes.

In the space below make any additional comments you might have for each of these techniques.

As you have just seen in Figures 11-9 to 11-12, the progression of the handles will take you through the process of isolating various sections of the clip art to make any necessary changes. In Figure 11-13, you see another transformation, the one used to edit the length of the sleeve.

FIGURE 11-10

ADVANCED

FIGURE 11-11

FIGURE 11-12

FIGURE 11-13

Special Notes

Let's do a quick review of the some of the changes you can make in your clip art:

a. Direct select
b. Isolate by sections for editing (ungroup)
c. Several edit options used: add or delete nodes and/or points
d. Reshape points or curves
e. Fill with color or pattern

Ok, now you try it!

Here we have provided ample room for you to jot down any notes or thoughts you might have on the concepts we have just covered. Be sure to include notes on the specific steps and techniques you needed to take based on the software and clip art you have available.

Special Notes

Name and version of software used: _____

List of additional steps you needed to take to execute the program that

was specific to the software program that you are using: _____

Biggest challenge: _____

What you learned that was new, and special notes on what you want to

always remember:

Miscellaneous thoughts: _____

As we go on into the next section, here are some additional ideas you may wish to consider. First and foremost, you may have noticed that the available clip art will not always suit your needs. However, you will soon discover that it is easier to edit existing clip art than to create the design from scratch. Why? Time! Many of you do not have the luxury of time to create your flats using the advanced drawing tools used in Chapter 7. Or maybe they were just too frustrating for you if you are new to all of this.

In the following examples we have shown you the sections and/or layers—the clip art logic—of how clip art was originally designed. From these examples you can determine if it is quicker for you to use the existing clip art or to create your own.

Figure 11-14 is an example of a basic bodysuit. But you are designing swimwear and need to render a "tank-ini"-style suit. Use a red pen to determine where you would split the suit in half (Figure 11-15). Then refer back to your notes in Chapter 7 on how you would split the suit in two.

FIGURE 11-14

FIGURE 11-15

Advanced Fashion Design Rendering Fabrics, Flats, and Prints

ADVANCED

Ok, how did you do? Want a few hints? We suggest you first use your invisible rulers to determine the best horizontal location for the split. Then, after accessing the node mode, use your right mouse button to make a cut or delete a point on both the right and left sides of the garment. Then use your right mouse button again to hit connect close.

For the top section, you need to add points. Again, move your invisible rulers up to where you want to add your points, click the right mouse button, and add and/or connect your points. When you are done your work should look something like Figure 11-16.

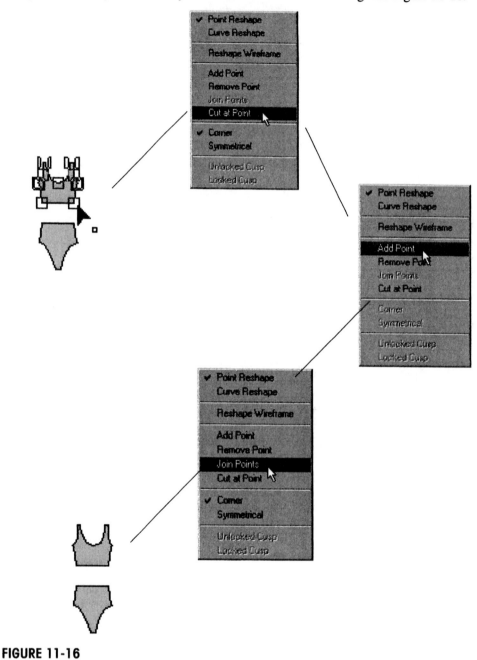

FIGURE 11-16

EDITING COMMONALITIES OF VECTOR-BASED CLIP ART, INCLUDING USING BGLA/SNAPFASHUN TECHNIQUES AND/OR SOFTWARE

These techniques are similar to the ones you will use when working with Bill Glazer and Associates' SnapFashun clip art that was mentioned in Chapter 9. If you recall, in Chapter 9 we

noted that SnapFashun disks can be used in conjunction with most vector-based software packages, for example, Micrografx Designer or Adobe Illustrator. Therefore, it is essential that the designer become familiar and comfortable with the basic editing functions we have been using in this section.

As you can see, applying advanced editing concepts to fashion or graphic art is universal to any vector-based program. Remember, vector-based illustrations are composed of objects that have one or more paths that have been created by a series of line segments, which all have anchor points.

Before you begin, be sure you are comfortable with the rendering process covered in Chapter 7. In addition, a complete overview, including file naming, saving, and transfer for exporting was highlighted in Chapter 5.

Special Notes

Now let's see how well you are able to apply this concept to other applications. Test your eye on the piece of clip art in Figure 11-17. Can you figure out the best way to modify a basic blazer?

1. Convert to a bolero.
2. Convert to a vest.
3. Convert to a waistcoat.
4. Shorten the sleeves.
5. Modify the collar
6. Add or delete details or trims.

Be sure you make notes on where and how you would do each modification. You may need to refer back to your notes in Chapter 7.

Special Notes

Are you beginning to see how to make good use of existing clip art? More important, as you experiment with breaking apart clip art, can you see the best or worst ways to create a vector-based drawing?

For many of you it may be just as easy to create your own flats from scratch, but believe me, for most, it is easier to modify what is already out there. One good suggestion for either method is to always make a copy of what you create or modify for use at a later date.

Another suggestion is to consider subscribing to a service that provides you with the latest fashion clip art. In our last chapter, on marketing the line, we will take a closer look at one such service—Snap Fashun by Bill Glazer and Associates. This fashion forecasting and design service will perform many similar functions to the techniques you have just mastered here using Micrografx Designer.

Applying Available Fills and Patterns to Clip Art

Now you have used simple vector-based clip art and you are ready to fill your flat with a print. Did you know that there are also premade pattern fills available to the designer? Before you dash off to render your own ideas, have a look at what may already be available for you to use and to modify.

As always, each of these techniques builds on the previous concepts you have been mastering.

The place we have chosen to start is with the pattern fill option found in most vector-based programs. We will be using Micrografx Designer pattern fill. These patterns are in a variety of locations depending on the program you are using. We suggest you look first

ADVANCED

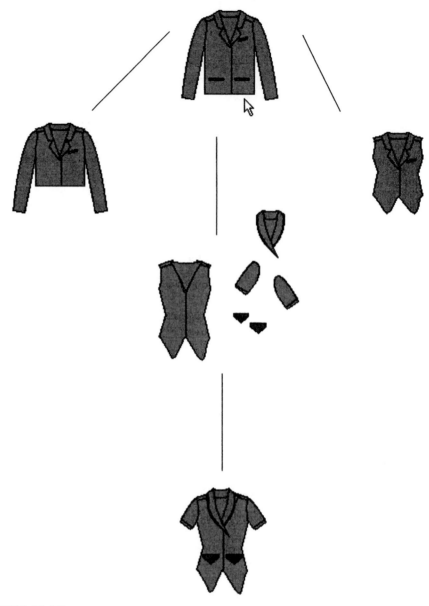

FIGURE 11-17

on your toolbox, then under the main menu bar at the top of your screen. If you are still having difficulty locating your selection of fill patterns, go to the help menu and check under the index.

Exercise 11-3 Locating and Working with Pattern Fills

Software Used

Micrografx Designer

How-to Steps

1. Open a new file.
2. Using the object-oriented drawing tool, make a square.
3. Select the square by making a bounding box.
4. Go to the Format menu and select Line Fill (Figure 11-18).
5. When the Object Format list box pops up, select Object (Figure 11-19).
6. Then select the Interior Fill dialog box; note the paint bucket icons on the left (Figure 11-20).

Skill Level: Advanced

FIGURE 11-18

FIGURE 11-19

FIGURE 11-20

Advanced Fashion Design Rendering Fabrics, Flats, and Prints

Special Notes

Name and version of software used: _____

List of additional steps you needed to take to execute the program that was specific to the software program that you are using: _____

Biggest challenge: _____

What you learned that was new, and special notes on what you want to always remember: _____

Miscellaneous thoughts: _____

Additional Comments

Figure 11-21 shows the steps to access these choices. Notice the list box in Figure 11-22 for choices. Also notice the edit button in Figure 11-23. Figure 11-24 shows the final submenu choices. We will explain these choices in more detail shortly.

Most of the choices in Exercise 11-3 are available in most vector-based software. We will give you a preview tour of the Micrografx Designer icon selections. In the screen shot for each of these choices you can clearly see what choices are available for the designer.

We suggest that you follow along if you have the software. Otherwise, go to your help menu on your software and search for comparable icons for each option in your software.

FIGURE 11-21

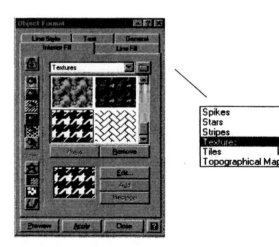

FIGURE 11-22

Skill Level: Advanced

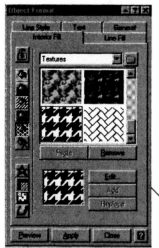

Edit... **FIGURE 11-23**

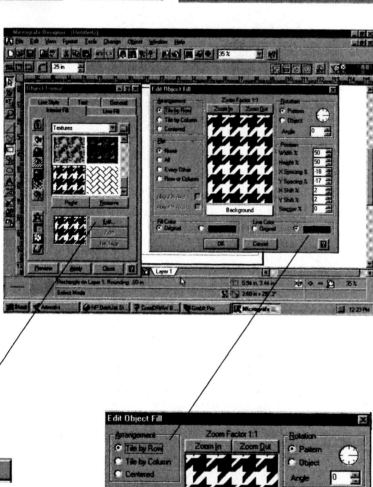

Edit...

FIGURE 11-24

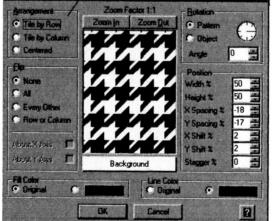

ADVANCED

Now we will take a closer look at each of these options and give you a chance to experiment with each of them and make any necessary additional notes. The main point you may wish to note is that there are a wide variety of submenus associated with this option. This means you must carefully explore the dialog box for additional choices. Sometimes the choices will be obvious dialogs, while others are more subtle, such as the one in Figure 11-25. Here is a pull-down menu with additional color selections for you to make.

Figure 11-25 represents solid color.

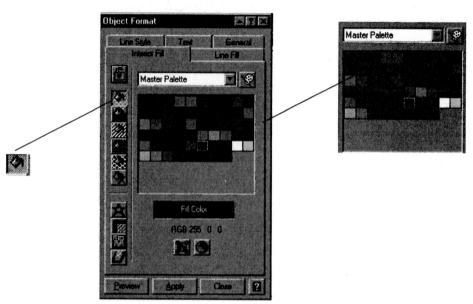

FIGURE 11-25

Special Notes

Figure 11-26 represents gradient fill.

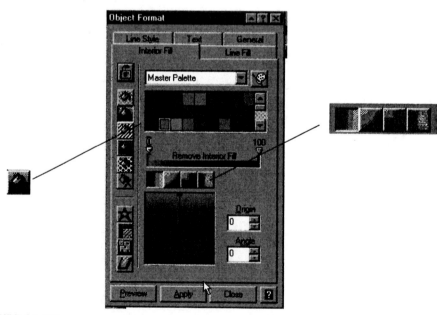

FIGURE 11-26

Skill Level: Advanced

Special Notes

Figure 11-27 represents hatch (line) fill.

FIGURE 11-27

Special Notes

Figure 11-28 represents image fill (limited edit options).

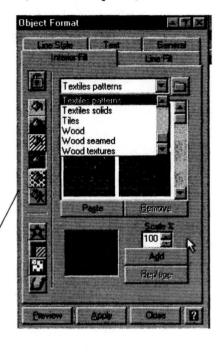

FIGURE 11-28

Special Notes

Figure 11-29 represents pattern fill (multiple edit options).

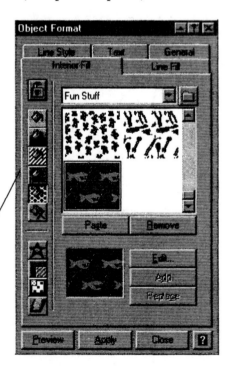

FIGURE 11-29

Skill Level: Advanced

Special Notes

By now you are beginning to see the practical uses of these options for rendering fabric. Next, you will notice several of the preliminary modifying options you may have available to use. Many of these techniques will be familiar because you have used them in your earlier basic design exercises (Figure 11-30).

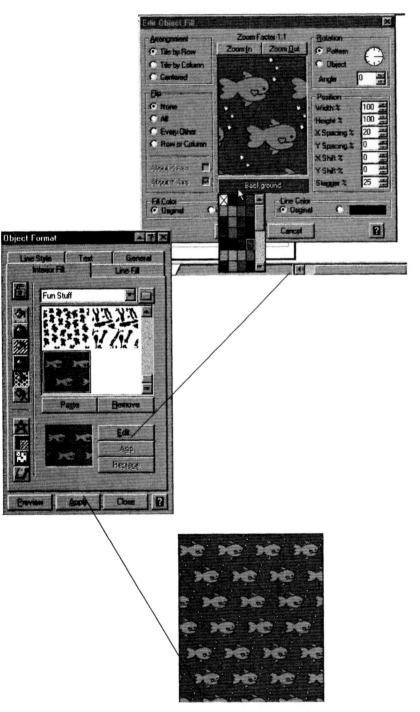

FIGURE 11-30

ADVANCED

Options to Modify a Pattern are:

1. Arrangement of the pattern repeat or isolate the motif
2. Fill the motif
3. Change the fill color
4. Change the line color
5. Change the background color
6. Rotate the pattern
7. Scale the pattern
8. Preview
9. Apply
10. Obtain help

Exercise 11-4 Applying, Editing and Modifying Pattern Fills Common to Most Vector-Based Software

Software Used

Micrografx Designer

How-to Steps

1. Open a new file and make a simple square with the object-oriented drawing tool, or choose a piece of black-and-white clip art to fill.
2. Open the format interior Fill menu.
3. Select the fifth paint bucket icon.
4. From the pull-down dialog box, select from the Miscellaneous menu (Figure 11-31).
5. Using the scroll bar, select a pattern.
6. Select OK to apply.
7. Begin to select and preview several of the patterns.
8. Make notes as you compare and contrast the changes to the first (original) pattern and the modified pattern. At this point, only add the pattern fill, do not experiment with editing the pattern fill.

Fun Stuff
Miscellaneous
Nature
Optical Illusions
Rocks & Minerals
Spikes

FIGURE 11-31

Special Notes

Name and version of software used: _____

List of additional steps you needed to take to execute the program that was specific to the software program that you are using: _____

Biggest challenge: _____

Skill Level: Advanced

ADVANCED

What you learned that was new, and special notes on what you want to always
remember: _____

Miscellaneous thoughts: _____

Now we are ready to take a closer look at the edit options. This feature will come in
handy when you are designing your own patterns. In Figure 11-32, notice the choices you
have to modify a given pattern, such as:

- Change line and interior fill colors
- Rotation
- Skew
- Flip
- Arrange
- Axis
- Position
- Zoom
- Help

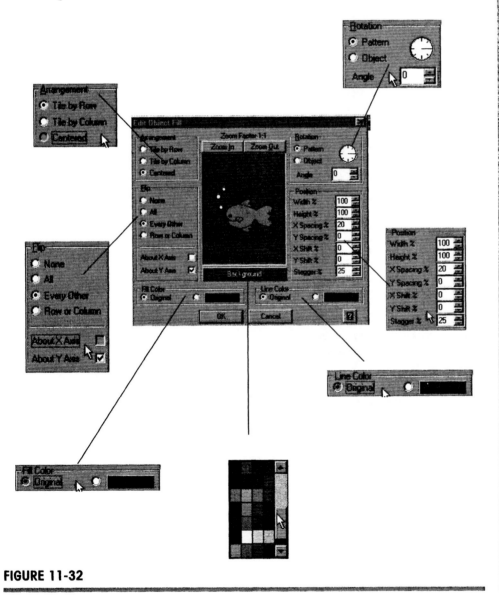

FIGURE 11-32

ADVANCED

The Basics of Editing Any Pattern or Motifs for Fabric on Vector-Based Software

In this section you will be using the basics of working with a pattern motif. The pattern can be isolated as a single motif or repeated in an almost endless series of alternatives. However, before you begin to modify your patterns, you must be familiar with several basic concepts that will have a great impact on the success or failure of your prints. You probably learned many of these concepts in a design basics class. Here is where you put those concepts into practice.

Take a minute to review these important concepts before moving on.

DESIGN LINES AND PRINCIPLES

Lines
- Straight, curved, broken, or bent
- Thick or thin
- Vertical, horizontal, diagonal, zig-zag, or ogee (S-shaped)
- Convey mood, movement, add or subtract weight, form silhouettes, guide the eye and/or create optical illusions

Proportion
- Pertains to scale
- Size
- Ratios
- Can be pyramid, step, repetitive, or zigzag

Balance (Equilibrium)
- Formal
- Informal
- Symmetric
- Indicates weight, quantity, and force

Emphasis
- Focal point by use or manipulation of color, line, shape, contrast, texture, movement, including intensity, optical center and/or object placement or detail

Rhythm
- Repeat of lines, colors, or trims
- Variations of repetition or flow
- Can be equal, continuous, graduated, progressive, linear, and/or radial

Harmony
- Unity of all the elements to convey message such as lines, shapes, size, color, texture, idea, or theme

Understanding these concepts and mastering print repeats is at the heart of fabric designing. Toward the end of this chapter we will put to good use these concepts as we begin to work with some of the industry software available. We are sure you will want to refer back to this section often as you begin to create and modify a motif.

Exercise 11-5 Modifying and Editing a Pattern Fill

Software Used

Micrografx Designer

Skill Level: Advanced

How-to Steps

1. Open a new file, using the object-oriented square icon.
2. Draw a box, and open the Fill Format option as listed in Exercise 11-2.
3. Select Edit button.
4. Proceed to experiment with the following options (Figure 11-33).
 a. Arrangement option
 b. Flip
 c. Fill and line color
 c. Rotation
 e. Position
5. Apply your selection and make any necessary notes.

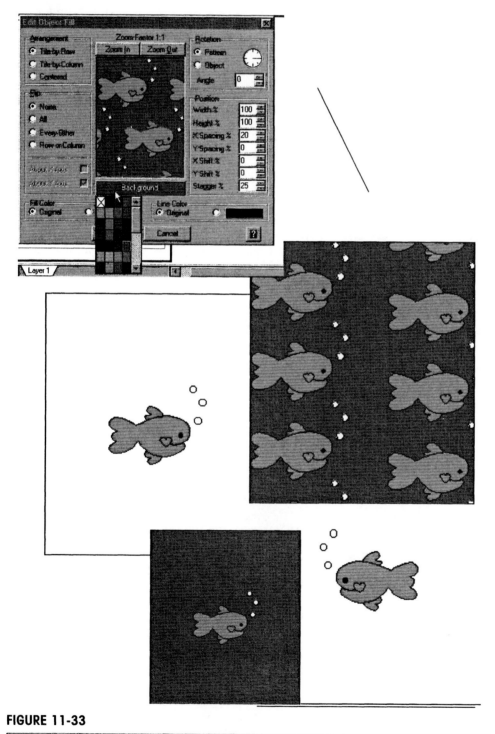

FIGURE 11-33

ADVANCED

Additional Comments

We suggest you make several other boxes and repeat the process, giving each box a different combination of chances, and record your notes for future reference. We have provided ample space for you to make any notes you may need.

Special Notes

Name and version of software used: _____

List of additional steps you needed to take to execute the program that was specific to the software program that you are using: _____

Biggest challenge: _____

What you learned that was new, and special notes on what you want to always remember: _____

Miscellaneous thoughts: _____

The exercises you have just completed represent just one method of pattern-design manipulation for the fashion designer. There are several methods a designer has to choose from, as well as several types of programs available to accomplish the task.

The big advantage of using pre-made vector-based clip art and pattern fills is obvious—Why reinvent the wheel?

Other Techniques Useful in Rendering Motifs and Patterns for Commercial or Industrial Vector- or Raster-Based Software

So, that is where I got my name from...I always thought it was because of my lightning speed!

In this section we will make the transition from working with clip art and patterns to several advanced techniques you may opt to explore for the rendering of fabric and prints. The topics will include:

- Scanning
- Using a Zip drive for larger files
- Using the trace option
- Creating or rendering a motif
- Converting a single motif into a repeat motif that can be used for prints
- Identifying and working with the basic repeats used in prints
- Working with layers
- Modifying prints with the use of filters found in Adobe Photoshop

Each of these techniques can be applied to the creation and rendering of fabric and/or prints. As always, we will be using both vector- and raster-based software that are either commercial or industrial software packages.

Working with Large Files to Design Patterns or Prints
So How Will You Know If You Need a Zip Drive?

Let's take some time to determine how you will know just how big your file actually is and how to store those larger files on a Zip drive. Did you notice in Exercise 11-1 that there was a section where you made note about you file size? Frequently, when you are

Skill Level: Advanced

working with realistic images they will require a larger amount of storage space on a disk or hard drive. For this reason we need to know how much memory is needed to fill a typical floppy disk and how much memory is available using a Zip drive.

Knowing when and how to use a Zip disk can make all the difference. This is especially true if the file you need to share with another user in the design process is too large to fit on a regular floppy disk.

In our next exercise we will show you another method of determining the size of your file. Once you know your file size you will have the option to use a Zip drive to store your work.

It is important to note that there are several ways to limit the size of your file. In our final chapter, on marketing your designs, you will hear from experts several other methods available to you. As in prior chapters, we are building a firm foundation for you to better comprehend the concepts before you actually go out to meet these challenges head on.

When you are working with larger files, there may be occasions when you encounter some unexpected difficulties. One such difficulty we mentioned over and over again was file size. Typically, when you are working with raster images you will need sufficient room on your disk to save these files. If you recall, we have certainly stressed the fact that making a backup is always a good idea. And most larger image files will consume valuable memory space on your computer.

For some, space on the hard drive is not an issue; for others, who are working either in school or in-house on the job, files will be stored on the network. But what if space is an issue and you do not have a network or you need to transport a larger file for some reason. What do you do if your traditional disk is not large enough?

What Do You Do If Your Work Is Too Large for a Traditional Floppy Disk?

For those of you working exclusively in a vector-based program, you are not exempt from the problem of file size. Sometimes you will find your files are too large to place on a floppy disk. In cases of both vector- and raster-based images, you may need to store your files using a Zip drive. Zip drives are great for large files. Some computers come with a build-in Zip drive, while most computers use an external or portable Zip drive.

Exercise 11-6 Determining a File Size Using Any Computer Software System

Where to Locate File Size

The following are the most common ways to determine the size of a given file:

- Scanner software will typically indicate the size of the file prior to placing the image into another program.
- My Computer on the Microsoft Windows Program will indicate the size of a given file, after the appropriate drive and file have been selected.

Special Notes

Name and version of software used: _____

List of additional steps you needed to take to execute the program that was specific to the software program that you are using: _____

Biggest challenge: _____

What you learned that was new, and special notes on what you want to always remember: _____

Miscellaneous thoughts: _____

ADVANCED

USING A SCANNER FOR DESIGNING FASHION

We are ready to break stride a bit and begin to talk about scanning. You might be thinking, What does scanning have to do with clip art and or designing a motif? Surprisingly, it can actually mean a lot, as you will soon see.

As always, whenever we are introducing new concepts we will begin by covering the basics of scanning and how it pertains to creating your own clip art images.

What Is Scanning?

Scanning is taking an original and converting it into a digital image for use on the computer. Although the size, price, and quality of scanners may vary, like anything else you will discover that they each operate in basically the same fashion. For this reason, we have kept our instructions very general so that you will easily be be able to follow along, regardless of the scanner you are using. So naturally your next question should be, Are there special terms with which I must be familiar in order to scan? Absolutely. In the terms listed below, you will discover that much of what was covered in Chapter 10 on color will begin to make even more sense to you. Take a moment to review these terms.

Scanning Terms

B/W: Black-and-white image or drawing

Brightness: Setting the overall whiteness of an image

Contrast: The difference in things being compared. For example, dark and light

Dithering: Creating dots to fool the eye into seeing shades of gray

DPI: Measurement of an image's resolution

Grayscale: Range of grays from white to black

Halftone: Using dot patterns to make black-and-white images appear to have shades of gray

Image: Usually a photograph that is translated into a bitmap image by scanning

Image type: Could refer to the options of B/W, gray, or color

Original: Art, photograph, transparency, or other item to be scanned

Pixel: A single dot on a monitor or on a digital image

Previous size: Used to control the size of an image to reduce size and or scanning time

Resolution: Measuring the fineness or detail of an image—the higher the resolution the finer the detail

Many of these terms should sound familiar. We discussed them in Chapter 10 when we covered the topic of color. In the next exercises you will see how many of these terms and concepts interrelate in fashion design on computers.

How Do I Scan?

Glad you asked! In the following exercise we will walk you through the basics of using a scanner. There are several great scanners available today, and thanks to constant leaps forward in technology, the prices for a good scanner are surprisingly reasonable.

Please note that the scanner you may have will usually have the same features used in our exercise, so you should have no problem following along.

We have provided a simple line drawing of a croquis for you to use in our exercise (Figure 11-34).

ADVANCED

By Yannique Rickards

FIGURE 11-34 Croquis provided by Yannique Richards and used with permission.

ADVANCED

Exercise 11-7 Basic Scanning: Black-and-White Drawing

Hardware and Software Used

UMAX Astra 1200S and Adobe Photoshop

How-to Steps

1. Trace the black-and-white drawing we have provided in Figure 11-34 with a fine black marker or ink pen. Place the drawing face down on your scanner.
2. From Adobe Photoshop, select Import.
3. Now select Twain_32 Source (Figure 11-35).
4. You will now see the UNMAX interface. Select Preview (Figure 11-36).
5. Make any necessary adjustments. (See "Additional Comments" before proceeding to step 6.)
6. Select Scan.
7. Exit the Scanning program.
8. Now you are ready to enhance or make additional editing modifications in Photoshop to suit your needs.
9. Be sure to name and save your scanned work in Adobe Photoshop as a TIF file.

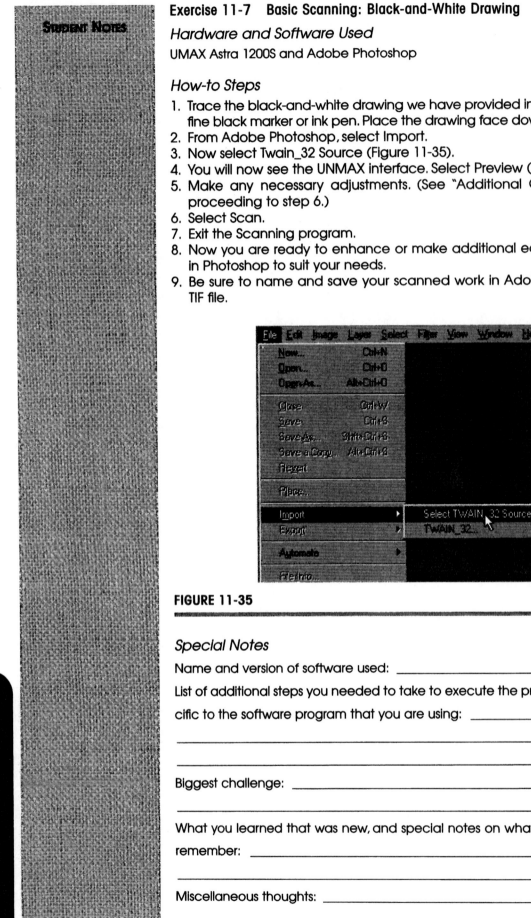

FIGURE 11-35

Special Notes

Name and version of software used: _____

List of additional steps you needed to take to execute the program that was specific to the software program that you are using: _____

Biggest challenge: _____

What you learned that was new, and special notes on what you want to always remember: _____

Miscellaneous thoughts: _____

Skill Level: Advanced

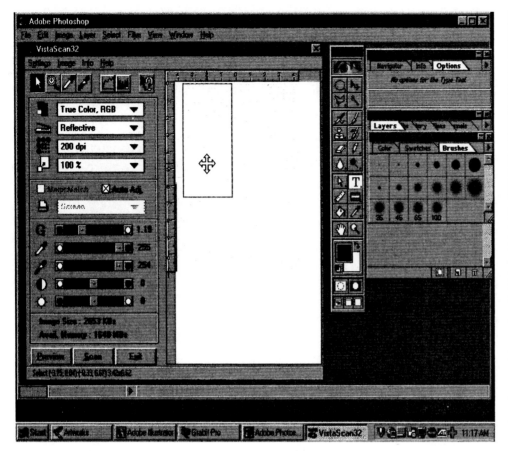

FIGURE 11-36

Additional Comments

You may have noticed that you have several options to edit your image, such as color mode, resolution, and size. These options and their layout may vary from scanner to scanner (Figure 11-37). However, most scanners offer these options. Take a moment to experiment with your options and then make any additional notes you might want in the space below.

FIGURE 11-37

ADVANCED

Color Mode Selection (Figure 11-38)

FIGURE 11-38

Special Notes

Resolution (Figure 11-39)

FIGURE 11-39

Special Notes

Skill Level: Advanced

ADVANCED

Image Size (Figure 11-40)

Special Notes

File Size (Figure 11-40)

FIGURE 11-40

Special Notes

Other Options (Figure 11-41)

FIGURE 11-41

Special Notes

Be sure to go back to step 6 at this point before moving on to the space provided for the rest of your thoughts on Exercise 11-7.

Exercise 11-8 Scanning a Photograph

Hardware and Software Used

UMAX Astra 1200S and Photoshop

How-to Steps

1. Place the photograph provided in Figure 11-42 on the scanner bed.
2. Follow steps 2 to 8 from Exercise 11-7.

ADVANCED

FIGURE 11-42 Photo of Robin Lenart taken by Doug Hicks.
Used with permission.

Skill Level: Advanced

3. Later in Photoshop you will have the ability to enhance or edit the image—things like lengthening the dress, making the eyes blue, and even changing the pattern of the garment. We will have you doing just this in Chapter 14.
4. Name and save as a TIF file.

You may opt to use your own color photograph for this exercise. The photo needs to be at least 7 inches high. We will give you the opportunity to use this photo again in Chapter 14.

Special Notes

Name and version of software used: _____

List of additional steps you needed to take to execute the program that was specific to the software program that you are using: _____

Biggest challenge: _____

What you learned that was new, and special notes on what you want to always remember: _____

Miscellaneous thoughts: _____

Challenge Exercise 11-9 Scanning Fabric

Hardware and Software Used

UMAX Astra 1200S and Photoshop 5

How-to Steps
1. We suggest you scan in black and white for your first attempt. There are several reasons: the most important are disk space and file size.
2. Be sure to press the fabric as smooth as possible to lay flat on your scanner bed before beginning the scanning process.
3. Follow the steps in Exercise 11-7.
4. Record any additional steps or challenges you may have encountered.
5. Jot down any additional thoughts for several different applications for this file.
6. Save as a TIF file.

Additional Comments

You can edit your fabric for a variety of different uses. For those of you already comfortable with this concept, feel free to scan in color and reduce the number of colors. Later you can opt to use this file in conjunction with the draping technique covered in Chapter 14.

Special Notes

Name and version of software used: _____

List of additional steps you needed to take to execute the program that was specific to the software program that you are using: _____

ADVANCED

Biggest challenge: _____

What you learned that was new, and special notes on what you want to always remember: _____

Miscellaneous thoughts: _____

Below we have included a list of scanning tips that you will want to refer back to later.

SCANNING REFERENCE CHARTS:

Scanning Black-and-White Line Art

- Keep drawings crisp and clean, use a fine-tipped felt pen.
- Scan in black-and-white drawing mode, and use 150 to 300 DPI resolution.
- Always save as a TIF file.
- Unless drawings are for use in a catalog, they may require additional considerations such as: Converting the file from grayscale to RGB, file format, size, storage and hardware requirements, platforms to be used, file transfer considerations, and other miscellaneous editing needs.
- Other considerations are overcome by practice and by seeking out expert advice.

Scanning Photographs:

- Pay attention to color settings that describe the type of photograph to be scanned.
- Typically for color photographs, you will use sharp millions of color.
- Usually 300 DPI resolution will suffice. Remember, the better the resolution, the larger the file size, the bigger the storage capacity needs to be.
- Typically you will always save as a TIF file.

Scanning Fabric or Other Miscellaneous Images

- Be sure to determine the appropriate color setting
- Be prepared: some files may require you to limit the number of colors to be used. This is one area where you may want to seek out expert advice as well as experiment with and/or practice on.
- Usually, 150 DPI resolution is sufficient. Don't forget, the larger the DPI, the larger the file size.
- Save fabric scans as TIF files.
- Take the time to learn to use all the tools in Adobe Photoshop to manipulate color. Don't be afraid to experiment and practice. There are, however, other great shortcuts, such as: use the filters menu in Adobe Photoshop to clean up your fabric; surprisingly, these filters such as Blur or Noise can actually help you work smarter.
- Make additional notes here every time you learn something new about scanning.

Special Notes

We have opted not to include the advanced instructions for color reduction in this particular edition. However, most of the image-editing software you will be using does offer this and you may consult your owner's manual for more specific instructions on this concept.

THE TRACING TECHNIQUE

So far so good. You have worked with basic patterns, clip art, scanning, and file size. Now we are ready to try some additional challenges using clip art.

The next technique we want to introduce you to is tracing. As my students would say, "This is really cool!" This technique will automatically trace an image. Ah yes, computers are our friends! But before you think "Hey, that's cheating," you can't say you haven't been thinking about how to use that Bezier pen and mouse to draw like you could by hand!

I shudder to think about every time I have taught that section of the book—the murmuring and whining I'd hear from students who were impatient with the learning process or themselves. Of course, we all want to be instant experts, that is why I promise there will be no whining from you on this section! You will find that this technique is not only easy, but fun to use!

By using the trace option, you will discover a variety of ways to enhance your work, even if you haven't mastered the compound line drawing! Here's where knowing how and when to scan comes into play.

At last you can use the rendering you have created by hand, yes—your hand—and transfer those drawings into the computer. Or you can incorporate a photo and make it appear like a rendering by hand. Imagine the possibilities!

Before we begin to show you how to trace, we need to take a few minutes to review the kinds of images you might be tracing.

Remember the term *bitmap*? These pixel images can now be converted into a vector-based image that will closely resemble the original. So you are thinking, "And the point is?" Again, if you recall, vector images are cleaner, smoother in appearance, and take up less disk space, as well as taking less time in print processing.

Although a variety of images can be used, you will soon discover that the tracing technique is best suited for simple shapes and lines, including the ones you drew by hand.

Tracing Using Vector or Raster-Based Software

We have selected two exercises on tracing, one in Micrografx Designer and one in Fractal Design Painter. Consult your software to see if you have this optional available—most do.

The first is a black-and-white bitmap image traced in vector-based software. The second is a color photograph bitmap image.

Exercise 11-10 Vector-Based Tracing—Preparing to Trace a Black-and-White Image

Software Used

Micrografx Designer

How-to Steps

1. Open a new file.
2. Under the View menu choose Toolbars (Figure 11-43).
3. Under the preferences menu be sure the ribbon option has been toggled on. This is indicated by a checkmark.
4. We will stop here. Make notes below on your steps up to this point.
5. Because the tracing concept is similar in most vector-based programs, we will stop here to go over several of the commands, icons, and options associated with tracing.

ADVANCED

FIGURE 11-43

Special Notes

Name and version of software used: _____

List of additional steps you needed to take to execute the program that was specific to the software program that you are using: _____

Biggest challenge: _____

What you learned that was new, and special notes on what you want to always remember: _____

Miscellaneous thoughts: _____

Before we begin to do the steps we need, take a minute to acquaint yourself with the toolbox and toolbar options you will be using (Figures 11-44 to 11-47). The first is the image tool icon. When this has been activated, it will pop-up on the toolbar.

These icons will permit you to begin the tracing process as well as define the trace quality, line type, and number of colors (available on most vector- and raster-based programs).

Make notes in the space provided about differences in options or locations of options in your software.

ADVANCED

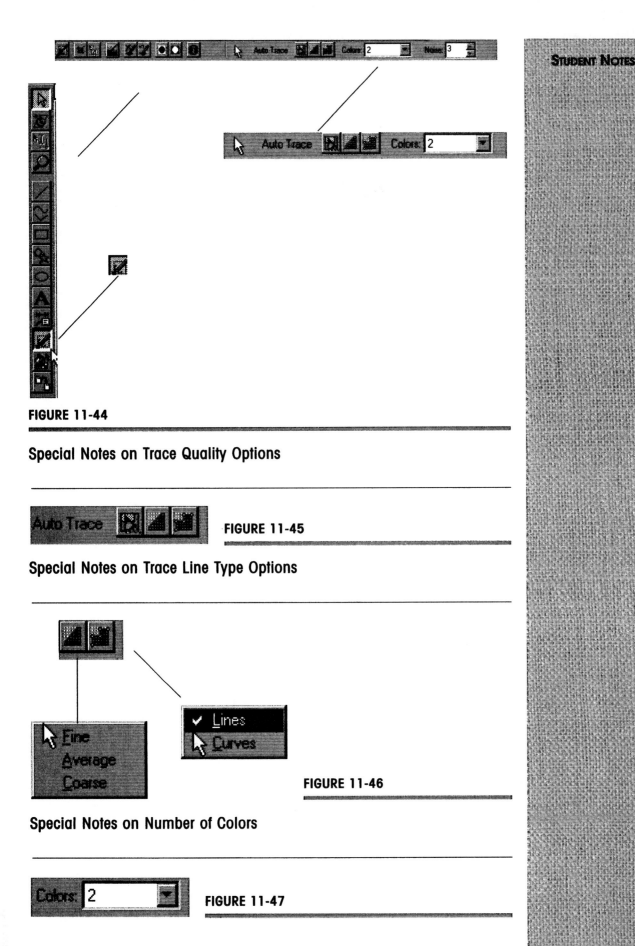

FIGURE 11-44

Special Notes on Trace Quality Options

FIGURE 11-45

Special Notes on Trace Line Type Options

FIGURE 11-46

Special Notes on Number of Colors

FIGURE 11-47

Now you are ready to complete the tracing we started in Exercise 11-10.

ADVANCED

Exercise 11-11 Tracing a Black-and-White Image

Software Used

Micrografx Designer

How-to Steps

1. Go to the main file menu and select Import (Figure 11-48).
2. From the dialog box, select My Computer.
3. Go to Gerber C and/or select Designer Folder.
4. From the Designer Folder, select the Tutorial Folder.
5. Select Duck.tif, and click OK (Figure 11-49).
6. Go to the trace icon on the toolbar.
7. For our purposes, select File Line Quality, Line Style, and 2 Color by clicking on each of the available icons or list boxes.
8. Using the mouse, draw a marquee around the image (Figure 11-50).
9. Now, wait, don't do anything. There will appear a small moving box in blue and yellow on the lower right of your status line. This indicates that the tracing is taking place. You must wait until the trace is complete before moving on to the next step.
10. Once the trace is complete, use you mouse to lift and move the traced image off of the original image (Figure 11-51).
11. Delete the original image. You are now ready to insert or manipulate the new image as you would any other vector image.

FIGURE 11-48

FIGURE 11-49

Skill Level: Advanced

ADVANCED

FIGURE 11-50

FIGURE 11-51

Special Notes

Name and version of software used: _____

List of additional steps you needed to take to execute the program that was specific to the software program that you are using: _____

Biggest challenge: _____

What you learned that was new, and special notes on what you want to always remember: _____

Miscellaneous thoughts: _____

Exercise 11-12 Tracing a Color (Complex) Image

Software Used

Metacreations' Painter

How-to Steps

1. Open a file.
2. We suggest you select the file located in painter tutorial entitled "Geisha.jpg" (Figure 11-52).
3. From the File menu, select Clone. This will make a copy of the image.
4. Once your new image appears, you may delete the original image.

ADVANCED

FIGURE 11-52

5. Choose, Canvas Option and then select Tracing Paper (Figure 11-53).
6. The tracing paper icon will be located on the vertical scroll bar on the upper right side of the desktop document.
7. You can now manually trace the image using the mouse and any of the drawing tools from the toolbox. We suggest a pen or pencil.

FIGURE 11-53

ADVANCED

Additional Comments

In step 5, don't panic if your image appears shadowy or ghost-like in appearance. This is the way it should look at this point.

Special Notes

Name and version of software used: _____

List of additional steps you needed to take to execute the program that was specific to the software program that you are using: _____

Biggest challenge: _____

What you learned that was new, and special notes on what you want to always remember: _____

Miscellaneous thoughts: _____

Tips on Tracing Bitmap Images

Now that you have practiced the tracing technique for yourself, here are just a few tips on what you can do with your traced bitmap images:

- Insert complex images to add excitement and depth to your presentations
- Use your bitmap image as a background
- Create a library of your own drawings as clip art

You may be wondering, "What are complex images?" Typically, photographs are considered complex images because they are frequently in color or because they may have a large number of anchor points associated with them. Anchor points can cause the image to appear blurred or fuzzy. Therefore, they may require some additional editing to decrease the number of points or colors in the image. The end results are worth it, because many fashion designers prefer to use photographs to enhance their documents or storyboards.

Additional Editing Comments: Dealing with Anchor Points

Should you need to insert complex images, we recommend using the pencil or pen tool on your computer to add a fine point size to the image when tracing. This will streamline the appearance of your image.

Another way to simplify your complex image once it has been converted by the tracing process is to delete some of the excess anchor points. Sound familiar? We covered the basic concept of anchor point technique in Chapter 7 in an attempt not to overwhelm or overload you with too many complex concepts all at one time.

Here, you should be able to see this technique in context. Now can you see the big picture of using this vector-based concept? It helped to build on elementary concepts slowly before moving on to more complex applications in order to reinforce the importance of this technique.

Finally, don't forget to use the editing tools and zoom option to clean up any stray pixels.

ADVANCED

One last thought on complex images. Due to the complexity of colors found in some images, we suggest that during the scanning process you consult your owner's manual on how to reduce some of the colors on images. This can avoid potential problems when you get to the tracing process for the image.

Wow, can you believe how far you have come in learning to create fashion on your computer? But we are not done yet. There is still more to come. Hopefully, your mind is going 90 miles an hour dreaming up all the things you can now create on the computer. In no time you will be putting all that creative energy to good use.

Before we move on to the next phase of design, designing fabric, we want to take a moment to remind you that although you have a grasp of just what the computer can do for you, we strongly suggest (again) that you continue to practice, practice, pratice!

While you are practicing and experimenting with some of the concepts and options you discover on your software, be sure to go slowly. Take notes. If things aren't going well, stop and work on something else. Make yourself take a break.

I can't tell you how often I will watch students in the classroom who think they are being persistent when in fact what they really are being is stubborn. They keep trying to figure it out, when all they are really doing is putting the wrong steps in their memory bank.

Now you may be thinking, "Hey you said start to use your critical-thinking skills and think like the computer." Isn't that a contradiction? Not really, what we meant by that was that as you get to know your computer and your software, you will discover that your software will typically perform certain functions or operations almost always similar in fashion. Knowing this will enable you to apply your critical-thinking skills based on previously learned concepts to determine the best way to meet a new challenge. However, if you hit a brick wall in the process of applying that knowledge, and you find that you are performing the same wrong steps over and over, Stop! Don't get frustrated by attempting to make something work that will not work. To do this is akin to banging your head on that brick wall. Take a step back and take one of those suggestions we just gave you.

Back to our old faithful car analogy. By now you have begun to see that working on computers is like driving. In fact, if you are used to driving one car and then switch to another car, you may have noticed that each car may have an entirely different feel in its gas or break pedals. You may hit the gas on one car and the next thing you know you are going 90 mph, while the other car may require you to use heavier pressure to get the car to begin to accelerate.

Sometimes, what worked in one software program may not work in the same fashion on another. So, slow down; pause between steps; ask yourself, "Am I doing what the steps say to do?" or "Am I driving too fast and overlooking the obvious, missing steps that would help me to accomplish the task?"

As frustrating as computers are, the fact is most of the time unless you have a glitch, the computer is always right, and you're wrong. Wrong because you didn't tell the computer what do or when to do the step.

So, one more time, here we go. Some more rules to follow:

- Save in versions, or save after every time something goes right.
- It is easier to reopen a version of the last correct step taken than to mess up what was right and not have a way to salvage it.
- Remember there is always Undo or Help or that good old standby of swallowing your pride and asking someone for help.
- Take a break if it is not going well, or move on to something you can do easily.
- Take good notes and refer to them.
- Practice each exercise one at a time and take time to review what additional steps you needed.

- Ask yourself, What is the easiest way to accomplish this task with the least amount of stress? Then do it!
- Don't reinvent the wheel. The most complex design made with the most difficult steps dosen't always produce the best results. For example, if you can't master a Bezier pen, draw the image and scan it, or modify a piece of clip art that is similar to what you had in mind. There is a difference between excellence and perfectionism.

Hey, didn't I warn you that I am a teacher and a mom? So take the advice, it comes from the heart. Why drive yourself crazy? Avoid the potholes, and learn to enjoy the ride.

USING INDUSTRIAL SOFTWARE FOR PRINTS

Before we move on to using industrial software to design prints, we have one last resource we'd love to share with you. While doing our research we came across a CD that is based on a book many of you might be familiar with, *Textile Designs,* by Susan Meller and Joost Elffers (New York: Harry N. Abrams, 1991). Many of us have this book in our libraries as a resource. It is a compilation of surface print images that can be scanned and used in Photoshop. Now there are several different sections of the book that are being sold on CD. These CDs can be opened and edited by fashion designers for a wide variety of different applications.

We have included some great samples in our final section on surface design. These samples come directly from Ms. Meller's CD, *Textile Designs.* We will be using the CD based on the floral patterns. This CD contains 496 patterns that can be accessed for some of the modifications we have explained in several of our exercises. This CD works as a stand-alone or in conjunction with Photoshop.

The best part of owning this CD is that it provides the designer with another resource for patterns that are royalty-free.

In Figures 11-54 to 11-57 we show you the basic steps for opening the *Textile Design* CD. Figure 11-54 is the main screen. Figure 11-55 is the main menu of prints by category. Figure 11-56 is an example of those prints and how to select them with the mouse and use the download icons (either low- or high-resolution) to download the file to your disk or desktop. Figure 11-57 is an example of a print that was enhanced in Adobe Photoshop.

Now we will round out your trip with a quick tour of designing and modifying prints for fabric using industrial software. You will be using the concepts covered earlier in the chapter on the importance of working with scale, drop, and repeat of prints. This was followed by an introduction of how to accomplish these techniques using Micrografx Designer software. We will conclude the chapter with several exercises on industrial software designed to give you a more in-depth grasp of designing prints for fashion.

As always we ask you to bear in mind there is a wide variety of other comparable software products available for you to choose from that will perform the same or similar functions.

We have elected to start with StyleClick (ModaCad) Textile Suite for Windows and Adobe Photoshop. We found this software package extremely user-friendly. This software from StyleClick (ModaCad) is a complete suite of software that performs a wide range of functions that are useful for the fashion designer. We will concentrate our exercises on the Textile Repeat Generator Plug-In Software by StyleClick (ModaCad).

ADVANCED

FIGURE 11-54 Main screen of the *Textile Design* CD. (Software courtesy of Susan Meller c/o info@designs-library.com)

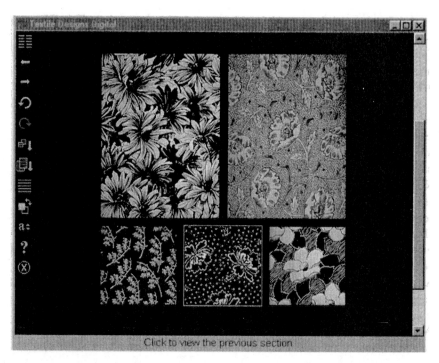

FIGURE 11-55 Main menu of prints by category from the *Textile Design* CD. (Software courtesy of Susan Meller c/o info@designs-library.com)

Skill Level: Advanced

FIGURE 11-56 Example of the prints and how to select them from the *Textile Design* CD. (Software courtesy of Susan Meller c/o info@designs-library.com)

FIGURE 11-57 Example of a print from the *Textile Design* CD that was enhanced in Adobe Photoshop. (Software courtesy of Susan Meller c/o info@designs-library.com)

ADVANCED

Understanding Prints

As part of a more in-depth look at prints and creating a repeat, we will continue our discussion of fabric prints to better acquaint you with the concepts and terminology used. The term *repeat* implies a design that is repeated within a print for use on the fabric. The basis of a repeat pattern is that the design or motif repeats itself across the surface of the fabric. Each repeat typically begins with a single motif (Figure 11-58). In order to be considered a repeat, the design must repeat and flow or follow itself, without any breaks in the pattern.

These patterns or repeats can be considered continuous; that is, every object that optically goes off the top and the right must continue on to the left and the bottom (Figure 11-59).

Another common version of a pattern is a straight repeat. Again, this is a continuous repeat of the motif (Figure 11-60).

Pattern can be also be described by the amount of drop in the repeat of the pattern. For example a half-drop describes the amount of drop in the pattern that follows the original (Figure 11-61).

Another simple variation is a mirror, which takes the original pattern and flips it to be an exact reflection or mirror image of the original (Figure 11-62).

The above list cover is merely a sampling of the basic variations a print can take. There are many other variations and combinations a designer might choose. Before long you will soon discover that half the fun is experimenting.

FIGURE 11-58　Pattern repeat.

FIGURE 11-59　Continuous pattern repeat.

Skill Level: Advanced

FIGURE 11-60 Straight pattern repeat.

FIGURE 11-61 Drop pattern repeat.

FIGURE 11-62 Mirror pattern repeat.

ADVANCED

Typically, the most common variations are done by degrees or in percentage increments. You will be doing this later in our industrial-based software exercises using the StyleClick (ModaCad) software. StyleClick (ModaCad) offers a wide variety of options to accomplish these design changes in the dialog box of the Repeat Generator option and using the layers option found in any raster-based software.

This is the perfect opportunity to become more familiar with the use of layers. Understanding this technique's advantages will actually increase your creativity and design potential.

The Importance of Using Layers

Up until this point you have been reminded to save in versions the files you have been working on. However, there is another important concept or option for designers to use—layers. The layers option will permit you to work on your fabric print ideas in saveable layers that can be altered individually to suit your needs. This technique permits you to experiment with ideas and compare them before choosing a final outcome for your design.

Perhaps you noticed the layers option in your software when you were working on the exercises in Chapter 6. Now you are ready to use this concept to your best advantage when designing prints for fabric.

This technique will allow you to view a floral with a striped background by using the layers option to view the floral with or without the stripe.

Use of Layers:

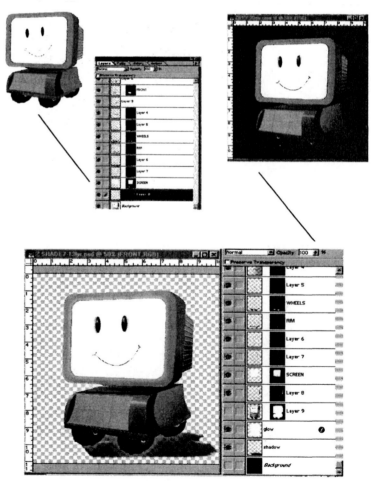

FIGURE 11-63

Skill Level: Advanced

The concept of layers is fairly self-explanatory and can best be understood by looking at Figure 11-63. We have selected a very familiar image to help you better understand this concept. All the different parts of Zippy are on layers. Each layer can be viewed separately. In fact as you can see, we experimented with the background and shadows for effect.

Notice that the first layer was drawn, then under the layers option menu as you can clearly see in Figure 11-63, additional layers were then created to represent other aspects of the drawing. After the rendering is completed, there are several options you choose, depending on which software program you are using, to group all of these layers into one image.

You will soon discover why this concept can be very useful to a designer in the creation of a pattern. Elements of a pattern or design can be viewed with only a + b, or with b + c, or perhaps with the combination of a + c or finally by viewing all three. There are many other different applications a fashion designer might choose when working with layers. Below we have included a few of the functions the layers option can perform.

LAYERS

- Create additional layers at any time
- Perform basic editing functions to modify layers
- Ability to isolate one layer or one object on a layer at a time or all at the same time
- Change the order of layers
- Change the order of objects on a layer
- Change the order of actual layers
- Multiple viewing options of layers, such as show, hide, and view multiple layers
- Lock or protect layers
- Delete layers or objects from layers
- Name and save individual layers
- Print specific layers

Why not jot down a few thoughts on how you might wish to apply the layer option to your work?

Special Notes on Layers

Rendering and Editing Prints on Industrial Software

Our goal as we begin this leg of our journey is to make these concepts as easy to understand as possible. We have taken into consideration those of you who do not have access to this kind of software. Therefore, in our exercises we will include a detailed series of screen shots for you to follow along with in our introduction to designing prints with industrial software.

We have attempted to include many of the steps in visual form for you to better understand the concepts covered. In these screen shots, you will see many of the selections a designer may encounter when creating or modifying a pattern repeat on industrial software.

We will begin with StyleClick (ModaCad) Textile Design Pro Suite software. This software is easy to use and works in conjunction with Adobe Photoshop as a plug-in. This software is located as an option under the Adobe Photoshop filter menu.

Obviously, as we introduce you to the StyleClick (ModaCad) software, you will also explore Adobe Photoshop in more depth. This was a natural bridge to again use Adobe

Photoshop for fashion design. Here again, you will begin to see not just how but when to apply the tools and techniques of image editing to your fashion designs.

Toward the end of the chapter we have provided you with ample time and room to experiment with these filters found in Adobe Photoshop to enhance your fabric. With just one selection of your mouse you can take your fabric and convert it to a textured surface or to a brushed fabric. Oh, the possibilities you will soon discover!

As always, we have including an easy to follow series of step-by-step pictorial instructions.

Exercise 11-13 Creating a Simple Repeat

Software Used

StyleClick (ModaCad) Textile Suite, Repeat Generator, and Adobe Photoshop

How-to Steps

1. Open a file in Adobe Photoshop. From the main program file go to:
 a. StyleClick (ModaCad) Applications
 b. ModaDESIGN PRO
 c. Textile Suite Tutorial
 d. Floral1.tif (Figure 11-64).

2. From the main Filter menu, select, ModaDesign Pro, Repeat Generator (Figure 11-65).
3. Be sure to rearrange all the windows so you can view the module's dialog box.
4. You may then opt to select the zoom tool from the Repeat Generator's tool palette (not the one from Photoshop). By clicking you can view the ratio of 1:2. Select the hand tool (Figure 11-66) on the StyleClick (ModaCad) source window; when you do, the hand will become a four-arrow cursor.
5. Double click on an area inside the selection area. You now have the ability to relocate the new selection as well as resize it.

FIGURE 11-64

Additional Comments

Before we show you how to modify the pattern further we will stop here and let you make additional notes you need before we move on.

Special Notes

Name and version of software used: _____

List of additional steps you needed to take to execute the program that was specific to the software program that you are using: _____

Skill Level: Advanced

FIGURE 11-65

FIGURE 11-66

Biggest challenge: _____

What you learned that was new, and special notes on what you want to always
remember: _____

Miscellaneous thoughts: _____

Advanced Fashion Design Rendering Fabrics, Flats, and Prints

337

ADVANCED

Now let's look a little closer at the Repeat Generator menu options. Note in Figure 11-67 the options to make the drop of your repeat in percentage for both vertical and horizontal. You have an assortment of other options. Of particular help is the New Preview button found on the lower right of Figure 11-68. Each time you change any other options, including the percentages, you have the ability to preview these new changes against the previous ones. This can be an extremely helpful feature.

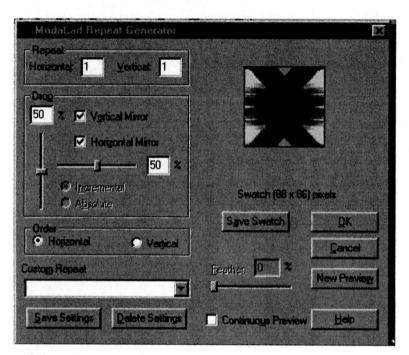

FIGURE 11-67

FIGURE 11-68

Figure 11-69 depicts one of several variations available in the Repeat Wizard Generator. The first two examples are full screen shots that show a close-up of the original, also known as source pattern. From there you will see the Wizard Repeat Generator we mentioned earlier.

These selections can be viewed in the top right corner of each figure. You will see the results of those choices in the preview window.

You can make choices based on first the location of your original selection and then on the amount of repeat and drop you wish to make within the Repeat Generator menu.

Finally, you will notice the option to actually name and save your swatch. This is done in accordance with any saving function you have used up to this point.

Now we are ready to create a custom repeat using several different techniques.

Exercise 11-14 Creating a Custom Repeat, Part 1

Software Used

StyleClick (ModaCad) Textile Suite, Repeat Generator, and Adobe Photoshop

How-to Steps

1. In Photoshop Open flower.tif in the ModaDesignPro\Textile Suite\Tutorial file (Figure 11-70).
2. Under the Filter menu select Repeat Wizard (Figure 11-71).

Skill Level: Advanced

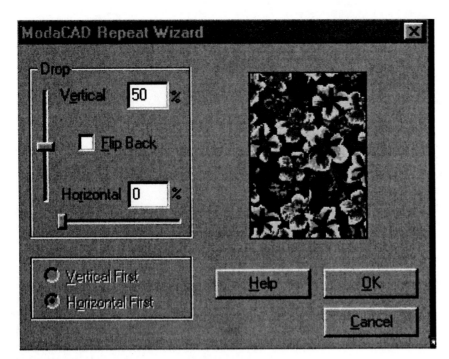

FIGURE 11-69

3. Begin by making sure the Flip Back option is checked, then enter the number 50 in the Vertical Drop field. This indicates a half drop. (See Figure 11-72).
4. You may need to arrange your screen. Be sure you have access to the Adobe Photoshop main toolbox. You will need to use the brush and poly-lasso tools shortly.
5. From the main toolbox, select a brush, brush width, and color from the color swatch palette (Figure 11-73).
6. According to the example in Figure 11-74, draw connecting brush strokes between the flowers.

FIGURE 11-70

FIGURE 11-71

Advanced Fashion Design Rendering Fabrics, Flats, and Prints

ADVANCED

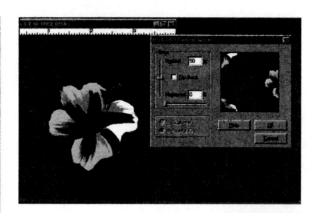

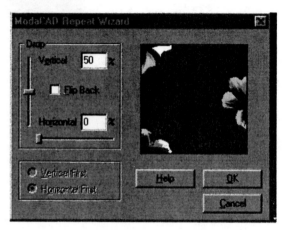

FIGURE 11-72

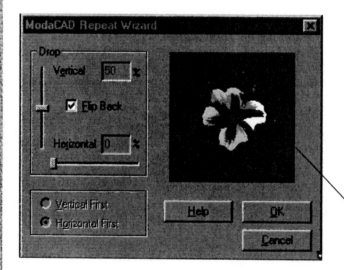

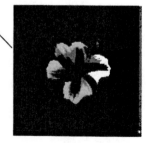

FIGURE 11-73

Skill Level: Advanced

Additional Comments

Notice the preview in Figure 11-74 of what your original pattern should now look like, if you opted to adjust your selection of increments to match.

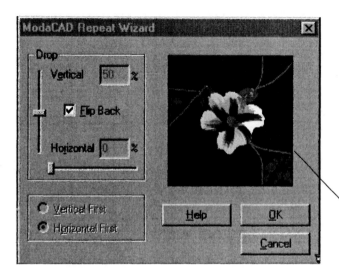
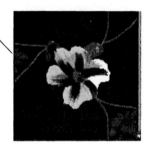

FIGURE 11-74

Special Notes

Name and version of software used: _____

List of additional steps you needed to take to execute the program that was specific to the software program that you are using: _____

Biggest challenge: _____

What you learned that was new, and special notes on what you want to always remember: _____

Miscellaneous thoughts: _____

Before we proceed, go back and make a note in step 6, where you added colored connecting brush strokes, that you have the ability to opt to make these new additions to your pattern by placing a new layer on top of your existing design. To add a new layer, merely go to the layer main menu at the top of the Photoshop screen and select New. It will be helpful to have a new layer opened before beginning the next exercise (Figure 11-75).

ADVANCED

Name:	Layer 1		OK
Opacity:	100	% Mode: Normal	Cancel

☐ Group With Previous Layer

☐ (No neutral color exists for Normal mode.)

FIGURE 11-75

Exercise 11-14 Creating a Custom Repeat, Part 2

Software Used

StyleClick (ModaCad) Textile Suite, Repeat Generator, and Adobe Photoshop.

How-to Steps

1. Open from the Adobe Photoshop\ModaDesign Pro\Textile Suite\Tutorial the file called floral2.tif.
2. From the Adobe Photoshop main Toolbox menu, select the polylasso tool (Figure 11-76).
3. As neatly as possible using the polylasso tool, select a flower from the floral2.tif file (Figure 11-77).
4. From the edit window, select the copy command (Figure 11-78).
5. Go back to the original pattern flower.tif, and place your cursor between the connecting brush strokes (Figure 11-79). Then go to the Edit menu and select the Paste command.
6. You may need to go to the Edit menu and choose to deselect the section you just pasted before you can go to the Layers menu and select Flatten Image (Figure 11-80).
7. From the Filter menu, select ModaDESIGN PRO and Repeat Wizard.
8. Again, you now have the selections with which you are familiar. So experiment; then name and save your work.

 FIGURE 11-76

FIGURE 11-77

FIGURE 11-78

Skill Level: Advanced

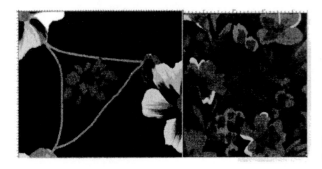

FIGURE 11-79

FIGURE 11-80

Additional Comments

In addition to using the ModaDesign Pro Repeat Wizard and Repeat Generator combination on your files, don't forget you can experiment with the Adobe Photoshop filter menu selections simultaneously to enhance your designs even further. Figure 11-81 is an example of what you work might look like.

Special Notes

Name and version of software used: _____

List of additional steps you needed to take to execute the program that was specific to the software program that you are using: _____

Biggest challenge: _____

What you learned that was new, and special notes on what you want to always remember: _____

Miscellaneous thoughts: _____

Advanced Fashion Design Rendering Fabrics, Flats, and Prints

ADVANCED

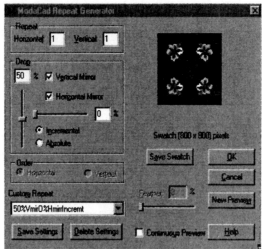

FIGURE 11-81

Fun with Filters

Why not take some time and experiment with the filters found in Adobe Photoshop on your prints? Refer to Chapter 7 to refresh your memory on the different kinds of filters available as well as other selection tools available. One other idea is to check out downloads on the Net. We were able to locate several free filters by conducting a simple search.

In addition, you may wish to enhance your prints in Metacreations' Painter. This program is also known for its wonderful array of natural medium tools, to which you were introduced in earlier chapters.

Here is the perfect opportunity for you to add life to your prints using those tools. Try adding brush strokes and applying the layers techniques similar to the ones just used in the StyleClick (ModaCad) plug-in software from Exercise 11–14.

Wasn't that fun? The modifying of an existing pattern or the creation of a custom repeat was easier than you dreamed possible with the help of this great software. Don't forget, you have the ability to accomplish the same task in most of the software we have been using, including just using Photoshop.

Once you are familiar with any design software you can begin to experiment with what you want to accomplish. Just like driving are car, there are many different roads that can take you to the same destination, especially if you have the time and don't mind the ride.

So as always, our suggestion is don't be afraid to experiment when you have the chance. Frequently you will find it is well worth the effort.

Our next stop is designing knits, so fasten your seat belts as we prepare to meet some more of our experts in our whirlwind tour of fashion designing on computers.

CHAPTER SUMMARY

Designers can use existing clip art or pattern fills already resident on most vector-based software to render prints for fashion. The greatest challenge is to manipulate clip art to avoid a canned appearance.

Rendering fashion on the computer involves a wide variety of techniques that previously required considerable time for the designer. In the past a fashion designer needed to be adept at sketching in order to render fabric prints.

Today, with all the software choices available, even a designer who possess only nominal sketching ability can render or edit a pattern in half the time it took by hand, with sensational results!

The designing of prints that are used on flats or on fabric typically start with a basic theme or design. In the case of a single motif, designers can render or manipulate a design in numerous ways, such as resize, reshape, repeat, apply layers, channels, and/or filters to enhance or alter the original theme or colorway.

The patterns that are then destined to become fabric prints are applied by a printing house or a print mill to the fabric.

The use of additional input devices, such as scanners, to digitally input patterns or fabric has become commonplace. However, the use of a scanner can greatly increase the number of colors used in a design, as you discovered in Chapter 10.

We also saw other techniques a designer uses on a computer for fashion and fabric rendering, such as:

- Computer-aided free-hand drawing
- Editing or using existing clip art
- Pattern fills
- Scanning
- Tracing
- Layers
- Combination of techniques

As the designer prepares to calibrate color, the outcome objective of the project is what drives the choices. It is highly recommended that the designer consult with other color experts, such as service bureaus, to help determine matching or reducing color, file size, and/or compression, as well as file exchange and file format.

There is a wide array of easy-to-use commercial and industrial software programs available for the designer to create flats and fabric prints. Vector-based software is used for clean line renderings, while raster-based programs and some plug-ins are used to manipulate and further enhance a design.

Best of all, today's designer can spend more quality time creating thanks to computer-aided design programs.

ADVANCED

CHAPTER 12

Design, Render, and Simulate Knits on the Computer

Focus: The Principle Fabric Design for Knits

CHAPTER OBJECTIVES

- Comprehensive review of knitted fabric/textiles
- Distinguish between knitted and woven fabric
- Introduction to industrial-based software for designing and/or simulating knits by industry experts
- Distinguish between creating, simulating, and generating a knit on computers
- Determine the cut or gauge of a knit on the computer
- Graph a basic motif for use in a knitted fabric
- Observe the CAD/CAM process of rendering a pattern motif that can be repeated for surface design use or converted into a Jacquard knit using industrial-based software

TERMS TO LOOK FOR

CAM	direct knitter	intarcia	purl
circular	flat knitting	jacquard	wales
contract knitter	float	jersey	warp
courses	gauge	knit	weft
cut	graph paper	knit atlas	yard goods
digitize	grin thru	knitting	

Can you believe you now are ready to actually begin to design fabric? We have chosen for this segment of your book to start with knits. Why? The reason is simple: everyone loves wearing knits because they are synonymous with comfort and ease. In fact, our goal is that by the time you have finished this chapter you will be using similar words to describe how you feel about designing knits on the computer—comfortable, confident, and that it was easier than you thought possible.

Everyone loves knits, but unfortunately, nowadays few students actually know how to knit. In fact, I have discovered that many young fashion-design students have only a basic understanding of how knits are made or how a knit differs from a woven material. Coming from a design background on knits will be useful in making the transition from manual design to computers. However, it is not an essential requirement to be an expert in knitting to accomplish the exercises in this chapter.

We have chosen to start our chapter with an explanation of knits, along with a review of several terms that are associated with knits. We will follow up the jargon with a little help from our friends at Monarch, a company whose name is synonymous with knitting and computers. We are proud to include an interview with Steven Greenberg of Monarch. In addition, Steven has agreed to share his "purls" of wisdom with you in a series of related exercises on design. He will take you through the basic elements of pattern design and colorways on the Monarch software by first designing a single motif, then manipulating and converting the original motif design for prints, concluding with translating that design into a Jacquard knit.

The section is rounded out with additional exercises using several other leading industrial software programs to design and/or simulate knits.

This chapter promises to lay a sure foundation. This will allow you, the designer, to really begin to grasp the big picture when it comes to designing fashions on the computer.

Before we start our tour of knits, we need to begin with the basics of how you can recognize and distinguish a knit from a woven. Probably the most simple way to distinguish the two is by determining where the stretch is. Typically, woven fabrics stretch only on the bias. Knits, on the other hand, usually stretch in a third direction, either side to side or top to bottom.

Another distinction between the two methods of making cloth is that knits run and wovens fray.

Now, for anyone who is muttering about all the exceptions to such a generic statement about how to recognize and differentiate a woven from a knit, relax; they were merely presented as a general statement of how these two methods of fabric construction usually differ.

We can define *knitting* as the interlooping of yarns at right angles and *weaving* as the interlacing of yarns.

Let's take a closer look at a few other facts relevant to knits:

- Knits can be classified (and made on machines of the same name) as either a warp knit or a weft knit.
- Knits can be either flat or circular.
- Knits can be made and sold as yard goods or complete garments.
- Knits can be manufactured by direct (from the manufacturer) or by contract knitters.
- The two basic stitches used in weft knitting are knit and purl (Figures 12-1 and 12-2).
- Horizontal rows of knitted stitches are called courses (Figure 12-3).
- Vertical rows of knitted stitches are called wales (Figure 12-4).
- The number of stitches that intersect in rows of stitches in a given measurement (usually an inch) are referred to as the cut or gauge.

Now that we have covered just a few knitting basics, get ready to take a quick tour of the most common knitting terms.

ADVANCED

FIGURE 12-1 Knitting.

Knitting Terms

Argyle: A knitted pattern generally is comprised of a diamond repeat intersected by narrow stripes.

Cable: A weft-knitted pattern of stitches that form a criss-cross or twisted cable appearance on the surface of the fabric.

Chevron: A repeat "V" design used on prints or in knitted patterns.

Circular: Fabric or garments that are knitted in the round or in a unbroken circular or tubular fashion.

Course: Horizontal rows of knitted stitches.

Cut (see *Gauge*).

Cut and sew: A yard good made from jersey that is cut and sewn to make a finished garment.

Double knit: A reversible knitted fabric that was constructed on a weft knitting machine.

Ends (also known as *Warp yarns*): Vertical yarns on a piece of woven cloth.

Fairisle: A knitted pattern that can consist of two or more colors to create a repeat pattern.

Float: When using two or more colors of yarn in a weft knit, the colored threads are carried across the reverse of the fabric in intervals of color forming a float made by the yarn not currently being knitted.

Full-fashion: In hand or machine knitting, portions of the garment are actually shaped or fashioned for fit to another garment piece that has been shaped or fashioned to fit against it—or example, a raglan sleeve that has been fashioned to fit against the raglan shaping of the body of the sweater. The pieces are joined by sewing. Knitted garments that are not full-fashion are said to be cut and sewn.

FIGURE 12-2 Purling.

Skill Level: Advanced

FIGURE 12-3 Wales.

Garter stitch: A reversible weft-knitted stitch consisting of alternating rows of knit and purl.

Gauge: A knitting term indicating the number of stitches and/or rows to an inch. The gauge of a swatch or a garment is measured by the size or closeness of the (stitches) or needles. For example, 7 stitches to an inch generally indicates the appearance of a hand-knit sweater, while the number 15 implies a finer machine gauge (cut) knit.

Grin thru: In a double-knit fabric that has a colored pattern, grin thru is the amount of color that is visible on the reverse side of the fabric.

Hand loom: A loom used in making a hand-woven fabric; it is often confused for a "loom," which can imply a commercially produced knitting loom used for making knitted yard goods or completed garments.

Intarcia: This is a weft-knitted design made of two or more colors. Unlike a jacquard that "floats" the color across the row on the reverse side of the fabric, in an intarcia these yarns are broken and knotted on the reverse side of the fabric, eliminating floats and bulk.

FIGURE 12-4 Course.

Design, Render, and Simulate Knits on the Computer

ADVANCED

Jacquard: A complex weaving loom created in 1805 by Joseph Jacquard, which used a punch card system. Woven: Originally, this was a complex design of texture, surface interest and color woven into fabric. Knitted in knitting: A pattern of two or more colors carried across in floats on the reverse of the fabric.

Jersey knit (also known as *Single, Stockinette,* or *Weft knit*): The face of the cloth is constructed of all knit stitches and the reverse is constructed of all purl.

Knitting: The interlooping of yarn to form fabric.

Motif: A single or repeat pattern or design that can be knitted into a knitted fabric, in addition a motif can also be added as a direct print.

Pile knit: Taking its cue from weaving, this is a knitted pattern of loops left on the surface of the fabric, which is cut or left uncut.

Pin-tuck: Horizontal rows of tubular relief on the surface of the knitted fabric.

Pique: A term we often associate with woven fabric, a pique knit is constructed by a tuck-like stitch, which gives a puckered appearance on the surface of the fabric. This stitch is very common in men's golf shirts.

Plating: Using two yarns simultaneously in knitting; one yarn will appear on the surface and the other will appear only on the reverse side of the cloth.

Pointelle: A mesh or open work constructed of missed-weft stitches; sometimes called *lace*.

Popcorn (also known as a *Bobble* or *Bubble stitch*): This stitch is made by isolating groups of stitches that will form a popcorn-like appearance on the surface of the fabric.

Purl: One of the two basic stitches in weft knitting, with the appearance of a horizontal ridge loop formed across the surface of the fabric.

Rib: A stitch pattern formed by alternating rows of knit and purl to form vertical ridges that provide additional surface interest as well as stretch. This is primarily used for cuffs and waist bands. This stitch is called a *Shaker knit* when the entire body of the sweater is of alternating rows of knit and purl.

Single (see *Jersey*).

Tuck A series of incomplete stitches formed on the surface of the fabric, causing a pucker-like textured appearance in the knit.

Wales: Vertical rows of knitted stitches.

Warp: A specific type of knitting loom and/or knitting machine used in the construction of knitted fabric. Typically, these kinds of knits are considered run-resistant when snagged.

Weft: One of the most common types of knit available; it is constructed from a combination of two basic stitches: knit and purl. These knits generally can easily snag or run.

Well, that wasn't that painful was it? Knowing and understanding the terminology of any subject makes you sound like a professional in any field of study. So you will be glad you invested the time.

Now that you have a proper foundation in knits we are ready to apply this knowledge to knits on computers.

STEVEN GREENBERG OF MONARCH

Steven's official title is Graphic Specialist and Training Director for Monarch, which is a leading provider of comprehensive CAD/CAM solutions to a virtual "Who's Who" of apparel and textile companies. Monarch's solutions, covering wovens, knits, textile prints, photo-realistic rendering, and more, range from fully integrated, customized systems to its trailblazing off-the-shelf software and Monarch School Classes.

Like many of Monarch's employees, Steven came directly from the fashion industry. Steven holds degrees from Parsons in both Communication and Advertising and Graphic Design. Before he came to work with Monarch, he was a Design Director for Federated Department Stores, designing for their boys' 2–20 private-label line.

Armed with a great education and blessed with the opportunity to design for Federated, Steven used his computer savvy by computerizing the department with the Monarch Systems.

Naturally, after his tenure with Federated, followed by some experience as a freelance fashion designer, he came to work for Monarch. Steven has been with Monarch for

the past 8 years, and as we spoke further with him it became apparent that this is by no means an ordinary job.

According to Steven, there is no such thing as a "typical day." Steven is still creating and solving "challenges," only this time, he is analyzing production and design solutions for such major companies as Nautica and Tommy Hilfiger.

It is not just the apparel industry that comes to Monarch for system solutions. Fabric manufacturers, garment manufacturers, fiber marketers, home furnishing, wallpaper designers, design houses, and retailers all have Monarch Design Systems software. In fact one of Steven's favorite challenges is working with any kind of surface prints, regardless of whether it's on fabric or wallpaper.

As he spoke, it was obvious that the subject of prints was his passion. Now the "designer" really began to surface in our conversation, as he discussed types of weaves, prints, repeats, drops, colorways and calibrating color, and so on. For Steven, surface texture and prints drive his creativity.

Without getting "too techno," we asked him to describe the advantages that a computer offers to a fashion designer designing prints. Traditional design studios do everything by hand, including sketching, painting and markers, colorways, weaving, and repeats. There is always the fear that the feel of the design may be compromised by using computers. This is not true. The computer quickly becomes another tool to enhance the design process. Scanning in an image and manipulating it on a computer adds an entire new layer of design. Creativity is increased as software features are utilized. Colorways and repeats are easily created and edited.

According to Steven, there is no more waiting for the next day for a service bureau to return a painting that now looks different from what you thought it would. Within minutes, software allows you to generate any conceivable colorway and then narrow it down to the few you really like. Palettes can be created and saved—so no more mixing paints. Virtually any repetitive task is eliminated—all resulting in a boost in productivity.

Images and color can be proofed on a desktop printer right in the office. The quality of low-cost printers has risen dramatically over the past few years. You no longer need a high-end printer.

We next asked Steven to share some of his success stories and insights with us. According to Steven, one of his greatest triumphs was a project he worked on with Richard Lerner of RSL Digital Consultants and Joni Johns, a well-known textile artist and designer working for both Broadway and apparel. On a recent project for a large entertainment company, whose name he could not mention, there was a call for many hand-painted costumes for both chorus and lead roles for a Broadway show taking place in multiple cities. Hand painting all of these costumes would be too time consuming. Instead they used Monarch software to produce an entire costume on the computer. We scanned Joni's hand painting of the fabric design and developed a repeat in Pointcarré textile and apparel software. We then color matched it on the computer, before digitally printing it on fabric using a dye-sublimation process. We went from file to fabric, never needing separations or screens.

As our conversation moved back to his sources of inspiration for prints, we also discussed Kandinsky, Jackson Pollak, and the 1950s making our imagination soar with

ADVANCED

baby-boomer memories of childhood to years at college studying art. As a reader, do you see the point? The key to any job is passion, enthusiasm, and yes, the love of challenges.

"Like many others we have spoken with, Steven echoed the sentiment that there are times you love what you do so much you would almost do it for free! He went on to say that "You've got to love what you do and the people you work with. . . . we spend too many hours at work not to." We asked Steven, to talk about several of the people he has worked for and the impact they have had on him both personally and professionally.

There are always two people in your life you will remember, the one who believed in you and the one who didn't. Who hasn't had a professor or other authority figure tell you, "You don't have what it takes." Although these remarks might be stinging for the moment, according to Steven, "If in your heart you know this is where you belong, you should use these remarks as a motivator to propel you to succeed."

Next, one of the best-kept secrets to anyone working in any field is finding a mentor. Steven was blessed to find two. Elaine Donato one of his bosses at Federated, according to Steven, "made all the difference, simply because she just believed in me." Steven's other mentor was a "practical mentor." Patrick McGarry taught Steven "the business of fashion and textiles." "Patrick showed me how to build a line, he pointed out the way to succeed."

So you can see from Steven's testimony, when it comes to mentors and "nay-sayers," you need both!

Steven concluded our interview with some additional "purls" of wisdom. When you use the computer and its myriad features and functions, "let your creativity flow, take things to the next step, don't just make your work a copy of another artist or style. Leave your mark. Make it your own! . . . The computer gives you the freedom to think beyond the limits, to keep going! . . . Don't lose yourself along the way."

"And lastly, to do a job right you need teamwork! No one does anything alone." We couldn't agree more. Steven lives up to this philosophy; you will find more of his expertise and insights later in this chapter on designing knits.

As we begin this next section of our book you will notice a slight variation in format. The information that is being presented to you has come directly from the computer of Steven Greenberg and Monarch. We have only modified the information to accommodate the outline of the material to match with our other exercises without disrupting the integrity of the instructions.

Many of the concepts you will encounter will be similar to those we have covered in previous chapters. However, it should be noted that due to the difference in presentation styles, the information presented assumes the reader has the software available, along with a fairly good grasp of the design process for prints and knits. Therefore, we are attempting to present the material in context along with ample space for you to take notes to assist you in gaining a better grasp of the volume of information presented.

Permit us to present you with a brief outline and overview of the materials to be presented by Monarch. Reviewing your outline below is similar to reviewing your road map before you start on your journey. So, don't be afraid to refer back to it.

OUTLINE FOR MONARCH'S SECTION OF FASHION DESIGN ON COMPUTERS

Each of our exercises will include complete step-by-step screen shots for you to follow along.

1. Introductory overview of the suite of software available.
2. Introduction to the software we will be using in our exercises.
3. Introduction to selection of color building and designing a color palette for your design.
4. Creating and viewing additional colorways.
5. Designing a basic pattern motif: paisley.

Skill Level: Advanced

6. Modifying and isolating the pattern into a single motif, including designing a toss repeat and using the repeat and stamp functions to modify the pattern and create a repeat.

7. Adapt and digitize the (paisley) pattern for use in a knit repeat, specifically, a jacquard.

8. Editing the color and graphing gauge for the (paisley) pattern.

9. Edit the (paisley) pattern for color and grin.

Introduction to Pointcarré Textile Software by Monarch

Possibly the best feature of this system is Creative Time. This is a comprehensive graphic design package. Pointcarré opens a world of unlimited creative choices for the designer. Pointcarré delivers more features and functionality than more expensive proprietary systems for sketching, textile prints, wovens, knits, stripes, plaids, storyboards, sales and marketing materials, colorway samples, fabric simulation, and automating design.

Designers can have unlimited creative freedom with Pointcarré automation of many repetitive design functions.

Input

There are several ways in which your designs can be input into the computer—via video capture, flatbed scanner, or freehand sketching. These images can be individually stored and then copied, modified, or incorporated into other designs at any time with the click of a mouse.

The Tools

Once the artwork is in digital form, Pointcarré has powerful intuitive features that will permit the designer to do image enhancement. For example, textures can be mapped to design for automatic fabric rendering, including automatic shading.

Image editing is simplified by using the multiple-window function. The tools are familiar graphics icons, such as pencil, paintbrush, rubber stamp, airbrush, and eraser. The extensive array of paint tools can produce stipple, watercolor, and airbrush effects. There are also more advanced tools, including painting with a pattern, and selecting a pattern from any open file and using it as a brush with a transparent background. This brush can be flipped, nudged, rotated, or even poured using the paint bucket tool. Zooming, scrolling, linked views, on-screen guides, and advanced grid features ensure precision measurement and control.

Using the textile design tools, in no time a designer can hit the ground running. The repeat option displays a design in many user-controlled options. Half-drops or other incremental offsets can be viewed vertically or horizontally. The stripe feature instantly creates vertical or horizontal stripes in inches or in stitches. The Paint with a Pattern tool embeds patterns or textures into your designs.

The Pointcarré Design offers extensive control of its preferences settings, enabling the designer to set up the software the way it works best for them.

Graph lines can be displayed on screen and in gauge, then printed in full color. Designs can be painted with stitch or symbol, resized, and printed in paint, stitch, symbolic, or color graph forms. Knit graphs can be scanned in and automatically converted to workable files. The Flash the Float Feature helps identify and eliminate impractical long floats. The number of colors per row can be automatically calculated and reported graphically. Designers will have incredibly realistic simulations of knit fabrics, which reduces sampling costs.

There is also a comprehensive library of flats, croquis, patterns, textures, knits, and woven stitches available to make the designer's job easier. Designers also have the alternative of adding their own work to the library for greater variety.

Color

Every design can include up to 254 colors, selected from a palette of over 16.7 million. Color palettes, including Pantone, can be swapped, changed, and named for easy customization, making this a tremendous time saver for developing and storing seasonal color palettes. Colorways can be created automatically.

These are several other advanced color control features:

- The color reduction tool creates flat art quickly and effectively from scans.
- Powerful color protection features for easy cleanup.
- Color percentage information is calculated automatically for costing purposes.
- Color blends and gradations are easy.
- You can save color palettes or individual color chips.
- Colors from palettes can be dragged and dropped into designs.
- The magic wand tool chooses continuous areas of color.

There are also several options for color management:

- Printer-calibrated color charts, via the ColorCharter module—this makes color selection a breeze and has predictable output reality.
- The Pantone Matching System is accessible from within Pointcarré.
- The MDS Color Management System provides effective color management from input to display to print. This system is based on Apple's ColorSync technology and uses a spectrophotometer to capture precise color characteristics from fabrics or other source materials.

Compatibility

Designs created in Pointcarré can be saved in several industry standard file formats including TIF, PICT, BMP, and TGA.

Marketing

For merchandising, the Illustration module allows designs to be placed and sized within flats or croquis for storyboards and other presentation materials. High-quality text can be easily added to images in your choice of typeface and point size.

The following exercises will include many of the concepts just covered, along with ample room for you to make notes.

Special Notes

Color Selection

Color management can be done is several ways in Pointcarré. The first is using Color-Matching/Management, which uses a spectrophotometer, such as the X-rite Digital Swatchbook. The user can capture a color story from any source, such as fabric, color chips, or even objects. The color is then acquired by Pointcarré and entered into the color palette.

The next method is Color Charts—a library of user definable color charts that can be created and printed directly from Pointcarré. The user may then match colors directly to the charts and import the color number into the program. Chips can be edited using RGB, CMYK, CMY, HLS, or HSB values.

ADVANCED

The final method is using the Pantone Color Matching, system—a color library that can be accessed through the Apple Color Picker. Colors are chosen and imported directly into Pointcarré.

Special Notes

In Chapter 10 we discussed the significance to a fashion designer of matching colors on the computer. In Chapter 11 we worked with choosing colors and creating colorways using several of the other leading software packages. Now we begin to plan our journey toward creating a knitted pattern, using color selection with the Pointcarré software.

Don't panic when you begin hearing new terms; they will be paired with some old familiar terms and concepts. For example, the term _color chip_ is not unlike the paint chips you might find in your local hardware or paint supply store. Frequently, you will find cards or pamphlets offering a variety of color variations. These choices use a sample swatch that has a numeric value associated with the chip. The swatch is of the color for you to review, while the number is associated with the chips telling the sales associate what colors to mix to match that exact color.

According to Steven, using Pointcarré, your color selections can be named and saved individually by chip. Each chip can be double clicked to access the chip attribute window. Here, the user can define a chip by name as well as edit the number of its value. The chips are saved into a color chip folder. These folders are linked to Pointcarré and are easily accessible at all times.

Exercise 12-1 Naming, Saving, and Changing Colors

Software Used

Pointcarré

How-to Steps

1. Begin with scanned piece (Figure 12-5).
2. Double click on the chip to be edited (Figure 12-6).
3. Enter the name of the color chip (Figure 12-7).
4. From the palette menu, select Save hue (Figure 12-8).
5. The hue is now stored for future use (Figure 12-9).

Special Notes

Name and version of software used: _____

List of additional steps you needed to take to execute the program that was specific to the software program that you are using: _____

Biggest challenge: _____

What you learned that was new, and special notes on what you want to always remember: _____

Miscellaneous thoughts: _____

FIGURE 12-5

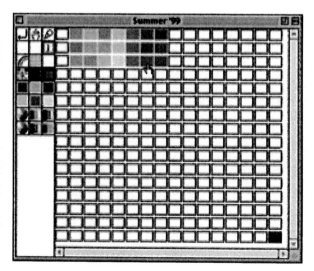

FIGURE 12-6

Skill Level: Advanced

ADVANCED

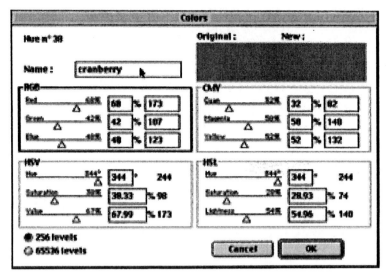

FIGURE 12-7

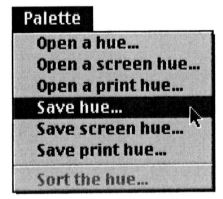

FIGURE 12-8

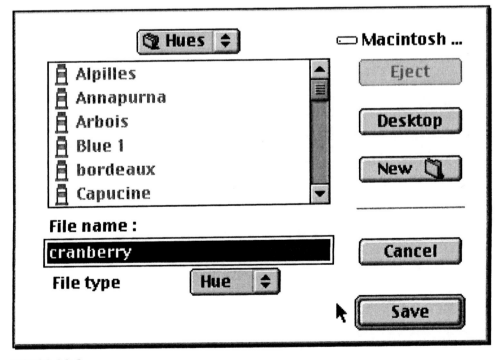

FIGURE 12-9

Design, Render, and Simulate Knits on the Computer

Working with Color

Colors can be named and saved by palette. Each palette can be named and saved to a specific folder on the computer. These folders are linked to Pointcarré and are easily accessible at all times. Multiple color palettes can be opened at any time.

Exercise 12-2 Building, Naming, and Saving a Color Palette

Software Used

Pointcarré

How-to Steps

1. Based on the steps in Exercise 12-1, begin to build a color palette of approximately eight colors.
2. Choose the palette menu and select Save Palette (Figures 12-10 and 12-11).

Special Notes

Name and version of software used: _____

List of additional steps you needed to take to execute the program that was specific to the software program that you are using: _____

Biggest challenge: _____

What you learned that was new, and special notes on what you want to always remember: _____

Miscellaneous thoughts: _____

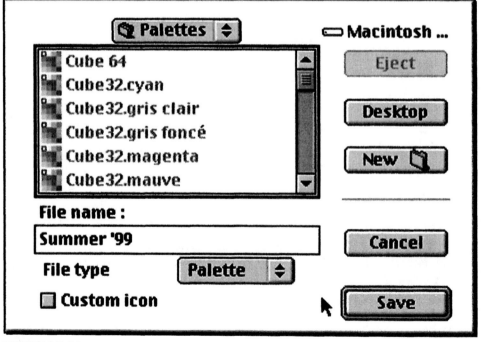

FIGURE 12-10

Skill Level: Advanced

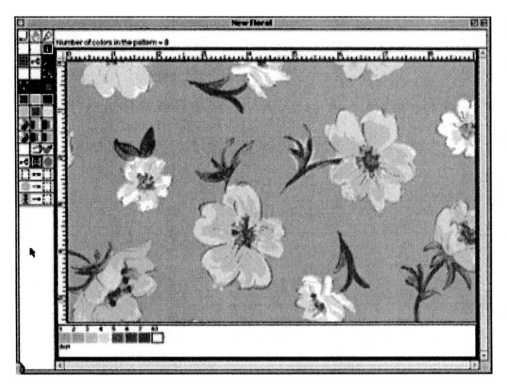

FIGURE 12-11

Colorways

Changing colors in Pointcarré is very user-friendly. Color chips can easily be dragged and dropped from one palette to another, from a palette to an image, or even from one image to another. There is also a colorways feature that allows the user to select a file and generate automatic colorways, or set a specific number of "like" colorways. Then these individual colors can still be edited.

Exercise 12-3 Changing a Color Palette

Software Used

Pointcarré

How-to Steps

1. Open a design to be edited (Figure 12-12).
2. Open the color palette to be used (Figure 12-13).
3. Select the new color chip to be used.
4. Click and drag the color chip over the design (Figure 12-14).
5. Release the mouse on the color to be edited.
6. You may also release the new color chip directly on top of the chip to be edited at the bottom of the screen. This will automatically change the colorways (Figure 12-15).

Special Notes

Name and version of software used: _____

List of additional steps you needed to take to execute the program that was specific to the software program that you are using: _____

ADVANCED

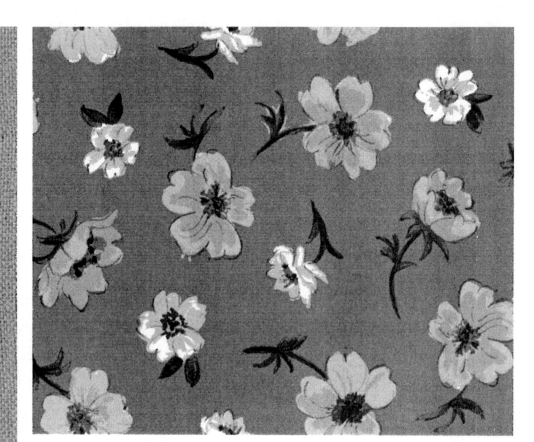

FIGURE 12-12

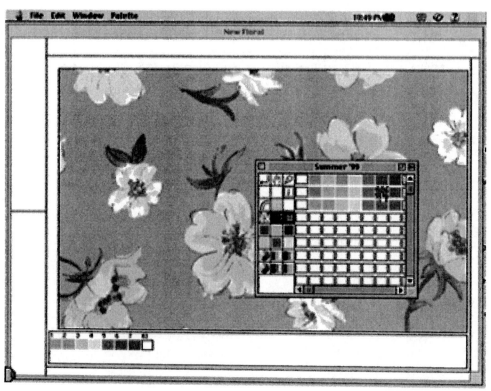

FIGURE 12-13

Skill Level: Advanced

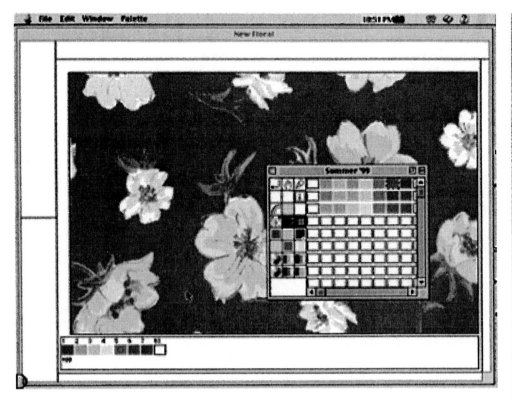

FIGURE 12-14

File

New pattern...	⌘N
New colorways...	
New dobby cloth...	
New multiple cloth...	
New Jacquard cloth...	
New magic cloth...	
New palette...	
Open...	⌘O
Capture	
Duplicate...	
Close	⌘W
Close all...	
Save	⌘S
Save as...	
Revert to saved	
Import...	
Export...	
Page Setup...	
Print...	⌘P
Print with	▶
Print Canon FP510...	
Quit	⌘Q

FIGURE 12-15

ADVANCED

Biggest challenge: _____

What you learned that was new, and special notes on what you want to always remember: _____

Miscellaneous thoughts: _____

Exercise 12-4 Setting up a Colorways File

Software Used

Pointcarré

How-to Steps

1. From the main file menu, drag down New Colorways.
2. A dialog box will appear. Click and hold in the gray square (Figure 12-16).
3. A small pop-up menu will appear, with the option to Open or Catch an image (Figure 12-17).
4. If you already have an image open on the screen, select Catch.
5. If the image you wish to use is saved on your hard drive, select Open.
6. A preview of the image will appear in the gray box.
7. Enter the number of colorways you would like to create (Figure 12-18). For example, choose 4.

FIGURE 12-16

FIGURE 12-17

Skill Level: Advanced

FIGURE 12-18

Additional Comments

There are two options at this point. You can use the Original Colors for each new colorway created and the positions will be the same. Or you may opt for Cycle Colors, for each new colorway created. The color positions will be rotated, creating new color combinations (Figure 12-19).

8. Choose one of these two options and click OK.
9. A Colorway window named Colorways no. 1 will appear, containing four colorways of the original image.
10. Each colorway can now be independently recolored. You may wish to leave the first colorway so that you can compare it with the new ones you created.

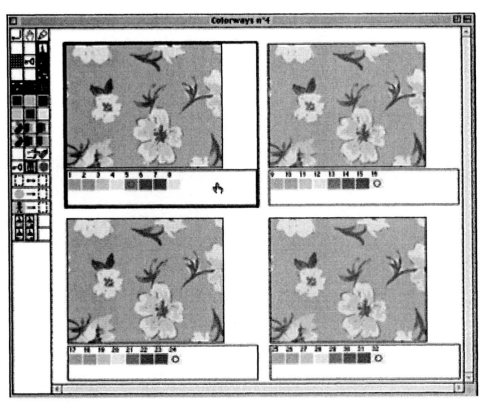

FIGURE 12-19

ADVANCED

Special Notes

Name and version of software used: _____

List of additional steps you needed to take to execute the program that was spe-

cific to the software program that you are using: _____

Biggest challenge: _____

What you learned that was new, and special notes on what you want to always

remember: _____

Miscellaneous thoughts: _____

Exercise 12-5 Creating a Different Color Combination

Software Used

Pointcarré

How-to Steps

1. Open up a palette.
2. Drag the palette over so you can view both the colorways and palette simultaneously (Figure 12-20).
3. Click on the chip tool (Figure 12-21).

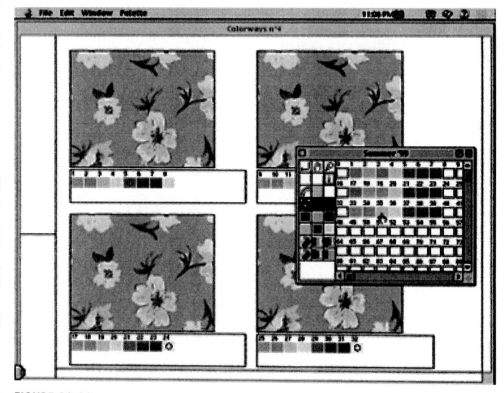

FIGURE 12-20

Skill Level: Advanced

FIGURE 12-21

STUDENT NOTES

4. Drag and drop a color chip from one palette to another (or drag and drop a color chip directly onto the image) (Figure 12-22).
5. Keep dragging and dropping color chips until you are finished (Figure 12-23).
6. You now have four different colorways (Figure 12-24).

Special Notes

Name and version of software used: _____

List of additional steps you needed to take to execute the program that was specific to the software program that you are using: _____

Biggest challenge: _____

What you learned that was new, and special notes on what you want to always remember: _____

Miscellaneous thoughts: _____

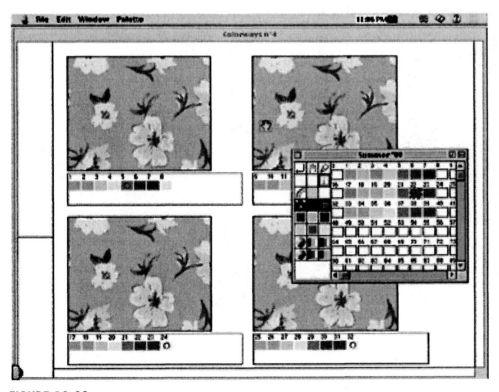

FIGURE 12-22

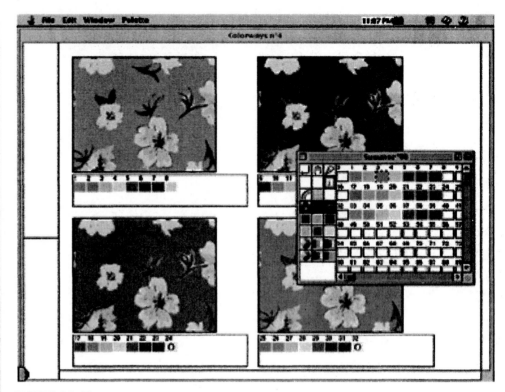

FIGURE 12-23

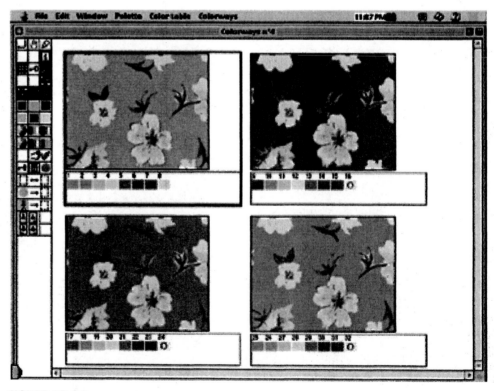

FIGURE 12-24

Skill Level: Advanced

Exercise 12-6 Printing a Colorway File

Software Used

Pointcarré

How-to Steps

1. Go to the main file menu and drag down to Print.
2. A dialog box will appear (Figure 12-25).
3. Choose one of the three options:
 a. On a single page—this will print the colorway on a single page.
 b. As displayed—this option will let you print what you see on the screen.
 c. One colorway per page—this option will print each colorway on a separate sheet.
4. Once you have made your selection, click OK.

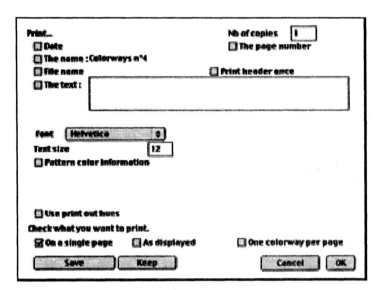

FIGURE 12-25

Special Notes

Name and version of software used: _____

List of additional steps you needed to take to execute the program that was specific to the software program that you are using: _____

Biggest challenge: _____

What you learned that was new, and special notes on what you want to always

remember: _____

Miscellaneous thoughts: _____

 Congratulations, now you understand the basics of how Pointcarré helps you create, modify, name, and save color ships and colorways. From here we will show you

how to begin to apply this knowledge by building a pattern design motif. For our purposes we have chosen to design and modify a paisley pattern. At the conclusion of these exercises we will take this pattern and convert it to a knitted pattern. This will really show you how the design process flows from start to finish, so be sure to take good notes.

Creating a Basic Pattern Motif

Challenge Exercise 12-7 Designing a Pattern Motif: Paisley

Software Used

Pointcarré

How-to Steps

1. You can begin by either scanning a piece of fabric or designing an original pattern.
2. Open the paisley file in Pointcarré.
3. You can now begin to reduce the file using one of three choices:
 a. Regroup colors: by Select, Pattern menu, and then cleanup to see the items shown in Figure 12-26. From here, after choosing Regroup colors (Figure 12-27), the dialog box allows you to select any single column of colors or click to individual color chips to customize the selection. By choosing OK, this will update the design and color reduce it, while maintaining the integrity of the design.
 b. Reduce color numbers option: will allow you to select a random number of colors to reduce to. By entering a number, Pointcarré will reduce by keeping the most frequently used colors until it arrives at the number you have entered as the target number of colors. Using this method also maintains the integrity of the design (Figures 12-28 and 12-29).

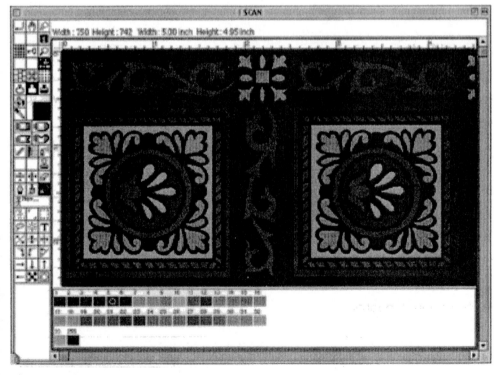

FIGURE 12-26

Remove Isolated dots
Remove horizontal double dots
Remove vertical double dots

Agglomerate to main background
Agglomerate
Agglomerate unselected hues

Regroup colors...
Color frequency draft
Reduce color numbers...
Adjust to selected hues

Thicken selected hues
Thicken top-left
Thicken bottom-right

Narrow selected hues
Narrow top-left
Narrow bottom-right

Digitalize...
Identify...

FIGURE 12-27

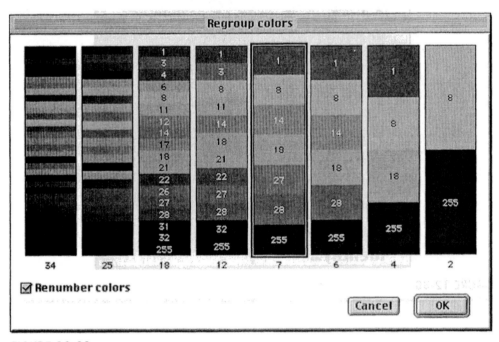

FIGURE 12-28

FIGURE 12-29

Design, Render, and Simulate Knits on the Computer

ADVANCED

c. Adjust to selected hues: This option allows you to select the exact hues you want to keep in the design simply by selecting them with the eye-dropper tool, directly from the scan. Making this selection then reduces the scan down to only those colors you selected while still maintaining the integrity of the design (Figure 12-30).

FIGURE 12-30

Special Notes

Name and version of software used: _____

List of additional steps you needed to take to execute the program that was specific to the software program that you are using: _____

Biggest challenge: _____

Skill Level: Advanced

What you learned that was new, and special notes on what you want to always

remember: _____

Miscellaneous thoughts: _____

Editing a Basic Pattern

Typically "noise" can be described as dots or specs of color. Sometimes this is a desirable feature; if you recall you were introduced to noise under the main filter menu in Adobe Photoshop. However, in this case we are referring to the unsightly specs or dots that characteristically come as a result of scanning (Figure 12-31).

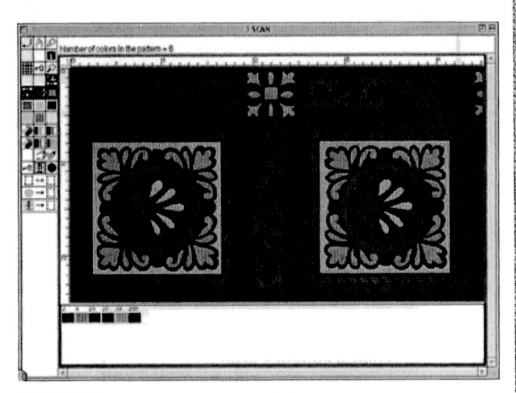

FIGURE 12-31

Challenge Exercise 12-8 Removing Noise from the Paisley Pattern Motif

Software Used

Pointcarré

How-to Steps

1. This is a continuation of Challenge Exercise 12-7; select Pattern.
2. Choose Cleanup and then select, Agglomerate (Figure 12-32).
3. Compare the difference between Figures 12-33 and 12-34.

Special Notes

Name and version of software used: _____

Design, Render, and Simulate Knits on the Computer

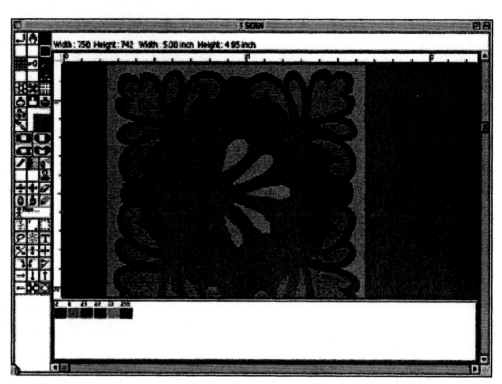

FIGURE 12-32

| Remove isolated dots |
| Remove horizontal double dots |
| Remove vertical double dots |
| Agglomerate to main background |
| **Agglomerate** |
| Agglomerate unselected hues |
| Regroup colors... |
| Color frequency draft |
| Reduce color numbers... |
| Adjust to selected hues |
| Thicken selected hues |
| Thicken top-left |
| Thicken bottom-right |
| Narrow selected hues |
| Narrow top-left |
| Narrow bottom-right |
| Digitalize... |
| Identify... |

FIGURE 12-33

Skill Level: Advanced

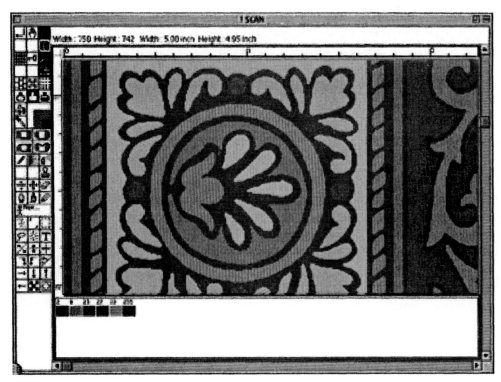

FIGURE 12-34

List of additional steps you needed to take to execute the program that was specific to the software program that you are using: _____

Biggest challenge: _____

What you learned that was new, and special notes on what you want to always

remember: _____

Miscellaneous thoughts: _____

Challenge Exercise 12-9 Using an Existing Motif to Build a Repeat: Paisley

Software Used
Pointcarré

How-to Steps

1. Looking at Figure 12-35 as an example select the area of the motif you wish to isolate.
2. Double clicking the mouse will crop out the selected area (Figure 12-36).
3. You may opt to edit the colors in the design by using any of the editing tools from the main toolbox, such as pens, paintbrushes, or airbrush (Figure 12-37).
4. Select the repeat tool, and choose the desired repeat (Figures 12-38). Note there is a wide variety of options from which to choose to customize your de-

Design, Render, and Simulate Knits on the Computer

ADVANCED

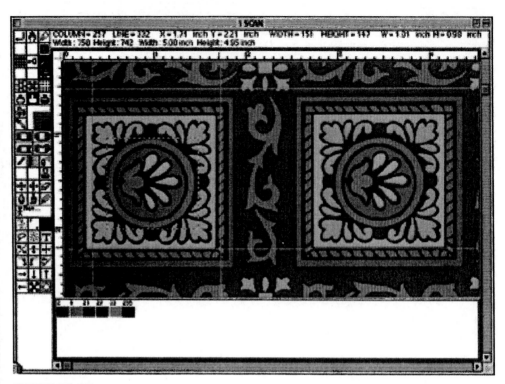

FIGURE 12-35

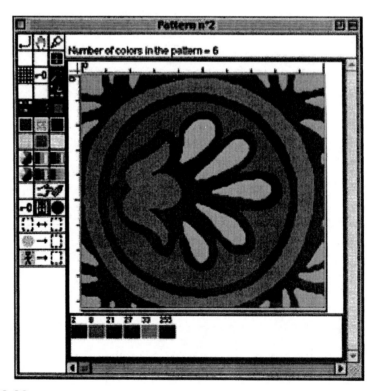

FIGURE 12-36

Skill Level: Advanced

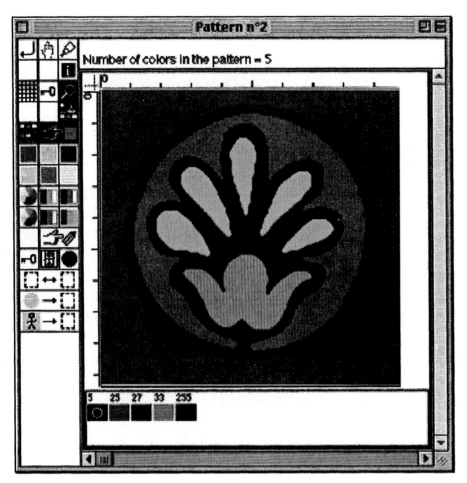

FIGURE 12-37

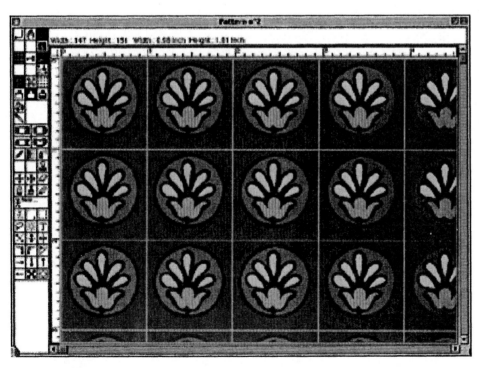

FIGURE 12-38

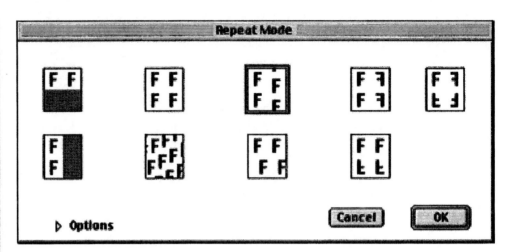

FIGURE 12-39

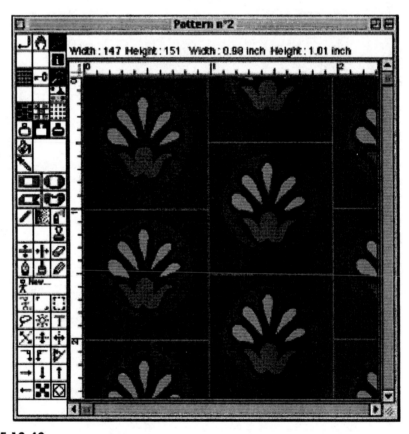

FIGURE 12-40

sign (Figure 12-39). The result of our selection can be viewed in Figure 12-40.

Special Notes

Name and version of software used: _____

List of additional steps you needed to take to execute the program that was specific to the software program that you are using: _____

Skill Level: Advanced

Biggest challenge: _____

What you learned that was new, and special notes on what you want to always

remember: _____

Miscellaneous thoughts: _____

Creating a Toss Repeat

Challenge Exercise 12-10 Creating a Toss Repeat with Our Paisley Motif

Software Used

Pointcarré

How-to Steps

1. Create a new file the exact size needed for the repeat (Figure 12-41).
2. Using your isolated paisley motif from Challenge Exercise 12-9, turn on the repeat function and "stamp" the motif; using the tool features, rotate and flip as desired (Figure 12-42).
3. Do not close your file just yet, we will continue from here in the Challenge Exercise 12-11.

FIGURE 12-41

Special Notes

Name and version of software used: _____

List of additional steps you needed to take to execute the program that was spe-

cific to the software program that you are using: _____

ADVANCED

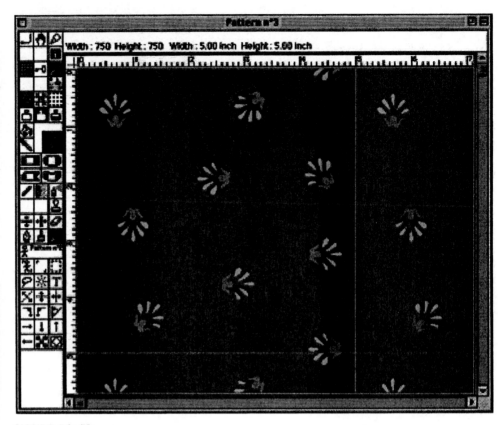

FIGURE 12-42

Biggest challenge: _____

What you learned that was new, and special notes on what you want to always

remember: _____

Miscellaneous thoughts: _____

Challenge Exercise 12-11 Creating and Adding a New Motif to Your Paisley Toss Repeat

Software Used

Pointcarré

How-to Steps

1. Go to the new pattern tool in the toolbox (Figure 12-43).
2. Add an additional motif similar to the one we made in Figure 12-44.
3. Name and save the file.

Additional Comments

From here you are now ready to create and adapt the motif for use in a knitted fabric.

 FIGURE 12-43

Skill Level: Advanced

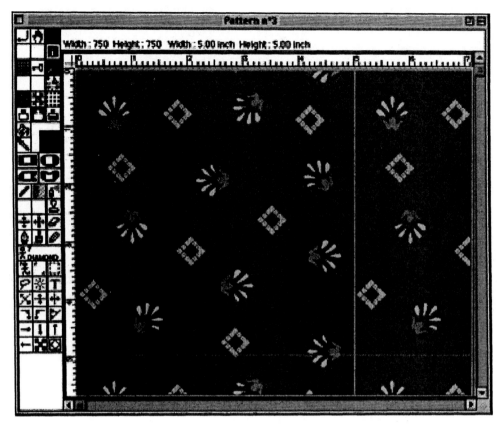

FIGURE 12-44

Special Notes

Name and version of software used: _____

List of additional steps you needed to take to execute the program that was specific to the software program that you are using: _____

Biggest challenge: _____

What you learned that was new, and special notes on what you want to always remember: _____

Miscellaneous thoughts: _____

Converting Your Pattern to a Knit

Many of the following steps are similar to the ones you have just completed. However, there are subtle nuances that distinguish this exercise from the previous ones. Don't go too quickly and make assumptions based on what you have just completed. Go slowly and follow along as we will build on the previous concepts and add new ones to convert your paisley for use in knit.

Design, Render, and Simulate Knits on the Computer

ADVANCED

Challenge Exercise 12-12 Re-creating and Converting a New Motif (Paisley Repeat) for Use in a Knit

Software Used

Pointcarré

How-to Steps

1. Create/scan the design. Scanned art can be edited after scanning and opening Pointcarré (Figure 12-45).
2. Color reduce the design by using one of the following choices:
 1. Reduce the color number option
 a. Regroup colors option
 b. Adjust to selected hues option
3. Your work should now look something like Figure 12-46 or 12-47.
4. You are now ready to digitize your design. Select Clean up.
5. Select Digitize. When given the wales and courses stitch count or width:height ratio of the final design, Pointcarré will digitize the image into a knit graph (Figure 12-48).
6. Choose the graph tool, which allows the user to customize the knit graph. Your choices are:
 a. Primary grid for every stitch, or
 b. Secondary grid for any desired scale (Figure 12-49).

Additional Comments

We will continue after your selection on step 6 in the next exercise.

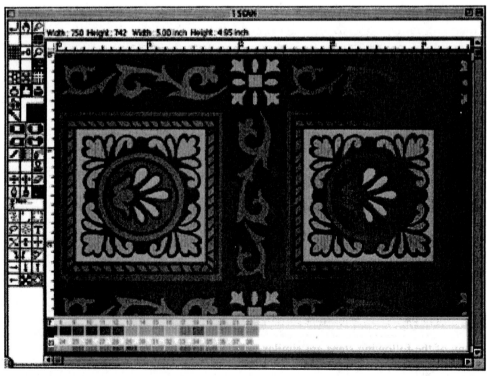

FIGURE 12-45

Skill Level: Advanced

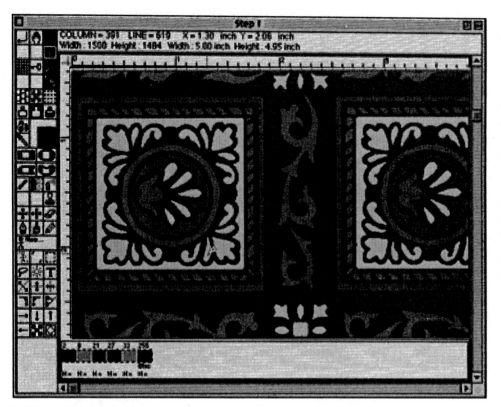

FIGURE 12-46

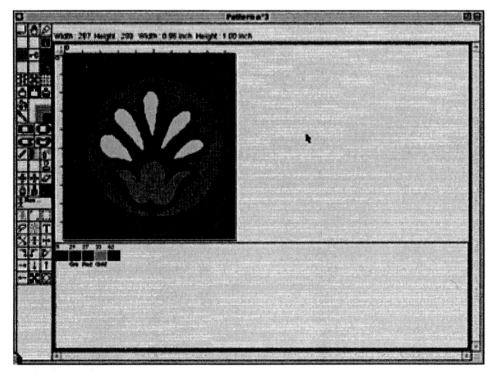

FIGURE 12-47

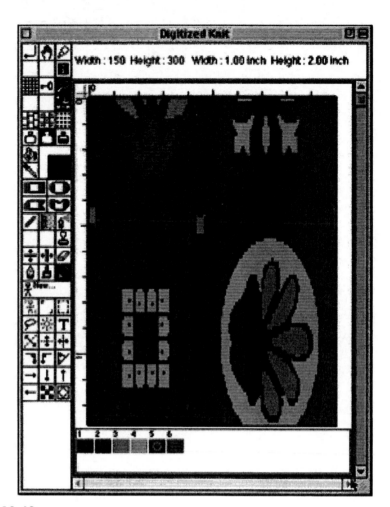

FIGURE 12-48

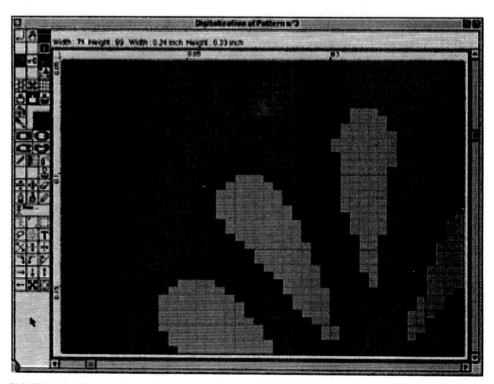

FIGURE 12-49

Skill Level: Advanced

Special Notes

Name and version of software used: _____

List of additional steps you needed to take to execute the program that was specific to the software program that you are using: _____

Biggest challenge: _____

What you learned that was new, and special notes on what you want to always remember: _____

Miscellaneous thoughts: _____

Digitizing and Graphing Your Pattern for Gauge

Challenge Exercise 12-13 Editing your Converted Paisley Motif

Software Used

Pointcarré

How-to Steps

1. This exercise picks up where Exercise 12-12 left off. Now the design can be edited by drawing or selecting any design tool from the toolbox. All the tools are now in knit mode.
2. To view the knit in correct gauge: simply double click on the zoom tool and enter the desired number of wales and courses.
3. Choose OK after your selection (Figure 12-50).

Special Notes

Name and version of software used: _____

List of additional steps you needed to take to execute the program that was specific to the software program that you are using: _____

Biggest challenge: _____

What you learned that was new, and special notes on what you want to always remember: _____

Miscellaneous thoughts: _____

EDITING THE FINAL COLOR AND GRIN

Challenge Exercise 12-14 Simulate Paisley Motif into a Jacquard Knit

Software Used

Pointcarré

ADVANCED

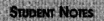

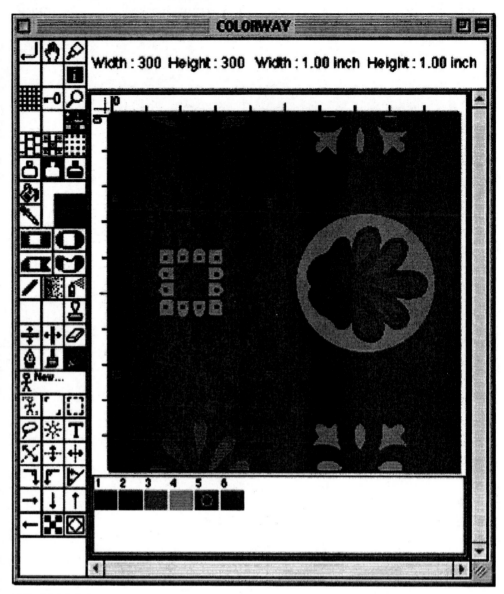

FIGURE 12-50

How-to Steps

1. From the knit menu, select Specify Jacquard.
2. Select Background color for a desired grin-thru color.
3. Select Felting for a brushed effect. Enter a felting percentage.
4. Select Color No. and choose All to enter the same stitch for all colors.
5. If different stitches are desired—for example; a reverse jersey in a specific color—they can be chosen separately.
6. Click in the stitch box at the bottom of the screen and choose Open.
7. You have at this point a direct link to the library icon in Pointcarré to choose a desired stitch.
8. Select OK.
9. To simulate the design, go to the knit menu and select Simulate Jacquard; click OK (Figure 12-51).

Special Notes

Name and version of software used: _____

Skill Level: Advanced

ADVANCED

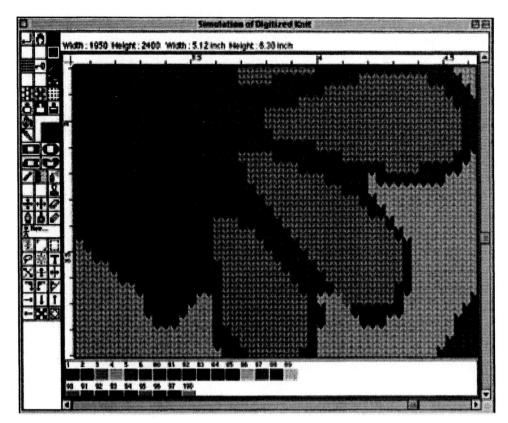

Simulation of Digitized Knit

Width : 1950 Height : 2400 Width : 5.12 inch Height : 6.30 inch

FIGURE 12-51

List of additional steps you needed to take to execute the program that was specific to the software program that you are using: _____

Biggest challenge: _____

What you learned that was new, and special notes on what you want to always

remember: _____

Miscellaneous thoughts: _____

Wasn't that fun and easy to follow? Those exercises were terrific for seeing the big picture when it comes to designing fashion on computers. They were a great review of many of the concepts we have covered in previous chapters.

For now, we will say good-bye to Steven and Monarch and thank him for the great tour of creating fashion using Pointcarré.

WORKING WITH OTHER SOFTWARE FOR KNITS

From here we will complete our journey of knits by working on a few exercises using several other software programs, beginning with Ned Graphics for Gerber Technology's Artworks Easy Knit. In its older versions, this software comes as an add-on that works

ADVANCED

and is accessed from the main filter menu of Adobe Photoshop. Today it is available as a stand-alone software program accessible from the main Artworks icon menu.

We will introduce you to the newest version, which is accessed from the main Artworks menu. This software also permits the designer to select a stitch from the stitch library. The knitted pattern can then be modified by color and gauge. Next, the designer can view the pattern in technical, simulated, or symbol modes simultaneously.

Let's begin by taking a quick tour of the main menu, toolbar and toolboxes of Easy KnitEasy Knit. If you do not have access to this software, you may opt to follow along. As in previous exercises we have included plenty of screen shots to accompany the instructions. Therefore, you should have very little difficulty understanding the process of creating and simulating knitted patterns.

We have also provided ample room for you to jot notes or questions. A quick review of the terms or taking the time to reread the material should solve any unanswered questions you might have if you are unfamiliar with working with knits.

It is important for you to note that when designing a knit most designers will opt to use graph paper.

A designer may also begin with a predetermined gauge or cut with which they need to work. From personal experience, when I was designing knitwear, I preferred to make my swatch first, then graph out my stitch and or color pattern choices. Frequently I was required to assign predetermined universal symbols to the graphed pattern so that another person reading the pattern would understand my instructions.

Typically a graph and grid, as well as symbol format of depicting a knitted pattern have been re-created in this software. These choices will enable a designer to see the stitches and color combinations in an easy-to read-format. You will discover that the Easy KnitEasy Knit software supports all three versions of designing a knit.

Understanding this information will be very useful to the reader who is following along with our instructions but doesn't have the actual software.

Exercise 12-15 Opening a New Project and Accessing Main Project Options

Software Used

Gerber Technology's Artworks Easy KnitEasy Knit Software

How-to Steps

1. From the Artworks menu, select Easy Knit (Figure 12-52).
2. From the Easy Knit main menu, select New Project.

FIGURE 12-52

Skill Level: Advanced

3. In Figure 12-53, you will notice the pop-up Project dialog box. We have selected the first of the repeat options.
4. From the Project dialog box, select the Pattern Draft option menu (Figure 12-54). This shows the default number choices.
5. In the Pattern Draft dialog box shown in Figure 12-55, we have chosen to make the gauge for our knit equivalent to a hand-knitted sweater to produce an easy-to-view graph. In the Parameters boxes, follow along with our selections of the Width (course) and Height (wales) of the sample. You may opt to use our choices or to make your own selection for the background color and the grid lines using your predetermined intervals.
6. Continuing in the Project dialog box, you will notice that you have additional choices, such as:
 1. Simulation: This dialog box will convert your graph view into a simulation of actual knitted stitches (Figure 12-56).
 b. Symbols: This dialog box will enable the designer to assign symbols to stitch patterns they have created. Using this option these patterns will then be rendered in symbol version to indicate the stitches. While this is useful to some firms with a wide range of stitches, typically this will not be necessary. Most designers prefer to view the knit in either graph (charted) format or in simulation format (Figure 12-57).
 c. Set Options: This dialog box has a list of additional choices (Figure 12-58).
7. After you have made your selections from the project dialog box, click OK. You will continue from this point in the next exercise.

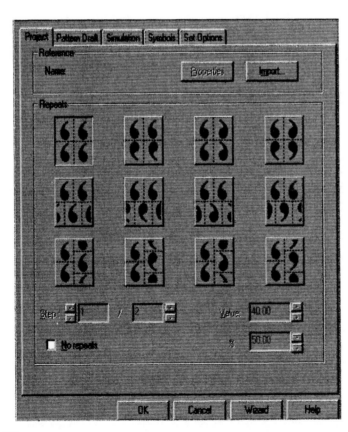

FIGURE 12-53

STUDENT NOTES

ADVANCED

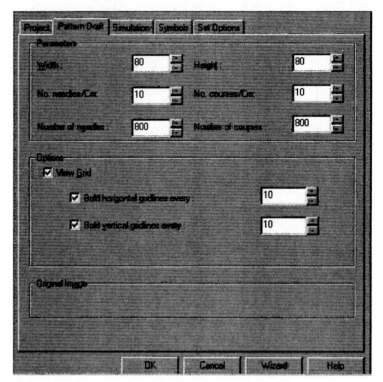

FIGURE 12-54

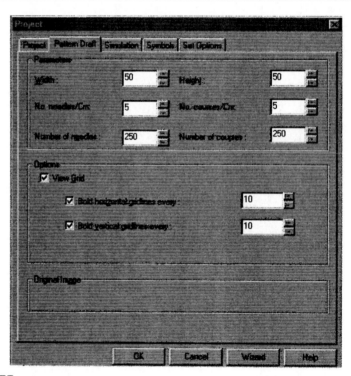

FIGURE 12-55

Special Notes

Name and version of software used: _____

List of additional steps you needed to take to execute the program that was specific to the software program that you are using: _____

Skill Level: Advanced

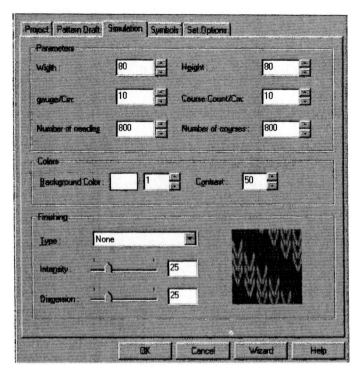

FIGURE 12-56

FIGURE 12-57

Biggest challenge: _____

What you learned that was new, and special notes on what you want to always

remember: _____

Miscellaneous thoughts: _____

Design, Render, and Simulate Knits on the Computer

ADVANCED

FIGURE 12-58

Special Notes

Exercise 12-16 Opening a New Project and Accessing the Main Menu, Toolbar, and Toolboxes

Software Used

Gerber Technology's Artworks Easy Knit Software

How-to Steps

1. Beginning at the end of step 7 in Exercise 12-17, we will now take a brief tour of the main menu bar, the toolbar, and the toolboxes. The options that are available should be familiar to you because they are similar to all the menu bars and toolboxes we have used so far. To avoid confusion, we have focused our exercise on the most basic choices you would make as you begin to learn the Easy Knit program. To begin, review Figures 12-59 through 12-62.

File Edit View Motif Tools Knit Preferences Window Help

FIGURE 12-59

Special Notes

Skill Level: Advanced

FIGURE 12-60

Special Notes

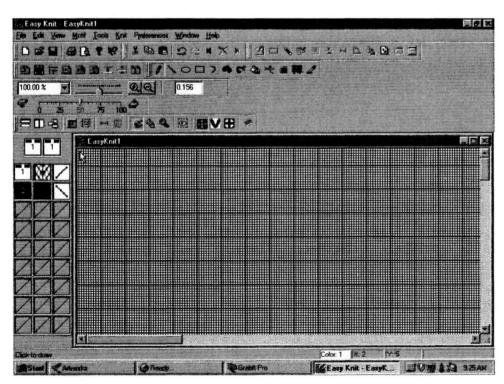

FIGURE 12-61

Special Notes

FIGURE 12-62

Special Notes

ADVANCED

Exercise 12-17 Working with the Stitch Pattern Selector and the Knit Atlas

Software Used

Gerber Technology's Artworks Easy Knit Software

How-to Steps

1. In Figure 12-63 shows the dialog box for both the type of stitch and the color of the stitch. For example if you double click on the 1, it will bring up the color palette (Figure 12-64). This color palette works very similarly to the color palettes we used in Chapters 10 and 11. As you can see from our example it supports most color systems and modes.

FIGURE 12-63

FIGURE 12-64

In Figures 12-65 we have selected a third color. As always, most actions are selected by a click or double click of your mouse.

If you go back and double click on the stitch symbol (it looks like the letter "v") next to color box 1, you will access the Knit Stitch Atlas option (Figures 12-66 and 12-67). For our purposes we have kept the pattern (in single knit) known as weft knitting. Recall

Skill Level: Advanced

that this means the face of the fabric is in all knit stitches and the reverse is in all purl. This means the machine, or in this case the computer, knows to make one row of knitted stitches and then one row of purl stitches until the sample or garment is complete.

FIGURE 12-65

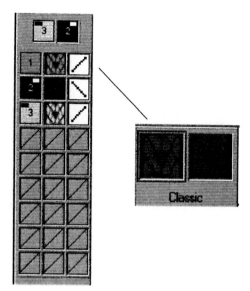

FIGURE 12-66

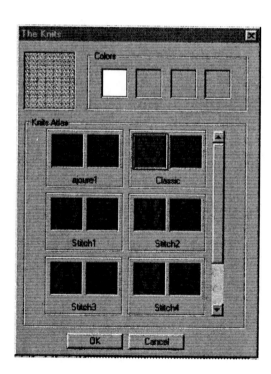

FIGURE 12-67

Next look at Figure 12-68, which shows the full screen. Note that in the lower right corner of screen is the drawing tool option menu (Figure 12-69). This corresponds to the toolbar options in Figure 12-70.

Design, Render, and Simulate Knits on the Computer

ADVANCED

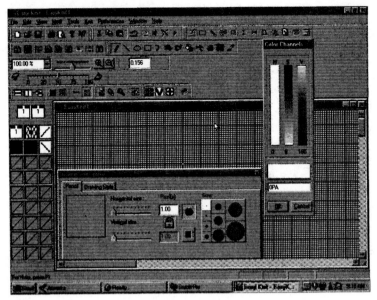

FIGURE 12-68

FIGURE 12-69

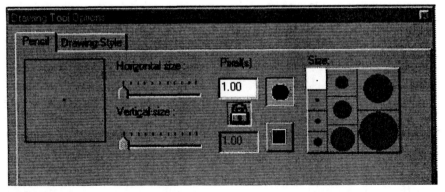

FIGURE 12-70

Skill Level: Advanced

Additional Comments

In Figure 12-70, note that you will have the option to make a wide variety of shapes and images. In fact, Figure 12-71 shows that you have the ability to draw stripes and checks; and Figure 12-72 shows that you can draw freehand. All of these options work similarly to the object-oriented drawing and freehand drawing modes found in most drawing programs or software.

FIGURE 12-71

FIGURE 12-72

In Figure 12-73 we have drawn several circles on our knit sample using color 2. This was accomplished by using the mouse and placing it on any section of the graph and then clicking and dragging the mouse to form circles.

Now we suggest you stop and review what you have seen so far and jot down notes or questions you might have. Spend some time reviewing the material to this point to see if you can apply what you have learned to resolve any questions you might have up to this point.

If you are still having trouble, go to the help menu or consult your owner's manual. For those of you who do not have the software, try reviewing the material with another student or designer to see if there is something you have overlooked.

Remember, it is always easier to understand if you have the ability to spend some time with the actual software. So do not get discouraged if you are having difficulty relating to or completing the exercises.

Believe it or not, showing the screen shots to someone who knits by hand will assist you in understanding knit concepts. So don't be afraid to ask someone who knits to review the material with you.

Design, Render, and Simulate Knits on the Computer

FIGURE 12-73

Special Notes

Name and version of software used: _____

List of additional steps you needed to take to execute the program that was specific to the software program that you are using: _____

Biggest challenge: _____

What you learned that was new, and special notes on what you want to always

remember: _____

Miscellaneous thoughts: _____

Let's review what you have learned so far:

- How to open a new project in Easy Knit
- How to knit using a single knit
- How to select the color by stitch and by row
- Where to make stitch pattern selections from the Knit Atlas
- How to draw objects, lines, and freehand images into your knit

Now, in the remaining exercises we will show you two more basic functions you can perform on your design. The first is to preview your work in either graph mode or simulation mode. Next, we will change the stitch pattern within the circles from knit to purl. If you recall, we were working exclusively in all single, or weft, knit. Now we will change our stitch pattern to add surface interest. Be sure to continue to take good notes as you proceed.

Skill Level: Advanced

Exercise 12-18 Switching from Graph View to Simulation Mode View

Software Used

Gerber Technology's Artworks Easy Knit Software

How-to Steps

1. We are continuing from our previous exercises. Your screen should have several sample circles in a contrasting color and be in graph mode view.
2. Go to the stitch simulation icon on your toolbar (Figure 12-74) and toggle it on with the mouse.
3. Notice your screen has changed from a graph (Figure 12-75) to a simulation of a knitted swatch (Figure 12-76).
4. You can easily preview your work in both modes.

 FIGURE 12-74

Special Notes

Name and version of software used: _____

List of additional steps you needed to take to execute the program that was specific to the software program that you are using: _____

FIGURE 12-75

FIGURE 12-76

Biggest challenge: _____

ADVANCED

What you learned that was new, and special notes on what you want to always remember: _____

Miscellaneous thoughts: _____

Exercise 12-19 Working with the Stitch Pattern Selector and the Knit Atlas to Change Stitches

Software Used

Gerber Technology's Artworks Easy Knit Software

How-to Steps

1. Referring to Exercise 12-17, steps 1 to 3, you will notice that we have shown you one of the ways to access the Knit Atlas.
2. Once you have located the Atlas, you should see approximately 8 to 12 different stitch patterns from which to select. Remember when you see the "v"-like stitch it will represent a knit; the "ridge-like" stitch represents a purl; and the "straight-bridge-like" stitch represents a miss stitch (Figure 12-77).
3. You may now opt to double click on the main stitch selection box on the left of your screen (Figure 12-78) to choose the appropriate stitch for your swatch or garment. To make complex versions of stitches, there are step-by-step instructions on the CD-Helps Tutorial that comes with the software.

FIGURE 12-77

Special Notes

Name and version of software used: _____

List of additional steps you needed to take to execute the program that was specific to the software program that you are using: _____

Biggest challenge: _____

Skill Level: Advanced

What you learned that was new, and special notes on what you want to always

remember: _____

Miscellaneous thoughts: _____

FIGURE 12-78

In our last section we will show you examples of rendered knitted fabric. Frequently, you might find clip art or other sources that will depict a knitted fabric. You may then resize, rescale, or modify it for use on your garment flats. Figures 12-79 and 12-80 show examples that were found in the interior pattern fill section of Micrografx Designer. Refer to Chapter 11 to refresh your memory of where and how to use the pattern fill option.

FIGURE 12-79

FIGURE 12-80

FINAL COMMENTS

Did you notice we have been using the terms, *create, render,* and *simulate*? To avoid any misunderstandings, we want to be sure that you understand the differences between those terms. So here is a quick review.

- *Creating* a knit on the computer implies using an actual graph or grid system to mathematically layout the swatch or fabric to the exact measurements used in production.

- To *simulate* a knit on the computer means to view the newly created computer-generated knit in a view format that will simulate the swatch or fabric as if you had the actual fabric in front of you. This technique of simulating knits is done by converting the computer-generated graph pattern into a computer-aided sample.

- To *render* the knit means to use the computer to draw the knitted fabric as it might look if it were created. The difference between simulating a knit and rendering it is that you can render a knit without the drawing of your knit being mathematically accurate. Instead, your drawing will merely be a representation of what the fabric might look like.

Wow, you can really say you have been shown the grand tour!

Our desire for you in this chapter was for you to not only create knitted fabric, but also to render and simulate knits on the computer, and hopefully, to walk away with a better understanding on the subject of knits then you ever had before. We trust that we have done our job and that you have enjoyed your tour of the world of designing knits.

Your next stop is creating, rendering, and simulating woven fabric.

CHAPTER SUMMARY

The goal of this chapter was to introduce students to the basic steps of rendering or simulating knits on computer, using several industrial vector-based software systems.

The chapter also included a complete review of the basics of knitted textiles in order to assist the reader to a better appreciation of the design process of creating knitted fabric.

This chapter was a contextual overview designed to walk the design student through the complete design process using industrial-based software. The process included the creation of a basic motif that was easily used as a surface design for fabric and then converted into a knitted pattern by computer-aided graphing.

Students discovered that original CAD/CAM designs can be digitally generated and then converted, by a fully integrated software system, from concept to fabric construction to consumer. Industrial software permits the designer the freedom to create a knitted fabric using any yarn or any cut (gauge) combination to form knitted fabric.

Skill Level: Advanced

Although we did not go through the mechanics of actually making the fabric on a loom, the designing steps within the process were conveyed using the same familiar concept-specific drawing tools used in prior projects.

Therefore, by incorporating basic textile knowledge in conjunction with a strong understanding of the computer-aided design principles of earlier chapters, the fashion-design student is better prepared for working in real-life scenarios in the field of fabric design.

ADVANCED

CHAPTER 13

Creating, Rendering, and Simulating Woven Fabric on the Computer Using Commercial or Industrial-based Software

Focus: The Principles of Designing Woven Fabric, Including Making a Digital Swatch Book

CHAPTER OBJECTIVES

- Comprehensive review of woven fabric/textiles
- Develop a better understanding of textile basics, including terminology relevant to woven fabric
- Distinguish between basic and fancy weaves
- Introduction to industrial-based software for designing and/or simulating woven fabric
- Distinguish between creating, simulating, or generating a woven pattern on computers
- Graphing color for use in a woven fabric
- Observe the CAD/CAM process of rendering a pattern motif that can be repeated for surface design use or converted into a Jacquard woven using industrial-based software from industry experts.
- Apply earlier skills to the computer to generate a digital fabric swatch book on any vector- or raster-based software (commercial or industrial)

TERMS TO LOOK FOR

dobby	Jacquard	pile	twill
ends	leno	satin	warp
fabric	loom	shuttle	weaving
fibers	natural fiber	synthetic	weft
head	picks	textile	yarns

ADVANCED

The most widely used method of making fabric has always been weaving. A simple definition for *weaving* is two yarns that interlace at right angles. It is fairly easy to recognize a piece of woven fabric; typically, it has stretch only on the bias. This means that the fabric will have its give on the diagonal—i.e., it will stretch from corner to corner (Figure 13-1).

Weaving is done on a device called a loom. Yarns placed on the loom in a vertical fashion are called the warp or end yarns. From here yarns are transported or laced across the warp yarns horizontally using a device called a shuttle. These horizontal yarns are referred to as the filling or weft yarns.

I often joke with my students, telling them it is easy to remember the difference between the terms. Think of it this way, the term *warp* ends in the letter *p;* so just remember that the warp are the u*p* and down yarns. The horizontal yarns are called filling or weft; why? Because they fill-in and go from *w*eft to *w*ight. I know it sounds corny, but it will really help you remember the difference.

These yarns can be laced across the loom in a variety of patterns. These patterns fall into categories of either a basic weave or a fancy weave. The most basic pattern is a *plain*, or *tabby*, weave. The yarns used to form this simple pattern are typically considered to be a 1+1 (1 over, 1 under) design (Figure 13-2).

Another variation of a basic weave is a basket weave, which is formed by a 2+2 pattern (or 2 over, 2 under) (Figure 13-3).

The next basic weave is a *twill* weave. A twill weave consists of yarns that form a distinct right or left pattern design. A variation of a twill weave is a herringbone, known for a combination of right and left patterns (Figure 13-4). Twill weaves are also described by the degree or "steep" of the angle of the pattern (Figure 13-5). Several examples of twill weave fabrics are denim, drill, gabardine, houndstooth, and herringbone.

A satin weave is also considered a basic pattern. Satin fabric is formed when the weft yarns float across the face of the fabric in intervals. This creates a lustrous surface on the face of the fabric. This pattern in weaving is used to enhance the natural reflection or shine of a filament yarn.

Filament yarns used in this pattern will typically include natural fibers such as silk, or synthetic fibers such as polyester. An obvious example of a satin weave fabric is satin (Figure 13-6).

FIGURE 13-1 Woven materials have stretch only on the bias (diagonal).

ADVANCED

FIGURE 13-2 A plain, or tabby, weave pattern.

FIGURE 13-3 A basket weave pattern.

Skill Level: Advanced

FIGURE 13-4 A herringbone weave pattern.

FIGURE 13-5 Twill weaves are also described by the degree or "steep" of the angle of the pattern.

ADVANCED

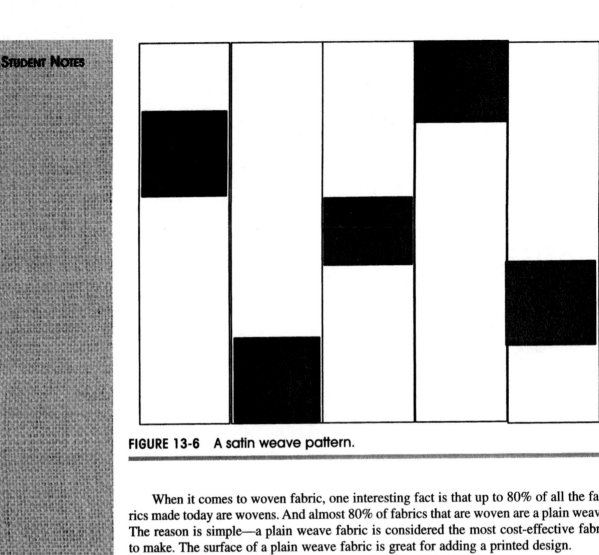

FIGURE 13-6 A satin weave pattern.

When it comes to woven fabric, one interesting fact is that up to 80% of all the fabrics made today are wovens. And almost 80% of fabrics that are woven are a plain weave. The reason is simple—a plain weave fabric is considered the most cost-effective fabric to make. The surface of a plain weave fabric is great for adding a printed design.

The next category of woven patterns is fancy. The list of fancy weaves includes *pile, leno, dobby, Jacquard, swivel,* and *lappet.* Pile weaves are formed by leaving loops on the surface of the fabric, which are cut or left uncut. Examples include terry cloth and velvet.

Dobby weaves on the other hand can be described as a small geometric repeat pattern, such as a diamond, that is formed by yarns on the surface of the fabric. An example of a dobby weave is pique. It is important to point out that even knitted fabric has its own version of pique; however, do not confuse a pique knit with a woven pique. These fabrics are constructed by two very different methods.

A woven Jacquard is a complex pattern and requires a special type of loom. You may recall that the term *Jacquard* was also used in knitted fabrics, and here it is again in woven fabrics. The difference is in the construction method. A Jacquard typically is considered a complex pattern. For example, a floral design is depicted by a print on a plain weave fabric; however, in a woven jacquard the floral pattern is woven into the cloth. Using a Jacquard design will allow anyone who handles a woven Jacquard fabric to feel as well as see the texture of the design on the surface of the fabric.

Creating woven fabric on the computer uses the same design concepts and drawing tools used in most vector- and raster-based programs. The main exception is that industrial-based software/systems have integrated additional tools and options to enhance a woven design so that is translatable for applying the computer-generated pattern to a loom used in the actual production of cloth.

Interestingly enough the term *Jacquard,* frequently associated with woven fabric, was named for a gentleman. In the early 19th century, Joseph Marie Jacquard developed a programmable punch-card system of pattern making for woven fabric. Jacquard was a forerunner in the development and understanding of the fundamental principles used in computers. This system is widely recognized today by the computer world. The Jacquard

looms were originally adapted as a primary form of computer input. So it is only natural that creating woven fabric on computers is not so much a quantum leap in design as it is a throwback to its original roots. Or to quote King Solomon "Everything old is new again." Only this time, instead of paper used for punch cards, the computer screen is the drawing board.

A leno weave is characterized by a figure-8 in the pattern. This pattern is also called a doup weave because it requires the use of a doup attachment to form the pattern in the fabric. The warp yarns are used to form cross-wise pairs. These pairs are then held together to avoid a slipping of the pattern. This fabric has a light, airy appearance.

The swivel pattern uses extra weft yarns, which are carried across the loom to form groups of warp yarns that are later clipped. This pattern forms spots on the surface of the fabric.

In the lappet pattern, which is not very common, the extra yarns used in a warp direction are left on the surface to form an eyelash effect.

As you can see, each of these patterns has several variations and applications. We will be including exercises on how to construct both basic and fancy weaves. We will also include in our exercises the rendering and applying of surface interest, such as a brushed effect.

In this section we will introduce you to one of our experts from StyleClick (Moda-Cad), Meredith Rossi. Meredith will briefly share her insights as a trainer. She will be focusing on areas she has observed her students contend with throughout the years. She will then offer some timely advice on how to overcome these challenges.

To reinforce the concepts associated with the weaving process, take a few minutes to familiarize yourself with some of the relevant jargon. Even if you do not grasp all of the concepts, you should at least sound as if you know what you are talking about.

All in all, this promises to be a very interesting and exciting chapter in our journey of designing fashion on computers.

Weaving Terms

Bias: The diagonal stretch or give on a piece of woven fabric.

Balance of cloth: A woven fabric in which the number of warp and weft threads that intersect within a given area are within 10 of each other.

Chevron: A twill weave pattern that has a zigzag appearance similar to a herringbone pattern.

Chino: A firmly woven fabric, typically trousers, made from cotton.

Chintz: A semigloss fabric.

Corduroy: A soft raised lengthwise pile rib woven fabric.

Count: The number of warp and weft threads that intersect within a given area, usually 1 inch. For example, the label on bed sheets may say 250 count; this number indicates the quality of the weave in the fabric.

Denim: A popular durable twill weave fabric that is often synonymous with jeans.

Dobby: A woven pattern with the appearance of a small geometric repeat pattern.

Ends: Another name for the warp yarns.

Ethnic (also known as *Folk*): This is a type of design or inspiration from a traditional national or regional costume.

Fabrication: How a design is made (knit, woven, other) and whether a design is made from natural or synthetic fibers.

Filling: Another name for the weft yarns.

Flannel: This fabric was originally made from wool, and has come to be known as a brushed fabric that can be made from many fibers, including wool, cotton, and synthetics. Also note that the term *Flannelette* has been given to a flannel-look fabric made from cotton.

Floral: A repeat pattern of flora and fauna. Floral patterns may also be woven into a Jacquard fabric.

Float: The weft yarns intentionally left on the surface of a piece of woven cloth.

Gouaches: Gouach is one of the more frequently used medium-made of gum Arabic and is used for textile designs. It is used for apparel or decorative field. It frequently comes from the tube and is too thick to be used alone and is mixed with water or small amounts of white paint. It is very thick and dries very slowly.

Greige goods: Unbleached or unfinished fabric that has no finishing treatment. Muslin is an example.

Herringbone: A twill weave pattern with a distinctive right and left pattern.

Jacquard: A complex weave that is created on a loom of the same name. This weave has the pattern constructed into the fabric. The design is a texture that can be seen as well as felt.

Lappet: A fancy weave constructed of warp yarns that form an eyelash effect on the surface of the fabric.

Leno: A fancy weave that has the appearance of a figure-8 within in the pattern.

Loom: A device used in the making of woven cloth.

Loop (also known as a _Pick glass_): A magnifier used in the inspection of a piece of woven cloth.

Muslin: A fabric that is generally a plain weave. This fabric is typically considered a greige good made from cotton.

Pile: This woven pattern is made from loops on the surface of the weave that are left cut or uncut.

Picks: Another name for the filling or weft yarns used in the construction of woven fabric.

Plaid: A checked pattern that is formed by the colored warp and weft yarns in a weave that can be either a plain or twill weave.

Plain: The most basic woven pattern that is formed by a 1+1 or 2+2 pattern of warp and weft yarns.

Point paper: Typically a graph paper used in the plotting of a woven pattern. The size of the paper in terms of number of blocks or series of grids to the inch may vary.

Satin: A basic weave formed by floats that are left at intervals on the surface of a fabric.

Selvage: The right edge of the fabric made from warpwise finished edges or self-edges.

Shuttle: This device moves the warp yarns across the weft yarns in the making of woven fabric. There is a standard, historical type of wooden shuttle as well as more traditional shuttleless versions that propel the threads, such as air jet and water jet.

Suiting: Fabrics associated with the construction of suits for men and women. They can be categorized as a bottom- or tropical-weight fabric, typically of worsted wool.

Swivel: A fancy weave made from groups of warp yarns that are later clipped in woven cloth.

Tabby: Another name for a plain weave.

Textile (also known as _Fabric, Cloth, Goods,_ and/or _Tuff_): Excludes findings. Latin for "to weave."

Thread count: (see _Count_).

Twill: A basic weave with a distinctive right or left angled pattern.

Warp: The vertical yarns placed on the loom in woven fabrics.

Weaving: The interlacing of two yarns at right angles to make fabric.

Weft: The filling or horizontal yarns used in the making of woven fabric.

Before we begin to render or design woven fabric, we have included a brief textile refresher course on fibers and fabrics, because in order to design fabric you must have a basic understanding of the fibers and yarns used in the construction of cloth. So naturally, we have included a basic review for your edification.

There are five basic units of study you can categorize textile study into. They are:

1. Fibers
2. Yarns
3. Fabric structure
4. Color
5. Finishes

Fibers are the basic building blocks for fabrics. A fiber is a hairlike substance that is either natural or synthetic. Fibers are the basic building blocks for yarn. Yarns are fibers (short) or filaments (long) that are laid together in varying amounts of twist.

When it comes to making fabric there are basically three ways to construct cloth: knit, weave, or other. _Other_ includes a range of different techniques such as bonding, laminating, and felting.

The term _color_ refers to the application, retention, or removal of dye to a fiber, yarn, fabric, or garment. A finish is anything that will alter the hand, appearance, or performance of a fabric. A finish can be added at any time in the production process.

Below is a list of the most widely used natural fibers.

FIBER NAME	KNOWN FOR	MOST COMMON SUBSTITUTE
Cotton	Comfort, wicking	Polyester
Linen	"Rich" wrinkles	Polyester or rayon
Ramie	China grass	Linen
Silk	Luxurious hand	Polyester, acetate, rayon, nylon
Wool	Protein/hair (not not just from sheep)	Acrylic, polyester

These natural fibers can be categorized as being either a cellulose or protein fiber. With the exception of silk (which is a filament), all the natural fibers are considered short or staple.

There are also a variety of other minor vegetable fibers such as: sisal, hemp, and pina.

Below is a list of the most common synthetic fibers.

FIBER NAME	KNOWN FOR	MOST COMMON SUBSTITUTE FOR
Acetate	After-five/cellulose	Silk
Acrylic	Faux wool	Wool
Metallic	Lamé, glitter	Gold and silver
Modacrylic	Faux fur	Fur
Nylon	Strongest synthetic	Silk
Olefin	Wicking	Cotton
Polyester	Industry workhorse	Everything
Rayon	First synthetic fiber	Silk, linen
Spandex	Stretch	Rubber
Triacetate	Holds pleats/cellulose	Silk
Tencel	Newest synthetic fiber	Cotton

Most of today's generation cannot recall a time without synthetic fibers. It is important to remember many of the synthetic fibers were designed to be a reflection of the natural fiber they were designed to mirror. The goal was to minimize cost and care for the consumer without sacrificing quality or appearance. To that extent, they have served us well. Many of the synthetic fibers are considered to be a filament fiber that can be cut and/or blended with natural fibers to ensure the best of both fibers in yarns or fabrics.

Now that you have finished your woven-textile refresher course, you are ready to begin to create, render, and simulate woven fabric on computers. You can choose to render the fabric in any vector-based software. You may also opt to scan your swatch, or you can choose to create the woven patterns digitally with the following software exercises.

It is only natural that as we proceed to show you how to render and create woven pattern/fabric that we mention that we have included a how-to chart for you to make a digital reference for your swatches. Our fabric reference chart can be found at the conclusion of this chapter.

As always, before we begin our exercises we will introduce you to one of our experts. Our exercises in the first half of the chapter come from a StyleClick (ModaCad) software entitled ModaWeave. Our expert is one of the trainers from StyleClick (ModaCad), Meredith Rossi.

ADVANCED

MEET MEREDITH ROSSI

Meredith Rossi is the Training Director for StyleClick (ModaCad) in Los Angeles. She graduated from the Fashion Institute of Design and Merchandising in 1992. Meredith started her tenure at StyleClick (ModaCad) as an intern. During her internship she learned a variety of StyleClick (ModaCad) design programs. She thoroughly enjoyed her training and was delighted to take a full-time position in the training department.

Today her job entails meeting with and training clients on how to use the Design Systems Software. She conducts training on all of the StyleClick (ModaCad) software, including ModaDrape, ModaWeave, and ModaCatalog, as well as 3DVM, which is used for merchandising.

According to Meredith, two of the greatest obstacles she constantly has to overcome in her training seminars is her clients' attitudes and fears of computers. Many artists and designers view computers as a cold piece of machinery that will not accurately represent their work. So as a trainer, it is her job to help her students see the computer as another tool or medium in which to work, just like a paintbrush or an airbrush. For example, instead of creating a sketch in a traditional way—with pen and paper—designers can now produce a sketch on a computer using a design program or by scanning in an existing sketch. The computer is used to clean up and recolor the sketch quickly and efficiently.

When it comes to designing fabric Meredith strongly recommends the use of the StyleClick (ModaCad)'s design software. Previously, a potentially wonderful apparel or textile design would have to be sacrificed because of a lack of time. Now, designers do not have to wait for the gouaches of new prints to dry or to worry about taking the time it takes to paint new colorways, which may never even be approved.

The same goes for creating a custom weave. The amount of time and energy that goes into experimenting with new ideas was practically out of the question in the past. Today it can be accomplished in a matter of minutes and key strokes on the computer. In a day when time really is money, the amount of valuable time saved is truly amazing.

In the following pages we will take you on a virtual tour of how to create woven fabric.

Beginning the Woven-Design Process

Designing a woven pattern is very similar to designing a knitted pattern. Both types of patterns can be drafted out manually on graph or point paper. Today, thanks to computer software, a fashion designer can accomplish this same task using a graph-simulation function found on most woven-pattern software. This function can include a pattern size that is as large as the designer requires to a pattern size as small as a single pixel.

Just as we have done in previous chapters, we will begin our introduction by first taking you on a "tour" of the StyleClick (ModaCad) program. We will then showcase several of the functions of the program.

We will begin our exercise portion of this chapter by introducing you to the StyleClick (ModaCad) Textile Design Software entitled ModaWeave. Here you can familiarize yourself with the ModaWeave main menu and options. As you can see in Figure 13-7, ModaWeave has its own program icon. Figure 13-8 shows the first screen you will encounter once you have accessed the StyleClick (ModaCad) program via the program icon.

Skill Level: Advanced

ModaWeave
1.0

FIGURE 13-7

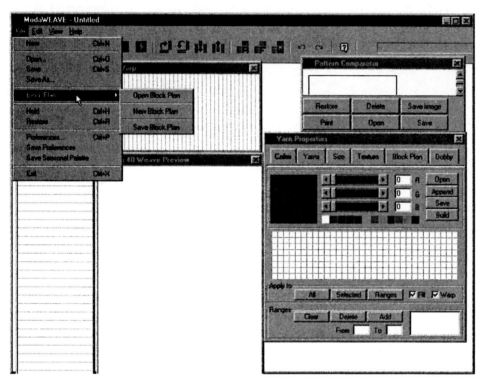

FIGURE 13-8

The designer now has several options from which to select. Note in Figure 13-9 that a designer may opt to begin to create a wide variety of woven patterns, located in the Look-in box. The choices are create a new pattern or open and/or modify an existing pattern.

Next we will take a look at the main menu toolbar. Note in Figure 13-10 going from left to right, you will have the following icon options:

1. Open a new file
2. Open a new folder
3. Save your work
4. Hold
5. Restore
6. Render
7. Flash render
8. Copy fill to warp

Creating, Rendering, and Simulating Woven Fabric on Computer

ADVANCED

411

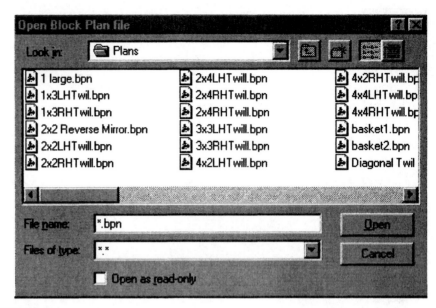

FIGURE 13-9

9. Copy warp to fill
10. Insert thread
11. Delete thread
12. Inverse all selections
13. Inverse fill selection
14. Inverse warp selection
15. Undo
16. Redo
17. Help

Take a moment to jot down any thoughts your may have on the use of these icons. And don't forget that the answers to your questions are just a click away, using the help icon.

FIGURE 13-10

Special Notes

Next, we will take a look at a new file screen in the ModaWeave program (Figure 13-11).

Skill Level: Advanced

FIGURE 13-11

Special Notes

On closer examination you will see several additional menu boxes from which to select. We will begin on the far left with the block plan box. This example is labeled 2×2 Oxford (Figure 13-12). This window contains the block pattern a designer can choose to create for their woven project.

Take a closer look at the black cells or squares on the block plan. These indicate where a fill is visible and the white cells or squares indicate the warp.

In Figure 13-13, the number of warp yarns a designer has selected is also indicated on the screen. An example of the number of fill yarns can be seen in Figure 13-14. Shortly, we will show you "where and how" these choices for the number of warp and fill yarns were made.

At the lower far right of your screen, you will see a Yarn Properties window. This window consists of several attribute boxes a designer can go through to narrow down choices for a particular project.

Let's begin by taking a closer look at another available selection: Color (Figure 13-15). As you can see, the designer can select the colors for both the warp and the fill yarns either

FIGURE 13-12

Creating, Rendering, and Simulating Woven Fabric on Computer

ADVANCED

individually or collectively. The colors can be selected by assigning a numeric value to the yarn, by selecting the color using the sliding color bar, or by selecting one of the color chips with the mouse.

FIGURE 13-13

FIGURE 13-14

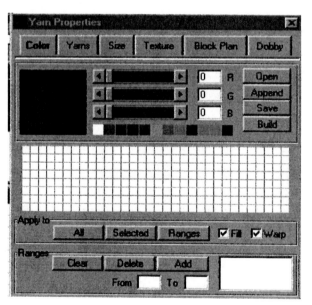

FIGURE 13-15

Special Notes

The next menu you will see going across the top of the Yarn Properties window, is Yarns. As you can see in Figure 13-16, the designer can select and preview a number of yarn types. Note that different yarns can be assigned to the warp and/or to the fill.

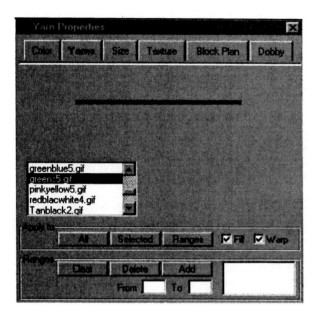

FIGURE 13-16

Special Notes

The next logical selection a designer has in the Yarn Properties window is the size of the yarn. In Figure 13-17, the designer can choose the size of the warp and fill yarns by pixel or by accessing the pull-down menu selection, which includes traditional choices such as English. In addition, a designer may determine the quality of the resolution of the project.

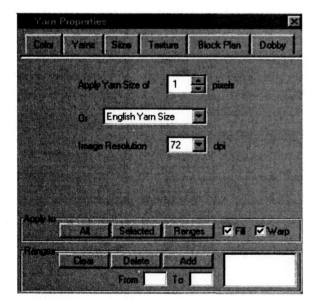

FIGURE 13-17

ADVANCED

Special Notes

Moving across the screen, you will notice that the next choice available is for the Texture of the warp and fill yarns (Figure 13-18). You may wish to experiment and preview these choices and their effects on the design. Make your notes about these options in the space we have provided below.

FIGURE 13-18

Special Notes

In Figure 13-19, the designer can determine the Block Plan for a project. As you can see, there are several predetermined selections for you to choose. These choices can be previewed from the scroll-down menu to the left of the main window.

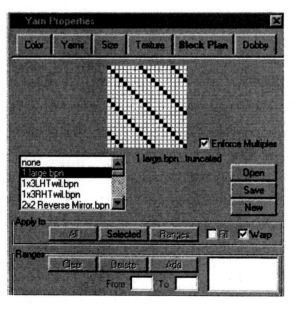

FIGURE 13-19

ADVANCED

Special Notes

The final choice available is for a Dobby weave. This window also includes a scroll-down menu with predetermined choices to preview and apply to a project (Figure 13-20).

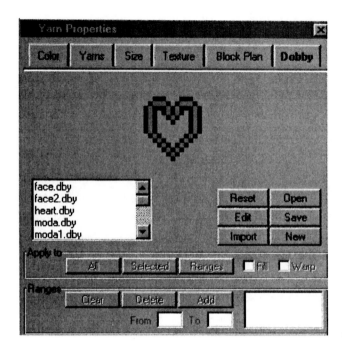

FIGURE 13-20

Special Notes

Our final example, shown in Figure 13-21, is the Pattern Comparator. This is located at the top right of your main screen. (You may wish to refer back to Figure 13-11, the main ModaWeave Window.) The Pattern Comparator permits the designer to view several versions of the same project simultaneously. The designer can then compare the different variations of a design before making a final decision.

Special Notes

As you have observed, there is an extensive variety of combinations and attributes a fashion designer can choose from in ModaWeave. Perhaps you may be wondering about making even more specific preferences for your project. ModaWeave offers the designer that too.

If you go to the file menu at the top of the screen, and choose Preferences, a dialog box will appear with the following options (Figure 13-22). We have also included a brief explanation of each preference selection to assist you.

1. Fill Yarns: Here, a designer can designate the number of fill yarns in a weave repeat.
2. Warp Yarns: Designates the number of warp yarns in a weave repeat.
3. Yarn Spacing: Specifies the spacing between yarns in numeric values; for example, 0 for closed or 1 for open weave.

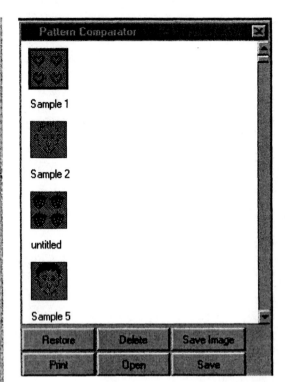

FIGURE 13-21

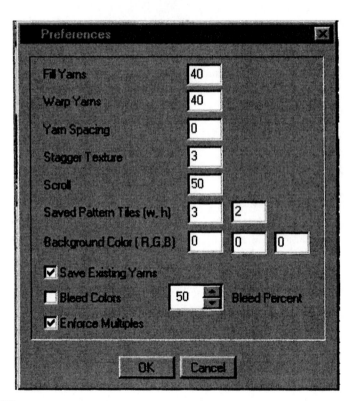

FIGURE 13-22

4. Stagger Texture: Specifies pixel interval applied randomly to yarn textures to cre-
ate a realistic weave effect.

5. Scroll: Set the yarn number that will appear in the warp and fill windows we saw
in Figures 13-13 and 13-14.

6. Save Pattern Tiles: Here the designer can opt to save the pattern tiles by height
and width that can be saved to graphic image files created in a weave project.

Skill Level: Advanced

7. Background Color: This options shows the number of background colors visible (1 to 255) when you render open woven patterns. (*Note*: In tightly woven patterns, no background color is visible.)

8. Save existing Yarns: This specifies warp and fill default numbers each time you open a new project.

9. Bleed Colors: Bleed will weave colors together in a rendered weave project.

10. Enforce Multiples: This option will automatically adjust the number of warp and fill yarns in your project to conform to a selected block pattern.

Now that you have a basic understanding of weaving and of the software, you are ready to begin a simple woven project using ModaWeave.

Exercise 13-1 Creating a Basic Oxford Cloth (Plain Weave)

Software Used

ModaWeave

How-to Steps

1. Open ModaWeave from its program icon.
2. You may opt to adjust the window layout to suit your needs, if any window is not visible, go to the view menu and toggle on the Block Plan, Warp, Fill Number, and Yarn Properties windows (Figures 13-23 and 13-24).

FIGURE 13-23

FIGURE 13-24

Special Notes

Name and version of software used: _____

List of additional steps you needed to take to execute the program that was specific to the software program that you are using: _____

ADVANCED

Biggest challenge: _____

What you learned that was new, and special notes on what you want to always remember: _____

Miscellaneous thoughts: _____

Exercise 13-2 Adding Color to a Woven Project

Software Used

ModaWeave

How-to Steps

1. Because the project will automatically default to black and white, click on another color in the built-in color palette (Figure 13-25).

FIGURE 13-25

2. The color appears in the preview window on the color page, next to the RGB color bar slider controls.
3. Begin now to paint the warp and fill yarns according to your color selection. For our purposes we suggest you make your Oxford blue and white (Figure 13-26).

FIGURE 13-26

Skill Level: Advanced

Special Notes

Name and version of software used: _____

List of additional steps you needed to take to execute the program that was specific to the software program that you are using: _____

Biggest challenge: _____

What you learned that was new, and special notes on what you want to always remember: _____

Miscellaneous thoughts: _____

Exercise 13-3 Change a Yarn Size in a Woven Project

Software Used

ModaWeave

How-to Steps

1. Continue from step 3 in Exercise 13-2, click on the size button in the Yarn Properties window. (You may wish to refer back to Figure 13-17).
2. Select the yarn size desired.
3. You can opt to resize either the warp, the fill, or both yarns.

Special Notes

Name and version of software used: _____

List of additional steps you needed to take to execute the program that was specific to the software program that you are using: _____

Biggest challenge: _____

What you learned that was new, and special notes on what you want to always remember: _____

Miscellaneous thoughts: _____

Exercise 13-4 Saving a Woven Project

Software Used

ModaWeave

How-to Steps

1. Continuing from Exercise 13-3, go to the main file menu and select Save.
2. You may also opt to click on the Save button.

3. Notice that ModaWeave automatically will select the Weave Project Folder in the ModaWeave Home Directory. If you do not wish to use this , merely type or select the directory you wish to save your file in.
4. Be sure to logically name your work, ModaWeave will assign it the ".wpr" file extension (Figure 13-27).

New	Ctrl+N
Open...	Ctrl+O
Save	Ctrl+S
Save As...	
Block Plan	▶
Hold	Ctrl+H
Restore	Ctrl+R
Preferences...	Ctrl+P
Save Preferences	
Save Seasonal Palette	
Exit	Ctrl+X

FIGURE 13-27

Special Notes

Name and version of software used: _____

List of additional steps you needed to take to execute the program that was spe-cific to the software program that you are using: _____

Biggest challenge: _____

What you learned that was new, and special notes on what you want to always remember: _____

Miscellaneous thoughts: _____

The following are several examples from Meredith Rossi of StyleClick (ModaCad). Figure 13-28 is an example of a houndstooth pattern and Figure 13-29 is an example of a strawberry dobby weave pattern. Figures 13-30 to 13-33 are some other examples found in the StyleClick (ModaCad)'s Samples library.

Now, let's have a look at another piece of industrial software you can use to create and simulate woven fabric. Remember there are many companies who produce software for designing a woven fabric. It is important you realize that although each offers different features, they all rely on the basic concepts of how to design and lay out a woven pattern.

Skill Level: Advanced

So look for the basics of textiles and apply the principles you have learned thus far on computers.

FIGURE 13-28

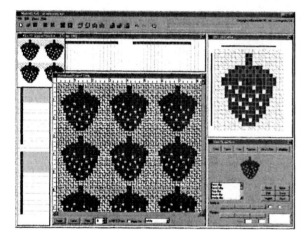

FIGURE 13-29

USING EASY WEAVE SOFTWARE

The software we will use is from Ned Graphics for Technology Inc. of Tolland, Connecticut. As we begin our exercise portion of this chapter we want to call to your attention some new features we will include in this section. In the bulk of this book, we have worked on exercises using different software companies to perform similar functions. Our reasoning was simply that we wanted to practically demonstrate that once a fashion designer understands the basic computer concepts, including how a technique is performed, she or he should be able to apply critical-thinking skills to translate that knowledge to perform a similar task on any comparable piece of software.

The following weaving exercises will continue to be concept-specific. (Because of software upgrades, the fashion designer may note that he or she now has additional choices or functions from which to select that were not available with an older version.) This time, however, we will use two versions from the same company to perform a similar task. In this section, you can compare designing woven fabric by working on two separate versions of the same product. We felt this would provide a unique opportunity for you to see how upgrades can increase a fashion designer's capabilities and possibilities.

Don't panic if you do not have either version of the software; merely follow along by reading our directions and viewing the accompanying screen shots. You will discover that our exercises are self-explanatory. This means you should be able to easily follow along as well as to comprehend the concepts covered.

FIGURE 13-30

FIGURE 13-31

Skill Level: Advanced

ADVANCED

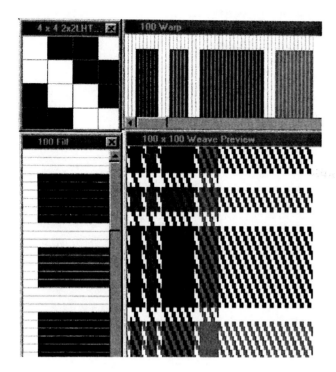

FIGURE 13-32

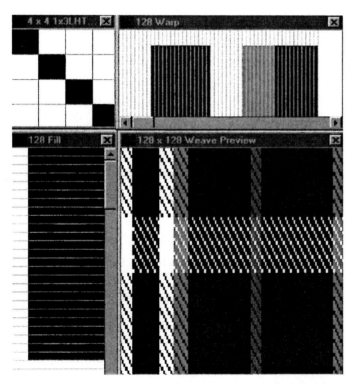

FIGURE 13-33

Previous versions of Gerber Technology's Textile Design Weave were used as plug-ins with Adobe Photoshop. Translation—you needed both pieces of software to render a project. This software was very user-friendly and easy to access.

Now this software allows you to create woven fabric using the Ned Graphics, Inc./Gerber Artworks Easy Weave software version. This software is considered a stand-alone, meaning you will not need to use a third-party software such as Adobe Photoshop. Many of the exercises have been adapted from the actual Gerber Technology training guides or on-screen help tutorials.

ADVANCED

This software includes additional design capabilities that can be accessed directly from the Easy Weave program icon located on the Artworks Studio program Menu (Figure 13-34). Figure 13-35 is an example of a full screen Easy Weave window after opening a new project.

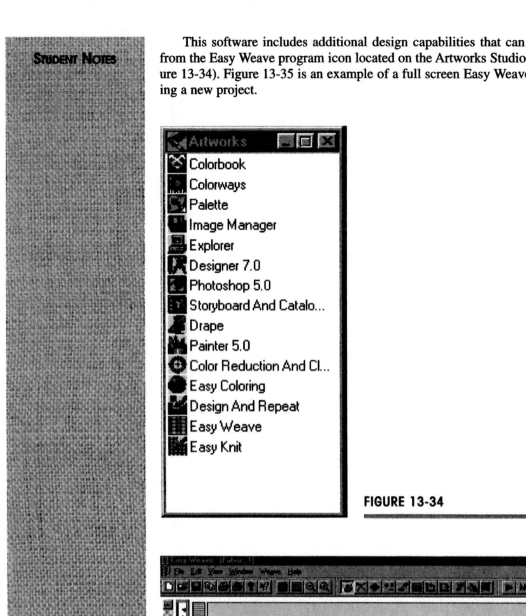

FIGURE 13-34

FIGURE 13-35

Now, look at the standard main menu (Figure 13-36) and the standard toolbar (Figure 13-37) in the Easy Weave program.

FIGURE 13-36

The list below gives the function each icon performs (beginning at the far left and moving right).

New Icon	Creates a new document
Open	Opens a Vision Easy Weave fabric
Save	Saves the current file document
Cut	Removes the selection cut and places the cut selection onto the clipboard
Copy	Copies the current selection and places it on the clipboard
Paste	Inserts the current contents of the clipboard
Print	Opens the Print dialog box to print a file
Print Colors	Prints the Vision Chart Pages
About	Displays software information
Help	Show advice for a menu command or a screen item
Hide Objects	Hides all the bars
Show Objects	Displays all the bars
Zoom Out	Reduces the view of the fabric
Zoom In	Magnifies the fabric

FIGURE 13-37

Special Notes

The other major toolbar used is the Functions toolbar (Figure 13-38). Again, if you follow along from left to right, the icons represent the following functions.

Warp Repeat	Set the repeat size in the warp fringe
Warp Repetition	Set a repeat tab in the warp
Warp Symmetry	Set a symmetry tab in the warp
Automatic Copy	Draw exactly the same stripes in the warp and weft (fill)
Weft Repeat	Set the repeat size in the weft fringe
Weft Repetition	Set a repeat in the weft
Weft Symmetry	Set a symmetry tab in the weft

 FIGURE 13-38

Special Notes

This additional list of general toolbar functions will typically appear to the right of the function toolbar:

- Hide Objects
- Show Objects
- Zoom In
- Zoom Out

The last toolbar we will review is the Design Tool toolbar (Figure 13-39). Here is a list from left to right of the icons. The names are fairly self-explanatory.

FIGURE 13-39

- Draw Stripes
- Stripe Deletion
- Stripe Rotation
- Stripe Resize
- Select Color
- Change Color
- Copy Warp to Weft
- Copy Weft to Warp
- Select/Copy
- Fill Stripe
- Color Atlas

Special Notes

Now that you have reviewed the main toolbars and menus, we will begin a sample exercise for you to follow. We chosen to create a custom weave using a pattern available directly from the Weave Atlas.

Exercise 13-5 Creating a Custom Woven Pattern

Software Used

Ned Graphics/Gerber Artworks Easy Weave and Adobe Photoshop

How-to Steps

1. Open a New File in Easy Weave.
2. Click in the center of your screen.
3. Choose Weave Customize, or you may opt to right click on the Pattern Box at the lower right side of your Easy Weave Window (Figure 13-40).
4. You may select or change the number of ends and picks in the (red box) repeat by clicking on the Repeat Button. Another option is to use your mouse and cursor to manually select, by clicking and dragging the box into whatever shape you like.
5. Begin to define the pattern you wish to create (Figure 13-41).

Skill Level: Advanced

FIGURE 13-40

FIGURE 13-41

Creating, Rendering, and Simulating Woven Fabric on Computer

ADVANCED

Special Notes

Name and version of software used: _____

List of additional steps you needed to take to execute the program that was spe-

cific to the software program that you are using: _____

Biggest challenge: _____

What you learned that was new, and special notes on what you want to always

remember: _____

Miscellaneous thoughts: _____

Exercise 13-6 Creating a Woven Pattern Using the Weave Atlas

Software Used

Ned Graphics/Gerber Artworks Easy Weave and Adobe Photoshop

How-to Steps

1. Open a New File in Easy Weave.
2. You have two places where you can opt to open an existing woven pat-
 tern. The first is under the main file menu (Figure 13-42). Choose Options
 from the fly-out menu, and select Weave Atlas (Figure 13-43). Note that
 the patterns are listed by number.

New	Ctrl+N
Open...	Ctrl+O
Close	
Save	Ctrl+S
Save As...	
Import From Weaving Deluxe	
Export To Weaving Deluxe	
Save Image	
Print...	Ctrl+P
Print Color Chart ...	
Print Setup...	
Options ▶	
1 Multi Colored.TIS	
Send...	
Exit	

FIGURE 13-42

Skill Level: Advanced

FIGURE 13-43

3. The second choice you have is to view the patterns. Go to the Pattern Graph at the lower left of your screen and right click your mouse (Figure 13-44).
4. From the pop-up menu select Weave Atlas (Figure 13-45).
5. Scroll through and choose a pattern. Double click on the red box to make your selection (Figure 13-46).
6. Go to the main View menu (Figure 13-47) at the top of the window and select Zoom In 2:1 (Figure 13-48).
7. Click on the Automatic Copy icon (Figure 13-49) and begin to choose a color from the color palette (Figure 13-50).
8. Fill in the first six yarns with one color, then the following six yarns in another color.
9. You have just made a pattern of 12 yarns. Now drag the Warp Repeat icon on yarn number 13 and click. This will define the size of the repeat pattern (Figure 13-51).
10. Repeat the process for the weft fringes.

FIGURE 13-44

FIGURE 13-45

ADVANCED

FIGURE 13-46

FIGURE 13-47

Skill Level: Advanced

FIGURE 13-48

FIGURE 13-49

FIGURE 13-50

ADVANCED

FIGURE 13-51

Special Notes

Name and version of software used: _____

List of additional steps you needed to take to execute the program that was spe-

cific to the software program that you are using: _____

Biggest challenge: _____

What you learned that was new, and special notes on what you want to always

remember: _____

Miscellaneous thoughts: _____

We will conclude our chapter on woven fabric by showing you several examples of where you can find prerendered simulated woven patterns using Micrografx Designer and in Metacreations' Painter.

Exercise 13-7 Locating a Rendered Woven Fabric Sample

Software Used

Micrografx Designer 7. You may also search for similar patterns in any vector-based software.

How-to Steps

1. Open a new file.
2. Using the square object-oriented icon, make a square.
3. Select or place handles around the square and go to the main format menu.
4. Select Interior Fill (Figure 13-52).
5. See Figure 13-53 for examples of prerendered woven fabric.

Additional Comments

Note that there are several examples that will lend themselves nicely to examples of woven fabric. Regardless of your software, scroll through your pattern fill options for comparable examples.

Special Notes

Name and version of software used: _____

List of additional steps you needed to take to execute the program that was spe-

cific to the software program that you are using: _____

Skill Level: Advanced

FIGURE 13-52

Biggest challenge: _____

What you learned that was new, and special notes on what you want to always

remember: _____

Miscellaneous thoughts: _____

Exercise 13-8 Locating a Rendered Woven Fabric Sample

Software Used

Metacreations' Painter. You may also search for similar patterns in any raster-based software.

How-to Steps

1. Open a New file in Metacreations' Painter, approximately 5 inches by 5 inches.

Creating, Rendering, and Simulating Woven Fabric on Computer **435**

FIGURE 13-53

2. Using the square object-oriented drawing icon, draw several boxes on your blank page.
3. Selecting one box at a time, go to the Pattern Fill Drawer.
4. From the Fill Box Drawer, go the Woven Pattern Option (Figure 13-54).
5. Scroll to locate the four versions of plaid fabric.
6. Choose one pattern version at a time. Select the examples of plaid or tartan fabric and begin to fill your squares with the plaid pattern (Figure 13-55).
7. On completion, you may opt to use filters to enhance the look of your plaid by adding surface interest to your patterns. (See Figures 13-56 and 13-57 for other examples.)

FIGURE 13-54

436 Skill Level: Advanced

FIGURE 13-55

FIGURE 13-56

Creating, Rendering, and Simulating Woven Fabric on Computer

ADVANCED

FIGURE 13-57

Special Notes

Name and version of software used: _____

List of additional steps you needed to take to execute the program that was specific to the software program that you are using: _____

Biggest challenge: _____

What you learned that was new, and special notes on what you want to always remember: _____

Miscellaneous thoughts: _____

Great job. Are you ready to put together a digital swatch book? We have included a list of the most widely recognized fabrics. You can use our list or create your own. When you begin to prepare a digital swatch library for reference, keep in mind what you want to have easy access to. For our purposes, we have included the elementary information you would be expected to know about a given fabric. In addition, we have included space for you to cut and paste or scan a photo of the actual fabric. We have also provided a spot for you to include a photo from a magazine or other resource of the fabric as it would be used in a garment.

Below we have filled out a sample of what your actual fabric journal entry might look. Be sure to designate one page for each fabric and leave plenty of room to modify the journal as your information base increases. As you can see, we have left sufficient space for you to cut out a photo of something made from chintz. This is followed by a space to place two swatches: one of the actual fabric and the second for a digitally created swatch.

In no time you will have an incredible reference tool at your disposal.

Skill Level: Advanced

SAMPLE SWATCH CARD

Name of fabric: Chintz

Description of fabric: A shiny-faced fabric

Probable fiber content: Originally cotton; can be a polyester or a polyester/cotton blend

Method of construction: Plain weave

Method of color: Frequently a fiber dyed (fabric may also have a direct print)

Type of finish: Glazed

Use: Commonly used for toss pillows, upholstery, and/or apparel

Care: See label, or machine wash/tumble dry

Miscellaneous: Place for any additional notes, such as fabric width or price per yard or even other trivial information about the fabric. You may also list the weight of the fabric, such as top, medium or bottom weight.

For example, frequently fabrics will get their name from the end use, method of construction, country of origin or even the fiber content.

For example, the term *Jacquard* came from the invention of the Jacquard loom. Or fabrics that end in the suffix "een" or "ette" generally indicate a fiber content of cotton.

CATEGORIZING FABRICS

When categorizing your fabrics, perhaps you may prefer to categorize them by fiber content. Or you may opt to consider either the weight or surface texture of the fabric. For example:

- Sheer fabrics
- Brushed or hairy fabrics
- Pile fabrics
- Ribbed fabrics
- Novelty and/or colored yarn fabrics
- Puckered
- Surface interest or textured fabrics
- Twills
- Cottony
- Silky/Shiny

Fabrics can also be categorized by end use:

- Interior design fabrics, e.g., upholstery, drapery, flooring, wall covering
- Bedding, linens, towels (kitchen, bed, bath)
- After-five or formal
- Bridal
- Work or uniform
- Suiting/career
- Power-stretch
- Accessories
- Sportswear (all categories—skiwear to swimwear)

(Continued on page 442)

ADVANCED

SAMPLE SWATCH LIST

The following is a suggested list of fabrics you may wish to use. This is by no means inclusive.

SUGGESTED FABRIC LIST

Antique Taffeta	Double knit	Lining fabric	Lamore
Bandana	Drill	Madras	Ottoman
Batik	Duck	Melton	Raw
Batiste	Eyelet	Moiré	Shantung
Bouclé	Faille	Muslin	Surah
Broadcloth	Felt	Naugahyde	Thai
Brocade	Flannel	Organdy/	Tissue
Buckram	Flannelette	organza	Stripe
Burlap	Fleece	Ottoman	Taffeta
Burned-out	Foulard	Oxford cloth	Tapestry
fabric	Gabardine	Paisley	Tartan plaid
Calico	Gauze	Percale	Terry cloth
Calvary twill	Georgette	Peau de soie	Ticking
Challis	Gingham	Pique	Tie dye
Chambray	Glen plaid	Plissé	Tricot
Charmusse	Grosgrain	Poplin	Tropical weight
Chiffon	Herringbone	Quilted	wool
Chino	Hopsack	fabric	Tulle
Chintz	Houndstooth	Raw silk	Tweed
Corduroy	Ikat	Sailcloth	Twill
Crepe	Interlock	Sateen	Ultrasuede
Crepe-backed	Jacquard	Satin	Velour
satin	Jersey	Seersucker	Velvet
Crepe de chine	Lace	Silks	Velveteen
Damask	Lamé	China	Voile
Denim	Leno	Douppioni	Window pane
Dotted swiss	Linen-look	Honan	plaid

NATURAL

Cotton	Linen	Silk
Jute	Ramie	Wool

SYNTHETIC

Acetate	Nylon	Spandex
Acrylic	Olefin	Tencel
Metallic	Polyester	Triacetate
Modacrylic	Rayon	

Skill Level: Advanced

SAMPLE SWATCH CARD

Below is the master page for your fabric swatch journal. Type the information once on your disk in any word-processing program. Then use the copy and paste commands to make additional pages.

Name of Fabric:_____ Photo:

Description of Fabric:_____

Probable Fiber Content:_____

Method of Fabric Construction:_____

Method of Color:_____

Finishes:_____

Miscellaneous:_____

<u>ACTUAL SWATCH</u> <u>DIGITAL SWATCH:</u>

Digital Swatch Notes:_____

Software Used:_____

Techniques Used:_____

Miscellaneous:_____

ADVANCED

- Daywear
- Children/Infants
- Men's
- Lingerie and loungewear
- Linings
- Trims

By doing this you will later be able to create a fabric swatch digitally in a raster- or vector-based program and then enhance it in a raster-based program such as Adobe Photoshop for the surface effect. For example, if you were to first create a plaid-twill weave fabric then add a Adobe Photoshop filter such as Noise or Blur, you could then convert that plaid into a napped or brushed finish fabric such as a flannel. Here's where the possibilities are almost endless, so don't be afraid to experiment.

Well, it is hard to imagine we are almost at the end of our journey. We have one last stop in our journey. We hope you have been thinking about what parts of our tour gave you the most excitement, challenge, and fulfillment. Every time you revisit any of these destinations you will begin to further fine-tune your skills and narrow your focus to the area(s) where you want to concentrate your future endeavors. Every stop we made included souvenirs or secrets of success for designing fashion on computers.

But we could not conclude our journey without making one last stop. In Chapter 14 we will show you several of the secrets of successfully marketing yourself and a fashion line using your computer.

CHAPTER SUMMARY

Today's fashion designer must have a basic comprehension of textiles, specifically the fundamental patterns used in creating, rendering, or simulating woven fabrics.

The most common pattern used in the construction of woven cloth is a plain weave. Plain weaves lend themselves to surface designs and/or prints. However, creating patterns ranging from checks and plaids to Jacquards can also be conveyed with the aid of CAD/CAM software.

Creating woven fabric on computer uses the same design concepts and drawing tools used in most vector- or raster-based programs. The main exception is that industrial-based software/systems have integrated additional tools and options to enhance a woven design so that is translatable for applying the computer-generated pattern to a loom used in the actual production of the cloth.

Interestingly, the term *Jacquard* frequently associated with woven fabric was named for a gentleman. In the early 19th century, Joseph Marie Jacquard developed a programmable punch-card system of pattern making for woven fabric. Jacquard was a forerunner in the development and understanding of the fundamental principles used in computers. This system is recognized today by the computer world. The Jacquard looms were originally adapted as a primary form of computer input. So it is only natural that creating woven fabric on computers is not so much a quantum leap in design as much as a throwback to its original roots.

ADVANCED

CHAPTER 14

Marketing the Line

Focus: The Advertising and Promotional Side of the Fashion Design Business; Putting It All Together Using Most Commercial or Industrial Vector- and Raster-Based Software

CHAPTER OBJECTIVES

- Investigate and apply the techniques used by graphic artists to enhance fashion projects
- Compare and contrast the commercial mask technique with the industrial digital drape technique
- Create templates for worksheets and other fashion-related projects
- Generate logos for use on hang tags, labels, business cards, and other promotional tools
- Prepare thumbnails of fashion publications before printing
- Prepare for an informational interview
- Investigate the advantages and opportunities available for internships
- Explore the fundamentals of desktop or electronic publishing to market fashion
- Create a digital personal promotion piece

TERMS TO LOOK FOR

desktop publishing	mapping	proportional scaling
drape	mask	template
electronic publishing	mentor	thumbnail
informational interview	personal promotion piece	
internship	promotional aid	

ADVANCED

443

FABRIC DESIGN

Help Wanted

Computer Graphic Artist

Top garment producer seeking graphic artist to create prints for use on fabric. College degree necessary; some prior industry experience preferred. Applicant must be capable of working on all current computer software. Salary commensurate with experience. Great benefits package. Call Ms. GotBucks, Human Resource Dept., at 1-800-FASHION.

Read this advertisement again, very closely. Did you notice anything unusual? No, it wasn't the name of the woman in the human resources department, or even the company's phone number. There is something else that should have jumped out at you immediately.

The job asked for a computer graphic artist who could design fabric prints for fashion. It did not ask for a fashion designer who could use a computer to design fabric prints.

Could you do that job? You bet you could! However, more and more jobs like that are going to graphic artists, and not to someone who really understands and has studied fashion like yourself.

So what does all that mean to you? Simply put, it means you will need to concern yourself with acquiring a well-rounded outlook and education when it comes to all aspects of fashion design on computers. You have already proven that you are one of those individuals just by reading this book.

In our first 13 chapters, we laid a firm foundation for you to launch your career as a fashion designer for the new millennium. In this, our final chapter, we will conclude our tour of fashion design on computers by showing you how to tie together all the knowledge and skills you have garnered from the previous chapters to begin to successfully market a line.

Most fashion design students have taken a course on design basics that included the study of principles and elements of design. In addition, we have found that most fashion designers have very strong opinions about how their line should be presented and/or marketed as well as to whom. Yet most designers may lack the ability to convey those ideas successfully on the computer by creating and using marketing aids.

Marketing aids can include brochures, worksheets, work boards, and catalogs, which are used to share with the trade and/or with the consumer. No one appreciates these marketing aids more than the sales and marketing department for a fashion line.

You maybe wondering, "Who creates these marketing tools?" Does a fashion designer or a graphic artist create these products? The answer is "It depends" on how big the company is and to whom the company is aiming its product line. Regardless of who actually makes the marketing aids, it will not surprise you that the fashion designer has a significant amount of input into the creation of these aids.

Obviously, because it is his or her name is on the label, the fashion designer wants to make sure that the marketing materials will convey the image the designer intended at the inception of his or her line.

In this chapter you will review the secrets used by advertising and sales and marketing experts. You will glean insights from computer graphic artists and desktop publishers to create logos, hang tags, storyboards, worksheets, and catalogs. And of course we want to hear from some recent graduates in the field of graphic and fashion design, who will share advice on where to direct your energies to land the job of your dreams.

We will conclude with exercises that walk you through additional advanced CAD techniques of drape and mask to simulate fabric and garments.

It is only logical that we begin this chapter with some firsthand insights from a sales and marketing expert, who is out there on the front line representing the line to the top retailer buyers. Sales representatives are the lifeline to the fashion designer; she or he gives valuable feedback from the stores on what customers are looking for.

Skill Level: Advanced

While as a consumer you purchase *a* jersey, a buyer for a national chain will be making buying decisions to buy *thousands* of items. Their ability to analyze past sales and predict what the customer will be buying next season can mean success or failure for both them and the company who produced the line. That's where the right sales representative can make the difference.

We will hear from John Linsk, the Sales Representative for the Southern United States for Karen Kane, Inc. John will share with you briefly the role of a sales representative in the successful marketing of a line.

MEET JOHN LINSK, SALES REPRESENTATIVE FOR KAREN KANE, INC.

(This interview came directly from John's computer to mine, thank heaven for e-mail!)

John was born in Philadelphia in 1932. After high school, he attended the University of Miami and graduated with a bachelor of arts degree in 1954. John's grandfather started a children's dress company in about 1925. This grew into a large company, which his father later changed from a children's line into juniors.

Actually, Betty Barclay (the company's trade name) was the first to use junior sizing—sizes 5 to 15. This company was sold in 1960 as one of the early acquisitions of the Jonathan Logan Company. According to John, the Jonathan Logan Company was that day's equivalent of Liz Claiborne.

Back when John sold for the Betty Barclay dress line (prices then were $6.75 to $10.75), his territory was Pennsylvania, Baltimore, and the Washington and surrounding Virginia area. John recalls that his "early learning experiences were vast. . . . Business was wonderful! . . . Stores were plentiful and anxious to purchase. I traveled with, and knew the best in the business." In those days, when there were no conglomerates, there were "fewer companies, which meant more business for those with good product."

John's Definition of the Role of a Sales Representative

In John's opinion, "Today's hi-tech computer oriented style of doing business is far different than days gone by. Today, some designers can rely too much on reports generated by

computers. I still believe in the importance of feedback from the field. The person who is most in direct contact with the consumer and the store buyer or owner. That feedback is the lifeline of the business from my perspective. That is not to say that designers should not rely on some of that information, they just put more importance on 'Big Store' selling."

What Is the Role of a Representative with the Store?

"In a word, that is what it is all about—Relationships. The product is really only as good as the company behind it and at the buyer level, the person representing the product."

John went on to say, "There are many occasions when a specialty store buyer will refuse to look at a good product, simply because she has not developed a relationship with the rep. The same applies to department stores and the company. Often, it is less the merit of the product, and more relationship of company owner to store management.

"There is a new breed of intermediate individuals bringing feedback now, they are called 'Merchandise Coordinators.' These are usually bright young men and women who spend much of their time visiting stores, the sole purpose of which is to keep an eye on the positioning of product on the floor, tracking competition, and developing relationships with sales associates. It has had a very positive effect on selling. It is most used with the large major stores."

What Role Do Marketing Materials Play?

John responded to this question with much pride, stating that "The Karen Kane Company in particular spends much time, effort, and money to develop wonderful selling aids. Marketing materials that are used by both store and sales offices. The role of the 'preprinted' order form has been a significant concept. When you do not have to ask a buyer to write out detailed information, but merely check some numbers, you increase your chances for a larger order. Quite simply, the buyer and the sales representative do not have to work as hard. It is psychologically an important player in the order taking game."

John went on to note that, "On the other hand, brochures have been a major force in the early years. As reps, we sent out to clients magnificent, full color sales brochures, modeled. The stores pre-bought the line just from the pictures. Brochures have been a strong factor in building sales and generating interest. I have used them extensively in mass-market mailings. It really worked!"

What Role Do Computers Play?

"What would I do with out them?" Speaking from the representative's point of view, "I use it to enter all orders, customer profiles, reports. . . . The computer allows me to quickly see who I am selling to in a given geographic area. History profiles are invaluable. I am able to look at a screen and see how much an account purchased from season to season, year to year. Reports are generated every week and sent to the home office for immediate review. Karen Kane in particular has always been at the forefront of new technology."

John remarked "We have also been using "cc:Mail" as the preferred way to communicate. . . . It keeps mistakes and confusion to a minimum."

The Role of Market Weeks

"There used to be very defined market weeks, that were always in New York. That has changed radically over the years. With the decentralization of markets, buyers go many places now. California, Texas, Las Vegas all put on giant apparel shows. The piers in New York house several of the most prestigious shows in the country and are widely attended. Sadly, local shows have suffered. The number of times a buyer is asked to go to market

is changing. There used to be five definite seasons, that is being consolidated and reduced to four. I see more future change not too far away. Maybe as in the European markets which are only Spring and Fall."

Any Advice to Fashion Designers Regarding Finding Representation?

"The most obvious, of course, is through the trade papers. *Women's Wear Daily* is considered the 'Bible' of the industry. Running an interesting ad with some background info should generate responses."

John went on to say "The other areas to investigate would be local markets, such as the trade shows. Don't forget, there are also national trade shows in Las Vegas, New York, etc. These are also wonderful places for designers to find the right person for the job."

Trade shows are usually run by the sales representatives, who attend the shows on behalf of the designer and/or that design firm to promote the lines. "So naturally that would be a great opportunity for a designer to meet with many of the reps simply because they are all gathered together in one spot and generally under one roof all at one time."

In conclusion we asked John how a designer should treat a prospective representative. "Well, the first thing that comes to mind is, courteously. But then, that's obvious! Seriously, a designer should not be afraid to ask questions such as:

- What is your background?
- What kind of account base do you have?
- Do you understand my product?
- Are both of us willing to make a long-term commitment?

These are some of the key issues for a fashion designer to consider when choosing the right sales representative to represent their line."

John's interview was filled with candid information that is to the point—spoken like a true rep! John has discovered the secrets to selling—always represent a line you believe in, then build long-term relationships. Honesty and integrity are everything, and time is money; get to the point—don't waste their time or yours!

The other thing that has always come across whenever I have spoken with John is that he loves what he does and he does what comes naturally. He is a real people person, and he is also a professional. Like any professional John appreciates great marketing aids. While you were reading, did you notice the role that these marketing materials play in the selling of a line? Today these items are standard procedure, and a good designer or design firm should furnish the representative with these tools to make the job of selling the line easier and more effective.

Knowing how to generate these materials and/or understanding the elements of what is included in these materials will go a long way for today's fashion designer. So it is only natural that we have included several exercises later in this chapter where you can create your own worksheets. The worksheets you create will be similar to Karen Kane's worksheets, which we showed you in Chapter 8. We have also included a catalog example from Karen Kane, Inc. This will be followed by a how-to exercise for you to create a similar catalog to showcase your designs.

Our next destination will be to meet Lorna Hernandez, a successful graphic artist. Lorna will share with you her insights about computers, graphic design, and desktop publishing to land jobs similar to the one described in our mock ad for a graphic artist.

MEET LORNA HERNANDEZ

Lorna has a B.F.A. in Painting and Cinematography from the University of Michigan and an M.A. in Multimedia and Visual Arts from Antioch University. She is the owner and President of Paradox Creative Services, Inc. This company produces graphic designs,

illustrations, multimedia, and web design in the greater Fort Lauderdale/Miami area. Lorna has also been a college professor for 12 years and has been awarded numerous accolades for her work.

While many of you were reading Lorna's outstanding list of credentials and accomplishments, if you are anything like my students you were also very impressed with her photo and kept going back again and again for another look. Isn't it awesome? In fact, we just know you kept studying it in order to check out just how did she digitally enhanced her photo.

You may not even have been aware of how you automatically began to pick apart the elements to see if you could identify the techniques she may have used to enhance the image. But most importantly, we bet you were wondering how you could emulate in your next creation what you discovered in hers. That is what a great artist does, she makes you think, and she inspires you!

When we interviewed Lorna, her teacher's heart came to the surface as she shared several of her favorite insights for you to use in your creations. So, without any further delay, let's hear from Lorna in her own words how you can make the most of your computer and your artistic talents to create fashion on computers.

Insights on Graphic Design for the Fashion Designer

These ideas are in a random order, we merely have given them simple headings that will make it easy for you to refer back later. We have also provided ample space for you to jot down your thoughts.

File Naming and Saving

"Time is Money. . . . I save from #1 to final. . . . Also it is critically important in using Adobe Photoshop or Painter that you save your files in layers or floaters in Painter—Riff. There are always inevitable changes, saving this way makes it easy for you and the client. Also make two backups on separate Zip cartridges."

File Format, Extensions, and Compression

"I usually save CMYK/EPS for files that are going to press; but ask your service bureau, everyone has different requirements. Even though I use a Macintosh, I usually add the ".tag" to my files, so they can (hopefully) be reopened later on a PC. Remember you have to use a PC formatted disk for that to happen!"

"For files that are compressed LZW/TIFF is non-lossy compression format and JPEG is lossy, but excellent for the items used on the Web. . . . And don't forget that Photoshop wants three times the memory at least of your file size! . . . so be careful that you have enough memory!"

File Conversions and Color

Learn the modes, RGB, Index, etc. Each one has its place depending on the application of your work. [Refer back to Chapter 10 of this book]

If you work in Adobe Photoshop in RGB mode, at some point if you are going to press with the project, you will have to convert to CMYK. This can be a great shock if you don't understand the difference between additive and subtractive. Check out the Info Palette, Out of Gamut Warning, CMYK Preview, and the Color Palette in Photoshop. And finally if you see the ("!"), Pay attention!

Masks and Other Useful Tips

"Conquer your fear of masks and channels. They make your digital life much easier! Layer masks are wonderful, so composite away! When using filters, Unsharp is very helpful for the Web, and Dust and Scratches works well for photo restoration."

Concluding Comments

- "The computer cannot solve design problems. Only you can, "garbage in = garbage out!"
- "The computer has not replaced the pencil or human brain so use both!"
- "Be calm, have a plan, know the limitations of the computer. . . . Know the power and creativity are in you not the machine."
- "Go to every seminar you can, join organizations or network for more insights."
- "Get on-line. . . . Surf the net, it is a storehouse of useful ideas!"
- "Spend your spare time at the computer, don't be afraid to experiment."
- "If you own your own computer, don't go out and buy that new dress, buy more RAM! You can never have enough!"

ADVANCED

- "Finally, the creative process is a flow, it is like time stops, hunger stops . . . hours pass and you are unaware . . . get into that flow and see where you go. It is an amazing journey!"

Special Notes

Well, now that you have heard what the experts have to say, the big question is, What new secrets did you discover that you want to apply to your work? We trust you enjoyed their advice and insights. But, before we show you how to create these marketing tools, we will cap off our introduction to marketing your ideas with a short review of several sales and marketing and graphic design principles you will want to remember.

It is always comforting to hear from a seasoned veteran like Lorna. But could a recent graduate offer any insights you could use while you are still in school? You bet!

Our next designer is a young graphic artist who can still relate to some of your fears and frustrations. Meet Peter Friedrich, an up-and-coming graphic artist and all-around good friend who specializes in logo design for labels. Peter was responsible for bringing Zippy to life!

MEET PETER FRIEDRICH: WITH SOME HELPFUL INSIGHTS, STUDENT TO STUDENT

As a former student and graduate of The Art Institute of Fort Lauderdale, Peter spent hours in the computer lab working and brainstorming with friends over the best way to accomplish an assignment—just like you do now! That is why you will want to learn from his successes and failures!

- "You don't have to give up rendering by hand. . . . For me everything starts with a blank piece of paper and a sketch of my idea."
- "Always begin your ideas in Black and White"
- "I found my teachers were right. . . . Preparation is the key to any project or job. Think of the final outcome you wish to achieve and begin to list the best ways to accomplish the task."
- "I was one of those students who needed to be shown the technique first, then I could develop a wide variety of alternatives based on a concept without much

problem. This meant spending long hours playing on the computer and developing ideas instead of going out with my friends, which leads me to another thing I discovered. . . ."

- "Most of the time I hit a brick wall on the computer, I didn't get my solution until a half hour or so after I gave up on it! . . . It isn't a defeat to walk away! . . . Many of my setbacks have led to major breakthroughs."

- "I'd also like to add, don't be afraid to start small or feel bad you only have access to older versions or inexpensive software. Let me explain what I mean. I was always plagued and had only a limited understanding of MASKS and CHANNELS, for example. However, as I experimented one day I discovered they are the keys to creating the most accurate selections possible, along with using my drawing tools to pixel-perfect accuracy. Interestingly enough I stumbled across this using a 'low-end' image program that I still use for cleanup jobs! What I found was that a mask is a grayscale image set to a selection . . . or the grayscale image represents a selection. Duh! I still use that inexpensive program for cleanup jobs because it is so easy to use and works so well! So if you are working on a low-end program don't forsake the experience you get from it. By working in the older programs I was forced to work through their limitations . . . and overcoming problems and limitations is the best confidence builder!"

- "When you get into the industry, you don't have the luxury of time to sit for hours and design. Sometimes I found that the most basic design convey what the client wants. So naturally it is hard on the ego to not be asked to create the computer's answer to the Mona Lisa."

- "In fact when rendering human attributes, try sitting in front of mirror or work from photographs for inspiration. I have it on good authority that Zippy's smile rather resembles the author's."

- "Don't be afraid to creatively compromise with the client on design decisions, it will be good for your reputation and your wallet."

- "Believe me I now know the real definition to graphic designing—keeping the customer satisfied!"

- "So pay attention to your business or marketing related courses. That will come in handy when you are planning many a proposal."

- "I can still hear my teachers telling me I will have to pay my dues. At the time I just did not want to hear that. But fortunately, it is true, even when it comes to psychologically preparing for a job interview. I will never forget how I felt. I went on an interview for a great job and I felt like I really nailed the interview. I was confident and self-assured of my talents. Then in came another manager who started to list off the job's duties and responsibilities. . . .I literally froze and lost my voice. Reality set in. This wasn't the classroom any more! Needless to say, I didn't get that job. But that's OK. Just you be sure you are ready when your turn comes. Maybe you can avoid making my mistake!"

- "When it comes to using the computer for fashion-related designing, who really should get the job? A graphic artist or a fashion designer trained on computers? My thoughts are that there is enough work out there for all of us, so give it your best shot!"

Marketing and Graphic Design Principles

As you may have noticed, many of our experts (including Peter, a recent grad) mentioned the need for a better understanding of the principles of business and marketing. So we have put together a rather eclectic list of sales and marketing, advertising, and graphic design principles. These principles should be very helpful later when you are generating your own marketing aids. As always, we have provided ample space for you to make notes or jot down some ideas.

Many of the principles that will be covered in this section have been adapted from lectures I have given to the students of The Art Institute in Fort Lauderdale, Florida. Later

in this chapter you will adapt these principles in exercises for creating or generating such items as worksheets, catalogs, hand tags, logos, mood boards, story boards, or other, similar, marketing tools.

INSIGHTS ON APPLYING SALES AND MARKETING, GRAPHIC DESIGN, AND DESKTOP PUBLISHING PRINCIPLES TO FASHION DESIGN

Premarketing Information

When you are analyzing your final audience always remember:

- Do your homework on your client through conversation, observation, and investigation.
- Research the demographics and psychographics for both the primary and secondary target market.
- Know and incorporate the needs and desires of your final audience/client.
- Always give clients what they want and they will give you what you want— money.

Graphic Design Insights

- Best rule of thumb: KISS—Keep it sweet and simple. In other words, don't overdesign (sound familiar?).
- All emphasis is NO emphasis! Avoid clutter.
- Don't send mixed messages. Be consistent.
- A great graphic design or marketing package has one goal: to convey a specific message and provoke a specific response.
- Headlines are for impact. Keep them short and concise. Position headlines at the head of the page and leave plenty of white space around them.
- Strive for contrast.
- Avoid negative white space.
- Don't mix too many font types.
- Strive for three-dimensional effects. Experiment with foreground, middle, and background.
- Consider the artful arrangement of all graphic elements, including text. Remember proportion, balance, and harmony.
- Keep subheadings short and in a font similar to the main headline. Also try bold or italic for emphasis.
- Keep captions fewer than three lines.
- Try to avoid widows and orphans in text.
- Experiment with frames around captions.
- Use drop caps or initial caps for emphasis.
- Avoid end-of-line word breaks.
- Be sure your work is complete.
- Ask for input. Have someone else evaluate your work.
- Accept constructive advice from others.
- Don't forget to set your work aside for a few days (if your deadline permits) and then come back to it. The perspective will do you and your work a world of good. When you pick it up again, see if your work answers the following questions.

Top Ten Questions to Ask Yourself Before Making Any Marketing Piece

1. What other factors must I consider?
2. Are there any budget restrictions I need to be aware of?

(continued)

ADVANCED

INSIGHTS ON APPLYING SALES AND MARKETING, GRAPHIC DESIGN, AND DESKTOP PUBLISHING PRINCIPLES TO FASHION DESIGN (CONTINUED)

3. How accurate or flexible are the deadlines?

4. Who else is participating on this project (copywriting, printing, distribution) who may determine the final outcome of the design? This includes other individuals who will have their say on the final product (in-house staff, sales representatives, buyers, consumers)? Who do I really need to make happy?

5. Is there anyone I can go to for help, or advise on the design to ensure it's quality and accuracy?

6. Will the reader get the message right the first time? Will this piece grab their attention and keep it?

7. In describing the features, did I stress the benefits of those feaures? Remember, a feature describes the materials used in construction of a product; for example, for cotton (fiber content is a feature), stress the benefit of wearing cotton—comfort!

8. How will the reader best use this information?

9. Will the reader see what I want her or him to see?

10. Will the reader respond the way I want or expect her or him to respond?

Now we suggest you take our earlier advice: "Observe, Investigate, and Converse with the experts!"

INTERNSHIPS, MENTORS, AND INFORMATIONAL INTERVIEWS: HOW ABOUT PAYING YOUR DUES EARLY?

As you reflect on the information that was just covered, what may begin to become apparent to you will be your areas of strength or a heightened awareness of the weaknesses you may have. Obviously, strength comes from the natural gift you have or from areas where you have invested repeated exercise and practice to refine or define your skills. On the other hand, weaknesses can come from a lack of skill, practice, or exposure to a given area.

There are ways to compensate as well as ways to transcend the typical learning curve or lag time. How? If time and circumstances permit, nothing beats an internship.

Many internships are paid opportunities to learn the job, while other internships are done free. You liked that four-letter word free when you heard it earlier. Believe us, it is still a good word. Think about it. What would you pay to save yourself years of frustration on a job? Maybe the cost is a few hours a week sitting at the feet of someone more experienced than you.

Time and time again we have heard how quarter- or semester-long internships have turned into full-time jobs after graduation. Gradually growing into a position and all of the responsibility it can bring is also an asset.

Don't forget about finding someone to mentor you. This was one of the secrets to success you discovered in Chapter 12. But did you know that you can conduct your own search or interview for a mentor? How? Well, in this next exercise we are going to ask you to conduct an informational interview. Simply put, you will do your homework on the companies that interest you the most before you graduate.

Finding out what the company is looking for and applying for an internship may lead you to the job of your dreams. Why? Because you took the time in advance of graduation to match your interests or skills to the right job or the right company.

ADVANCED

Informational interviews can also be the key to unlocking a job that will bring a certain amount of personal satisfaction and sense of accomplishment every designer wants. If the right job brings satisfaction, the wrong job can bring discouragement or unnecessary frustration. Doing several informational interviews can propel you into the job of your dreams or keep you from a costly mistake.

As I often tell my students, it seems that sometimes we are hard-wired to do some jobs with ease and grace while others can have us grinding our teeth and in tears. The reality is that every job has its peaks and valleys. In fact, most jobs can be defined as being designed to appeal to preferred skills and/or individual temperaments. Discovering what you enjoy and what your are suited for takes time, and the investment in an informational interview and internships can be time well spent.

There are many practical perks for companies that hire interns. One benefit is the fresh approach and enthusiasm for tackling challenges that students often bring to the workplace.

At the beginning of our book we mentioned that fashion designers must be able to adapt to all types of computers and software. Many times you will take a job or an assignment using software and/or computers different from the ones you were trained on. Unfortunately, that's life!

A Student Success Story: Margarita Kiang

Have you realized that even as a student you can have an impact on what software your company selects? The following testimonial came directly from my classroom.

As part of the standard policy where I teach, we strongly recommend that our students pursue internships within the fashion industry in the tricounty area. In one case, a student by the name of Margarita Kiang was assigned the position of intern at a local but internationally known design firm in Miami. As part of her responsibilities she was expected to generate: garment flats, worksheets, spec sheets, and storyboards. At the time she began her internship, the company was primarily using office-related software and a scanner to accomplish most of the fashion-related tasks and projects.

Margarita began to share with her boss, her excitement about what she had been learning in the classroom. She suggested that the company research and acquire the same or similar software to the ones she had used in the classroom. (She knew that acquiring this software would make her job a lot easier, resulting in saving her time and the company money.)

That knowledge and excitement translated into the management of the company heeding her recommendation. So as you can see, you too, can have a great impact on the direction of fashion and the future in many ways.

Applying for an internship or scheduling an informational interview is not difficult. Informational interviews provide the opportunity for you to glean information and insight to give a clearer direction to your goals. So why not work smarter instead of harder?

There are some things you may wish to consider before conducting an informational interview. For example, do your research:

1. Use the research skills you learned in Chapter 9 and find companies in your area who have hired fashion designers with your skills or talent.
2. Get all the information you can about the company before you call. This information can be used as an ice-breaker for starting your conversation.
3. If possible, get a name before you call to set up an appointment.
4. When you call, identify who you are and what your intentions are; request approximately 20 minutes of their valuable time. Be sure you schedule the appointment for their convenience, not yours.

5. Prepare and practice your questions well in advance.

6. When the day arrives, be sure you dress professionally to reflect the company philosophy. If you are a woman, watch the makeup, jewelry, and hem length. It is a given that there should be no gum, no smoking, and no showboating. You are there to make a contact and to learn from them.

7. Plan your day to arrive at least 15 minutes early.

8. Be polite and enthusiastic. Shake the person's hand and introduce yourself. Thank the person for her or his time.

9. Make eye contact, smile, and take notes on your conversation.

10. When you are done, thank the person again for her or his valuable time.

11. Send a thank you note to follow-up.

You may have guessed by now that it is your turn to schedule an informational interview in your area.

Exercise 14-1 Informational Interview

Locate someone in one of the following fields:

- Fashion design
- Graphic arts
- Fashion photography
- Advertising or marketing for fashion-related products
- Sales representation for fashion

Give yourself the opportunity of learning from the mistakes of others. Most individuals you request an interview from are more than happy to share their wisdom and insights with students. Don't be afraid to ask them the hard questions—but always start with the basics.

BEGINNING THE INFORMATIONAL INTERVIEW

Challenge Exercise 14-2 Suggested Format and Questions

How-to Steps

Here is a list of question you may want to ask.

1. How did you get started?
2. What education and skills are required for your position?
3. Did you intern when you started?
4. Did you have a mentor?
5. What are some of your responsibilities?
6. What was your biggest challenge?
7. What was your greatest success?
8. If you had it to do over again, what would you do differently?
9. What types of computer and software do you use and why?
10. Do you have any advice for someone starting out in fashion design?

When you have concluded your findings, compare the insights and advice of your expert against the experts in this book. Next jot down below any thoughts or information you might have.

Special Notes

ADVANCED

Did you enjoy your interview? Perhaps you discovered the ideal job or met the perfect mentor or even landed an internship. Regardless, the truth is that no matter what you discovered about fashion or the business world your best discovery was probably about yourself. An interview can help you distinguish what you really like doing from what you don't enjoy.

Now that you have heard from the experts, learned the basics of how to design on computers, and reviewed the principles of business and marketing, not to mention conquering your fear of interviewing, you should feel confident enough to begin another challenge—creating your own marketing aids.

CREATING YOUR OWN MARKETING TOOLS: GENERATING A WORKSHEET IN ANY VECTOR-BASED SOFTWARE

The first marketing tool you will generate is a worksheet. Let's begin by looking at the worksheet example provided by Karen Kane, Inc. in Figure 14-1. (This worksheet is similar to the one you saw in Chapter 8.)

This is an exact copy of one used by Karen Kane Sales Representative John Linsk. He uses this worksheet to show to shop owners and retail store buyers in the process of order-taking. You can generate a similar worksheet using any vector-based software.

In these challenge exercises, we will begin by providing you with:

- What your project should include
- Several helpful tips on how to implement your ideas
- Samples of what your work might look like
- And as always, space for your personal notes

Challenge Exercise 14-3　Create a Worksheet Template

Software Used

Any vector-based software

How-to Steps

1. Using object-oriented drawing tools, begin to make place holders for the following information (Figure 14-2):
 Company name and logo
 Name of the line (theme for the season)
2. Include mix of both knits and woven fabric
3. Make five to seven flats of garments in black and white
4. Label garments by style number and available size range
5. All text should be in appropriate fonts

Additional Comments

Do your actual flats in black and white. There are several reasons for this. Some of the most important reasons are a combination of psychological, practical, and economical. When worksheets are done in black and white, the viewer can zero in at a glance on the key items, without the distraction of color. Remember that color can work against you. Often, color is all the viewer can see, and they miss the important details or new features you maybe trying to convey. Finally, black-and-white worksheets are the most cost effective because they are much more crisp, clear, and easy to read and reproduce.

Special Notes

Name and version of software used: _____

Skill Level: Advanced

KAREN KANE LIFESTYLE
TWILIGHT 12/31/98

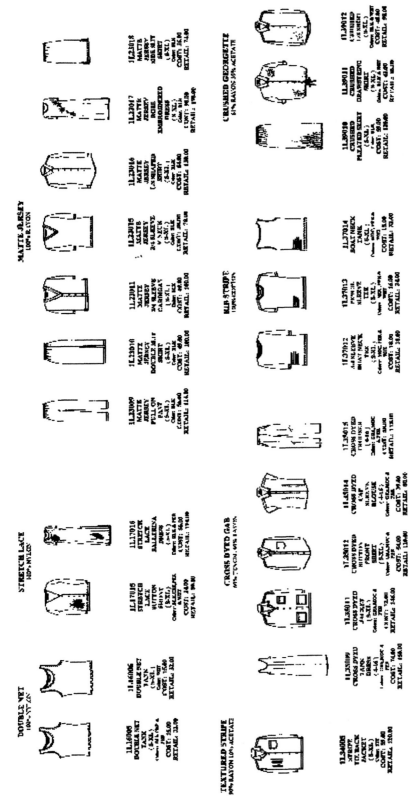

FIGURE 14-1 Worksheet from Karen Kane, Inc.

Marketing the Line

ADVANCED

FIGURE 14-2

List steps you took to locate these options that are specific to the software program you are using: _____

Biggest challenge: _____

What you learned that was new, and special notes on what you want to always remember: _____

Miscellaneous thoughts: _____

Challenge Exercise 14-4 Create a Worksheet for a Petite Misses Line of Lingerie for the Fall Season

Software Used

Any vector-based software

How-to Steps

1. Begin by making a copy of your template.
2. Start to remove the place holders with the following information. (Figure 14-3 is an example provided to us by M. Kiang.)
 Company name and logo
 Name of the line (theme for the season)

Skill Level: Advanced

ADVANCED

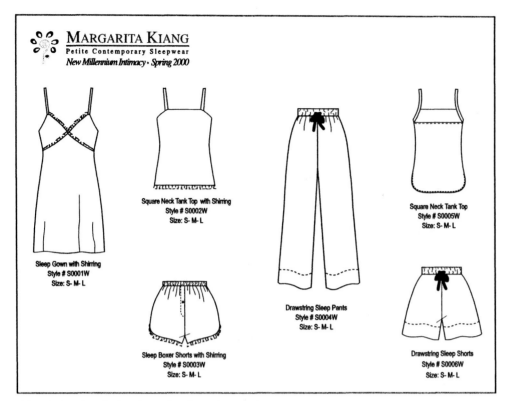

FIGURE 14-3 Actual student worksheet.

3. Include mix of both knits and woven fabric.
4. Make five to seven flats of garment in black and white.
5. Label garments by style number and available size range.
6. All text should be in appropriate fonts.

Special Notes

Name and version of software used: _____

List steps you took to locate these options that are specific to the software program you are using: _____

Biggest challenge: _____

What you learned that was new, and special notes on what you want to always remember: _____

Miscellaneous thoughts: _____

Great job! Now we will move forward and put into practice several of the insights you have gleaned from our discussion of graphic-design principles. We will couple that information with your knowledge of working with both vector and raster images for you

ADVANCED

to begin the layout of your own logo, hang tag, and business card. You will incorporate the elements of all your prior vector-based assignments.

Challenge Exercise 14-5 Create a Simple Logo

Software Used

Any vector-based software

How-to Steps

Generate the following items, and be sure to incorporate your logo (see Figures 14-4 and 14-5):

1. Hang tag for garment
2. A personal or company business card tag. You have the chance for your work to be seen by a top Bridal-wear company and you want the job! . . .

Your research tells you this company is a moderately priced line that specializes in romantic revivals reflecting popular historic styles. The company wants to see only four sketches, along with a resumé, before they schedule any interviews. What are you going to do???

FIGURE 14-4 An example of a logo.

FIGURE 14-5 Margarita Kiang's logo on a hang tag.

Skill Level: Advanced

Challenge Exercise 14-6 Create a Sample Line (Four Sketches) of Bridal Fashion

Software Used

Any vector- or raster-based software

How-to Steps

1. Consider the challenge. What did they ask for? Four garment sketches and a resumé, that's it.
2. For our purposes, focus on the designing portion of the exercise only. We will focus on resumé and/or personal promotion cards later in this chapter.
3. To begin with, do your research on bridal-wear manufacturers, including what they are known for.
4. Determine their signature look or key items from season to season, including historical references.
5. Determine who is their primary target customer—i.e., what is the retail source and who is the retail client, including average age, dress size etc.?
6. Evaluate your budget and timeline to prepare a package of your ideas.
7. Prepare the package and have it critiqued for errors or oversights before you send it.
8. Ask yourself, Did I create the most distinguishable packaging along with the most clear and understandable designs to grab the attention of the person who is reviewing all the applicants?

Special Notes

Name and version of software used: _____

List steps you took to locate these options that are specific to the software program you are using: _____

Biggest challenge: _____

What you learned that was new, and special notes on what you want to always remember: _____

Miscellaneous thoughts: _____

Well how did you do?

Let's evaluate another student's work. The following samples were provided by Gudrun Ossurar, a fashion design graduate of The Art Institute of Fort Lauderdale. In Figures 14-6 to 14-9, Gudrun used a combination of computer techniques to render her bridal collection. Figure 14-6 reflects the Gothic period of history. Figure 14-7 reflects the Renaissance. Figure 14-8 reflects the Rococo period. Figure 14-9 reflects the Neo-Classical period.

Each of these designs was a combination of techniques used on any commercial vector- and raster-based software. The designs were made in a booklet format. Each individual design measures 5 inches high by 10 inches wide (landscape) and can be clipped comfortably inside a CD case.

ADVANCED

FIGURE 14-6 Sample from the Gothic period of history.

FIGURE 14-7 Sample from the Renaissance.

FIGURE 14-8 Sample from the Rococo period.

Skill Level: Advanced

ADVANCED

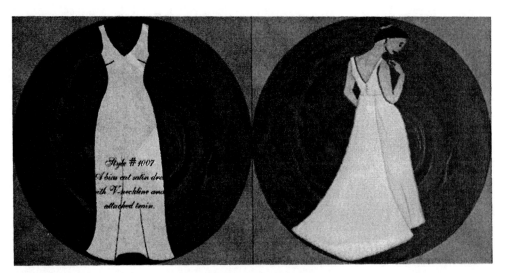

FIGURE 14-9 Sample from the Neo-Classical period.

The final elements—the actual renderings—were then stapled together in a booklet format to use as an insert behind the CD cover. The front cover seen in Figure 14-10 is at the preliminary or thumbnail stage prior to completion. As you can see, a template was created using a place holder for where a final photograph was inserted.

A mock-up is a tool for gaining valuable feedback from others before you go to press. The final goal of the project was to create a CD showcasing Gudrun's bridal designs. The final product would reflect or mimic a music CD (Figure 14-11).

Front of CD

The Bridal Collection

Place holder
for cut/paste
photos of
Roses

By: Gudrun Osswar

Border of ivy

Place holder for photo
of actual gown

FIGURE 14-10 Front of CD cover for a bridal collection.

Back of CD

The Bridal Collection

Side One:

Style 101 Gothic- Camelot
Style 102 Renaissance- Romance
Style 103 Rococo- Rapture
Style 104 Neo- Classic- Josephine

All Designs by: Gudrun Osswar

Print Back Cover
on Floral
Background

FIGURE 14-11 Back of CD cover for a bridal collection.

ADVANCED

The final front cover was an actual photo of the designer wearing a bridal gown she created during her tenure as a fashion-design student. The actual CD was a copy of all her designs, including a copy of her resumé. Wasn't that a clever solution to a possible real-life challenge?

You can see that this assignment incorporated of a wide variety of techniques you have been learning on the computer. However, the computer and the software used were only the tools Gudrun used to showcase her talents. The real genius or star was Gudrun, not the computer.

The previous exercise can be completed using any available commercial vector- or raster-based off-the-shelf software. The results are extremely professional and successful.

In later exercises we will show you how to create a storyboard using electronic publishing software as well as how to use industrial CAD software that was especially created for generating a storyboard or catalog.

Now you are ready to tackle some new concepts useful in presenting your line. So get your engines revved up. Our next stop is more graphic design and desktop publishing.

GRAPHIC DESIGN SECRETS: MASKS

Are you wondering if we aren't really beginning to confuse fashion designers for graphic artists? Believe it or not, we haven't made a mistake. There are several great tricks used by graphic designers that you will want to incorporate into your designs.

The first technique—masking—is available on most vector- and raster-based programs. In this first exercise we will be applying the advice from Diane Blazy, the photographer you met in Chapter 10.

In case you are wondering what a mask is, according to Micrografx Designer's Help menu, "A Mask is an object whose shape is used as a stencil to determine what parts of another object are displayed. When you use the shape of one object to 'mask' or overlay on top of another object." The "masking object" is known as a mask.

The mask acts as a stencil, so that only the parts within the shape of the masked object are visible. You can use any closed object as a mask, including text, as long as the individual fonts have been converted to curves.

There are a variety of software programs that offer the user the mask option. As always we will walk you through the steps of creating a mask. This technique is a real time saver in rendering your ideas for use in a catalog.

You can use a scanned fabric to mask on top of a garment flat for use in storyboards or other marketing aids, as well as a variety of other bitmap images.

The mask technique is easy to use. It saves not only time, but also money. Why is it so popular? Because it is also a great way for your client to preview your ideas before the garment sample has even been made.

We promise that by the time you have completed these exercises you will have thought of hundreds of applications. We will walk you through the process using both commercial and industrial-based software.

Exercise 14-7 Creating a Mask in Almost any Vector-Based Software

Software Used

Micrografx Designer

How-to Steps

1. Select the garment flat you wish to work with. Open an existing file (Figure 14-12).
2. Select, open, or import the file you wish to use to place inside the garment flat (Figure 14-13).

Skill Level: Advanced

FIGURE 14-12

FIGURE 14-13

3. Select the object (mask)—in this case the pattern you wish to use as a mask (Figure 14-14).
4. From the edit menu, select Copy.
5. From the object menu, select Masking (Figure 14-15).
6. From the fly-out menu, select Paste Inside (Figure 14-16).
7. Drag the blue outline (Figure 14-17) and position the mask on the garment flat.
8. Release the mouse for the mask outline to appear.
9. Repeat steps 7 and 8 until the masked object is positioned correctly.
10. Double click the mouse or hit Esc to create the mask (Figure 14-18).

Additional Comments

Be sure you scale or resize your pattern to match the scale of the garment flat size before you use it as a mask. This is another way to add surface interest to your flats. You can use many different styles of artwork, including bitmap images.

ADVANCED

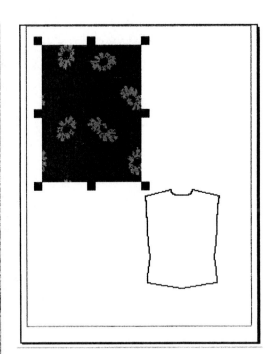

FIGURE 14-14

FIGURE 14-15

Skill Level: Advanced

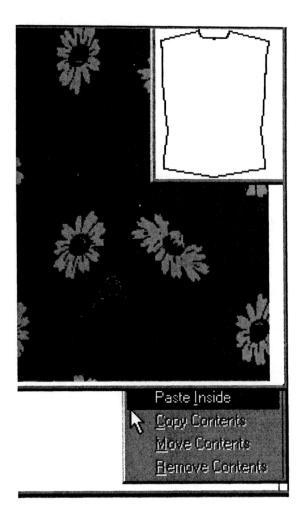

Paste **I**nside
Copy Contents
Move Contents
Remove Contents

FIGURE 14-16

FIGURE 14-17

FIGURE 14-18

Special Notes

Name and version of software used: _____

List additional steps you need to take to execute the program that was specific

to the software program you are using: _____

Biggest challenge: _____

What you learned that was new, and special notes on what you want to always remember: _____

Miscellaneous thoughts: _____

Draping

What Is a Draped Image?

Draping is a system of visualizing, rendering, and applying complex texture or surface interest to a two-dimensional or three-dimensional image. You will be using software that permits the designer to literally drape a digital fabric swatch onto a photo of a garment or other key fashion item.

Why would you do this? Because it saves time and money. Buyers or management around the country or the globe can preview lines before they are made.

How to Drape

According to Gerber Technology's Artworks Studio—Drape, the user defines masks and grain line grids around areas of a garment image. Once these have been defined, the user can place textures onto the image regardless of whether the image is two- or three-dimensional. Depending on the software used, the semantics of the terms used to describe the process can vary slightly. For example, another great software company that specializes in the drape technique is StyleClick (ModaCad/StyleClick). According to their sources, the drape window and process consists of the following elements:

- The canvas (the bitmap image)
- The parts and patches (the overlays on the canvas image accomplished in parts or patches)
- The map (showing the texture in an infinite repeat)
- The texture (the swatch)
- Modulation (contains grayscale version of canvas to indicate light and dark areas)
- The library (depicting thumbnails and descriptions of parts and patches)

The draping system can be used for a variety of different industries, including the fashion industry. The draping technique can replace sample products or costly prototypes with realistic photo simulations suitable for use in most marketing tools such as catalog storyboards and advertisements.

As you can see from the definition, draping takes masking to the next level. Best of all, this technique can work with a variety of vector (or flat illustrations), as well as with raster images that include several of the following file types:

Skill Level: Advanced

- .tga
- .tif
- .bmp
- .wmf
- .gif
- .pcx

Regardless of the file type selected, the computer can render the surface details of textures and finishes as well simulate shading, lighting, and perspective in minutes.

In the examples we show you work from two draping systems: StyleClick (ModaCad/ Style Click)'s, StyleClick (ModaCad/Style Click)—Drape and Artworks—Drape by Ned Graphics/Gerber Technology. While we realize that not everyone has access to industrial software, building on the understanding of the masking technique will enable you to follow along. Reviewing the basic elements of drape and the tools available, you will certainly get an overall grasp of how the technique is accomplished.

Each of these programs offers the fashion designer a variety of features to simulate a drape texture on an existing image. Both are easy to learn and use.

We will begin our tour of the draping technique by using the Gerber Technology Drape program from the Ned Graphics, Inc., Artworks Studio Suite software.

Basic Elements of and Tools for Draping

The tools are accessed from the Drape icon from the Artworks Studio Menu (Figure 14-19). Follow along as we walk you through the Artworks Drape Exercise: Draping a Fabric onto a Photograph.

FIGURE 14-19

ADVANCED

We have opted to take our usual tour of the menu and toolbar because they are similar to the techniques you have used in Adobe Photoshop. In fact many icons we will be using are very similar to the tools found in any raster-based software program.

Draping Technique

The Main Menu

From left to right, the icons represent the following (Figure 14-20):

☐ File Image Masks Surface Textures Drape View Options Window Help

FIGURE 14-20

Special Notes

Let's have a look at our main series of toolbars. Figure 14-21 shows the standard toolbar. From left to right, the icons represent the following:

```
Save, Paste, Print, Help, Anti-Alias Drape,
    Use Proportional Scaling, Choose Texture,
Redraw Screen, Temporary Drape, Permanent Drape,
    Zoom In, Zoom Out and Exit Current Menu
```

FIGURE 14-21

Special Notes

Figure 14-22 shows the Create a Mask toolbar. From left to right, the icons represent the following:

Special Notes

Figure 14-23 shows the AutoMask toolbar, From left to right, the icons represent the following:

FIGURE 14-22

FIGURE 14-23

ADVANCED

Marketing the Line

Special Notes

Figure 14-24 shows the Align Texture toolbar. From left to right, the icons represent the following:

Special Notes

FIGURE 14-24

Skill Level: Advanced

Figure 14-25 shows the Edit Mask toolbar. From left to right, the icons represent the following:

FIGURE 14-25

Special Notes

Figure 14-26 shows the Define Surface toolbar. From left to right, the icons represent the following:

Special Notes

Figure 14-27 shows the Define Repeat toolbar. From left to right, the icons represent the following:

Special Notes

ADVANCED

FIGURE 14-26

FIGURE 14-27

Skill Level: Advanced

Figure 14-28 shows the Define Scale toolbar. From left to right, the icons represent the following:

FIGURE 14-28

Special Notes

If you have the software, you are now ready to try your hand at the draping process.

Our first exercise is done using Gerber Technology's Artworks Studio—Drape. However, you will find that the icons, toolboxes, and menus may appear different from software to software. The concept of draping and the steps to achieve the process are usually similar.

We have opted to create the drape in a series of exercises because of the large number of steps involved. Although there are a large number of steps, they are simple in nature and relatively easy to perform. Our goal was to keep the steps or stages of the process short and understandable.

Exercise 14-8 Draping a Fabric onto a Photograph: Defining the Mask

Software Used

Gerber Technology's Artworks Drape

How-to Steps

1. From the file menu, select New Mask.
2. From the menu, choose the name of the photo usually saved as a TIFF (Figure 14-29).
3. First define the masks by choosing the masks menu.
4. Select Edit Mask.
5. Using the dotted line tool (this will remind you of using the polylasso tool in most raster-based software) (Figure 14-30), begin to trace around the fabric where you wish to apply your new texture. Be careful to be precise,

ADVANCED

FIGURE 14-29

 FIGURE 14-30

and also be sure to do one part of the garment at a time. For example, do sections one at a time—first the sleeves, then the collar; be sure you isolate related larger sections (Figure 14-31).

6. When you are satisfied with the outline, click on the thumbs up button.
7. A mask number will be assigned and added to the new mask list on the left of your screen (Figure 14-32).
8. Repeat steps 5 to 7 until the whole garment has been selected.
9. When you are satisfied, click on the exit door button to exit (Figure 14-33).
10. Name and save your work; use the native file format (.msk) extension.

FIGURE 14-31

Special Notes

Name and version of software used: _____

List additional steps you need to take to execute the program that was specific to the software program you are using: _____

Skill Level: Advanced

FIGURE 14-32

 FIGURE 14-33

Biggest challenge: _____

What you learned that was new, and special notes on what you want to always

remember: _____

Marketing the Line

477

Exercise 14-9 Draping a Fabric onto a Photograph: Defining the Three-Dimensional Surfaces

Software Used

Gerber Technology's Artworks Drape

How-to Steps

1. To add three-dimensional surfaces from the surface menu, select Define Surface (Figure 14-34).
2. Double click on any mask shape.
3. Be sure your three-dimensional surface is larger than the mask shape.
4. Click on the surface top button. Click points along the top of the mask, imitating the drape of the garment or fabric. Be sure to draw left to right. Click the thumbs up button when complete.
5. Choose the Surface Bottom button, repeating clicking points from left to right.

FIGURE 14-34

478

Skill Level: Advanced

6. Click the thumbs up button when complete.
7. Repeat steps 4 through 6, only this time use the surface left button.
8. Repeat again using the figure right button.
9. Now choose the draw grid button (Figure 14-35). If it does not look correct, feel free to go back and redraw the steps 4 to 8. It should look like Figure 14-36.
10. When you are pleased with your selection's appearance, click the thumbs up button.

11. Use the finger button (Figure 14-37) to select another section. Repeat steps 10 and 11 until you have completed your garment.

12. Select the exit door.

13. Select File and Save As to update your file (Figure 14-38).

FIGURE 14-35

FIGURE 14-36

FIGURE 14-37

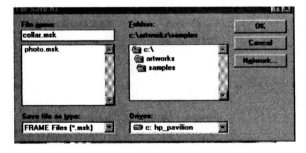

FIGURE 14-38

Special Notes

Name and version of software used: _____

List additional steps you need to take to execute the program that was specific

to the software program you are using: _____

Biggest challenge: _____

Marketing the Line

ADVANCED

What you learned that was new, and special notes on what you want to always remember: _____

Miscellaneous thoughts: _____

Exercise 14-10 Draping a Fabric onto a Photograph: Completing the Texture Drape by Define Repeat and Scale

Software Used

Gerber Technology's Artworks—Drape

How-to Steps

1. Continuing from Exercise 14-9, Select File, Open Texture (Figure 14-39) to select any texture you wish to add to your garment. This can be a sample file or it can be a previously created and stored fabric texture file tif.
2. You also have the option to select New File and choose a New Texture.
3. Select the Textures menu and choose Define Repeat (Figure 14-40).

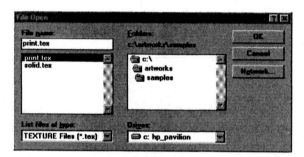

FIGURE 14-39

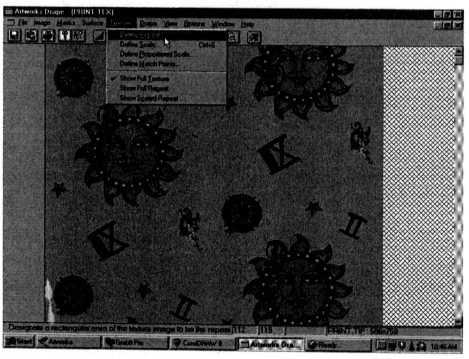

FIGURE 14-40

Skill Level: Advanced

4. There are several choices such as None (Figure 14-41) or ½ drop (Figure 14-42).
5. Click the thumbs up button.
6. Go back to the textures menu and select define scale (Figure 14-43). This will change by percentages. Select the eye button to view the new scale.
7. When you are satisfied, click the thumbs up button (Figure 14-44).

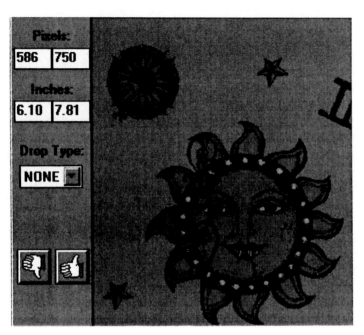

FIGURE 14-41

FIGURE 14-42

ADVANCED

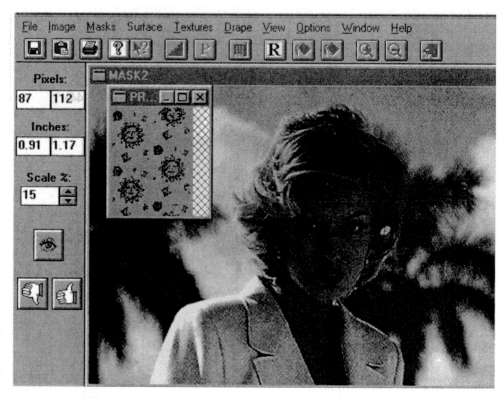

FIGURE 14-43

 FIGURE 14-44

Special Notes

Name and version of software used: _____

List additional steps you need to take to execute the program that was specific

to the software program you are using: _____

Biggest challenge: _____

What you learned that was new, and special notes on what you want to always

remember: _____

Miscellaneous thoughts: _____

Skill Level: Advanced

Exercise 14-11 Draping a Fabric onto a Photograph: Selecting and Applying Texture to a Drape Image

Software Used

Gerber Technology's Artworks Drape

How-to Steps

1. From the file menu, select Save Texture Info. Type in a new name and click OK.
2. Select the photo window by highlighting it.
3. From the main menu bar, select the mask menu and choose Select Draping Textures and highlight to select Row 1 (Figure 14-45).
4. Click on the Browse Button (Figure 14-46).
5. Select a .tex file and click OK (Figure 14-47).
6. Click Accept.
7. From the file menu, select Save Mask Info and Yes.
8. To apply the texture select the drape menu and choose Drape All Areas (Figure 14-48).
9. You may opt to click the yellow bucket icon (Figure 14-49), which represents "Preview of."
10. Select the gray bucket to represent "Permanent" (Figure 14-50).
11. When you are satisfied, and have made your selection permanent, from the file menu, select Save Image.
12. Give your file a new name to indicate that it is the final version.
13. From the file menu, select Exit. See Figures 14-51 to 14-53 for examples of what your work should look like.

FIGURE 14-45

FIGURE 14-46

FIGURE 14-47

FIGURE 14-48

 FIGURE 14-49 **FIGURE 14-50**

Special Notes

Name and version of software used: _____

List additional steps you need to take to execute the program that was specific

to the software program you are using: _____

Biggest challenge: _____

Skill Level: Advanced

FIGURE 14-51

FIGURE 14-52

ADVANCED

FIGURE 14-53

What you learned that was new, and special notes on what you want to always remember: _____

Miscellaneous thoughts: _____

Another great program that will enable you to use the drape technique is: StyleClick (ModaCad/Style Click) Textile Suite—ModaDrape. With functions similar to those we have just seen, ModaDrape performs the same drape technique as seen in Figures 14-54 to 14-56, provided to us by Meredith Rossi of StyleClick (ModaCad/Style Click), Inc.

One observation you may have made as you worked on our last project or on any drape program is the time it requires to master this technique.

Although it is not difficult to learn, it will take some time to become familiar with the sequence of steps necessary to perform the task. In addition, it will take some practice to become accomplished at outlining an area. A keen eye and a steady hand are needed to apply the new fabric, texture, or drape. This is especially true for those who

FIGURE 14-54

Skill Level: Advanced

ADVANCED

FIGURE 14-55

have had minimal exposure to or practice working with lasso and/or wand-like selection tools. Patience is the key and practice is the rule!

In fact, according to the StyleClick (ModaCad)—Drape tutorial handbook, it should take approximately 2 hours to complete the entire drape techniques series of exercises for the first time.

DRAPING PROCESS PRINCIPLES

We have adapted these concepts from the StyleClick (ModaCad/Style Click) Instruction Manual for you to review the draping process.

1. Begin to plan and build your project in stages; divide the image by parts and patches.
2. Trace as accurately and as close as possible to the original image.
3. Look for common borders or boundaries between parts.
4. Always build clockwise.
5. Edit and reshape as needed by using the following techniques: scale, rotate, move, or reposition to correct errors and distortions.
6. Open your texture or fabric file for placement of the drape.
7. Preview or do a quick render before final application of the drape; then make any final editing to distortions.
8. Always change or correct the scale of the fabric to suit the image it will be draped on.
9. Finally, in the case of multiple versions, render the new drape fabric versions to the image one at a time.

FIGURE 14-56

ADVANCED

Special Notes

We hope you can now see the benefits and the creative possibilities of using a draping program. In fact as we begin our next segment, you may wish to apply the draping technique or the basic masking technique to a swatch and photo for use in the production of a fashion catalog.

MAKING A FASHION CATALOG

In our next section we want to introduce you to the basics of producing a catalog. Like anything else we can turn to others for inspiration and insight on how and where to begin.

For starters let's take another look at the catalog example provided by Karen Kane, Inc. In Chapter 8, you were shown the front cover of one of the Karen Kane catalog's. In Figures 14-57 to 14-61, you can see the complete catalog in context. Note that next to each page we have provided you with space for you to jot down your observations on the use of the graphic design principles we covered earlier in this chapter.

The other observation we would like you to make is the use of white space for emphasis. Begin to jot down the program and the techniques you believe were used to create this catalog. As you do this, be sure to think about how you could produce a similar mock catalog to market your line. Begin to ask yourself, Was this done in a vector- or raster-based program? Can I use one or the other or would I like to use both? What principles of design were used? How important is color to my idea?

THE SUMMER 1999 COLLECTION

FIGURE 14-57

Special Notes

Skill Level: Advanced

FIGURE 14-58

Special Notes

FIGURE 14-59

Special Notes

ADVANCED

FIGURE 14-60

Special Notes

FIGURE 14-61

Special Notes

Skill Level: Advanced

Basics of Desktop Publishing

Using Electronic Publishing Software, also known as Desktop Publishing

Now, let's talk about working with the software that will tie everything together and help you create a fashion catalog using electronic publishing.

There are two kinds of electronic publishing: web and print. We will be introducing you to electronic publishing for print media. In this section will be introducing you to two different software programs that were especially designed to produce catalogs. Both of these programs are currently used in the fashion-design industry.

The first piece of software comes to us from Quark; it is called Quark XPress. This is considered one of the industry standard programs used in electronic publishing. In fact this software was used in the creation of this book. As we begin, please note that every reference to Quark and all trademarks noted herein are either the property of Quark or their respective companies.

The next piece of software we will review is an industrial program from Ned Graphics (Gerber Technology—Artworks Studio, known as Storyboard and Catalog). This software was expressly created with the fashion-design industry in mind. It is a very effective tool that lives up to its name: "Storyboard and Catalog."

Both of these programs can be considered desktop publishing or electronic publishing. But don't let the desktop publishing reference scare you off. Of course we understand your natural apprehension that this kind of work is typically performed by a trained graphic artist. However, more and more fashion designers are branching out their skills and expertise to include all phases of fashion design, including the marketing production end of the business.

Here again, the fashion designer who will go the extra mile and learn about electronic publishing has a distinct advantage over the one who does not. In the fast paced world of fashion and computer, if you snooze you loose.

Chances are, if you find yourself going in this direction, you will be using a version of one of these programs. The good news is that for much of this work you already possess the skills necessary to perform the tasks. Therefore, for some of you with strong marketing or graphics skills, this side of the fashion-design business can be very rewarding.

Knowledge of these programs certainly should help you command a better salary and position within a company. In fact, we recommended earlier that you should interview someone already successful in this field. We also suggest that you take additional course work or electives or consider doing an internship where you can learn more about this aspect of the design business. Why? Let's have a closer look at what you can produce using this kind of software.

Electronic Publishing with Quark XPress

Here with a list of what fashion designers can use Quark XPress to create:

- Catalogs
- Storyboards
- Mood or theme boards
- Personal promotion sheets
- Almost any other marketing aid

You can see the advantage to expanding your knowledge and expertise to include electronic publishing. From here we can move on to exploring the fundamentals of electronic publishing beginning with an overview of Quark XPress.

Overview

Quark XPress is considered an industry standard for professional electronic publishing. Quark XPress software is used by designers, artists, writers, typesetters, and document producers around the world. In fact, Quark XPress, we produced this book using Quark XPress.

For those of you who have never been introduced to any electronic desktop publishing software, it should be pointed out that this software assumes you know the following:

- How to launch an application
- How to use a mouse and keyboard
- How to work with icons, toolbars, and toolboxes
- How to access and use menus, dialog boxes, buttons, and fields
- How to do document and page layout, using text, frames, and graphics

Well then, the big question is, Are you familiar with those items? Can we give you a hint? You should have responded, "Yes"!

As you can see from this list, this software actually uses our concept-specific style of creating electronic publishing documents. Quark XPress assumes that because you have worked on other software that possesses similar functions and operations, you are now able to apply that knowledge to using Quark.

In earlier chapters you were introduced to the majority of these concepts. From there you began applying that information by doing the exercises.

By now, you are probably wondering about the specifics of how this software is similar, how it is different, and how it is best used by fashion designers. To respond to each of these questions, we will begin first with: How is Quark XPress similar to the other software you have seen up to this point?

Let's answer that question in pictures. Launch the Quark XPress program from the Quark XPress program icon now (Figure 14-62).

QuarkXPress
for Windows **FIGURE 14-62**

After launching the program you will have several choices, such as:

- New Document
- Book
- Library

Figure 14-63 shows what your Quark XPress main window should look like. Once you have opened the program, you have several selections you are familiar with from the main menu (Figure 14-64), such as:

> File, Edit, Style, Item, Page,
> View, Utilities, Window and Help.

Now, we will take a closer look at each of these pull-down menus. These menu selections are affiliated with the document environment. Many of these choices have accompanying subdialog boxes and menus.

We have provided ample space for you to jot down any observations you make on what each of these menus has in common with ones with which you are already familiar. You should have noticed on the main style menu in Figure 14-64 many familiar headings. You will see that several menu selections, such as the style menu, reflect choices that are synonymous with the text options you were introduced to in Chapter 5.

Take a closer look at each of the main menu selections depicted below, starting with Figure 14-65, the File menu.

Skill Level: Advanced

FIGURE 14-63

File Edit Style Item Page View Utilities Window Help

FIGURE 14-64

FIGURE 14-65 The file menu in Quark XPress.

Special Notes

Marketing the Line

ADVANCED

FIGURE 14-66 The Edit menu in Quark XPress.

Special Notes

FIGURE 14-67 The Style menu in Quark XPress.

Special Notes

Skill Level: Advanced

FIGURE 14-68 The Item menu in Quark XPress.

Special Notes

FIGURE 14-69 The Page menu in Quark XPress.

Special Notes

ADVANCED

FIGURE 14-70 The View menu in Quark XPress.

Special Notes

FIGURE 14-71 The Utilities menu in Quark XPress.

Special Notes

ADVANCED

Skill Level: Advanced

FIGURE 14-72 The Window menu in Quark XPress.

Special Notes

FIGURE 14-73 The Help menu in Quark XPress.

Special Notes

As you may have noticed, there are many features with which you have become very familiar.

Next, we will have a look at what Quark XPress offers that is different from what you have seen. The first feature we want to point out that we found very exciting is the Passport-Multilingual Version. As the name implies, this version of Quark XPress enables the user to create multilingual documents or projects.

There are other features, options, and terms that may be new to you. The first one we want to explain is the dialog box associated with the use of fields. The term *field* means an area that is a mathematical designation for a column, position, or area. The use of field math, according to the Guide to Quark XPress states: "it is the application's ability to accept math operators (such as +, −, /, and *) into the field of dialog boxes and palettes."

In these dialog boxes, the user will make an entry into the field that has a numeric value associated with it. This number can then correspond to an action that can make a rendering symmetrical or columns of text separated by precise mathematical intervals.

Anyone who has worked with software that performs math functions, such as database or spreadsheets, will be very familiar with this term. For electronic publishing this function can take the guesswork out of routine to complex page layouts.

The next list is of some of the basics principles of how to use Quark XPress to create a document. Most items generated, opened, or imported into Quark XPress go into a box. This includes:

- Text in text boxes
- Pictures or graphics in picture boxes

Next, from within a box, pictures or text can be controlled by the user to edit any of the following aspects:

ADVANCED

Marketing the Line

- Size
- Shape (proportion)
- Layers
- Color
- Other related properties

Also within Quark XPress, the user can opt to work with either original master pages or templates.

The work that is created, imported, or opened is manipulated by a method referred to as paste-up. Most electronic paste-ups in Quark XPress can be accomplished with mathematical precision using X and Y coordinates found on the Measure Palette (Figure 14-74).

FIGURE 14-74

An alternative method is found off of the Main Item menu, in the pop-up Modify dialog box (Figure 14-75). Here the user can alter each item separately by:

- Box
- Text
- Frame
- Runaround

FIGURE 14-75

- Also size
- Position
- Background color
- Other important properties commands

Special Notes

The most widely used menu selection is the main toolbox (Figure 14-76). From top to bottom, the icons represent the following:

```
Item, Content, Rotation, Zoom, Rectangle text box tool,
Picture box tool (with fly-out menu), Rounded corner tool,
Oval picture box, Bezier picture box, Line tool (with fly-
out menu), Orthogonal line tool, Line text path tool (with
           fly-out menu), Linking, and Unlinking
```

FIGURE 14-76

Special Notes

As we conclude our introduction to Quark XPress, we wish to point out that many of the features, options, and principles you have just covered will also apply to our next section using Gerber Technology's Artworks Studio, Catalog and Storyboard software.

As always, it is a good idea to take a moment to review your notes before we move on. You will find that these notes will come in handy because you will be building on these concepts in our concluding exercises.

GERBER TECHNOLOGY'S ARTWORKS STUDIO—STORYBOARD AND CATALOG

As you can see in Figure 14-77, the Storyboard and Catalog software icon can be accessed directly from the Artworks Studio main menu.

FIGURE 14-77

Special Notes

Figure 14-78 is an example of a full screen shot of a new project window.

Special Notes

Now we would like to acquaint you with the main menu toolbars and toolboxes of the Storyboard and Catalog program. Going from left to right across the main menu (Figure 14-79), the choices should be familiar. Notice that the menus in this program are layered in tiers across the top. Each has a series of choices starting with the main menu, which has several familiar titles including:

```
File, Edit, View, Insert, Format,
     Tools, Windows, and Help.
```

Special Notes

FIGURE 14-78

FIGURE 14-79

Figure 14-80 shows a tier menu called the standard object toolbar icons. Notice that it offers choices in 11 distinct series or groups of icons.

FIGURE 14-80

Tier 1: Standard Toolbar Menu

Group 1:

- New Document
- Open Existing Document

ADVANCED

Group 2:

- Page Set-up
- Print
- Zoom
- Send Mail

Group 3 (Editing):

- Cut
- Copy
- Paste
- Undo
- Redo

Group 4:

- View Page (pull-down menu)

Group 5 (Help):

- About Help
- Help

Special Notes

Tier 2: Objects Toolbar

Group 6 (Selection) (Figure 14-81):

- Select
- Apply Fabric
- Displace Repeat

Group 7 (Drawing):

- Straight Line
- Rectangle
- Oval

Group 8 (Insert):

- Text
- Image
- Fabric
- Article
- Object Easy Map
- Object Easy Weave
- Rotate

FIGURE 14-81

Special Notes

Tier 3: Books Toolbar

The next row or menu tier in Figure 14-82 represents the main toolbar icons, going from left to right and top to bottom:

FIGURE 14-82

Group 8:

- Open Picture Book
- Open Fabric Book
- Open Article book
- Open Easy Map (3D)
- Open Easy Weave
- Open Texture

Group 9 (Arrange Window Layout):

- Cascade
- Horizontal
- Vertical

Group Number 10 (Window Display Options):

- Rulers
- Grids
- Color Atlas

Tier 3: Text (Figure 14-83)

Group 11 (Text):

- Font Family
- Style
- Format

FIGURE 14-83

Special Notes

It is important to become familiar with each of these icons before moving on to the next section. We suggest that if you have this software, you take some time to experiment with each of them in detail before we actually begin to construct a catalog.

ADVANCED

INDUSTRIAL-BASED DESKTOP PUBLISHING

In this section we will introduce you to the Storyboard and Catalog software from Ned Graphics, Inc./Gerber Technology. While researching this segment we spoke with one of the top trainers for Gerber, who shared with us several tips and tricks you may want to apply when generating your fashion catalog.

One of the best features of the Storyboard and Catalog program is the drag and drop option. Notice in Figures 14-83 and 14-84 that you can see the open Picture Book pop-up menu choices to the far left of the screen. In the center of the screen, the cursor indicates the drag and drop positioning of the photo selection made. This feature, along with the ability to edit the fabric, color, and many other choices make designing a storyboard or a catalog a breeze.

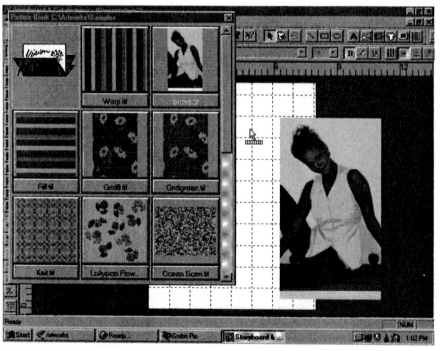

FIGURE 14-84

Are you ready to put all this knowledge to good use? Well, no surprises here—now it's your turn. You get to begin to make your very own catalog based on your observations and the skills you have mastered.

In the following exercises you may opt to use any of the software packages we have just introduced you to or any comparable software. You would do well to go back and review in Chapter 5 planning, service bureau questions, and file formats. The key to electronic publishing is planning.

Skill Level: Advanced

Challenge Exercise 14-12 Create a Fashion Catalog

Software Used

Quark XPress, or Gerber Technology's Artworks Studio—Storyboard and Catalog, or Adobe PageMaker, or StyleClick (ModaCad/Style Click)—ModaCatalog or any comparable desktop publishing software.

How-to Steps

1. You should have several photos of garments to be scanned; you may opt to use magazine photos as examples for your catalog.
2. Select the layout, size, resolution, etc. for each of the pages of your catalog. We suggest you save one file for each page.
3. Be sure you choose an appropriate font to enhance your work.
4. We also suggest you insert/import or create a logo to be used in the headline.

Additional Comments

Don't forget to look back at the sample provided by Karen Kane, Inc. Also, don't hesitate to refer back to any of the previous chapters and your notes for performing a given task. Figures 14-85 to 14-86 are examples provided by Ned Graphics, Inc./Gerber Technology, using the Storyboard and Catalog program.

As we said earlier, there is a wide variety of software available that will perform similar desktop or electronic publishing functions to those we have seen in Quark XPress and in Gerber Technology's Artworks—Storyboard and Catalog. This final example (Figure 14-87) is from Meredith Rossi of StyleClick (ModaCad/Style Click) using ModaCatalog.

For your catalog, brochure, or storyboard, make additional notes in the space provided.

FIGURE 14-85

ADVANCED

Visual Merchandising GERBER TECHNOLOGY

FIGURE 14-86

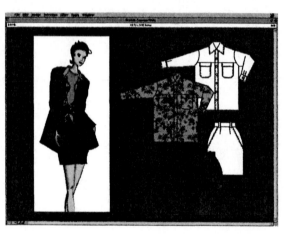

FIGURE 14-87

Special Notes

Name and version of software used: _____

List steps you took to locate these options that are specific to the software program you are using: _____

Biggest challenge: _____

What you learned that was new, and special notes on what you want to always remember: _____

Miscellaneous thoughts: _____

Well, how did you do? We bet you did great!

Skill Level: Advanced

CREATING A PERSONAL PROMOTION PIECE

Before we say farewell, we have one final exercise. Here, we would like to show you one last marketing aid you really want to know how to produce: a personal promotion sheet. This can be part miniportfolio and part mini-resumé. In it we recommend that you draw on all the skills you have garnered and all the knowledge you have acquired to produce one final piece that will really take you places.

In this concluding assignment, it is your choice to use any combination of software that you have available to produce a promotional piece on your most marketable asset—YOU.

What better way to conclude your journey, than to showcase your talents and skills in a personal promotion piece?

We have provided you with the basic steps you will need to generate a successful promotional card. We will start by giving you some suggestions for the layout and production of a personal promotion piece. From there, we will offer some practical marketing advice on the informational elements this project should include.

In addition, we have also included an example from a recent fashion-design graduate: Margarita Kiang.

This project is a great tool to really set you apart. It can be used at your portfolio review or as a handout to prospective employers or clients.

We know you will really enjoy this final assignment. Feel free to make it as creative as you are, but be sure that is constructed in a professional manner that will be well suited to your intended audience.

The following is a list of items you will want to consider including in your personal promotion sheet:

1. Your photo
2. A brief bullet-style bio of your skills and accomplishments. This can be either chronological, if you are showcasing time and industry experience, or functional, if your are showcasing your skills but have little industry experience.
3. Be sure you qualify and/or quantify your skills or experience. Be sure to mention people skills, not just computer skills.
4. It is not necessary to show your GPA unless it is over a 3.5; also avoid personal data or statistics.
5. Include samples of your work.
6. Be sure your font selection, clip art, scanned work, and digital work use the principles of design covered earlier in this chapter to send a clear, consistent message.
7. We suggest you use any combination of techniques to best showcase your talents.
8. The final product should be on the best-quality printer and paper stock you can afford. First impressions count.

Additional Comments

- Be sure you use the correct jargon when describing your computer savvy.
- Use action verbs and short concise descriptions of your areas of specialization.
- Don't offer personal information, but do offer to provide references, a list of clients, or access to further examples of your work.
- Don't forget to mention if you are bilingual.
- Avoid making the profile sheet looking too generic. Instead, construct your profile sheet to attract the job and/or the type of company you want to work for. For example, if you wanted to work for a higher-priced, updated-styling misses manufacturer, you would not make your profile sheet look like all you can design is for trendy, popular-priced juniors.
- Use the computer to generate a piece that would be a reflection of the work you could do for the company you want to work for! Got it?

ADVANCED

■ Finally, like an ad or newspaper article, did you answer all the readers possible questions about you and your skills? Remember the old who, what, where, when, why, and how questions? Be sure you answer them in words or images.

■ Be creative, not shocking.

■ Be sure to use an address and contact point that is unlikely to change in the next 6 months to a year, just in case your card is kept on file.

Let's look at an example of what we mean (Figure 14-88).

Special Notes

Name and version of software used: _____

List steps you took to locate these options that are specific to the software program you are

using: _____

Biggest challenge: _____

What you learned that was new, and special notes on what you want to always remember:

Miscellaneous thoughts: _____

FIGURE 14-88

Skill Level: Advanced

Can you believe we have finally come to the end of our journey? For 14 chapters we have been putting you through your paces to see what you could learn. And now, indulge us as we reflect on what you have seen and what you have learned.

You will see in our list below, we have made every attempt to provide you with the tools and skills you will need as you move into this next century filled with promise, challenge, and change.

- In Chapters 1 through 5 we refreshed your basic computer knowledge and shared the secrets of what computer experts know.
- In Chapters 6 and 7 we covered what computer graphic designers know.
- In Chapters 8 and 9 we showed you what top fashion designers and researchers know.
- In Chapter 10 we covered what photographers who use computers know.
- In Chapters 11, 12, and 13 you learned what the computer fashion and textile industry insiders know.

Now, in our concluding chapter we have shown you some of what fashion marketers, desktop publishers and graphic artists know.

Well, are you now ready to put us to the test? Have we done our job? We think so! We have literally taken you around the world of fashion design on computers, building line upon line, precept upon precept, preparing you to meet the challenges of the new millennium. We hope you have enjoyed your journey.

Our final advice is one last proverb, "Don't despise small beginnings." It is OK to be slow, or even feel slow, in the grand scheme of things "it does take along time to comprehend all this information" but in the long run it will be worth the effort and investment of your time.

On a personal note, I remember when I began designing, I used to make so many mistakes I thought my middle name was "Rip" (You know, a cross between "All I do is take my work apart and do it over" and "This feels like it is going to kill me!" as in Rest in Peace! Ugh!). So don't get discouraged!

Always remember our real-life examples in Chapter 8. There is an old saying, "A man's gifts make room for him." You have to admit that this was certainly the case for both Karen Kane and Pamela Dennis. The fashion world really made room for their gifts and talents. And there will be plenty of room for yours too.

When you begin to really consider this advice and what it means to your world of fashion, you may just discover that they are akin to other unshakable principles, such as gravity. Applying these principles can really hold your world together!

One last word of encouragement: Don't settle for a career, go for *your* destiny! And don't ever give up. If it is your destiny, we believe no one can keep you from it, not even you!

And finally, probably the best advice and conclusion we could use comes from a famous motivational speaker, and it really rings true: "We really do hope we see you at the top!"

All the best,

ADVANCED

Chapter Summary

In our concluding chapter, as a fashion designer, you can now apply all your skills and techniques, including several new ones, to create fashion-related promotional tools.

As a designer you will be expected to generate thumbnails, templates, and ultimately, camera-ready promotional pieces for fashion.

Examples of the most widely used fashion promotional tools are: logos, hang tags, business cards, labels, worksheets, workboards, and catalogs. Each of these tools can be created on either commercial or industrial software.

Typically, renderings are generated in vector-based software, while real-world images are prepared in raster-based software. However, fashion designers frequently prefer to use both kinds of software for presentations.

Some of the hot techniques used to showcase fashion are the techniques of masking and draping. Each of these techniques can apply a proportional design to an existing image such as a croquis, garment flat, or a photo to simulate actual fabric.

Today's designers must combine the skills of a graphic artist, the savvy of an advertising specialist, and the business know-how of a fashion marketer in order to create salable fashions and understandable marketing tools used to promote those fashions.

Finally, we see that in addition to promoting fashion, the fashion-design student must learn and apply the secrets of promoting their talents and skills to land a job. Internships, mentors, informational interviews, and computer-generated personal promotion pieces are all useful in preparing for a great fashion future.

ADVANCED

INDEX

Intranet, 207
Irregular polygon lines, 154
ISP. *See* Internet service provider
Item lines. *See* Line(s)

J

Jacquard, Joseph Marie, 406, 442
Jacquard knit
 definition of, 350
 simulating paisley motif into, 383–385
Jacquard woven pattern, 406, 408
Jersey knit, 350
Jobber, definition of, 200
Johns, Joni, 351
Jointed lines, 151–152
Jonathan Logan Company, 445
JPEG file format, 73, 257, 449

K

Kane, Karen
 background in fashion design, 194–195
 sketches made by, 196
 work sheets, 197
Karan, Donna, 205
Kerning, definition of, 130
Keyboard, computer, 32–33
Key items, definition of, 200
Key resource, definition of, 200
Kiang, Margarita, 454, 507
KISS, 130, 256, 452
Klein, Calvin, 14, 15
Knit(s)
 Atlas, 392–393, 395–396, 398–399
 circular, 347
 designing, 386–390
 double, 348
 flats, 347
 jersey, 350
 pile, 350
 pique, 350
 re-creating and converting motifs for
 use in, 380, 383
 warp, 347
 weft, 347, 350
 vs. woven fabric, 347
 as yard goods, 347
Knitted Textile Association, 247
Knitters, contract/direct, 347
Knitting
 definition of, 201, 347
 terms, 348–350
Knitting Times, 209
Knock-off, definition of, 201

L

Lab color image mode, 251
Label, definition of, 201
Labor practices, meeting marketing
 regulations and, 210
Landscape, definition of, 25

Langa, Fred, 222
Lappet fancy weave, 406, 407, 408
Lasso tool, 178
Layer(s)
 concept of, 335
 definition of, 130
 importance of using, 334
 masks, 449
 option, functions of, 335
 techniques for working with, 258
Leather Apparel Association, 247
Leather Industries, 247
Leno fancy weave, 406, 407, 408
Lerner, Richard, 351
Letter, rotating/dropping, 116–118
Libraries, researching fashion trends
 through, 235
Licensed software, definition of, 25
Licensing, definition of, 201
Light pen, definition of, 130
Line (collection)
 definition of, 190, 193, 201
 factors to consider for designing,
 192–193
Line(s)
 art, 130
 compound, 149–150
 Bezier curve, 153
 B-Spline, 152–153
 curved, 152
 freehand, 153–154
 irregular polygon, 154
 jointed, 151–152
 definition of, 130
 design, 308
 drawing icon, 154–155
 graph, 353
 simple, 149, 154–158
Line-for-line copy, 201
Line segment(s)
 adding, 159–160
 call-out option for editing, 158–159
 deleting, 160–161
Linsk, John, 195, 445–447, 458
List box, definition of, 25
Locating
 clip art, 291–292
 drawing tools, 81–83
 pattern fills, 298, 300, 302, 305
 rendered woven fabric sample,
 434–436, 438
 text, 100, 102–103
Logo
 definition of, 201
 designing, 122, 460
Loom, definition of, 403, 408
Loop, definition of, 408

M

Mac platforms, 14–15
Magic wand tool, 179
Magnetic tape, definition of, 25
Managing, text, 99
Manufacturing. *See* Production
Mapping, 468
Marker, definition of, 201

Market(ing)
 aids, 444, 510
 computer's role in, 10–11, 211, 446,
 451–453
 considerations for promoting prod-
 ucts and, 189
 creating personal promotional piece
 and, 507–509
 definition of, 201
 impact on designers, 188–189
 mix, 188, 189
 plan, sources for developing, 209
 primary, 201
 principles, 206, 451–453
 regulations, labor practices and, 210
 research for effective, 211
 sales representatives and, 446
 sourcing concept and, 204–206
 target, 202
 terms, 190–191, 199–202
 understanding consumer buying
 power and, 204, 208
 web sites related to, 225–228
 weeks, 446–447
Marquee, 95, 109
 definition of, 130
 option, using, 87
 tool, 178
Mask(s)
 creating, 464–465, 467–468
 definition of, 130
 layer, 449
 techniques for working with, 258
Matching system, 252, 282
McGarry, Patrick, 352
MDS Color Management System, 354
Meller, Susan, 288, 329
Memory, definition of, 25
Men's Apparel Guild of California-
 MAGIC, 247
Mentors, searching for, 453
Menu
 bar, 25, 139
 definition of, 25
 object format, 139
 pull-down, 26
 Repeat Generator, 338
 standard toolbar, 501–502
 view, 137
Merchandise Coordinators, 446
Message box, definition of, 25
Metacreations' Painter
 drawing tools in, 169–170
 experimenting with basic tools in, 176
 exporting color palette in, 268–269
 locating rendered woven fabric
 sample in, 435–436, 438
 opening color palette in, 271
 opening file in, 171, 173
 tools and brushes in, 175
 tracing color images, 325–327
 viewing tools in, 173–174
Meta Search Engine, 219
Micrografx Designer. *See also* Vector-
 based programs
 clip art structure in, 289
 exercises with
 adding/deleting anchor points,
 164–165